UNDERSTANDING
GRAFFITI

UNDERSTANDING
GRAFFITI

MULTIDISCIPLINARY STUDIES
FROM PREHISTORY TO THE PRESENT

EDITED BY

TROY LOVATA & ELIZABETH OLTON

Routledge
Taylor & Francis Group

LONDON AND NEW YORK

First published 2015 by Left Coast Press, Inc.

Published 2016 by Routledge
2 Park Square, Milton Park, Abingdon, Oxon OX14 4RN
711 Third Avenue, New York, NY 10017, USA

Routledge is an imprint of the Taylor & Francis Group, an informa business

Copyright © 2015 Taylor & Francis

Library of Congress Cataloging-in-Publication Data:
Understanding graffiti: multidisciplinary studies from prehistory to the present / edited by Troy Lovata and Elizabeth Olton.
 pages cm
 Includes bibliographical references.
ISBN 978-1-61132-867-7 (hardback) –
ISBN 978-1-61132-868-4 (paperback) –
ISBN 978-1-61132-869-1 (institutional eBook) –
ISBN 978-1-61132-870-7 (consumer eBook)
 1. Graffiti—History. I. Lovata, Troy, 1972- II. Olton, Elizabeth.
GT3912.U53 2015
080—dc23
 2015008320

ISBN 978-1-61132-868-4 paperback
ISBN 978-1-61132-867-7 hardback

CONTENTS

ILLUSTRATIONS

INTRODUCTION

ELIZABETH OLTON + TROY LOVATA

W e, the editors of this volume, share an interest in the varied functions and contexts of graffiti. We come from differing training and experience: Lovata is an anthropologist/archaeologist; Olton is an art historian. When we began to formulate this book, we found ourselves separately teaching about images, culture, and graffiti in the explicitly interdisciplinary Honors College at the University of New Mexico. The Honors College asks faculty to generate their own curricula based on individual experience. No specific text lists are required, nor are specific courses taught unless faculty in the College proposes them. We were asked to be experts and use our expertise as we saw fit. We—as our own entries in this volume show—were separately interested in understanding the practice and function of graffiti. Our individual circumstances also showed us that the topic was much larger than any single field or methodological approach. In our ensuing conversations, it became clear that each of us was synthesizing diverse resources, diverse data, and diverse approaches to the study of graffiti, and pushing our students to do the same. Juxtapositions of graffiti, images, and texts stirred multiple questions, research projects, and understandings. Separately, we concluded that graffiti—a form of expression both ancient and modern, public and private—is a medium of communication that crosses boundaries among academics, cultural theorists, public policy experts, and laymen. Understanding graffiti requires a broader perspective of the contexts of this expression, as well as more inclusive working definitions of its forms, both in research and in teaching.

Much of the extant literature on graffiti is centered on the history of the form or a typology of inscriptions or art styles. Work based around problems or themes that highlight diverse contexts, histories, and styles of graffiti is rare in the prevailing literature.[1] We found these chronologies, descriptions, and hagiographic artist/writer biographies insufficient to teach this topic in an interdisciplinary setting. Against this backdrop, we proposed this volume. Our aim is to show how insightful scholars from different disciplines and

perspectives approach and understand graffiti. Rather than defining what graffiti is or is not, the following 15 chapters demonstrate the varieties of contemporary practice in analyzing the expression (known as graffiti). This introduction and the brief guides that precede each section are intended to help the reader synthesize the varied case studies included in the volume.

Graffiti by its nature is cross-disciplinary; a breadth of research underlies its universal appeal and its efficacy as a form of communication. Expressing oneself through visual narrative, symbolic languages, or iconic marks is a tool in our quest as humans to make sense of the world and ourselves. Today, the act of scrawling phrases in spray paint over a surface does not always engender praise. Nonetheless, these unsanctioned messages have become embedded in the visual culture of the late twentieth and early twenty-first centuries. Scholars know that erasing graffiti with swaths of white paint will not stop this expression; graffiti writers will merely adapt their texts and morph their imagery to new contexts and other surfaces. Incising an image or phrase on a wall, tree trunk, or fresco; painting a billboard or a train; and reshaping stone are socially embedded acts that invite the viewer to engage in a dialogue (Baird and Taylor 2011). Experiencing these texts changes viewers; it asks them to see differently.

"Symbolic Destruction of Social Relations"

The concept of vandalism in the form of spray can markings and contemporary ordinances banning the practice evolved in New York City in the late 1970s. Contrasts between brash colors, black contour lines, and compressed scripts were hallmarks of the "wildstyle" from almost 40 years ago, a style that continues to this day. The rapid proliferation of this aggressive style of writing appearing on the walls of urban centers all over the world has become an international signifier of rebellion.

In 1993, cultural theorist Jean Baudrillard described the graffiti of New York City as a positive, if not revolutionary, act, calling it the "symbolic destruction of social relations" (Baudrillard 1993, 77). Baudrillard took pleasure in the leveling effect on social mores induced by the tags and wildstyle calligraphy he saw in subway tunnels. He cheered their subversion of official signs and the chaos that ensued. The pervasive, repeated marks that he found aggressively painted on walls and trains were largely unintelligible to Baudrillard. Thus, they became "empty signifiers" and, for a poststructural semiotician, they symbolized an act of war that bombarded the banality and excess of late twentieth-century life.

By its very nature, graffiti is subversive because it is applied to a surface where it technically does not belong, changing the built environment (Frood 2013, 287). Daniell (chapter 14 of this volume) provides a more legalistic definition of graffiti as something "where no permission has been given by the owner . . . and damages any property belonging to another." Graffiti is omnipresent in both the built and natural environments of virtually every country and culture in the world (see Lovata in chapter 6 of this volume for a study of graffiti on trees in wilderness settings). This universality makes it hard to define. Like quicksilver, it is not easily contained. Its malleability is both its strength and its weakness. The very presence of graffiti on a wall or on a train, incised on architecture or inside a church, scrawled on a bathroom stall, displayed in a gallery, or seen among ancient ruins, allows it to become a catalyst for dialogue and controversy. When graffiti in these many contexts are juxtaposed, as they are in this book, graffiti becomes a complex expression that can be explored as a cultural document and as a witness to human experience that rarely coincides with dominant cultural narratives. Instead, it tends to run parallel to or intersect at hard perpendiculars to such narratives.

Graffiti itself is a polyvocal medium. It is composed of ideas, expressions, and emotions translated into brief written phrases or visual codes with fluid meanings. Baudrillard enjoyed the visual anarchy of New York City in the 1970s, but the "nonsense-forms" he identified actually had significant meanings for those creating these tags. In at least one sense he was right: graffiti in New York did start a revolution that was related to past "unofficial" expressions, and yet it gave birth to a wholly different visual text. Explaining the value of these expressions through cultures past and present—including examining their context and meaning—is part of this book's mission.

Context and Form

Graffiti, as a meaningful visual expression or text, is almost entirely dependent on two elements: context and form. For example, an artist crafting latrinalia on bathroom walls is speaking to a smaller audience than a graffiti writer who goes "all city" using a can of spray paint on a moving train. Similar-scaled differences hold true when examining arborglyphs found in the forests of southern Colorado and northern New Mexico, ancient Maya palace graffiti, and personal commentaries found scratched into early sixteenth-century frescos from a church in northern Italy (all examples from this volume).

Graffiti can be seen as a parallel text within a culture. It is composed of signs that are inspired and shaped by societal context and physical environment. Graffiti, like written language, can be read as a text that communicates meaning through its composition, style, and use of syntax. However, graffiti can also be analyzed though its forms and designs. Formal visual elements are characterized by the qualities of lines, colors, shapes, textures, and patterns. The size and scale of a piece, relative to its physical environments, affects how a viewer reads and experiences graffiti. Understanding the subject of a particular graffito, inscription, or image is more subjective; these expressions are driven by emotions and are often spontaneously made, but they can also be carefully planned texts with sober messages. Scholars and civic leaders alike will stumble over interpreting the messages of these works, modern and ancient, whose meanings can be direct or ambiguous. Swaths of paint, carved marks, and scratches might be seen as defacement, as clever, or even as artistry. Graffiti is contradictory; graffiti can be at the same time a snapshot, a witness of human experience, and an archive of these experiences.

Graffiti can be considered a form of communication that is an unedited mirror of culture. Explored in this way, it is a separate genre of expression occupying a unique place in the study of texts and images. Graffiti is related to drawing, painting, the graphic arts, pictographic communication, hieroglyphic writing, and calligraphy. Humans may have communicated first through sound, then speech. Later, experiences became codified, archived, and open for interpretation when these expressions, emotions, and ideas were translated into signs and visual narratives. Historically, graffiti—in the form of carved marks, scratches, tags, and inscriptions—has been dismissed as the musings of societal outcasts or belonging to the visual detritus of urban life. Yet these largely anonymous expressions complicate and challenge our understandings of built environments and the official narratives these structures convey. In transforming our past and our notions of self into universally coded and shared histories, little room has been left for alternative forms of storytelling and of archiving information. The graffiti examined in this book are representative of these other expressions and other narratives: some quiet and some loud, some shared widely, and some intended for just a few. Their omnipresent existence in ancient, historic, and contemporary life shapes how we define public space, official stories, and vandalism.

Many chapters in this book present new interpretations of old imagery such as arboreal graffiti, ancient graffiti, "burners" on subway cars, latrinalia, carved rocks, inscriptions on army barracks walls, and writings on sacred saints' portraits. Theoretical tools culled from cross-disciplinary sources

along with close examinations of form, context, and subject matter has inspired these re-readings of texts, which were dismissed previously as mere vandalism. Other chapters in this volume examine contemporary spray can art and stenciled imagery as an evolving genre with complex forms that, upon close inspection, reveal surprisingly impassioned and intimate messages. This colorful and, at times, virtuosic imagery challenges the role of the curator and collector. These expressions were illegally produced, yet they have become historic markers of their times. Examples in this book include wildstyle-painted subway cars, the marring of advertisements and billboards, slogans surrounding Tahrir Square in Cairo, inscriptions in the Love Tunnel at the Nevada Test Site and the Toronto Brickworks, and the mythic imagery from the neighborhood of Regina 56 in Mexico City. The interplay between material culture, imagery, and the physical environment is traced in voices of protest carved a millennium ago on palace walls from the Casma Valley in western Peru and in a prehistoric image of the horseman from the Carpathian Mountains in Romania. Chapters addressing the historiography of "vandalism" in the form of spray-can writing and a critique of graffiti exhibited in commercial galleries examine new ideologies of graffiti scholarship, providing an additional anchor from which to explore this phenomenon.

Graffiti as Dialogue

Graffiti is a genre that invites dialogue. The four sections of this volume that follow request a conversation between the authors and the reader. These conversations address the function, form, context, and politics of graffiti, and how graffiti can serve as a witness to history. The chapters within each section range from contemporary to historical to ancient. The authors show that viewing graffiti can be transformative, didactic, and disturbing. They highlight the visual codes, unusual semantic structures, imagery, colors, and media unique to a culture or subculture in creating and codifying meaning. Graffiti conveys an emotional immediacy that is valuable both for those inside a subculture and for the outsiders, including those who study it. Ironically, these essential anarchic features also make it a target for devaluation and erasure. We deliberately chose the word "understanding" for our volume and its subsections to invite thoughtful analysis and dialogue of the phenomenon of graffiti.

In a genre that is often remarkably stable in form and tone, graffiti is also continuously evolving and presents scholars with many unknowns. The value of graffiti as an intimate, sub-rosa human narrative will be better

understood and valued through rigorous investigation. We are grateful to the authors of these chapters for introducing us to their fresh takes on this ancient visual language. Their individual studies contain powerful claims and intriguing questions that, when juxtaposed, create a dynamic collection of research. Experiencing these texts might well change a reader, as the content and analysis from these chapters encourages a change in perspective regarding graffiti. In short, graffiti is yet another tool in our quest to make sense of—to understand—our world and ourselves.

SECTION I
UNDERSTANDING THE FUNCTION OF GRAFFITI

Scholars examining graffiti often face two daunting but ultimately essential tasks: first, they must come to an understanding of how they and others actually talk about graffiti and how this reflects the ways people conceive of such visuals. Second, they must use that knowledge to determine and declare the value of studying graffiti. They must confront the parallel and perpendicular nature of graffiti in contrast to larger art historical, aesthetic, and social narratives. The authors in section I of this book use a variety of approaches to explore the forms and meanings of this expression. These four chapters—which include two chapters examining messages embedded in latrinalia, a chapter examining historic narratives scratched into frescos from a church, and the recent expressions of conflict and rage seen in Tahir Square, Cairo—provide a cross-disciplinary perspective on graffiti. By speaking in both general terms and focusing on specific types of graffiti, the authors also provide examples of the unique function and value of graffiti.

Understanding how fundamental graffiti is to the human experience is a recurrent theme throughout this first section of the book. In chapter 1, Amardo Rodriguez examines graffiti's origins and looks at its reception within academia and how it has been investigated. He helps to define graffiti by questioning our a priori assumptions—both modern and ancient—as just

vandalism or purely low-level markings. He shows how graffiti can communicate a voice of protest as well as affirmation, and that its presence in the built environment can effect change, counsel, mentor, and create dialogue between individuals or groups. Rodriguez specifically considers subcategories of graffiti, such as bathroom inscriptions or latrinalia, and explains how the physical context of these expressions often informs the subjects of the texts, which are anonymously written, cover private feelings, and reveal provocative topics.

Like the game Exquisite Corpse, a supposedly static word or form will, over time, be transformed according to the needs of the writer. In chapter 2, Melissa Meade complements Rodriguez by targeting her analysis on one group of graffiti from the women's bathroom in the basement of the Van Veldt Library at the University of Pennsylvania. She looks at one provocative trope written on a stall wall and compares it with the extensive responses "clustering" and dialogue spawned by this one seemingly flip comment. Rodriguez and Meade successfully argue that far from being vulgar and thoughtless, inscriptions from bathroom walls transform a private and anonymous environment into a meeting place mediated by a wall, where often-serious concerns are honestly expressed.

In the following chapters, Véronique Plesch (chapter 3) and John Lennon (chapter 4) similarly ask us to questions our assumptions about graffiti; however, they are each working with vastly different forms from the mid 16th century to the late 19th century. In the Piedmont region of Italy, Plesch documents the graffiti scratched onto a series of frescos within a small town church. When examined in aggregate, these small ad hoc inscriptions can be seen as an unofficial history of the town. The texts and pictures recount famine and sickness as well as less-destructive events. Plesch also notes a relationship between the frescos' subjects and the subjects of the graffiti; in this way, the written expressions have a relationship to the images and are not merely random. Lennon focuses his discussion on "conflict graffiti" from Egypt. Graffiti created during the Arab Spring was transformative for local viewers and globally transported via the Internet, thus becoming an ever-changing global text. A YouTube video made in 2012 during the Tahrir Square uprisings concludes with the poignant phrase, "Egypt is changing, witness her growth" (Hijabi Fierce 2012). The video depicts colorful, graphic narrative pieces that refer to both pharaonic Egypt and the Egypt of 2012. Lennon observes that Egyptian graffiti writers have moved from a vulnerable subculture to a concretized public voice of protest and comment. These two case studies place graffiti in the center of their investigations of human expe-

rience. Plesch, an art historian, gently challenges the history of art that ig-nores the subtexts scrawled on paintings and walls. Meanwhile, Lennon ex-plores the rich complexities of contemporary Egyptian graffiti, a visual nar-rative that borrows from the visual culture of ancient Egypt and integrates it with commentaries from today. Rodriguez, Meade, Plesch, and Lennon all demonstrate through a variety of perspectives and contexts why graffiti is valuable as both a local phenomenon and as a poignant mirror of human ex-perience.

CHAPTER 1

On the Origins of Anonymous
Texts That Appear on Walls

AMARDO RODRIGUEZ

Although scholars have been studying graffiti found in nearly all possible venues, bathroom graffiti, or latrinalia, has received a fair amount of scholarly attention because the privacy made possible in bathroom stalls assures the highest degrees of anonymity and also allows us to explore differences in how men and women relate, consume, and produce graffiti. However, in highlighting many diverse theories and methods of inquiry, certain questions remain; for example, why do human beings produce, engage with, and validate these marks on walls? Queries about how the context affects the function and meaning of graffiti or, more specifically, latrinalia, deepen our understanding of this very human practice. (In chapter 2 of this volume, Melissa Meade explores latrinalia from a women's bathroom and engages with questions of identity, metaphor, and communication.)

Graffiti are a phenomenon driven by the need to express a proscribed opinion, thought, or experience. Graffiti allow the key benefit of anonymity, which protects the writer from retribution. Any person can say whatever, however, and whenever, to whomever. In fact, graffitists acknowledge this benefit: "It's a chance to vent frustrations, to say things you wouldn't dare speak up about . . . because sometimes you feel like letting the whole world know how you're feeling w/out [without] giving yourself away" (Fraser 1980, 258, 260). As an anonymous and democratic expression, the lack of explicit rules and protocols allows people to express themselves in many different ways; usually, there are no rules. Accordingly, graffiti level the playing field by getting past factors of privilege, such as social status, ethnicity, education, skill, and experience. It is the only rhetorical form that affords such egalitarian virtues (John Lennon in chapter 3 explores how graffiti can inspire social

Understanding Graffiti edited by Troy Lovata & Elizabeth Olton, 21–31. © 2015 Taylor & Francis. All rights reserved.

and governmental change while Véronique Plesch in chapter 4 examines the unofficial and parallel nature of its narratives).

As Bruner and Kelso (1980, 241) note, "Although written in the privacy of a toilet stall, the writing of graffiti is an essentially social act. . . . To write graffiti is to communicate; one never finds graffiti where they cannot be seen by others." Moreover, graffiti function as a reliable and unobtrusive means to identify latent conflicts and grievances. For instance, the increasing incidences of racial graffiti on college campuses suggest that students are using graffiti to express their sentiments on race issues that in any other medium would bring sanction and retribution. Graffiti in female bathrooms on college campuses also reveal that women use graffiti when they believe a college lacks appropriate means to handle sexual assault (see Meade, this volume). Ultimately, what emerges from my literature review is that graffiti is a compelling practice that is most heuristic when approached using different theories and methodologies. This acutely democratic and polyvocal form of communication is best understood, by scholars and the general public, as a medium that invites many perspectives and styles of investigation.

The popular media often presents graffiti as a social activity deserving of condemnation and punitive action. Statements such as "Graffiti is not Art—Graffiti is a Crime" (City of Antioch n.d.) are commonly read and seen in the mass media. This perspective exists because the creation of graffiti entails the defacement of private and public property. Indeed, the nationwide cost of graffiti removal exceeds $4 billion annually (Brewer and Miller 1990). This cost continues to escalate in the face of many old and new initiatives to curtail the practice (Barker 1979; Brewer and Miller 1990; Deiulio 1978; Dill 1993; Fagan 1981; Feiner and Klein 1982; Glazer 1979; Malecki 1992; Nagourney 2011; Rees 1979). The rift between popular portrayals of graffiti practice and the history of this expression is full of irony, as the prevailing scholarship agrees that both imagery and writing have existed on walls for around 30,000 years. Suffice it to say, human beings have long been producing graffiti (Baird and Taylor 2011; D'Avino 1964; Lindsay 1960; Tanzer 1939; Varone 1991). As a mythical graffitist once noted, "If God did not want us to write on walls, he would not have set an example."

Many conflicting explanations abound as to why people produce anonymous wall inscriptions. Early investigations focused on identifying the psychological origins of graffiti. Dundes suggests motivation for writing graffiti is related to an infantile desire to play with feces: "The fact that much of the content of latrinalia does refer to defecation and urination would tend to support the assertion that there is some relationship between the acts of writing on walls and playing with feces" (1966, 101). Furthermore, Dundes

contends that the act of defecation is the male analog of childbirth, and the writing of graffiti while defecating becomes, by association, a more or less permanent substitute for the creation of a child (1966). This contention rests on the theory advanced by Dundes and others that men are envious of women's ability to bear children and thus seek to find various substitute gratifications. Women presumably produce less graffiti because they have no need for such substitutes. Gadpaille speculates that a primary motivation behind graffiti production involves "the urge to express forbidden desires, to release repressed wishes and to break taboos, whether individual or societal, or both. The very act of defacing a wall or other surface is defiance of a prohibition, whatever the nature or content of the mark" (1971, 45). Debates concerning graffiti as defacement are explored in Beaton and Todd (chapter 7) and Pozorski and Pozorski (chapter 10). Graffiti as a violation may revolve around implicit cultural and personal taboos, or among contemporary practitioners there is a need to break the law. Another primary motivation for graffiti production, Gadpaille (1971, 45) and later Spann (1973) both claim, involves the desire to leave a mark attesting to one's own existence and thereby achieve "a certain pitiful immortality" (See Lovata's discussion of arborglyphs in chapter 6 for a comparison with this idea). Melhorn and Romig (1985) speculate that graffiti constitute a product of the adolescent personality, and is motivated by subconscious urges, impulses, and conflicts, while Lomas (1973) contends that bathroom graffiti probably reflect the persistence of infantile sexuality.

Similarly, Abel and Buckley (1977) posit that graffiti are artifacts of the less-talented segments of society. Opler (1974, 87) believes that graffiti are low-level expressions of thwarted human interests "which might have found pleasanter expression both in art and in more normal modes of living" (these more critical explanations are reviewed in Mitman's discussion of graffiti from New York City in chapter 13 of this volume). Klein (1974) suggests that a lack of maturity is a prerequisite for graffiti indulgence. Bonuso (1976) believes that graffiti satisfy a need to escape to a world of fantasy, and Feiner and Klein (1982) posit that visually oriented people produce graffiti to negotiate developmental issues. Durmuller (1988a) believes that people use graffiti to share their thoughts and feelings with others, marking their social and cultural identity, and to define their social relationships. From observations of college campus graffiti, Nierenberg (1983) concludes that writing graffiti releases suppressed libidinal thoughts and frustrations. Reisner (1974) speculates that graffiti reflect an unconscious effort to recapture childhood to repair psychological damage.

New investigations are much less concerned with the psychological origins of graffiti and are more concerned with the political, sociological, and anthropological aspects of graffiti (Benavides-Vanegas 2005; Brass and Roth 2013; Farnia 2014; Rahn 1999; Rodriguez and Clair 1999; Teixeira and Otta 1998; Teixeira et al. 2003; Tracy 2005; Trahan 2011). There is now a broad scholarly consensus that graffiti are a social phenomenon deserving of attention and study for many compelling reasons (e.g., Brown, 1978; Bruner and Kelso 1980; Dumdum 1986; Gonzales 1994; Haan and Hammerstrom 1980, 1981; Jones-Baker 1981; Jorgenson and Lange 1975; La Barre 1979; Longnecker 1977). Folklorists, psychologists, political scientists, public policy analysts, sociologists, anthropologists, and others now study graffiti as an unobtrusive measure to afford insight into human behaviors and social attitudes. Ley and Cybriwsky (1974) contend that graffiti are potential indicators of attitudes, behavioral dispositions, and social processes in environments where direct measurement is problematic. Deiulio (1978) likewise believes that graffiti offer an accurate index of the political temper in a society or community. Abel and Buckley (1977) posit that graffiti capture the more elusive aspects of a society's character (See Olton in chapter 11 of this volume on the question of "sub-rosa" texts.). D'Angelo (1976) posits that graffiti reflect contemporary customs and moral values. Moreover, graffiti reveal intimate details about everyday life. Pou contends that graffiti are "the pulse of the way certain prejudices operate and how things get repressed" (in Cody, 1993, B1).

Scheibel (1994) investigates reflections of group communication and organization modes and posits that examining graffiti as an organizational document significantly contributes to the understanding of organizational life from a critical standpoint. Loewenstine et al. (1982) find that people produce graffiti to fulfill a need for communication, recognition, and affirmation. (Nevada Test Site tunnel graffiti discussed in chapter 12 support these interpretations). Indeed, various scholars (e.g., Bruner and Kelso 1980; Cole 1991; Hentschel 1987) argue that the graffiti in women's bathrooms reflect a deliberate attempt to create a reality devoid of male dominance. Chaffee (1989) contends that the working class in Argentina uses graffiti to create an alternate political media system because of their distrust of mainstream media organizations. Reisner and Wechsler (1974) and Newall (1986–1987) contend that adolescents use graffiti to vent hostilities, express fantasies, communicate triumphs, declare rebellion, and promote their propaganda (Gopinath examines and complicates these ideas in chapter 8 of this volume). Luna contends that graffiti reflect "profound social, psychological, and cultural information worthy of serious attention" (1987, 73). Alonso (1998) claims that graffiti offer a vivid and often unflattering insight into the hidden side of our

society, but it also represents an intriguing and important source of information for those studying the behavior of human beings. Grider (1975) finds that Mexican-American youths view graffiti as one aspect of a communication code that places extremely high value on personal names with the phrase *con safos* (a Chicano term that literally means "with respect"). Adolescent graffitists from the Los Angeles area contend that graffiti offer an outlet for self-expression to the poor and an alternative to gang life. One of these graffitists boasts, "We have a creative impulse that never stops, no matter what you do. Like a river, it will flow, and if you block it, it will find ways to flow around the obstacle" (Hubler, 1993, B4). Similarly, in Vervort and Lievens' (1989) exploratory study of graffiti in sports centers, they find that the graffiti reflect contemporary problems and reveals other elusive aspects of society. Misic (1990) also finds that soccer fans use graffiti and other symbols for identification, communication, integration, and ritual purposes.

Evidently, these emergent perspectives of graffiti function from a different definition of graffiti other than mere vandalism. Kostka (1974) and Bushnell (1990) consider graffiti highly structured communication media. For Durmuller (1988b, 1), "Graffiti are written cultural phenomena making use both of symbolic and iconic language." Similarly, Gumpert views graffiti as "a rhetorical act which exists . . . because other means of public self-expression are barred or limited to the individual" (1975, 37). Luna (1987) contends that graffiti serve as a means of communication among homeless youth to declare their identities, relationships, and communities. Moreover, graffiti constitute a means of communication in gang subculture. Nilsen (1978) views graffiti as a rhetorical form that expresses antiestablishment sentiments. For Bush (2013, 2), "Graffiti is . . . a spatialized form of communication; the study of which offers a lens that can be used to examine competing authority structures within the contested, fluid, and volatile urban environments of both war zones, and non-war zones."

Individuals or groups may use graffiti as a tool of protest, to communicate subversive opinions and experiences. For instance, women students at Brown University resorted to graffiti to address issues of rape and sexual harassment. Accused men were exposed and identified when their names were scratched and written on women's bathroom walls. After one name appeared, lists of other abusive males began to appear in the stalls. The presence of the first graffito invited others to "Compile a list of other men to watch out for" (Starr 1990, 64). According to Lisa Billowitz, a student representative on Brown's Sexual Assault Task Force, "The bathroom list arose out of frustration, anger and pain. Many of the women have tried to go through proper channels and have been thwarted" (Starr 1990, 64). The women's actions

resulted in the implementation of many new programs and services to address issues of rape and sexual harassment. At Columbia University, names of men accused of sexual assault also began appearing anonymously on women's bathrooms walls (Taylor, 2014). Once again, women said that the graffiti were in response to the failure of the university to properly and transparently deal with an important matter.

Minority ethnic groups are also frequent targets of graffiti (Higgins 1989; Kirk 1990; Stern 1990; Taylor 1990). For instance, the level of racist graffiti increased at Wellesley College during a period marked by intermittent tensions over ethnicity and sexual orientations (Flint 1992). Jones (1991) posits that the proliferation of racially insulting graffiti on U.S. campuses reflects a genuine conflict between and among ethnic groups, particularly between blacks and whites, resulting from the impact of economic, political, and social factors.

Graffiti offer profound social, political, psychological, and cultural insights. It facilitates a discourse that refuses to adhere to any normative protocol. The discourse is inherently democratic because all persons possess the capability to initiate and/or participate in an uninhibited manner. According to one example, "It's a chance to vent frustrations—to say things you wouldn't dare speak up about" (Fraser 1980, 259). No rules define or constrain graffiti discourse: individuals are unrestrained to determine the topic, the language, and the duration of the interaction. This autonomous quality represents an integral and distinguishing component of graffiti (Rodriguez and Clair, 1999).

"Is the writing on the wall only graffiti?" (Ezrahi 1988, 137): should distinctions be made among anonymous texts, drawings, and paintings? Or is the activity of producing anonymous text equally valuable and deserving of equal scholarly attention? This concern appears in different literatures. Chaffee (1989) makes a distinction between graffiti and wall painting. Reisner and Wechsler (1974) make a distinction between wall inscriptions that are significant and others that are insignificant, banal, and sheer defacement. Blume (1985) advances a topology based on communication functions that exclude certain kinds of graffiti (similarly, Duncan in chapter 9 of this volume critically analyzes the efficacy of graffiti found in the street with those found in an art gallery). This topology includes mass communication, categorical communication, individual communication, and reflexive individual communication. Reisner (1974) also calls for a distinction between true and false graffiti, but offers no reliable, methodological way of distinguishing one from the other. (In contrast, Daniell in chapter 14 of this volume examines

the differences between historic graffiti and calliglyphs, and his evidence serves as a way to further our understanding of these typologies).

Durmuller warns against using intuition when making these kinds of distinctions. Instead, he advises researchers to consult members of the audience for their interpretations before making any determination: "This seemed especially important with regard to assigning graffiti texts to socio-cultural domains, and to the reading of these texts as speech acts" (1988a, 279). For Lomas (1973, 89):

> We can no more understand graffiti by separating them from the walls on which they appear than we can fully understand dreams by neglecting their obvious connection with sleep or comprehend jokes by ignoring the laughter they produce in the listener. It is this relation of the writer to the wall that holds the key to our investigation.

What should ultimately matter is that any proposed distinction between types of wall markings or spray can art be rigorous in its material evidence, theory, and method. This means grappling with questions addressing the role of artist/writer, audience, context, aesthetics, iconography, language, preservation, erasure, and history (for additional information on these ideas see Scheinman's discussion of wall in Mexico City in chapter 15).

Studying Graffiti

In an early study of bathroom graffiti, Kinsey et al. (1953) found that men produced more graffiti than women. Men also produced a higher proportion (86%) of erotic inscriptions/images than women. In addition, men's graffiti were more concerned with male genitalia and functions rather than with female genitalia and its functions. Kinsey et al. (1953) hypothesized that women are less inclined to produce graffiti because of their greater regard for moral codes and social conventions. In a cross-cultural study between the United States and the Philippines, Sechrest and Flores (1969) found that 42% of the bathroom graffiti were related to homosexuality in the United States, while only 2% of the graffiti from the Philippines were related to homosexuality. Martilla (1971) found that the most recurring theme in female graffiti at the University of California, Berkeley, related to women's liberation. Moreover, a sizeable proportion of graffiti elicited concurring responses that appealed for solidarity among women. Martilla posits that bathroom graffiti appeal to women's liberation because it violates convention and is "essentially

aggressive and self-assertive" (1971, 49). Consistent with previous results, purely sexual and erotic graffiti were less frequent among women's bathroom graffiti.

Solomon and Yager (1975) found that women's bathroom graffiti were significantly more hostile than those of men. Pennebaker and Sanders (1976) found that higher authority (social, political, or hierarchical status) and greater threat (any perceived threat to status) increased graffiti production. In a study involving four high schools with different socioeconomic and racial populations, Wales and Brewer (1976) found that females wrote more graffiti in all schools than males. Consistent with previous results, more romantic rather than erotic graffiti were found in female bathrooms compared with those in male bathrooms. Race was found to have little or no influence on the amount or content inscribed. The school with the greatest heterogeneity of race and socioeconomic level produced more than twice as many graffiti as the more homogeneous school populations. Boyd (1981) examined graffiti found in women's bathrooms in three culturally diverse universities—Howard University, Gallaudet College, and Georgetown University—to determine cultural differences in the graffiti and the role of a person's background and environment on graffiti. Boyd (1981) concluded that the graffiti revealed cultural differences in female graffiti. Examples from Howard University contained words and phrases widely used in African-American language styles. Also, the graffiti were relatively lengthy, and many sought and gave advice. These types of graffiti were unique to Howard University in this study.

Bruner and Kelso (1980) use a semiotic perspective to facilitate a different insight into gender differences in graffiti. They contend that a thorough understanding of gender can only be achieved by moving beyond positivistic and psychoanalytic perspectives to the underlying level of meaning found in the graffiti and by constructing an interpretation that simultaneously considers both the male and female data. The semiotic perspective begins with the recognition that bathroom graffiti are communication: a discourse among anonymous persons. To write graffiti is to communicate, since graffiti are always found in visible areas. Bruner and Kelso (1980) found two major differences between male and female bathroom graffiti. First, women's graffiti are more interactive and interpersonal. Women raise serious questions about such topics as love, sexual relations, and relationships. Also, women's graffiti solicit advice and share experiences. Neither type of graffiti were found in men's bathrooms. The graffiti found in men's bathrooms were more self-centered and competitive. The second major gender difference Bruner and Kelso find in graffiti is that men make significantly more derogatory graf-

fiti. Jews, African Americans, homosexuals, and women were the primary objects of the disparaging graffiti. Indeed, this reality figures prominently in bathroom graffiti research. Many scholars (Bruner and Kelso 1980; Cole 1991) contend that dominant groups—especially white heterosexual men— use the open nature of graffiti to intimidate and discipline minority groups. The contention is that graffiti allow for open discourses (sexist, racist, and homophobic speech) that organizations cannot sanction, but which may also act to establish or reinforce the privileging aspects of patriarchal practices, thus supporting the hegemonic order. What emerges from the study of bathroom graffiti is that context affects the message and meaning.

Bathroom stalls are by no means the only sites of graffiti investigations. Deiulio (1973) collected graffiti from desktops to identify students' concerns and to evaluate teacher education programs. Deiulio (1973) found that the graffiti reflected students' problems, needs, and concerns. The graffiti also highlighted flaws in the curricular structure and offered clues to the reasons for those flaws. Nilsen (1981) also collected a large and diverse sample of graffiti from desktops in a university. Nilsen (1981) found that graffiti writers were very careful and deliberate in their word choices. Some writers strived for shock value, others used wordplay, and others attempted to force the reader into an indiscretion themselves. Sex-related graffiti were most common: subjects included marriage, family life, birth control, overpopulation, fetishes, politics, sex-related diseases, homosexuality, incest, masturbation, prostitution, rape, and oral sex. Homosexuality was the most popular subject. This finding, and others previously discussed, reminds us that although graffiti may provide a powerful outlet and a form of resistance, it is also possible that graffiti act to perpetuate an intolerant system if various privileged groups use graffiti to silence and intimidate other groups. Therefore, a serious tension may exist between graffiti enacted as resistance and graffiti articulated as oppressive practices. It is also possible that graffiti function simultaneously as both resistance and oppression.

Shulman et al. (1973) found graffiti an effective means of promoting communication between patients and staff in a mental health unit in Chicago. The walls of the unit were covered with brown butcher paper and writing utensils were attached by tape. Both staff and patients used the walls to indirectly communicate with each other. The graffiti produced by the patients were funny, angry, insightful, complaining, stimulating, and provocative. According to Shulman et al. (1973), such graffiti usually provided the staff with clues about how to approach and relate to the patients. For example, manic patients preferred to draw pictures than write. Angry, rebelling adolescent patients often wrote obscene and scurrilous remarks. Patients who preferred

not to associate with others isolated their graffiti from the main body of inscriptions. Patients suffering from anxiety were more likely to use smaller script. Patients who were angry or manic wrote in large script. Depressed patients wrote less than other patients, and when they did, wrote unhappy comments or composed syrupy platitudes. Shulman et al. (1973) contend that the anonymity allows patients to express what otherwise might be inhibited by fear, convention, and embarrassment.

Gilmar and Brown allowed a class of high school students to produce graffiti on blackboards. They found that students used graffiti to reveal their deepest thoughts, concerns, and frustrations: "Silently the words clamor for our attention. They are a key to the locked door, which when opened shows us their humor, cynicism, faith, and despair" (1983, 45). Moreover, the students seemingly found graffiti conducive for discourse with other students whom they did not share any meaningful relationship. They produced a variety of graffiti on different issues, including philosophy, religion, and war, and were sometimes strategic in their placement. Interestingly, many students attached their name to their inscriptions. Gilmar and Brown noted, like Deiulio, that students' graffiti provide invaluable insight on the effectiveness of the curriculum and their deepest sentiments.

Scheibel (1994) adopted a cultural and critical-cultural perspective to examine graffiti as organizational documents that facilitate a form of critical discourse. This critical-cultural perspective entails viewing graffiti as dialogues that reveal tensions and conflicts between the sectional interest of domination and the sectional interest of alienation. Scheibel examined graffiti produced by film students to understand the variety of themes related to their alienation and the discourse that counter that alienation. Graffiti were collected from the editing rooms of Loyola Marymount University; University of California, Los Angeles; and the University of Southern California. He used ethnographic methods to both collect and analyze the data and found a variety of explicit and implicit underlying themes in the data, including avoidance, isolation, lack of artistic control, destruction, frustration, and career filters. Scheibel (1994) concluded that graffiti reflect and create film students' meanings and expectations, and also identify the students' many sources of frustration and alienation.

The study of twentieth-century graffiti beyond the confines of bathrooms affirms that graffiti offer scholars an opportunity to harvest data that tap important social, psychological, and political issues. Largely autonomous of rules and expectations and also anonymous, graffiti are a medium of communication that embraces unedited opinions that may reveal certain social truths. In this regard, graffiti continue to represent "an intriguing and impor-

tant source of information for those studying the behavior of human beings" (Alonso 1998, 21).

In many ways, graffiti afford a vital human function by allowing people to anonymously share sentiments and their most private and vulnerable thoughts. The following graffito appears in a female bathroom at Howard University and constitutes a chain-response (graffiti responding to other graffiti) to someone on the editorial board of the school's newspaper who wanted to write about female homosexuality:

> Can you promise confidentiality? I am not ashamed of my love for other women, but I would hate to open myself up to the ridicule of sexual bigots. Take a look at the poorly stated but strongly felt comments written here and try to imagine what a can of worms such disclosure in your medium would open up for me and other women like me on campus. (Rodriguez and Clair 1999, 6).

This type of disclosure fulfills a fundamental physiological need; social norms that inhibit personal and traumatic expression can help to induce harmful physiological conditions (Blotchy et al. 1983; Garcia and Geisler 1988; Jourard 1971; Stiles et al. 1992). In this regard, graffiti afford a similar space to persons who need to make comparable types of confession. Further, when various public discourses are officially and oppressively muted by government officials, graffitists consistently resort to public walls to hold such discourses (Chaffee 1989). Graffiti allow all conflicts and concerns to be equally visible and known to all who pass by, regardless of whether the anonymous texts and drawings are defined as art, communication, sexual harassment, or something else. These texts and drawings do reveal sentiments that demand attention and in response to wholesale erasure of graffiti, municipalities should refrain from blaming the medium for the sentiment. We would be better advised to deal openly with the origins and reasons for the sentiments rather than focusing on creating new kinds of paints and wall surfaces and enacting regulations and legislation to make these anonymous texts impossible.

CHAPTER 2

Latrinalia in a Room of One's Own: Language, Gender, and Place

MELISSA R. MEADE

n *A Room of One's Own,* Virginia Woolf suggested, "A woman must have money and a room of her own" (Woolf [1929] 1957, 4). Woolf wrote about her attempt to enter a library at an elite educational institution, "Oxbridge," where she was intercepted by a man "who regretted in a low voice as he waved . . . [her] back that ladies are only admitted to the library if accompanied by a Fellow of the College or furnished with a letter of introduction" ([1929] 1957, 8). She pondered the shut doors of the library and wondered how women could be writers in a society that prohibits women from then male-dominated occupations. Woolf's essay reminds the reader of the spatial relationship between educational access, social positioning, and the financial freedom necessary to govern a woman's own space and perhaps even her own body. For Woolf, writing, like other material and social circumstances, were constrained by class and gender systems that privileged white, male elites in the post–World War I Britain in which she was writing. Woolf highlights the historical phasing out of nobles' social privileges: those who excluded women and the poor from education. This process meant that the same wealth landed in the hands of (male) manufacturers and industrialists, who continued to exclude the non-wealthy and women from the universities where they donated their money. Generations of this exclusion affected women's writing, the topic on which Woolf was asked to speak in a series of lectures on women in fiction.

In the late 1990s, women at the University of Pennsylvania (Penn), like Woolf, required a room of their own to write and to express themselves; ironically, some of this writing took place in the women's lavatory of the university library. The connection between the two spaces—Woolf's Oxbridge

Understanding Graffiti edited by Troy Lovata & Elizabeth Olton, 33–46. © 2015 Taylor & Francis All rights reserved.

campus and the present example at Penn—is not at all ironic because the women in the library lavatory at Penn contemplated the physical space of the elite institution in which they were writing and therein debated issues concerning the gender and social circumstances. The medium for this writing was the library restroom stalls: faded, olive-green metal canvases replete with unsanctioned writings that marked a contrast between the women's lavatory space and the library's reading room and stacks that abound with canonical and sanctioned writings. Texts on the walls of the women's lavatory collide, and the authors' past and present ideas make claims over the space. By physically writing on the stall walls, the women transformed the lavatory from its functional designation as a place to relieve oneself to a place to inscribe narratives and counternarratives (see Rodriguez in chapter 1 for additional ideas and resources on this topic).

The writings on these bathroom walls were grounded in dialogic interaction through discursive features that functioned together as a narrative about larger societal discourses related to women and to Penn's educational apparatus. In this chapter, I argue that through the trope of "tight black pants," women engaged with discourses relating to women's language, health, and fashion, as well as anti-Semitism, general feminist discourse, and mass-media representations of women and of the Penn community. In contrast to previous studies of graffiti (compare with Cole 1991), women's language is not necessarily more supportive and often reproduces patriarchal conventions even within female spaces. It is within this female space that women engage their subjectivities to transform a lavatory into a place where different narratives vie for dominance. Different women engaged varied meanings of this trope and the discourses surrounding it (e.g., critiques of women's bodily comportment and health, dating and sexual behavior, etc.) and pitted them against each other in disputes over meaning. New narratives emerged from these discursive struggles that try to define relationships and positions within the text (with the inclusion of graffiti, walls, tree trunks, paintings, and subway cars become documents of human experience; see chapters by Măndescu, Lovata, Plesch, Gopinath, and Olton in this volume).

Situated in the often-crowded University of Pennsylvania's Van Pelt Library, located in Philadelphia, the graffiti in the present study were found in the basement-floor women's lavatory near the elevators. This floor houses a computer laboratory, a large study area with tables, and the Rosengarten Reserve Room (an area where professors reserve books for students in their

FIGURE 2.1 (Opposite) Material positioning of Penn latrinalia.

i) WEAR WHATEVER THE FUCK YOU WANT TO
(her capitalization)

2) Clothes should add to your personality - not define it!

1) Indifference isn't back. It means you're worried about yourself ... the only one who should matter. If you derive happiness in putting down other people's pants, maybe you really need to examine yourself.

5) Reading this door I'm starting to realize that I've been wrong, Penn girls CAN be intelligent. So the question is why the hell do so many of them act like airheads? (her emphasis)

k) Indifference

j) Women are by far the most beautiful and complex beings in the world. Just watch men trying to figure us out!

n) Black girls always look good in tight pants ?/////?

y) The more we differentiate as a people & a gender, the more we can accomplish & the more we have to love about each other. So wear the black pants if you want, but be yourself.

u) Why demean others? All women deserve respect, even those who wear tight black pants.

v) All women deserve to respect themselves.

3) close mindedness (sic)

h) BUT EVERYONE ELSE HATES YOU! I SWEAR IF I HAVE TO LOOK AT ONE MORE J.A.P. CRACK (her capitalization)

g) You can still wear tight black pants and love yourself.

m) It's not about conforming to one ?/////? another, but to mass female image. Don't get sucked in by film images.

s) I think that it is nice to see a debate of some, however, minimal, substance on a bathroom door. Better than some of the others I've read ...

w) I like jeans.

7) Get a life.

x) LOVE YOURSELF (her capitalization)

6) I know most UPENN girls are morons with the same fucking hair.

o) LIFE is just too short to bitch about black pants. Does it really matter? (her capitalization)

f) Personally, I'm not wearing any pants when I get laid.

'You are succeeding
Succeeding in believing
What they tell you to be true
about you ____'

a) So do large, baggy cargo pants!

Tight black pants
Conform narrowly
The form of woman'

e) The pants are NOT the problem. Wear the pants, but be yourself. Be smart, work hard, educate others, and the problem will slowly change (underlining her emphasis)

r) Black pants look Good and fashionable, that is not saying anything about individuality or tendency to conform ... I look good for MYSELF. No one else! (her emphasis)

p) Okay girls- for months now I have been watching this door & I have to say that well this - WHY ?/////? DON'T TELL OTHERS WHAT TO DO (her capitalization)

q) Shit ... I don't know about you but I've seen some girls look like shit squeezed into hernia causing pants. It's all about the anorexics winning out.

t) BE YOURSELF BE CREATIVE AND FUNK OUT (her capitalization)

4) "I am not this Fragile Body." Deng Ming Dao

1) Its (sic) obvious that the people making the negative comments are just too fat to look good in black pants! Lose some weight and the jealousy! Penn love, (The exclamation points were dotted with smiley faces.)

2) You have got to be kidding! Grow up! (Oh, and kiss my fat ass.) (her emphasis)

b) Why wear something that exposes and objectifies your body? Why not expose your mind and who you are?

c) Your sexuality is part of who (her emphasis) you are. And if your sexuality calls for tight black pants then wear them ?/////? fabulous. Just remember that you're the reason you are fabulous & not your tight black pants.

d) Beautiful PENN wimmin' LOVE YOURSELF CRITICALLY (her emphasis)

16) anywhere else you'd find screwed up obscenities on bathroom doors. Only at Penn would you find a discussion to ?/////? women.

11) guess its true, nobody likes smarty pants

10) GET MENTAL HELP! THINK YOU HAVE UNRESOLVED ISSUES. (her emphasis) 19) ARE RESOLVING (crossed out) "have unresolved" in previous post)

9) (yes, we're sorry we should be medicated & stop plaguing everyone with CRITICAL THINKING then maybe some nice boy will take me away & solve all my irksome problems) (her emphasis)

15) NEVER WILL HAPPEN WITH THE BOYS HERE! TRY THE MED STUDENTS

8) get fat get old get lost

18) b/c the only thing we have in common is that we sit to pee (p.s. I am out there.)

17) make the inside and the outside match.

13) These are both "dos" (circled word "do" in post 12)

14) I bet the guys' bathroom doesn't look like this.

12) You are not what you WEAR
You are not what you EAT
You are what you DO
What you GIVE
What you BELIEVE

classes); therefore, many undergraduate and graduate students use this bathroom. A narrow hallway connects the busy study area with the flanking women's and men's lavatories.

The graffiti were documented from the door of the women's lavatory during the fall of 1998 and spring of 1999. Initial observations of the graffiti text took place in the spring of 1997 and the fall of 1998 when I noticed lengthy latrinalia. I took three weekly trips to this lavatory to check for new contributions. The graffiti were comprehensively hand-recorded in a notebook. They were further documented on a diagram the size of the stall door that showed the location of each contribution, the arrows drawn by contributors, the use of capitalization and underlining, and the relative spatial positioning of each contribution. This diagram (Figure 2.1) was then mapped electronically to show the material positions of each contribution. With a total of three stalls in the lavatory, only two contained graffiti, and the center stall contained the bulk of the graffiti: 45 individual contributions. This stall was located perpendicular to the sinks and diagonal from the entrance. All of the graffiti were lexical, and a variety of writing instruments were used (markers and ballpoint pens of varying hues as well as pencils), with the latrinalia appearing to grow out from a centrally positioned text that influenced the rest of the contributions: "'You are succeeding / Succeeding in believing / What they tell you to be true about you _____ / Tight black pants / Conform narrowly / The form of woman.'" Comments responding to this "core" phrase or contribution were indicated with arrows and lines, with the positioning of contributions closer to the text, and vis-à-vis the repetition of the words such as "tight black pants," "pants," "woman," and "narrowly."

Latrinalia

This study contributes to a body of research on lavatory graffiti or "latrinalia" dating back to Allen Read's study ([1935] 1977) of public restroom graffiti in the North American West. Later, Alfred Kinsey's influential study (Kinsey et al. 1953) focused on the supposed gender differences in sexual content of graffiti of male and female latrinalia. Previous studies on latrinalia have found it to be an alternate form of expression, but the extant literature on graffiti focuses either on topical content or on gender differences. For example, one study on women's university latrinalia suggests that women were afforded the privacy to express themselves in a domain free from direct male evaluation in which participants discovered the social nature of problems affecting women on campus. The writers used the closed environment of bathroom stalls as a setting to voice opinions, solicit advice, and offer support,

consolation, and encouragement (Cole 1991). Cole examined elements such as politeness, chaining (connecting a series of ideas with a preceding contribution), and humor in her investigations into the nature of this women's graffiti (Cole 1991). The graffiti examined by Cole (1991) are presented as a complex of supportive expressions that are in marked contrast to writings on the walls of men's bathrooms. Men's latrinalia centers on statements of dominance, including anti-Semitism, racism, homophobia, sexual conquest, sexism, isolated sex acts, sex organs, and sexual prowess (Bruner and Kelso 1980; Nwoye 1993); in a Nigerian study, male graffiti served as an avenue through which a minority group, denied other forms of public discourse, articulated sociopolitical concerns (Nwoye 1993).

In this study, I apply Pierre Bourdieu's notion of "linguistic habitus" or the style of speaking and writing that circumscribes membership in particular social groups (1991, 38). Participants create social worlds that are maintained by language themes or rules. Latrinalia is also an interchange of language, interpretations, and ideologies by members of a group; it is an organized system where language functions, social practices, and agency (such as dominance, resistance, conflict negotiation, critique, commands, challenges) are intertwined and whereby writers deploy these practices to actively reproduce and transfer aspects of culture.

Evidence from the graffiti in the basement of the Van Pelt Library women's lavatory contradicts assumptions that women's language and social interaction is more collaborative, supportive, or gentle than men's language (Cole, 1991). In the Penn library example, women writers used both linguistic and cultural resources, as well as the physical space of the lavatory, to reproduce social tensions. The present study differs from previous work (see Gilligan 1982) by countering binary approaches to gender and instead noting power "asymmetries" among women as well as between women and men. This interpretation was also developed in Marjorie Harness Goodwin's linguistic anthropological research, which examines how girls create social worlds through talk-in-interactions, where "participants co-construct their social universe" (2006, 71). Goodwin's study is particularly informative when applied to situated activity systems, which is a partially closed "circuit of independent actions" (Goffman 1961, 96; Goodwin 2006, 36–37) that terminates on its own. Written dialogues found on the stall walls in the Penn library women's lavatory is best seen as a kind of Goffmanian situated activity system that is materially and place-based rather than as a simple expression of female essence; that is, the performative and emergent aspects of graffiti unfold through discursive interactions in the privacy of the women's lavatory, wherein the women use conflict and negotiation strategically to construct

events and to put forth opinions, thereby complicating this previous language and gender research (Lakoff 1973; Spender 1980).

Previous work on latrinalia (Cole 1991; Bruner and Kelso 1980) assumed biological gender distinctions and ignored the social and performative construction of gender (Butler 1993). This work seeks to leave space for additional graffiti research on the situated emergence of gendered identities. Bourdieu's (1991) work also usefully highlights the tensions between the structural organization of systems of domination and the more emergent or situated aspects of social interaction. Social worlds—including those highly structured by patriarchal norms—reproduce themselves through language wherein women use, participate in, and contradict dominant rules of discourse and linguistic expression within a lavatory setting. As this research attests, even in a room of one's own, patriarchal norms are expressed as well as challenged.

The latrinalia in this study unfolded through written conversation among different voices in a situated activity system: a frequently used yet segregated space. This dialogue was delimited by the physical context of a women's restroom (i.e., a room of their own) in an elite academic institution with all the associated social and linguistic constraints. Divergent voices within a text of a single author could capture the social reality of a particular moment; Mikhail Bakhtin (1981) argues that dialogue or dialogism creates a continuous relationship with other voices, works of literature, and various authors by maintaining a two-way engagement called *heteroglossia*. In Bakhtin's formulation there is a single authorial voice that orchestrates the language of the literary characters in a novel. Yet the physical materiality of the lavatory allowed women to preserve their contributions in situ as time passed; with the passage of time, the dialogue became multivocal (this theme is also discussed in chapters by Plesch, Olton, Daniell, and Beck et al. in this volume). Although these women shared this space, it was not without contention. Each voice offered its own interpretation of the university space in relationship to gender and conventions of female beauty. Each voice also exploited the physical space by directing her displeasure, irony, and support toward the others. As Bourdieu (1991) might say more generally, linguistic habitus is always both influenced and reproduced by institutional and material constraints and social conventions.

Unlike a linear novel with dialogue set in temporal order, the present sample of latrinalia is defined by its organic nature with little to signal primacy or importance except for some use of graphic paralanguage. Authors used arrows to connect their contributions to previous writings. They also relied on underlining and capitalization for emphasis. The latrinalia lacks a

single author or dominant editorial voice. Nevertheless, the dialogue is not completely freeform or divorced from social or linguistic conventions. With institutional constraints in play such as the material context of the women's lavatory and the formal status of the University of Pennsylvania, a number of women coordinated their texts in such a way that the textual cacophony is representative of a particular historical moment and social milieu in which "tight black pants" were a meaningful trope. "Tight black pants" worked as a linguistic and visual theme that created a flashpoint for a type of heteroglossia that examined and challenged conventions of female beauty.

In my analysis, I look at language in relation to its social function (Halliday 1985) and rely on two functionalist assumptions: "(a) language has functions . . . external to the linguistic system; (b) external functions influence . . . the organization of the linguistic system" (Schiffrin 1994, 22). A functionalist view of discourse maintains that language should be analyzed in use and that linguistic forms are not independent from human concerns (Schiffrin 1994); indeed, all symbolic acts are necessarily also social acts. In the present study, the temporality of the dialogue was "discoursal" in that earlier contributions influenced following interpretations (Nwoye 1993, 133). With each new contribution, the stall door became a more richly symbolic surface that invited participation. At the institutional level, the women's writing was left on the wall for at least one and a half years, thereby contributing to the discursive environment of the university.

Discussion

The documentation of these graffiti texts has been reproduced in a diagram (Figure 2.1) that attempts to replicate the linguistic and physical arrangement of the dialogues. I transcribed the text into the accompanying graffiti diagram noting the position of the graffiti and the placement of arrows. With the exception of the central contribution, its number or letter will refer to each additional contribution in the discussion. The symbol "?//////?" was used when the written discourse was erased, hidden, or otherwise unreadable. No adjustments for grammar, punctuation, or language were made in my documentation to preserve the authenticity of the original language.

The graffiti covered the door of the lavatory stall documented here, with most contributions relating back to a centrally positioned text: "'You are succeeding / Succeeding in believing / What they tell you to be true about you _____/ Tight black pants / Conform narrowly / The form of woman.'" This performative statement speaks directly to both the reader and the author in the stall. The encounter is mediated by the discursive personal pronoun

"you," who is to be held responsible and challenged for believing ideologies about gender and women's clothing. The present continuous verb tense, "are succeeding," grounds the reader in the space and gives the temporal structure of a social problem that extends beyond calendar time. Finally, the reference to *women's* clothes and "the form of *woman*" (emphasis my own) connects writing in the *place* with the actual place in which the writing is performed: the women's lavatory.

Social issues revolve around the initial metaphor of "tight black pants," a productive trope expanding in meaning and spurring reflections in a creative, playful, and also in an insulting manner. For instance, E) picks up on the frame of "black pants," but unequivocally states *her* position. She writes: "The pants are NOT the problem. Wear the pants, but be yourself. Be smart, work hard, educate others and the problem will slowly change" (emphasis original; see Figure 2.1). For E), the pants are not the unspoken problem, with emphasis placed on "not," which appears in capital letters. In lieu of mentioning "the problem" specifically, she alludes to larger societal structures that oppress women and that can be changed by hard work and education.

The core of E)'s response is a retelling of the original narrative; her use of "yourself" and commands such as "work hard" implicate the reader in a "slowly" changing "problem." E)'s omission of a statement concerning the nature of "the problem" reveals her assumption: the problem is supposedly obvious and therefore not in need of articulation. The omission of a specific referent for "the problem" functions as a kind of framing device, recruiting future contributors to oscillate between unspoken views. These linguistic frames function as "principles of organization" (Goffman 1974, 232) mediating expectations, communication, and cultural production through the text and its readership. As such, the Goffmanian frame invites people who may be strangers to each other to relate to a common trope—"the tight black pants"—and to further engage in multivocal dialogue.

Unlike E), who suggests that women can "wear the pants" but be themselves, B) asserts that women have two choices: to wear the pants and be exposed and objectified, or to be intellectually assertive and expose one's mind and self: "Why wear something that exposes and objectifies your body? Why not expose your mind and who you are?" B)'s use of a large number of personal pronouns ("your," "your," and "you," consecutively) and her use of questions indicate a different position. If for E) women can still be themselves in "the pants," for B), identity and responsibility is at stake. B) writes that the woman who wears the pants creates "the problem" of female objectification and bodily exposure in lieu of exposure of the mind and inner identity.

Although some latrinalia frames wearing tight black pants negatively by addressing the reader directly, other texts disrupt the dominance of the clothing trope. For instance, D) writes "Beautiful PENN wimmin LOVE YOURSELF [sic] CRITICALLY" (emphasis original). By using the phrase "LOVE YOURSELF CRITICALLY," she positions the women at Penn as agents of self-love, in addition to offering a command. Her use of the word "beautiful" to describe the women at Penn serves to frame and evaluate all Penn women as beautiful and avoids any conversation about clothing. Capitalization serves paralinguistically to emphasize her statement.

Significantly, this woman changed the spelling of "women" to "wimmin," thereby challenging sex-specific language and establishing a feminist space within the stall. Linguistic features such as spelling link latrinalia to larger societal discourses from which particular regimes of representation are drawn. A feminist voice is likely the author of this challenge to sex-specific language, with "Penn wimmin" as her addressees. She urges "Penn wimmin" to be self-reflective by using the word "critically." Feminist linguists have long pointed out that the word *woman* can be problematic, making woman the marked variety (*wo* + *man*) and *man* the unmarked variety of human being (Graddol and Swann 1996). In support of the movement to challenge these linguistic categories, some individuals have altered the spelling of "woman" and "women" "wimmin." The use of the term "wimmin" by D) is evidence of exposure to feminist theory (either in an academic context or in a general intellectual context).

In contrast, other contributors are dismissive of what is commonly characterized as "women's language," repeating age-old patriarchal critiques of language generally coded as female. O) writes, "LIFE is just too short to bitch about black pants." Her characterization of women's talk as "bitching" is used to trivialize the discussion. Language labels have often been used to silence women by calling their talk "*chatter, . . . nag, bitch, whine,* and *gossip*" (Cole 1991, 403, emphasis original; compare with Spender 1985). O)'s use of this evaluation links her response to the larger societal discourse of silencing women by trivializing their speech. Finally, she calls into question the discussion of black pants by writing, "Does it really matter?" Yet this text can also be seen as a critique of those authors who reproach women who wear tight black pants.

The focus of the discussion then shifts to tight black pants and their relationship to health. Q) uses simile to liken some "girls" who wear this type of pants to "shit squeezed into hernia causing pants." Such use of simile is an example of generalization and exaggeration, which along with hyperbole

"are techniques employed by 'attackers' in debates" (Nwoye 1993, 426). Q) writes: "Its [sic] all about the anorexics winning out." This statement exposes Q)'s assumption about who wears tight black pants and why; however, her reference to anorexia is less a concern for the health of so-called anorexics and more a critique of thinness, which she likens to sickness. According to this contributor, if tight black pants do not cause a hernia for the wearer, then she is likely already ill.

Such references to the larger discourse of illness and weight can also be found in the texts of 1) and 2). 1) writes: "Its [sic] obvious that the people making the negative comments are just to [sic] fat too [sic] look good in black pants! Lose some weight and the jealousy!! Penn love." 2) used an arrow to direct the reader to her response to 1), writing, "You have got to be kidding! Grow up! (Oh, and kiss my fat ass.)." Whereas 1) asserts that most women actually want to lose weight to "look good in black pants," 2) then challenges this discourse using irony. 2) delivers a moral reprimand to 1) to mature and "grow up"; she then challenges hegemonic discourses of body dysmorphia by instructing 1) to actually "kiss" her "fat ass."

In fact some women—particularly university students—do unnecessarily attempt to lose weight to look good. Many women suffer from severe eating disorders; more than 25% of students engage in binging and purging (see http://nationaleatingdisorders.org). In the stall next to the one documented in this study, one contributor even writes: "Yesterday my friend told me he'd <u>rather</u> his girlfriend be bulimic <u>than</u> fat" (emphasis original). Another contributor asks: "What does college mean to you?" The most prominent answer on the wall is "15 lbs."

Although there is a larger discourse that equates looking good with losing weight, this perception may be assisted in part by the mass media images and discourses mentioned by M). She suggests confronting conformance to "mass female image" and commands the readers: "Don't get sucked in by film images." Here she implies that films and the media produce particular images of women and challenges women to avoid reproducing those images with their own bodies. Some research *does* suggest that the mass media contributes to an idealized form of femininity. In fact, images of unreal women (airbrushed and physically altered) saturate the media, circulating images of so-called female perfection and then insinuating that the reader/viewer/listener falls short of perfection (see Wolf 2002). Thus, M) warns women against the oppression that these images may encourage. In addition, she reflects back the language of the first contribution ("tight black pants conform narrowly") through her use of the word "conforming" in the initial phrase.

Talk about health continues with 10), 19), 9), and 15)'s discussion of mental health concerns. 10) suggests that someone has "UNRESOLVED ISSUES" and therefore may need "MENTAL HELP" (in all capital letters), but 19) challenges this assertion. She crosses off "have unresolved" and changes it to "are resolving" to challenge and modify the previous assertion. The edited text now reads, "GET MENTAL HELP! THINK YOU ARE RESOLVING ISSUES." This action suggests that 19) saw value in bathroom wall discourse, was not in agreement with the stigmatization of mental illness, did not see a problem with psychotherapy, and/or that she felt that the medium of the lavatory offered a space for valid responses, discussion, and ire. The use of a cross-out in graffiti often means that the second author believes her contribution is superior. Her choice to challenge this language by changing the verb tense from the present perfect to the present continuous grounds both her as the author and the reader(s) in the space in an ongoing process of resolution.

To reproach 10), who writes that someone has "unresolved issues," 9) uses irony to suggest that psychiatric medication will not solve women's problems. She writes "(yes, we're sorry we should be medicated & stop plaguing everyone with CRITICAL THINKING then maybe some nice boy will take me away & solve all my problems) [sic]." This text presents critical thinking as valuable, including the thinking going on in the stall. 9) further challenges the rescue fantasy that "a boy" will solve a woman's problems. Yet 15)'s contribution reads: "NEVER WILL HAPPEN WITH THE BOYS HERE! TRY THE MED STUDENTS." 15) suggests that both a rescue fantasy may unfold with medical students or that the medical students will be able to prescribe the medicines that 9) mentions. Either way, entry 15) offers an ironic and pedagogical tone reflective of the space: the medical students will not likely be found in this particular library. Indeed, the Biomedical Library is located across campus.

Using capital letters implying an increase in volume, H) dismisses the value of the text about self-love. She writes that if a woman were to wear "tight black pants," then everyone would hate her. In her next sentence—which functions as an indirect threat—she reveals her own assumptions and expectations about who wears tight black pants: "I SWEAR IF I HAVE TO LOOK AT ONE MORE J.A.P. CRACK." This situation frames "J.A.P.s" as causing her annoyance, but the action she threatens is left up to the reader to infer. The term "CRACK" can mean a remark, like a wisecrack, or the physical crack that an individual has in her buttocks. The doubled nature of the meanings of these terms and insults is characteristic of many of the contributions and is the source of much of their humor and wit.

In addition, H)'s use of the acronym "J.A.P." supplies evidence for an underlying frame suggesting a very particular social discourse. Why does she assume that the statement(s) that she read were what she calls "J.A.P. CRACKS"? Her use of language reveals her assumption that other readers will be familiar with the larger discourse of "J.A.P.s." The University of Pennsylvania has one of the highest populations of Jewish students at any private university; although Jewish people make up only 2% to 3% of the general population, a third of the student body at Penn is Jewish (Arenson 1999; see http://hillel.org). The university includes historically Jewish sororities and fraternities, a Hillel (campus center for Jewish life), and kosher dining. In this context, a Jewish American Princess (J.A.P.) is a negative stereotype of some Jewish women. According to Riv-Ellen Prell (1990, 248), the stereotypical J.A.P.s "require everything and give nothing [T]hey are . . . focused on . . . their overwhelming needs . . . [and] obsessed with their physical attractiveness." H)'s text linked loving oneself and wearing tight black pants with this stereotype of some Jewish women.

Yet 3) does not agree with the use of the acronym J.A.P. by H), which promoted a stereotype of Jewish women; she drew an arrow to the comment and wrote "close mindedness [sic]." I) follows H)'s response with an overlapping celebratory remark: "Women are by far the most beautiful and complex beings in the world." This statement functions to negate H)'s comment about hating women in tight black pants, namely the stereotypical Jewish American Princesses.

Institutional references were present in at least five contributions, tying texts with the environment in which they were produced: 1) and D) (both discussed previously), 5), 6), and 16). 16) suggests that Penn is a special place, and even the bathroom walls contain a valuable discussion: "Anywhere else you'd find screwed up obscenities on bathroom doors. Only at Penn would you find a discussion to ?/////? women." In a flanking stall, a contributor dismisses the "local" latrinalia by drawing an arrow to the stall analyzed in this chapter: "The intelligent discourse is one stall over." 5) offers mixed interpretations of this dialogue: "Reading this door I'm starting to realize that I've been wrong. Penn girls CAN be intelligent. So the question is why the hell do so many of them feel like they gotta act like airheads? [sic]." She suggests that the bathroom door challenged her stereotype of Penn "girls," but that they still act like "airheads." Yet 14) writes, "I bet the guys' bathroom doesn't look like this," questioning the physical aesthetic wrought by the graffiti and implicating the women in its ornamentation.

6) asserts a monolithic female Penn student body: ". . . most UPENN girls are morons with the same fucking hair." This stereotype was also explored

in an article in the University newspaper published several years after this latrinalia sample was collected. *The Daily Pennsylvanian* article "'Penn Girl' stigma, black pants and all" refuted the notion that "all girls at Penn belong to sororities, are from New York, have Daddy paying their credit card bills, and all wear the same black pants" (Rosner 2003). The stereotype that Penn female students mostly hailed from New York was common in the late 1990s and early 2000s; as in text H), it was deployed to suggest that most Penn females were Jewish and disliked by others. *The Daily Pennsylvanian* article went on to reference the ideas of columnist Rory Levine, who wrote about "the ladies of Penn's campus," calling them "eating disorder-prone sorority girls." The article (Rosner 2003) also implicates the editor of a Penn-run student magazine, who wrote that a bevy of Penn women could ward off crime because "what could be scarier than 20 girls in identical black pants walking down the street carrying identical Herve Chapeliers [a type of handbag]?" Rosner's (2003) article reprimands those who circulated the stereotype of Penn women as unlikable, black-pants-wearing, and lacking uniqueness, a debate women were having several years earlier in the library lavatory.

In this charged discursive context, the present study offers a microhistory of a particular moment by illuminating the language and writing of women in the setting of a lavatory located at an Ivy League university library. The study was conducted to shed light upon a moment when the tight black pants discussed by the women signified something particular about gender and social relations at the University of Pennsylvania. Read as a novelistic scene combining the unruly voices of a group of anonymous women, the lavatory wall takes on new significance as a window into a moment when tight black pants more powerfully signified particular modes of being, bodily comportment, health, and gender subjectivity for some students at an elite institution. The status of tight black pants as such a powerful symbol was transitory, but latrinalia's potential as a means to illuminate meaningful frames of language use remains important as a particularly rich source to study issues of language and gender. In this research I frame latrinalia as an agent of history, an unedited reflection of raw, 1990s-era female concerns from the University of Pennsylvania and most likely other competitive and elite institutions. Like the chapters in section III of this book, the Penn latrinalia is a witness to history.

I began this chapter with a reflection on Virginia Woolf's ([1929] 1957) essay about being denied entrance to the library at Oxbridge without a male. In Woolf's essay, the metaphor of distraction/privacy/a room of one's own runs throughout. The reader is drawn through her thinking to see the effects that the constant interruptions she experiences have on the development of

the female writer. Throughout the essay, she draws the reader's attention to the material circumstances of Oxbridge: the opulent food at lunch, the superior accommodations, and the leisure time. Since late 1999, the Penn library has been reconstructed and upgraded. The bathrooms have more stately stalls reflective of the new design, and graffiti rarely appear there. Women obviously *can* enter the library at the University of Pennsylvania, and they made the lavatory into a Woolfian room of their own for a brief historical moment in which they debated social circumstances in relative privacy. Yet it is ironic that this room was a toilet into which bodies were segregated because of their supposed biological nature: female or male.

With this chapter, I have attempted to make several additional contributions to the study of graffiti. First, this study shows the dialogic nature of a particular sample of graffiti, which was characterized by a rapid response rate. Although some contributors demarcated importance through the use of capital letters, underlining, or through the size of the text, in the context of other graffiti studies, less aesthetic attention was given to the art of the lettering. Second, the space of the women's lavatory provided a collaborative female audience in a room associated with private functional activities—to relieve oneself—embedded in an institution of higher education. The privacy of the space allowed women to employ confrontational writing and ironic and insulting innuendoes about female bodies, thereby complicating research that argues for essentialized gender differences such as collaboration, politeness, kindness, care, and support. Yet to render apparent women's agency in reproducing hegemonic discourses within a university or within society-at-large presents a challenge to some popular notions of feminism and female solidarity. But through this writing we can see that even in a room of one's own, dominance, control, and conflict often play out alongside the citation of patriarchal norms. The material constraint of the lavatory stall divider combined with social norms renders apparent this complex form of linguistic habitus, which simultaneously confirms and defies gender stereotypes. Last, the graffiti discourse in this study appropriates and is made possible by the educational/disciplinary apparatus of the university. The latrinalia is intertwined with institutional discourses and informal power structures within the university, which in turn relate to larger societal discourses of gender. A text written in the next stall sums up one woman's questions about gender and university life: "Do you feel like you're equal to guys—in the classroom or anywhere else on a daily basis? Do you feel like you have to prove your intelligence & worth b/c, as a female, people may make different assumptions about you? [sic]." There was no direct answer to this challenge.

CHAPTER 3

Beyond Art History: Graffiti on Frescoes

VÉRONIQUE PLESCH

Many years ago, as I was documenting Passion cycles frescoed in cha-
pels that were part of the Duchy of Savoy, I visited the small oratorio
di San Sebastiano, outside the Piedmontese town of Arborio, some
60 kilometers west of Milan, and noticed graffiti scratched on some of the
frescoes (Figure 3.1). The mention of a "major plague," right on the body of
St. Anthony Abbot, was both disturbing and moving (Figure 3.2). A few years
later, as I was preparing to teach a seminar on the art of late medieval private
devotion, I thought again of these inscriptions and began a reflection on the
phenomenon, which led me to publish several articles. Although I will have
the occasion to mention some of the results I offered in these publications—
and in so doing present this rich corpus of graffiti, which forms a chronicle
documenting the life of a small rural community written by the very folk
who were experiencing the events the inscriptions record—what I wish to
do in this chapter is to consider the ways in which this material challenges
conceptions about graffiti and the way we practice art history.

San Sebastiano at Arborio: A Privileged Case Study

Located at the south entrance to Arborio (about 350 meters from the parish
church of St. Martin in the center of the town), on the main road to Vercelli,
the oratorio is a modest building, roughly some 18 meters long and 7 meters
wide. When exactly it was built remains uncertain, perhaps as early as the
Romanesque period (Piemonte 1976, 555) or as late as the fifteenth century
(Quaglia et al. 2004, 56). Frescoes decorate the nave, the apse, and an apsi-
diole. Among them is a narrative cycle on the Passion of Christ, composed

Understanding Graffiti edited by Troy Lovata & Elizabeth Olton, 47–57. © 2015 Taylor &
Francis. All rights reserved.

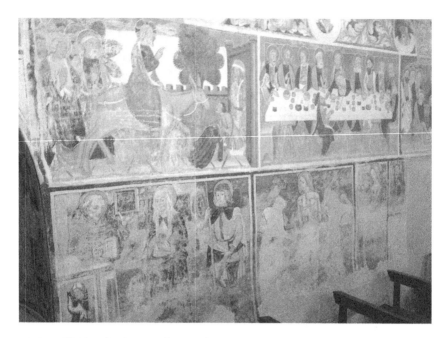

FIGURE 3.1 Visiting the Oratorio di San Sebastiano, Arborio, in 1997. Paintings in the apsidiole, from left to right: St. Anthony Abbot, enthroned Virgin and Child with a donor, St. Bernardine of Siena, a bishop saint, St. Sebastian. Photo by author.

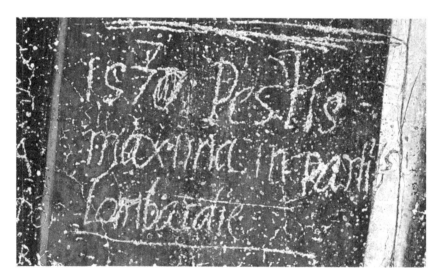

FIGURE 3.2 Oratorio di San Sebastiano, Arborio, detail of a graffito on the figure of Saint Anthony Abbot: "1570/7 Pestis maxima in partibus Lombardie" ("In 1570 [1577] there was the greatest plague in Lombardy"). Photo by author.

of 19 scenes (starting with Christ's Entry into Jerusalem and ending with his Ascension), that wraps around the nave walls (Figure 3.3) and above an opening that connects the nave with the narthex.[1] In the apse we find a Christ Pantocrator in a mandorla surrounded by the symbols of the Evangelists, and on the wall below a series of apostles with St. Sebastian in the middle. Additional frescoes include an Annunciation at the top of the triumphal arch, a Crucifixion on the upper part of the small apse on the south wall, the Vision of St. Eustace and St. Agatha's martyrdom on the triumphal arch over the apsidiole, the Martyrdom of St. Bartholomew on the north wall, and a series of saints. At the upper edge of the nave walls, a frieze with busts of Old Testament figures completes the decoration.[2]

San Sebastiano's paintings were executed over a period of time: several hands can be distinguished and, in some areas, several pictorial layers. According to the most comprehensive study to date by Vittorio Natale, the paintings in the apse, the apsidiole, and the eight first scenes of the Passion cycle were executed over a couple of decades between 1450 and 1470 (Figure 3.3). An anonymous master, whom Natale and others refer to as "Maestro

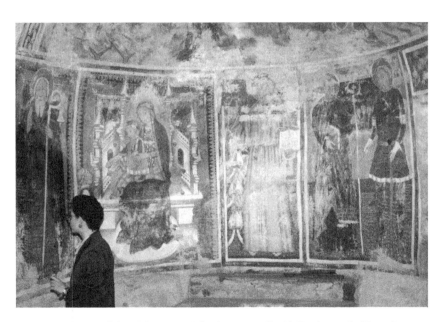

FIGURE 3.3 Oratorio di San Sebastiano, Arborio, nave wall with Passion cycle (Entry into Jerusalem and Last Supper) and saints: a bishop saint (St. Gothard?), St. Bernardine of Siena, St. Clare of Montefalco, St. Roch, St. Sebastian, St. Agatha, St. Gothard. Photo by author.

del Cristo della Domenica" after a fresco in Biella's cathedral (Natale 2005, 67), was in charge, along with local collaborators. In the last decade of the fifteenth century, Tommaso Cagnola,[3] an artist from Novara, and his workshop painted the saints below the Passion cycle on the south wall (Saints Bernardine, Catherine of Siena, Roch, and Agatha, and the Martyrdom of St. Sebastian), while his workshop finished (around 1500) the second half of the Passion cycle (Mazzini and Romano 1976, 105–106) and reworked some of the earlier scenes.[4]

Overall, San Sebastiano's decorative scheme is very much like many other northern Italian chapels: both in style and iconography, its pictorial decoration is rather standard and rooted in a long tradition, which explains its scarce scholarly notice. What is unusual here is the wealth of early modern graffiti on these frescoes, which spurred me to conduct an in-depth analysis and to reach conclusions about the conditions and motivations for these graffiti.[5] I have been able to record about 150 decipherable entries, all dated, with the earliest surviving one going back to 1531 and the most recent to 1889.[6] It is likely that this inscriptional practice may have started earlier: I already mentioned that pictorial layers can be seen under the mid- to late-fifteenth-century frescoes, and there is no reason not to suppose that the earlier stratum also contained inscriptions. It should also be noted that several inscriptions have been cancelled by scratching. Arborio's corpus is extraordinary because of the number of graffiti, but not unique; I have recorded many instances of similar inscriptions made on frescoes (among which some are earlier).[7]

As it turns out, this body of inscriptions challenges some of the accepted notions about graffiti, such as that they are "illicit,"[8] "illegal," or even "unsolicited" (McDonald 2013, vii), since the practice was carried out for no less than four centuries, thus suggesting that it must have been, at the very least, tolerated by the authorities[9] (See chapters by Mitman and Daniell in this volume for a review of the legality of graffiti in the contemporary era). Its survival also contradicts the conception of graffiti as ephemeral. Far from being random marks, Arborio's inscriptions form a homogeneous corpus. All of the 150-some entries I have deciphered—most of which are in Italian, with a few earlier ones in Latin—follow the same structure: starting with a date, with in most cases the year appearing first, they record significant events in the life of this community, using a simple vocabulary and grammatical structure that remain constant over the course of the centuries. The entries can be assigned to several thematic categories, most of which were related to the subsistence of the townspeople: meteorological events, observations about crops and livestock, the ebbing and flowing of the Sesia

River (Figure 3.4), records of war, and some news of local interest, such as the death of notables and the construction of roads and bridges. The corpus is similarly coherent in terms of placement, as the inscriptions appear near or on iconic depictions of saints rather than on narrative scenes. It is clear that the Passion cycle was only chosen as a support because the inscribers had run out of space on the saints. Only the first three scenes received inscriptions, with an overwhelming majority found on the first panel, Christ's Entry into Jerusalem (Figure 3.4), with 28 entries. The following panel, the Last Supper, has three entries, while the next two, Christ Washing the Feet of the Apostles and the Agony in the Garden, have each one inscription, both recent. Among the saints, Anthony and Sebastian (Figure 3.1) are the ones who received not only the most graffiti, but some of the earliest surviving ones.[10] St. Anthony was invoked against ergotism (or St. Anthony's Fire, as it was then called) and other skin diseases, as well as for veterinary cases, in particular for pigs (his attribute) and horses; he was certainly a useful saint in rural areas (Walter 1996). His feast day on January 17 was the occasion for an important celebration in Arborio (Quaglia et al. 2004, 147). Sebastian, to whom the oratorio is dedicated, was particularly popular in the Duchy of Savoy, with many chapels decorated with cycles of his life or dedicated to him (Plesch 2010, n. 38). He owed his popularity to his protection against the plague, which, at that time and place, was endemic. His importance at Arborio is further expressed by the fact that he appears no less than three separate times: in the center of the apse among the apostles, a second time in a small side apse, and also in the nave. Although Sebastian "specialized" in the protection against the plague, Anthony as well was considered a *saint antipesteux* or *pestheilig*. On St. Anthony (Figure 3.2), an inscription records an outbreak in 1570 and, with a seven added over the zero, a second one in 1577 (the so-called "Borromean plague" that hit Milan from 1575 to 1578), while another graffito, placed on the depiction of an enthroned Virgin and Child, recalls the 1630 epidemic. This last outbreak, often referred to as the "Manzonian plague" because the nineteenth-century novelist immortalized it in *I promesi sposi*, was particularly devastating and raged for several years, from 1629 to 1633. In nearby Casale, for instance, during the summer of 1630, 30 to 50 people died each day.

The homogeneity of the inscriptions and the longevity of the practice undermine conceptions of graffiti as informal and ephemeral, as does the weightiness of the topic, of import to a whole community, and consisting of events worth recording for posterity. The idea that graffiti are popular in nature is also somewhat contradicted by the fact that only select individuals would have been able to write on the oratorio's walls (see chapters by Meade,

Olton, Lovata, Beck, and Daniell in this volume for additional discussions). My research in Arborio's archives confirms the extremely limited literacy in this rural zone into the eighteenth and nineteenth centuries.[11] Although for the most part the inscriptions are anonymous, a few bear a signature (only

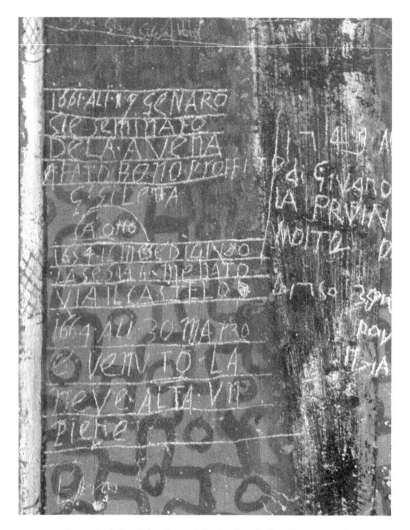

FIGURE 3.4 Oratorio di San Sebastiano, Arborio, detail of graffiti on St. Sebastian: "1661 ali 17 genaro si e seminato dela avena a fato bono proffito G. Giletta" ("1661 on 17 January we sowed oats and made good profit, G. Giletta"); "1654 [a otto] il mese di giuno la sesia a menato via il castello" ("1654 on 8 June the Sesia River took away the castle"); "1664 ali 30 marzo è venuto la neve alta un piede" ("1664 on 30 March a foot of snow fell"). Photo by author.

five, two of which are by the same individual), all indicating men from important families, town counselors, and mayors. If signatures are a rarity, a name that recurs with more frequency (18 recorded instances) is that of the town, Arborio, or "Arboro," as it used to be called.[12] The individual identity is obviously not so relevant here, and what the graffitists share is their relationship to the place, and indeed their ability to record its history.

In his typology of graffiti, Vittorio Formentin (2012, 100) distinguishes four types: emotive/connotative (of a private or occasional nature), practical, historical/memoir-like, and performative. Formentin adds that the first three are anonymous or semi-anonymous, while the fourth tend to be signed. Although the third type corresponds to what we find at Arborio,[13] our corpus fits as well into the last category, in which, according to Formentin, the graffiti are constitutively linked to the surface that receives them. Interestingly, this last category tends to be signed: in our case, I would go as far as suggesting that the true signatory is Arborio, rather than the individuals who produced the marks. Furthermore, the performative dimension has been central to my analysis of Arborio's graffiti and is in fact a common thread to many of the theoretical frameworks I have used (the performative nature of graffiti is also discussed by Meade, Gopinath, Duncan, and Scheinman in this volume).

It could be argued that graffiti, to varying degrees perhaps, but always to some extent, interact with their support, and that the support is part of the message. Graffiti on paintings offer thus an extreme case, one in which two discourses engage in a dialogue which, at times, may be agonistic. Here, for instance, we have a location—a place of worship—and a pictorial support—depictions of saints—that are religious, while the graffiti are verbal and secular.[14] To some extent, the graffiti offer a competing and disfiguring discourse, one that, if carried on for too long, threatens the legibility and integrity of the artwork.[15] This being said, I should note that at Arborio we also find a few instances of nonverbal messages or purely image-based forms of communication: coats of arms and stick figures of soldiers.[16] The proof that the support is part of the message is particularly clear in nonverbal and nonpictorial examples; for instance, scratches defacing a figure, which powerfully convey feelings toward the depicted character (see Plesch 2010, 152–153). These interventions represent a tangible proof of the reception of the artwork, for they bear witness to an interaction between beholder and work. They thus affirm the importance of the work of art and its resonance for the viewers, whether in a negative or in a positive way. Besides being a response to a pictorial text, they also constitute an appropriation of the work, which is transformed into a site intended to receive the expression of certain ideas.[17] In

that sense, the image thus altered becomes a palimpsest, a new text that re-places an earlier one and communicates devotion, anger, hatred, or fear. And, because the action consists of a mark made on a material object in a durable way, it maintains the memory of those feelings. The desire to leave a tangible mark for posterity is at the core of any intervention on a wall, be it a simple "attack" or a written statement (*lontexts*, or canvases transformed by graffiti, are also discussed in chapters by Măndescu, Lovata, Beaton and Todd, Gopinath, Duncan, Pozorski and Pozorski, and Mitman in this volume).

To See or Not To See?

If this material challenges some of the commonly accepted notions of graf-fiti, the presence of inscriptions on frescoes also makes us think differently about works of art and the discipline of art history, how it is practiced, and with what preconceptions. A first revealing issue is that although graffiti on paintings are not that rare, they are seldom documented.[18] Why? I suggest that we tend not to see them, or perhaps (unconsciously) block them out, as we perceive them as a form of "visual noise," getting in the way of a proper viewing of the work.[19] But their presence can make us think differently: this blind spot reveals our tendency to focus on the work of art itself, leaving aside a constellation of contextual elements that are crucial to its proper un-derstanding.[20] And more often than not, when graffiti on paintings *are* seen, they are considered mere acts of vandalism, not pertaining to the artwork or even threatening it, and, as a result, to be removed through restoration. This, of course, renders the task of documenting graffiti on wall paintings harder still. I've had the occasion to mention a few examples of early modern graffiti that restoration thoroughly obliterated.[21] This being said, recent years have witnessed a shift in how vandalism is theorized, recognizing that it is a com-plex and rich issue, one that deserves careful consideration[22] (see Mitman, Daniell, Schienman, Beck et al., Lovata, Duncan, Gopinath, and Lennon in this volume).

Very often, the frescoes that have received graffiti are not the kind that would usually be considered worthy of study, except by local art historians. This is the case for Arborio's paintings, which are far from being masterpieces, but are rather run-of-the-mill, a pictorial ensemble among many similar ones in the area that have received very little attention (and never outside Piedmont). This of course goes against the grain of art history, aimed, as Vasari put it, at distinguishing "the better from the good and the best from

the better" (Vasari 1912–1915, Vol. 2, 78, in Belting 1987, 6). As long as quali-
ty—defined by criteria of aesthetic and technical excellence and by innova-
tion—continues to determine what we study, conservative, anonymous, and
"damaged" works will be neglected.[23]

These paintings—and this is true for many pictorial cycles in small rural
chapels, for instance, in the area I have studied in the western Alps—per-
petuate a medieval tradition and thus belong to what I have called an artistic
longue durée,[24] while their survival, although the result of external forces
such as poverty and the inability to finance a new, up-to-date set of paint-
ings, does also suggest that for the community they continued to be consid-
ered satisfactory. Furthermore, the presence of graffiti bears witness to these
paintings' continued relevance, and indeed of their power and of their use.

If, as Hans Belting puts it, art "was described and celebrated as an inde-
pendent branch of human activity . . . by means of a linear, unidirectional
history, with artists as its heroes and works as its event" (Belting 1987, 57),
Arborio offers a very different set of circumstances, one in which, instead of
an outstanding artistic event by a pioneering artist, we have unremarkable
frescoes on which anonymous men—not artists—wrote, not a single time,
but repeatedly and over a long period. Thus, the artwork, the "object" I
study, is not just the paintings but the paintings *and* the graffiti, depictions
in a specific site that generated a practice carried over a long period and that
altered them in a profound manner. This object thus conveys its meaning
in all its materiality, beyond mere questions of medium choice, in its very
density, since the graffiti—true graffiti in the etymological sense of *graffiare*,
"to scratch"—penetrate the pictorial layer. Even more than a palimpsest,
although inscriptions on paintings and graffiti in general have a palimpsestual
dimension, Arborio's graffiti go beyond the layering that characterizes such
phenomena: the inscriptions, because they are incised, become one with the
paintings.[25]

Already back in 1984, when Belting published his *pavé dans la mare*, as he
concluded the first part of his questioning of the state of the discipline, he
chose to give the last word to the object, the "work"[26] (Belting 1984, 63). Con-
sidering the shift to interdisciplinarity well under way at the time of his writ-
ing, Belting declared that the object, as it is considered through a wide and
varied methodological approach, is no longer "expected to testify to a general
system of representation . . . but to disclose its own particular truth or mes-
sage" (Belting 1987, 63). Three decades later, the return of the material object
as central to the practice of art history is powerfully demonstrated by the title
of the 33rd Congress of CIHA (Comité International d'Histoire de l'Art/Inter-
national Committee of the History of Art): "The Challenge of the Object."[27]

Theoretical Opportunism

To let the object "disclose its own . . . truth or message," Belting advocated the recourse to "several alternative means of access to the object," to be taken together "instead of compelling us to exclude any one in favor of another" (Belting 1987, 63). That is, in a nutshell, what I've done in my work on Arborio's graffiti. Since my first conference paper in 1997, I have resorted to a plethora of approaches, all pertinent and none exclusive of the others, to fully grasp this phenomenon. Perhaps this modus operandi replicates the very palimpsestual quality of San Sebastiano: as I apply a new methodology I always recapitulate the others, refusing to favor one in particular, convinced that the best grasp of the material will come from their alliance. From my first analysis, perhaps the most art historical, in which I attempted to understand Arborio's graffiti in light of devotional practices (Plesch 2005),[28] I moved on to considering them the product of what Kathleen Ashley and I have previously called the "cultural processes of appropriation" (Ashley and Plesch 2002; Plesch 2002b), to reflecting on the practice within the framework of ritual behaviors (Plesch 2002a), and finally, given the fact that the events recorded on the walls of the chapel are overwhelmingly negative, that of trauma studies (Plesch 2014), suggesting that the graffiti acted as a form of self-help and perceiving parallels with tattooing and even self-injury. In the course of these publications, I used other theoretical models, for instance (and to name just a few), Jean Delumeau's discussion of fear in medieval and early modern societies (1978), Pierre Nora's *lieux de mémoire* (1984), Michel de Certeau's ideas on the writing of history (1975), Armando Petrucci's "exposed writings" (1986), and Béatrice Fraenkel's "écrits d'action" (2002; most recently in Plesch 2014).

This methodological *bricolage* was prompted by a rather uncanonical object for which traditional art historical methods were inadequate. What I am tempted to call my "theoretical opportunism"—grabbing and using whatever model is, to use Claude Lévi-Strauss's phrase, "good to think with"[29]—is a strategy that goes against the methodological grain of academic research in general and of art history in particular: one tends to choose an approach and build a career on it. It is indeed time, as Griselda Pollock suggests, after the "theoretical turn" and the interdisciplinarity that is now old hat, to adopt a "transdisciplinary" attitude, one based on what she calls "research as *encounter*" (Pollock 2007, xiii–xiv; emphasis in original). Moreover, many of the approaches I have adopted come from beyond the strict confines of art history, and in so doing correspond to what Mieke Bal has called "travelling concepts" (Bal 2002). Several of the concepts that have helped me shape my

reflections on Arborio's graffiti over the years had already "travelled" quite a bit by the time I engaged with them. For instance, Béatrice Fraenkel's "action writings" ("écrits d'action"; Fraenkel 2002, 23), in which it is the act of writing, more than the text's content, that fulfills a function, obviously originated in linguistic speech act theory, and is applied to what paleographer Armando Petrucci called "exposed writings" (texts that are not filed away but visible to all). At the same time, Fraenkel, who holds the chair of "anthropologie de l'écriture" at the École des hautes études en sciences sociales, has greatly benefited from the work of anthropologists such as Alfred Gell and his discussion of agency (Gell 1998; see Olton in this volume).

As Mieke Bal puts it: "By selecting an object, you *question* a field" (Bal 2007, 1). Bal affirms her belief that one can learn from an object when, rather than applying a single method to it, the object becomes a participant in a meeting between several methods, a "third partner" in a "symbiotic interaction between critic and object." I can only agree: 18 years after delivering my first conference paper on Arborio's graffiti, I am still learning.

Writing with a Global Accent:
Cairo and the Roots/Routes of Conflict Graffiti

JOHN LENNON

Introduction

G raffiti are unsanctioned and unregulated; due to its illegality, it has a spontaneous, rupturing quality. The "tags" hastily written on lampposts, the "throw-ups" on alley walls, and "pieces" in abandoned factories are an ongoing open dialogue that is overheard by passersby (see related ideas in this volume from Rodriguez, Meade, Plesch, Lovata, Beaton and Todd, Gopinath, Duncan, Olton, Beck et al., Daniell, Mitman, and Scheinman). It is a forbidden language that forces itself into polite society, allowing for a circulation of knowledges that transform physical space into contested sites as the walls' declarations reflect the larger political discussions of the day.

Writing on walls offers a disembodied protest that interjects itself into daily life; the paint on surfaces speaks, and if we stop and pause for a few seconds in front of them, we are partaking in the conversation. These conversations are increasingly, as scholars Sasika Sassen (2011) and Jeff Ferrell and Robert Weide (2010) state, transnational. Images are recorded, uploaded on social media sites, and globally shared. As much as graffiti take places on particular walls in specific places, they also take place between these places as writers pursue the work of other writers on Flickr, Tumblr, and the countless graffiti black-book websites. Shadowy introductions are made, techniques shared, and subcultural bonds formed.

With this sharing, however, comes a phalanx of questions. What are the routes of influence, and how do these graffiti translate across geographic areas as "foreign" graffiti mix with "local" graffiti? Specifically, should these transformations be considered imperialistic: is graffiti another avenue of cultural

colonization that imposes its will on a host country? Just as multinationals are consistently attempting to find spaces to expand their brand and influence, we can argue that Western-style graffiti is expanding its reach of influence at the expense of local styles and writers. With Obey t-shirts selling for $32 and Hollywood customers purchasing Banksy pieces for more than a million pounds (Bishop 2013), the global routes of graffiti could be read as simply multinationals capturing the subcultural "cool" of youth, repackaging it into safe, acceptable forms of "art," and selling back to consumers a branded, toothless subculture.

While this branding certainly is apparent, street graffiti, regardless of the packaging, are also political expressions etched, sprayed, and stickered onto walls. During times of relative economic security, as people make their daily commutes to work or tourists walk in and out of stores and restaurants, graffiti quietly murmur hidden subcultural desires that may not be readily heard by passersby eager to get home or grab lunch (see chapters by Gopinath and Duncan in this volume for other discussions of contemporary graffiti in an urban setting). But graffiti are also used as a political weapon during times of war, extreme poverty, and natural disasters. During these chaotic times, graffiti are a roar. Placed by its practitioners at extreme bodily peril, conflict graffiti are immediate, intense discourses forming from the deadly material conditions in which the writers find themselves living. As the geographic area transforms from outside pressures (bombs exploding, factories abandoned in blighted neighborhoods, buildings crumbling from typhoon winds), citizens write their public protests and anguished desire throughout their transforming neighborhoods, rooting their graffiti in a specific time and place. While sharing similar routes of influence as the graffiti produced in relative stable areas, new questions arise that speak specifically to this type of graffiti's "placeness": Why would a young African-American woman in New Orleans write a scatological joke about President Bush on a crumbling wall of her house as Hurricane Katrina floodwaters rose in 2005? Why would Israeli soldiers spray-paint quotes from the Na Nach Nachma Nachman on Lebanese walls during the conflict of 2006? What makes a young Arab man—as tear gas explodes on the street—write his anger at Hosni Mubarak on a wall in 2011? And, after watching these protests in Cairo on TV, why did young Syrian boys write antigovernment graffiti on grain silos in Daraa? (Ideas of "placeness" with regard to graffiti of a transgressive nature are also discussed in this volume by Olton, Pozorski and Pozorski, Beck et al., and Daniell.)

There are no easy answers: to even begin to unravel the questions, one must analyze graffiti in a particular area and context (its roots) before teasing out the ways that the form itself speaks to, and is interpreted by, a global audi-

ence (its routes). For example, how we interpret the routes and roots of the fat-bubble, "wildstyle" graffiti found in back alleys of Tripoli after the death of Gadhafi should be the result of a concentrated examination of the intersections between the recent globalization of graffiti subcultures with the specific material culture born from particular situational local politics. Specific geographic and national case studies that analyze these roots and routes of conflict graffiti are essential when developing a framework in understanding how globalization affects subcultural graffiti practices. Here I wish to pinpoint a

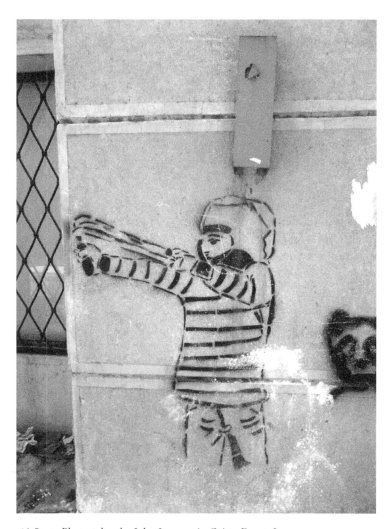

FIGURE 4.1 Photo taken by John Lennon in Cairo, Egypt, June 2015.

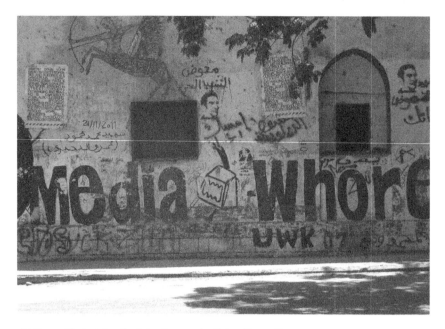

FIGURE 4.2 Photo taken by John Lennon in Cairo, Egypt, June 2015.

specific thread in the tapestry of a larger case study examination: how conflict graffiti in Cairo, Egypt, during the Arab Spring and its aftermath reflect both a rich history rooted in Egyptian tradition that is paired with a globally inspired style consistently morphing among the ebb and flow of revolutionary desire.

Conflict Graffiti in Cairo, Egypt

For writers in Cairo, graffiti was one of many in a constellation of resistances that led to the abnegation of the presidency by Hosni Mubarak and the continued protests against the Supreme Council of Military Forces (SCAF). Ordinary surfaces of the city were illegally marked, displaying revolutionary potentiality by allowing the seemingly powerless rhetorical openings of engagement. Far from being a monolithic discourse, graffiti created geographies of protest that were locally enacted but globally contextualized. Graffiti are part of the revolutionary conversation that exerts opinions; it is a tangible display of the political complexity embodied by those inhabiting the streets. Saskia Sassen (2011, 579), in an article discussing the Middle East

uprisings, imagines a newly birthed "global street" that has become a home for the powerless: "Urban space makes their powerlessness complex, and in that complexity lies the possibility of making the political, making the civic." For Sassen, the conceptual nature of the term allows for a linkage between the many different types of protest that have recently exploded throughout the MENA (Middle East and North Africa) region, theoretically connecting them while acknowledging their varied, specific, and separate political projects. As she makes clear, powerlessness is not an absolute condition, and these resistive expressions—converging on a city square, writing on its walls—help form a fluid civic community that is materially based in particular city streets but conceptually linked to other streets throughout the region and the world. A quick example from the Tahrir demonstrations of 2011 will illustrate the point:

During the occupation of Tahrir Square, "The End" was painted in English in large black letters on a side of a truck, scrawled over the Arabic words "Down with Mubarak." The palimpsest of Arabic and English speaks to a larger audience than the one present in Tahrir Square; it is a rhetoric of protest meant for dispersion past the city walls. In the upper right hand of the photo, one can pick out an advertisement for air travel. Although certainly captured in the photo accidently, it is a visual reminder that city space is at once a physical location as well as a global entity: images of conflict graffiti are transported at the speed of a Twitter post and can be easily seen by clicking on Al Jazeera or Flickr. This clicking is not just mindless Internet surfing; for some, it offers an intensely desired virtual connection. Iman Mersel (2011, 672), an Egyptian-born poet who was living in Canada at the time of the revolution, wanted to feel the spirit of the revolution. Instead of reading traditional newspapers, she searched for images of her home on the Internet, seeking out the graffiti-covered walls. For her, these were the loci of the uprising, stating, "From the early days of revolution onwards, the walls became us." Even from a distance of thousands of miles and an ocean in between, for Mersel, the graffiti-covered walls became the conduit to experience the revolution that reflected the passion, humor, and determination of the Egyptian protesters.

This graffiti-covered truck is indicative of the global street Sassen described earlier: there is an emergence of the powerless participating in civic action that is being witnessed by a global audience. The graffiti painted on this truck are part of a visual narrative revealing the social construction of a city that is in a moment of upheaval and movement. Just as bullets and blood become part of the materiality of the walls during conflict, changing those walls and infusing them with a new ideological identity and physical form,

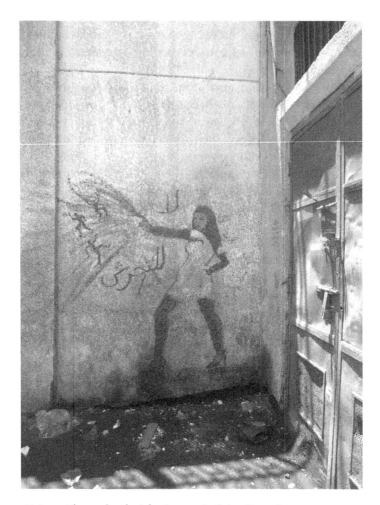

FIGURE 4.3 Photo taken by John Lennon in Cairo, Egypt, June 2015.

conflict graffiti transform the essential structures of a city, reconstituting the architecture to create for viewers a subjective perceptual relationship with the environment. The walls speak and enter into a collective conversation expressing plural identities and revolutionary desires of the people inhabiting the streets. This conversation—partially overheard, sometimes (mis) translated, often contradictorily interpreted—is joined by people from all areas of the world.

One of these people participating in this conversation is Mahmoud Aly, 19, a self-identified writer who wrote during and after Mubarak's leadership.

When Mahmoud was 16, he became interested in graffiti. Not knowing writers in his hometown in Alexandria, he was first influenced by U.S. and other Western writers, including cope2 and can2, learning about graffiti by watching videos and balancing an understanding of the global history of graffiti with tutorials on how to make it (Lennon 2013). This influence can be seen in his "wildstyle"-like signature graffiti, with its fat bubble letters and arrows exploding into different directions.

While developing his graffiti style (he began in 2008), Mahmoud also wrote explicit political graffiti, which for him is the "strongest revolutionary art" and the one that "is closest to the people" (Lennon 2013). Revolution is an aesthetic discourse that unites people and translates from images on the wall to people in the street. But for him, there is no distinction between his fat-signature graffiti and his more overt political pieces: they are all expressions of his aesthetic sensibilities.

Examining Mahmoud's graffiti, his pieces are certainly part of the Egyptian urban geography, but as Jeff Ferrell and Robert Weide (2010, 53) suggest about contemporary writing, "it does so beyond and between cities as much as within them." Mahmoud learned graffiti style and history from writers he met online and the countless "black-book" websites easily found on the Internet, then practiced his own art in Alexandria and Cairo. The specific local walls therefore acquired a global dialect as he tagged them. Mahmoud views his writing as art and believes in its capabilities in the same way as Joe Austin does (2010, 44): "Graffiti art provided (and still provides) a way of seeing something new; an-other visual order is possible and so an-other city is possible and so an-other life is possible as well." As part of a global graffiti youth subculture, Mahmoud Aly learned to write from virtually examining the walls of New York, Los Angeles, and Tokyo, forming online friendships with graffiti writers from around the world who were encouraging him to identify and think of himself as a graffiti writer. When the demonstrations began, he joined them, both in person, standing with others in Tahrir Square, and disembodied, his name and message marking the walls. For Mahmoud, his desire to write graffiti did not suddenly appear; it was a logical extension of the global graffiti scene of which he had already been a part. Thus, to understand Mahmoud's conflict graffiti, one would have to investigate the routes of his understanding that helped frame his political messages on the walls of Cairo during the revolution.

This transnational graffiti scene, evident in such recent documentaries as *Bomb It* and *Bomb It 2*, reveal the routes of influence in style found in Mahmoud's graffiti. Following these routes runs the risk, however, of discounting

FIGURE 4.4 Photo taken by John Lennon in Cairo, Egypt, June 2015.

the materiality of graffiti. In these documentaries, there are numerous quick jump cuts from one geographic area to the next, and the dizzying nature of these jumps can lead to an ambiguous universalizing of graffiti, shorn of local politics. This depoliticizing is readily apparent when watching the countless fan-sourced graffiti videos found on YouTube that privileges specific writers or styles but does not identify where the actual graffiti are found. Although graffiti are ephemeral and are often erased soon after they are placed on a wall, the roots of graffiti run deep and springs from their material past. In a country such as Egypt, where anthropologists have unearthed graffiti near a temple of the nineteenth Pharaoh Seti I (fl. C. 1294–1279 BCE), more than 3,000 years of history inform the current writing on the walls (Mairs 2010). Graffiti artists in the second decade of the twenty-first century often look back to this rich lineage, incorporating traditional images and styles, remixing them to speak to the present day situation in Cairo. This is evident in the murals of Alaa Awad, which hold an ambiguous fluid position between graffiti and classic art.

Alaa Awad, an accomplished artist and instructor in mural painting in Luxor's Faculty of Fine Arts, painted (with Abu Bakr and Hanaa El Deighem)

the graffiti mural for those who died in the Port Said massacre in February of 2012. According to Awad, the mural, which used a particular historical Egyptian aesthetic, depicts current-day female revolutionaries confronting Mubarak; the painting was a way to celebrate and recognize women in the current revolution and emphasize their vital place in Egyptian political culture. By depicting some of the women nude, he rejects the Whahabi style of Islam, stating, "Egypt has a long, long history and its own traditions" (Davies, 2012). Awad's style reflects his belief that this tradition—that mixes classical art forms with graffiti—informs the present-day revolution.

This tradition frames much of the graffiti found in Cairo after the first wave of revolutionary protest. It is a tradition, though, that does not attempt to cement the graffiti or the protests in the past; rather, it presents a lineage to the current-day movement, allowing protesters to justify their fight in light of the past. Keizer, a prolific graffiti artist whose clean, clear stencils are present throughout Cairo, certainly is an example of a writer who uses the past to offer political commentary in a moment of great uncertainty in his country.

Just like Alaa Awad, Keizer imparts a strong female presence throughout his works. One of his most famous is a graffiti stencil of Nefertiti, the royal wife of Pharaoh Akhenaton. Together they ruled Egypt at a time of great wealth and prosperity; it was also a time of revolution: during his reign, they moved to worshiping only one god, Aten (Kemp 2014).

These graffiti are a perfect example of the many roots and routes of graffiti. Nefertiti speaks of an earlier time in Egyptian history—one of revolution as well as prosperity—linking the twenty-first-century graffiti subculture with an icon of a woman who enjoyed unprecedented power and influence: recent findings show she may have been elevated as co-regent of Egypt with her husband (Dodson 2009). But while this image is certainly rooted in Egyptian history, her image is global. In Berlin's Neues Museum, the famous ancient bust of her by the Pharaoh's sculptor Thutmose is on display, and her likeness is one of the most-copied works of ancient Egypt. Keizer's realistic stencil (which emulates Thutmose's style), placed in the Zamalak neighborhood of Cairo that saw revolutionaries in the streets during the Mubarak and Morsi demonstrations and is less than two miles away from Tahrir Square, contextualizes the Egyptian revolution, intertwining the present with a rich history. Nefertiti is no longer a popular museum attraction for German tourists patiently waiting to snap a photo, but with her sharp glare and confident regal form (the stencil is in purple spray paint), she is a nationalistic presence overlooking the revolution. Keizer appropriates a familiar image, reframing it to present a specific politicized discourse.

This discourse—and the way graffiti are being used—is certainly volatile, and numerous political factions have used graffiti to propagandize their own message—graffiti are not the sole property of radical youth. During Morsi's time in office as well as after his ouster, graffiti have been a conduit for layered, complicated, and site-specific conversations/arguments, followed and analyzed by a diverse group of people from within Egypt and around the world. During Morsi's shortened presidency, graffiti were seen as threats, and writers could be arrested for their crimes, yet words and images continued to appear on Cairo's streets. After Morsi was deposed and arrested, graffiti persisted in being a voice of popular uprisings, with writers from opposite sides of the ideological gulf writing on the walls against the army-controlled government headed by General Adbul-Fattah el-Sisi. Anarchist symbols were placed near Arabic verses from the Koran, which were located inches away from stenciled images of sexual assault victims from recent protests; the walls became a palimpsest of various political discourses all vying for a space, paralleling the larger political posturing taking place within Egypt.

Although the graffiti discussed in this article have been from mostly liberal protesters, Islamists have also used graffiti, most noticeably after the vio-

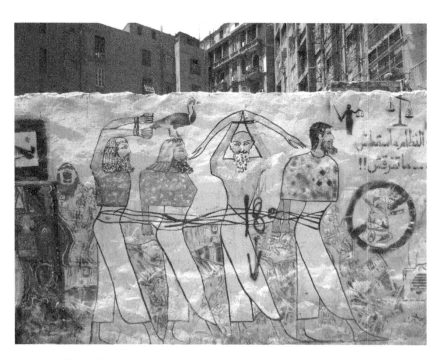

FIGURE 4.5 Photo taken by John Lennon in Cairo, Egypt, June 2015.

lent suppression of the Muslim Brotherhood and its followers. This sectarian oppression has been severe, with at least three documented mass shootings at pro-Morsi protests resulting in more than 1,000 Egyptians dying and scores more injured (Mayer 2013). The international routes of graffiti produced at these particular protests are different from the routes followed by Mahmoud Aly when learning his style, and yet we can assume that the Islamists writing their messages are informed by the conflict graffiti they virtually witnessed in the surrounding nations so influential in the Egyptian uprising as well as the protest graffiti physically spray-painted within their own city. A specific example highlights the complexity.

On August 13, 2013, Islamists spray-painted graffiti on the Nahdat Misr statue, located in Nahda Square in the Giza region. The statue, located near Cairo University, celebrates the cultural renaissance that began in the late nineteenth and early twentieth centuries in Egypt (and throughout MENA) that inaugurated a period of cultural and political reform. The sculptor, Mahmoud Mukhtar, was commissioned to commemorate the Revolution of 1919 and with much fanfare he created *Nahdat Misr: Le Reveil de L'Egypte*.

The statue is of a peasant Egyptian woman calling upon the Sphinx to arise from his prostration, signaling a new Egypt whose history would help write its future. Completed in 1928 using both private and public funds, it was intended for both the Egyptian people and, due to its location, for foreign consumption, helping to advertise the renaissance in Egyptian arts and politics to a global audience. The statue, according to Prime Mininster al-Nahhas, who spoke at its unveiling, "represents the glory of the past, the earnestness of the present, and the hope of the future" (Colla 2007). That future's direction is under grave debate in 2014. So is its past, as the statue and the "renaissance" itself, has been a site of much political debate. *Nahda* is not a word with fixed politics; it is used to mobilize political agendas that revive the past, whether Pharonic or Islamic. For example, Khairat Al-Shater, the Deputy Guide of the Muslim Brotherhood, titled his lecture on April 21, 2011, "Features of Nahda: Gains of the Revolution and the Horizons for Developing," in which he refers to non-Islamists as pre-Islamic; reclaiming the culture in the name of El Nahda plays on the way Pharonism was used to forge a new nationalism in modern Egypt, attempting to legitimize the political aspirations of the Muslim Brotherhood.

This belief in the Muslim Brotherhood is underscored when reading the graffiti on the statue, which states in Arabic, "Islamic Rule/Islamic Egypt." On its base, the writers declared, "Thugs + Christians = Tamarod." Although graffiti have been viewed as a tool of secular revolutionaries, in this case, it

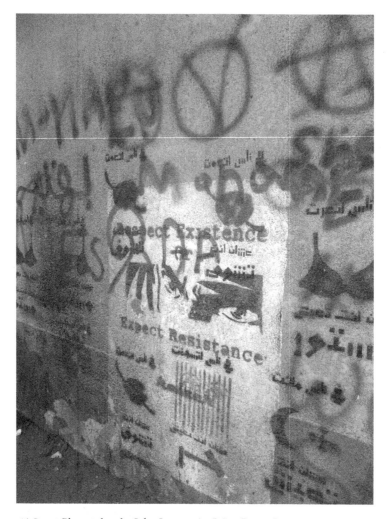

FIGURE 4.6 Photo taken by John Lennon in Cairo, Egypt, June 2015.

is the Islamists who used this medium to make their feelings known, spray-painting their beliefs as they occupied the area around the statue, chanting for a reinstatement of Morsi. The inflammatory rhetoric on the defaced statue's base that equates all Christians with the Tamarod (a grassroots organization formed to oppose Morsi) speaks to the layered tensions and bubbling violence in the present moment, but whose roots dig into previous eras. The ephemerality of the graffiti on the seemingly permanent stone statue is striking: contemporary conversations dripped in blood are being

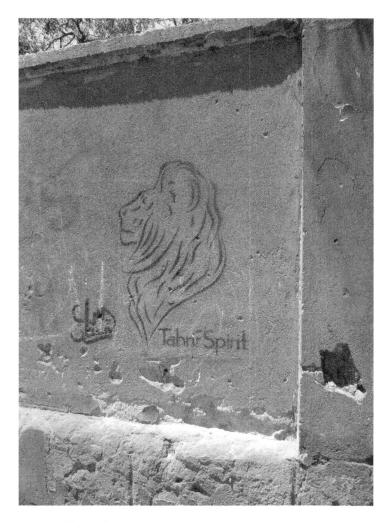

FIGURE 4.7 Photo taken by John Lennon in Cairo, Egypt, June 2015.

written over Egyptian historic symbols. Will the writing be cleansed from the statue, quickly forgotten if a more secular Egyptian era begins? Or will this writing, infused with the historic symbolism of the statue, help create a "new renaissance" of Islamist rule in Egypt? In terms of conflict graffiti, will an Islamist-based graffiti style emerge to combat the radical secular graffiti represented by Keizer and, if so, will we see wall battles that mimic the violence on the street? While not yet clear, it is certain that the answers will be painted on the walls in the days, weeks, and years to come.

Conclusion

In New York City in 1973, after examining the tags of Taki 183 and Junior 161, Norman Mailer (1973, 31) wrote in *The Faith of Graffiti,* "From which combat came these curious letters of graffiti, with its Chinese and Arabic calligraphies; out of what connection to the past are these lights and touches of flame so much like the Hebrew alphabet where the form of the letter itself was worshipped as a manifest of the Lord." Touching walls and offering a commentary on graffiti that was born from racial economic injustice and urban blight, Mailer was hypothetically following the routes of graffiti, poetically offering a roadmap to understand the discourse of these taggers. Forty years later, it would behoove us scholars to go further and develop methodologies that would allow us to more thoroughly examine the politics of conflict graffiti by not only seeing the paint on the walls but to understand the specific "combat" that produced them and "connections" that are locally rooted and globally contextualized.

SECTION II

UNDERSTANDING THE FORM
AND CONTEXT OF GRAFFITI

ocumenting the broad physical and cultural contexts of graffiti is fundamental in understanding the dialogue between the creator and the audience. Analyzing the surfaces where these texts are found and where they are viewed or read informs the efficacy of their messages and contributes to how narratives of place can be examined. The style of graffiti and how and where they were created affects a viewer's experience. Exploring point of display or questions surrounding what type of mode of encounter exists between audience and object, whether it be a carved rock face, an arborlyph, walls of an abandoned factory, moving subway train, or gallery, complicate our understanding of graffiti. Graffiti are narratives applied to surfaces where they do not naturally belong (Frood 2013). Surfaces are changed by the presence of graffiti and, depending on the viewer, will be considered a form of defilement or beauty. Graffiti remain dangerous because their intent and messages are often slippery and subjective.

Graffiti are site specific: surfaces, texts, styles, and colors are meaningful when they are considered in their original context. Sociolinguist Urs Dürmüller has observed that the surface on which these texts appear is part of their "semantic structure" (1988, 1), but the physical contexts of graffiti are a varied lot of surfaces with tenuous history and preservation. When decontextualized, however, the creator's voice and the function of their expressions lose meaning, becoming scratches on a random surface. Without context,

the role of audience is lost and the important exchange between viewer and object is greatly diminished. Philosopher and phenomenologist Han-Georg Gadamer has observed that "the work of art is not an object that stands over against a subject for itself. Instead the work of art has its true being in the fact that it becomes an experience that changes the person who experiences it" (Villhauer 2010, 32). The chapters in this section consider graffiti visual objects experienced in a specific environment where communication and interpretation happen in the form of a dialogue between context, object, and viewer.

These vagaries of sight, which are dictated by the physical environment and the intentions of the artist/writer, are analyzed in separate chapters by archaeologists Dragos Măndescu and Troy Lovata. Artists' intentions are difficult to ascertain, but when the content of a piece is carefully compared with the sight lines, placement, and point of encounter, the meanings of ancient and historic graffiti expressions are more comprehensible and also read as something of value rather than vandalism or mindless doodles. In the Carpathian Mountains of what is today Romania, an image of an individual on horseback was carved into a cliff face. Large and commanding, the horseman is intentionally public, and his form remains intelligible after hundreds of years. Nonetheless, the image's message remains unclear. By comparing and contrasting this image with similar rock carvings from the region, Măndescu proposes a new interpretation of the horseman figure. In another hemisphere, Lovata explores how public and private contexts contribute to the audience's comprehension of graffiti. He considers how isolated sheepherders, recreationalists, or hikers in northern New Mexico and southern Colorado altered the natural landscape—through carving on trees—as a form of reaction, self-expression, and control. Lovata employs theories of phenomenology in his exploration of meaning and examines the surface of the trunks and the physical context of these carvings to help discern their function. He shows how some carvings serve to direct a viewer's line of sight to water resources or clear trails through the woods, while other imagery express sentiments not entirely intended for public view or understanding.

In the following chapters, Bruce Beaton and Shannon Todd, Gabrielle Gopinath, and Alexandra Duncan consider contemporary urban graffiti, which are frequently considered more defacement than the previous examples of ancient or historic rock art and arborglyphs. These modern inscriptions are often ephemeral, and are dangerous in life and limb for the writer to create and complete. Beaton and Todd discuss a group of abandoned buildings on the periphery of mainstream Toronto culture. A ruined factory

functioned as a haven for marginalized populations to congregate. Transformed by tags, symbols, and markers, the urban decay of a factory became a monumental, ever-changing site of conversation between many people (see also the discussion of these dynamic types of exchanges in the chapter by Meade earlier in this volume). This series of structures was later rehabilitated into a multiuse community complex with the graffiti included. How the graffiti were integrated into this new space is at the crux of their chapter. Further south and a few decades back in time, 1970s and 1980s New York City is the context for the beginning of wildstyle graffiti. Like the graffiti from Beaton and Todd's chapter, it was the expression of a marginalized voice. Gopinath talks about New York City teens and young adults who went "all city," a term used by the writers to describe both their method of blanketing the urban spaces with their inscriptions and also their zeitgeist, to speak loudly and from an almost omnipresent platform. The style was a highly calligraphic collection of names, attitudes, and desires applied to subway cars and translated into glyphs and designs. The French graffitist Zevs bridges the divide between protest inscriptions scrawled across billboards and public advertisements, with the creation of scaled-down, fine-art versions of his critiques curated and put up for sale in commercial galleries. Duncan analyzes the two points of display/sale of Zevs's work, which speaks to the power of graffiti and its newfound popularity and value; however, do they function the same, and are the gallery works still graffiti?

CHAPTER 5

Archaeology and Graffiti Carved in Carpathian Rock: The Thracian Horseman, or an Early Medieval Image of Power and Authority?

DRAGOȘ MĂNDESCU

Introduction

I n this chapter I discuss a case study of ancient graffiti carved into the rock at the well-known archaeological site at Cetățeni, on the upper valley of Romania's Dâmbovița River at the southern margin of the Carpathian Mountain foothills (Figure 5.1). This settlement is mentioned as *Cetățuia lui Negru Vodă* ("The Black Prince's Citadel" in Romanian) in the end of the seventeenth-century correspondence between the scholar, soldier, and virtuoso Luigi Ferdinando Marsigli and Constantine Cantacuzene, High Steward of Wallachia (Iorga 1901; Ortiz 1916; Stoye 1994).

The first archaeological excavations were conducted here in the last quarter of the nineteenth century by Dimitrie C. Butculescu, a pioneer of Romanian archaeology (Butculescu 2010). Systematic excavations began in 1956 and lasted, with many interruptions, until 2004. They were organized first by the Institute of Archaeology in Bucharest, later by the Romanian National Museum of History, and finally by the The Argeș County Museum (Măndescu 2006). These excavations have revealed the existence of an important pre-Roman Dacian settlement dating from the Late Iron Age (2nd century BC–1st century AD) with a trading function (Babeș 1999; Măndescu 2006; Mîrțu 1963; Rosetti and Chițescu 1973; Tudor 1967; Vulpe 1966). It is overlain by more than 12 centuries of development by a prosperous medieval settlement starting in the thirteenth century, before the establishment of the medieval state of Wallachia (Chițescu et al. 1986).

Cetățeni is strategically located in front of the Carpathian Mountains, in a spot where the Dâmbovița River flows among the rocky slopes that dominate

Understanding Graffiti edited by Troy Lovata & Elizabeth Olton, 77–89. © 2015 Taylor & Francis. All rights reserved.

FIGURE 5.1 Cetățeni archaeological site's location in the northern Balkans.

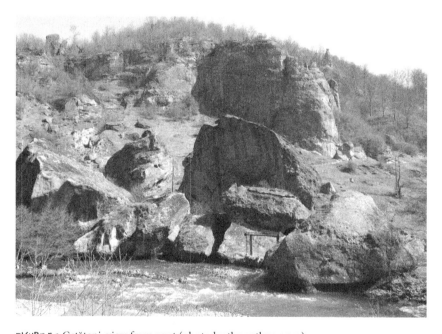

FIGURE 5.2 Cetățeni, view from west (photo by the author, 2010).

the banks (Figure 5.2). This is the narrowest crossing point from north to south of the entire valley, and thus is the best location in the Dâmbovița River valley to control traffic from the Danube Plain northward toward the Carpathians and Transylvania.

Both the Late Iron Age settlement and the superposed medieval settlement at Cetățeni consist of an open, unfortified community on the left bank of the river, between the river and rocky slope from the east. At the top of the east slope, in an almost impregnable position, sits a brick- and stone-walled fortress. This citadel was located on a dominant peak at an altitude of more than 700 meters and afforded the inhabitants total visibility and control over a large sector of the Dâmbovița River valley to the south, controlling the traffic, trade, and communication on the long route between the Danube and the Carpathians. Today, there is an Orthodox monastery on the peak that uses an old cave as a church.

The archaeological complex of Cetățeni is well known because of the Dacian settlement Dâmbovița on the left bank of the Dâmbovița River as

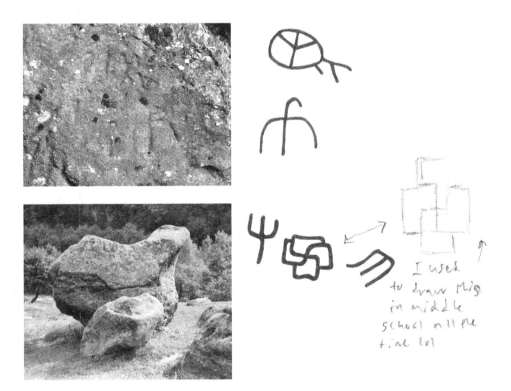

FIGURE 5.3 Symbols on the rocks at Cetățeni (photo by the author, 2002).

well as its location near medieval Romanian ecclesiastic monuments. The site is also remarkable for lesser-known features: graffiti chiseled onto the surface of massive stones at the foot of the rocky hill Cetățuia lui Negru Vodă, along the ancient and medieval roads. They include combinations and intersections of straight and curved lines, a compound swastika (Figure 5.3), and an anthropomorphic silhouette (Figure 5.4). The graffiti appear to be carved on the rock all around the open settlement, apparently randomly and without any order or uniform size.

These carvings were first recorded in the second half of the nineteenth century by the romantic-era archaeologist Dimitrie C. Butculescu, who interpreted them in a fantasist manner, likening them to northern European cult

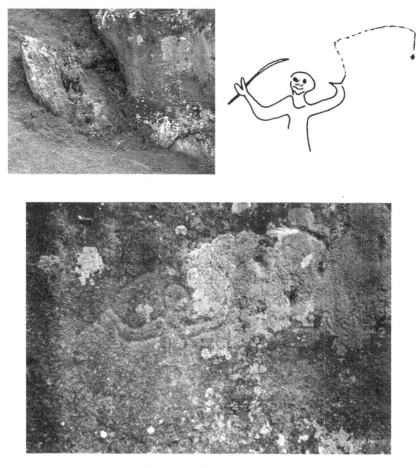

FIGURE 5.4 Medieval warrior silhouette on the rocks at Cetățeni (photo by the author, 2002).

symbols such as Thor's hammer, which are found on many Scandinavian monuments. Butculescu (2010, 108, plate 13/1) thought—according to the romantic spirit of the time—that the authors of those cult messages were "the Celts during their expansion through Europe." Archaeologist Dinu V. Rosetti (1960, Fig. 2; 1962, 73, Fig. 1/1-2), who worked at the site in the second half of the twentieth century, also noted the symbols from the terrace of Dâmboviței and labeled them as "alfabetiformes signs . . . dating from about the beginning of our political state [i.e., the first half of the fourteenth century]."

Similar markings were discovered at many points in both the outer and inner Carpathian areas. At Slon (Prahova County, south of the Carpathians), in the areas known as La Comoară (Romanian for "At Treasure") and Stâna Veche ("The Old Sheepfold"), there are two fortifications dating from the ninth and tenth centuries. Archaeological investigation identified them as probable control points on the road that climbs along the Teleajen River valley as it crosses the mountains to the Bârsa Land in southern Transylvania. Carvings were discovered in stones and bricks at both sites (Comșa 1960b). They were recorded in 1869 and 1871 by Cezar Bolliac, who interpreted them as a Dacian alphabet formed out of a mixture of "Celtic, Celtiberian, Celtic-Greek, and runes, symbols and letters" (Bolliac 1871, 2; Măndescu 2001, 17–18). In the settlement of Bucov (Prahova County), symbols similar to those at Cetățeni and Slon were cut in the adobe wall of a smithy that date to the tenth century (Comșa 1960a, 1960b). Similar markings are also cut into monoliths in Transylvania on the Upper Mureș at Ditrău, near Gheorghieni (Harghita County) (Bakó 1962). The inscriptions from Slon and Ditrău are considered Proto-Bulgarian in origin, while those from Bucov are labeled as Palaeo-Slavic and resulted from the increasing authority of the first Proto-Bulgarian czardom in the northern part of the Danube in the ninth and tenth centuries.

Indeed, the closest analogies for the runic, proto-literate symbols from the northern part of the Danube are found in Bulgaria and date from the ninth, tenth, and eleventh centuries, after the Christianization of the Bulgarians and their adoption of the Glagolitic and Cyrillic alphabets, which are found in both secular and ecclesiastical contexts in the capital cities of Pliska (Mijatev 1943) and Preslav (Čangova 1957), and nearby at Vinica (Stančev 1952). Such inscriptions are also present in the region of Šumen, at Novi Pazar (Stančev 1957), and further into northeastern Bulgaria at Carali (Comșa 1962). The weapon included with the silhouette of a warrior chiseled into the rock at Cetățuia is further evidence of a Proto-Bulgarian origin (Figure 5.4). The rider has a slightly curved blade in his right hand, and in his left hand he holds a fighting whip. This was a weapon often used in the early Middle Ages

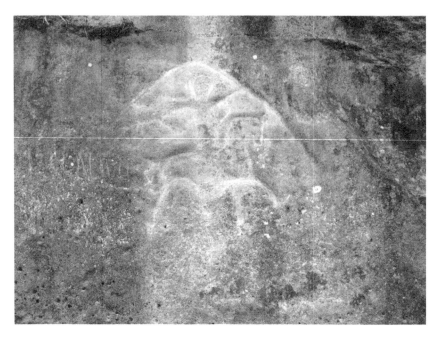

FIGURE 5.5 The rider from Cetățeni (photo by the author, 2007).

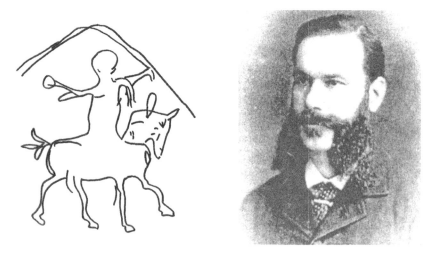

FIGURE 5.6 Dimitrie C. Butculescu and his first drawing (1881) of the Cetățeni horseman (from Butculescu's manuscripts kept in the Museum of Bucharest's archive) (image courtesy of the Museum of Bucharest).

by the Turkic riders, a collection of ethnic groups that include the Proto-Bulgarians (Ștefan et al. 1967).

But the main element is the rider chiseled on the highest rock in the top of the hill, in the citadel, on the northern wall of the rock (Figure 5.5). It is the same huge rock into which the current cave church was dug. Dimitrie C. Butculescu, the first to describe and record the graffiti (Figure 5.6) in 1881, determined that it represented Saint George, "the patron of the church" (Butculescu 2010, 113). Today, this seems a fantastic claim. The rider does not appear to have anything to do with Christian religious representations, and is unconnected to the little cave church, which has "The Healing Spring" rather than Saint George as a patron. Moreover, such patrons are usually permanently established at the founding of a church and do not change over time.

The rider is depicted in a triumphant pose, with his left arm raised high and his right arm resting on his hip. A mantle seems to wave on his back. The horse appears to walk elegantly turned to its left side (toward the west), with its front foot slightly raised. A simple arcade binds the whole image at the top. Scaffolding or other accessories were not needed to raise or suspend the artist; everything is accessible from ground level at the height of an ordinary man. Today, the image of the ancient rider has become one of the most popular points of interest for visitors and pilgrims to the site. In the last few years, the orthodox monks who administer the citadel area outlined the graffiti silhouette with ordinary paint to make it more visible to visiting tourists.

Today, many scholars studying the site label the graffito as a representation of "the Thracian Rider." This assertion is based on the rich Dacian heritage of the archaeological site from Cetățeni, dating back from pre-Roman Dacia (2nd century BC–1st century AD). For the northern Thracians, including the Dacians and the Getae, the horse is often a mythical character that is a complementary and auxiliary symbol of heroes. The horse is placed in direct relationship with the rider-hero, the god-riders of old Thracian mythology. Horse and rider duos often occur in northern Balkan Thracian art in the five centuries before Christ. The image is present on both daily-use Dacian pottery as well as luxury vessels in metal, such as the Silver mastos cup from the Yakimovo hoard (1st century BC) (Figure 5.7). The image of the Thracian rider appears on many silver phalerae for dress or harness ornamentation, discovered both south of the Danube in the hoards from Letnica, Lukovit, and Galice, and north in Transylvania Dacia in the hoards from Surcea and Lupu (Sîrbu and Florea 1997; Spânu 2012).

Images of a hero hunting or fighting also adorn the silver Thracian parade helmet discovered at Agighiol, in northern Dobrogea, in the grave of a Getian basileos (Sîrbu 2004). A Thracian horseman is also present on the Dacian

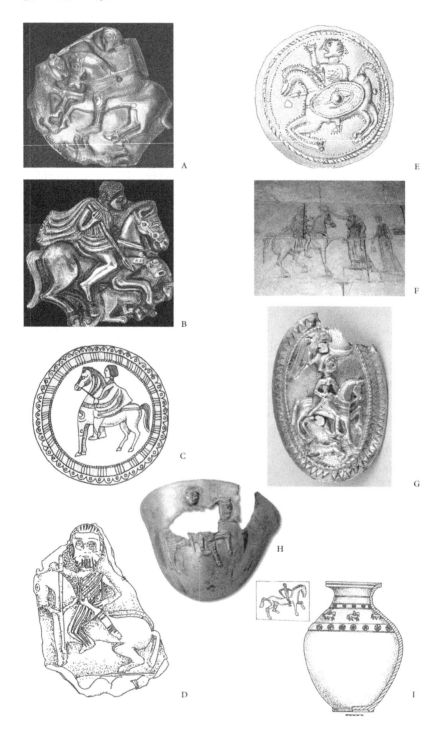

A

E

B

F

C

G

D

H

I

silver coins minted in the second century BC after the Macedonian proto-types of Phillip the Second (Preda 1973). The image of the rider followed the Thracian kings even in death, as seen in the paintings inside the famous tombs from Sveštari and Alexandrovo (Chikikova 1992).

Horses were much valued and respected by the Thracians. The image of horses joined their masters even at parties in the form of rhyta-type vessels, horse-shaped drinking horns made in silver from the fifth to third centuries BC (Ivanov 1980), and in clay during the second and first centuries BC (Mîrțu 1964). The care and respect showed by the Getae for their horses is evident in horse graves arranged inside some community cemeteries such as the necropolis of Zimnicea, on the northern bank of the Danube (Alexandrescu 1983).

But nowhere else in the pre-Roman Thracian world are there representa-tions of horsemen carved in stone like those found at Cetățeni. Moreover, rock art is not specifically part of the artistic repertoire of Late Iron Age Thra-cian tribes. In light of this, I propose looking instead for links at a site 300 km away to the southeast of Cetățeni, near the village of Madara in northeast Bulgaria, at the eastern end of the Balkan Mountains. With this we leave the field of Thracian art and examine early medieval equine representations.

Chiseled in high relief is the Madara Rider (Figure 5.8), a life-size figure of a knight triumphing over a lion. The image was carved into a 100-meter cliff about 10 km from the early medieval Bulgarian capital of Pliska. Inscrip-tions near the sculpture tell of events that occurred in the eighth century. Most researchers agree that the Madara Rider was created during the time of either the Bulgarian khan Tervel (who ruled in the first two decades of the eighth century) or Krum (who ruled in the beginning of the ninth century) as a memorial to the victories over the Byzantines and as an expression of the glory of the newly founded Bulgarian state (Košev 1981, 130–131; Mijatev 1929, 90–126).

Like the rider from Madara, the rider from Cetățeni is chiseled in the upper part of the rock, which has symbolic overtones, and has the same atti-tude. The location is one of the most dominant on the landscape, on the peak of the rocky monticule and under the protection of the political authority that ruled the area. The horseman's stone was inside the citadel on the top

FIGURE 5.7 (opposite) The Thracian rider in various Thracian (4th–3rd centuries BC) and Geto-Dacian (2nd century BC–1st century AD) art representations. A) Letnica. B) Lukovit. C) Galice. D) Răcătău. E) Lupu. F) Sveštari. G) Surcea. H)Yakimovo. I) Zimnicea. (Different scales; images reproduced from Valeriu Sîrbu, Gelu Florea, Daniel Spânu, and Maria Chikikova.)

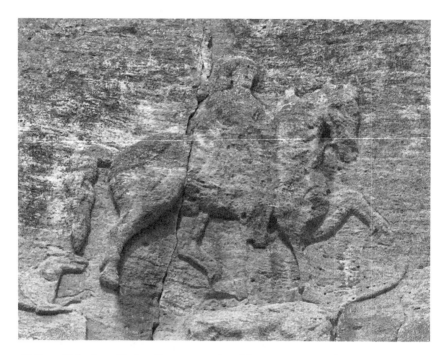

FIGURE 5.8 Rider from Madara (image reproduced from Istorija na Bălgarija 1981).

of the monticule, placed in a space of power and authority designated to the upper class, the landlords. At the same time, it is located above the ordinary people that lived down in the valley, and also above the travelers crossing the gorge at the foot of the monticule. It is the most suitable place to display a message for the community as well as visitors and newcomers. Both Madara and Cetățeni share a spectacular rocky landscape with steep slopes. Moreover, both riders are situated in the vicinity of sanctuaries and places of worship cut in the rock with a long history of use that precedes Christian times and, in the case of Cetățeni, are used as such today. Images of similar riders are common in the art at the beginning of the Middle Ages in Eastern Europe. For example, a similar rider (Figure 5.9) is depicted on a golden flask in the treasure from Sânnicolau Mare (Florescu and Miclea 1979; László and Rácz 1984). These features indicate that the graffiti rider at Cetățeni is related to the Proto-Bulgarian origin images chiseled into the rocks at Madara and date to the same period: the ninth and tenth centuries. But how and in what circumstances could an image specific to the first Bulgarian khans reach the Carpathians?

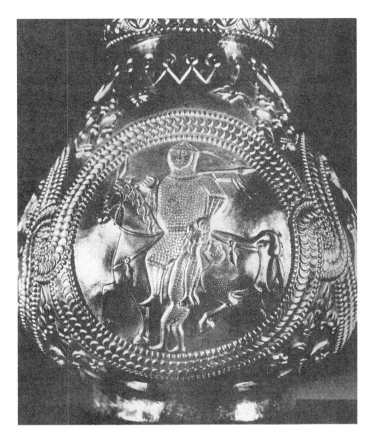

FIGURE 5.7 Rider depicted on a flask from the Sânnicolau Mare hoard (image reproduced from Radu Florescu and Ion Miclea).

There is a long-running and unresolved dispute in the Romanian historiography regarding the existence of a "Bulgaria" in the northern part of the Danube in the ninth and tenth centuries. There are three main opinions: for (Grecu 1950), against (Bănescu 1947; Bica 2002), and undecided (Barnea 2001). The graffiti from Cetățeni appear to support Grecu's (1950) opinion. They can be matched with other archaeological evidence, such as the Pliska and Madara amphora-type pitchers present in the northern part of the Lower Danube that are probably a ceramic style; the tombs from Sebeș and Blandiana; and the gold vessel hoard from Sânnicolau Mare (Comșa 1960a). Furthermore, the funerary horizon from the ninth and tenth centuries at the Lower Danube indicates the sudden appearance of big, bi-ritual necropolises

along the river (Luca and Măndescu 2001), and is considered by some scholars to represent the "archeological reflex of the political structures of the Proto-Bulgarian czardom" (Fiedler 1992, 312–330; Harhoiu 2000, 148–150).

In the present state of the research, it is possible to affirm that the Proto-Bulgarian czardom controlled the Lower Danube as they became stronger and more powerful at the beginning of the ninth century during the reign of Krum Khan (803–814 AD). He was the master of the Trans-Balkan route, which connected the Danubian regions to Constantinople; this led some Byzantine authors to mention the existence of "a Bulgaria in the northern part of the Danube" (Theodorescu 1974, 47–48). The influence and even the effective presence of the Proto-Bulgarians in the northern part of the Danube appear logical if we take into consideration the key moment of the collapse of the Avar Kaghanate from Pannonia at the hands of Charlemagne and his Franks at the end of the eighth century. Widely spread territories from the northern side of the Danube, once under Avar supremacy, certainly remained outside the new established Carolingian Mark in Pannonia around the year 800 AD. It appears almost impossible for the Proto-Bulgarians, who were in a period of political and military expansion, not to take advantage of this situation to spread their control beyond the Danube and up to Transylvania. The territories beyond the Carpathians were always of strong interest and a target (not just an economic one) because of the abundance of salt, a natural resource so cherished and valued during the Middle Ages (Holban 1968).

P. Magister, the author of the *Anonymous's Chronicle* (*Gesta Hungarorum*), finds it necessary to mention the fact that ". . . from that land of Transylvania . . . salt and salted material are extracted" (Popa-Lisseanu 1934, 95). According to the *Legend of St. Gerhardus* (*Legenda Sancti Gerhardi*) in the eleventh century in Transylvania, salt was successfully exploited and transported on the Mureş River to Hungary (Szentpétery 1938). But an older text from the ninth century, preserved in *Annales Fuldenses*, is of greater importance because it includes the stipulations of the pact between the German king Arnulf and the khan from Pliska, Vladimir (Pertz and Kurze 1891, 121–122). The act decreed that the latter was to forbid the trading of salt (from Transylvania, obviously) to Moravia, but these stipulations would have been unenforceable if the khan did not exert political and economical dominance over the salt mine region from beyond the Carpathians. The existence of the runic Proto-Bulgarian symbols at Cetăţeni, Slon, and Ditrău thus must be connected to the important mountain passes crossed by strategic and trade routes that linked Transylvania to the outer Carpathian territories from the south and east: Rucăr-Bran, Bratocea, and Tabla Buţii, present-day Ghimeş and Bicaz, respectively. Some of the German chronicles, as well as Constan-

tine Porphyrogenitus, mentioned that the Bulgarian state bordered the Caro-lingian state as well as Moravia (Panaitescu 1994). We should note that in the year 813 Krum Khan deported no fewer than 10,000 inhabitants from the Adrianopole area to north of the Danube, according to Byzantine authors such as Simeon Magister and Leo Gramaticus (Elian and Tanaşoca 1975); although it was indeed a peripheral area of the Proto-Bulgarian state, there is no doubt that it was under the khan's control and authority.

The proto-literate runic symbols from the rocks at Cetăţeni could be considered another important testimony to the control that the khans of the first Bulgarian state exerted in the ninth and tenth centuries at the strategic mountain passes that crossed the Carpathians to Transylvania through Bârsa Land. It seems that the Cetăţeni area played the same role for the Rucăr-Bran mountain pass as the one that the Bulgarian outpost from Slon had for supervising the route toward Transylvania from the Teleajen River valley. If this is so, the "Thracian Rider" label assigned to the rock art at Cetăţeni should be abandoned, and the famous horseman from Madara would gain a little brother, if even more modest, 300 km further north, displayed on the Carpathian rocks.

Marked Trees: Exploring the Context of Southern Rocky Mountain Arborglyphs

TROY LOVATA

Culturally Modified Trees and Graffiti on Trees

Culturally modified trees (CMTs) is an overarching term for trees shaped by a variety of intentional human activities. CMTs can exhibit evidence of activities such as bark stripping, felling for logs, testing for soundness, and plank removal (Long 2005; Resources Inventory Committee 2001; Stryd and Feddema 1998). Arborglyphs (Figure 6.1) are a CMT subset that includes images or text—such as graffiti—carved into bark or, less commonly, painted on a tree's bark or wood or etched into wood where bark has been removed (Mallea-Olaetxe 2010; Resources Inventory Committee 2001; Worrell 2009). Arborglyphs have been left on numerous species of trees and are widely distributed across different continents (Figure 6.2). This diversity extends beyond trees themselves; I have recorded similar graffiti carved into woody bushes or on the broad leaves or bodies of cactus, agave, or other succulents in places as diverse as the archaeology site of Ingapirca in the Ecuadoran Andes; along the Makapu'u Hiking Trail on Oahu, Hawaii; and in the Domain Park in downtown Auckland, New Zealand. Carved quaking aspen trees (Populous tremuloides) are especially prominent in the western United States, where their fine-textured, white-colored bark offers a clear canvas. Nineteenth- and twentieth-century aspen graffiti by Basque, Irish, and Hispanic sheepherders are abundant and well known in the region (Gulliford 2007; Mallea-Olaetxe 2000; Pederson 2003). In addition, there are many pre-Columbian CMTs across North America and around the globe, as arborglyphs are found deep into antiquity (Stryd and Feddema 1998; Worrell 2009). For example, the first-century BC Roman poet Virgil's *Bucolics*,

Understanding Graffiti edited by Troy Lovata & Elizabeth Olton, 91–104. © 2015 Taylor & Francis. All rights reserved.

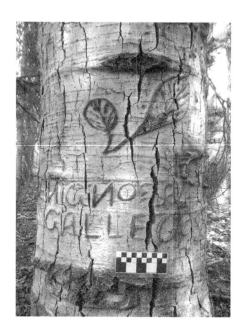

FIGURE 6.1 Graffiti carved onto an aspen tree in a grove on the east side of Buckles Lake, south of the town of Pagosa Springs, Colorado. The arborglyph features aspen leaves and the name Benigno A. Gallegos, who marked numerous trees with a variety of images and styles of text in the area during the early twentieth century. Photograph courtesy of the author.

FIGURE 6.2 Graffiti carved on a royal palm tree (*Roystenea regia*) on Kitchener's Island, Aswan, Egypt. The Arabic text includes the names Abdullah and Hassan and a third, illegible word. It was likely carved, based on the depth of the carving and the general growth pattern of palms, not long before it was recorded in May 2012. Translation courtesy of Dr. Muhammed Ali of the University of New Mexico. Photograph courtesy of the author.

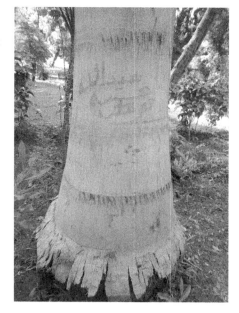

or herdsmen's songs, recount a shepherd carving his name on a beech tree (Alpers 1979). On the other end of the spectrum, carving graffiti on trees continues today with marks left by indigenous peoples, immigrants, locals, travelers, tourists, pilgrims, outdoorsmen, lovers, and the lovelorn.

Varied and Contradictory Methodological Approaches to Arborglyphs

My own interest in arborglyphs developed out of encountering aspen carvings in many years hiking through Rocky Mountain forests and my general research into how and why people mark their presence on the landscape from prehistoric megaliths to contemporary public art. While developing the course "The Archaeology of Walking" for the University of New Mexico's Honors College, these theoretical and material strands came together. I began making preliminary observations of aspen graffiti along wilderness trails in the San Pedro Parks in the Jemez Mountains outside Cuba, New Mexico; on popular recreational trails across the crest of the Sandia Mountains east of Albuquerque, New Mexico; and around Buckles Lake in the high country south of Pagosa Springs, Colorado. My catalog eventually constituted more than 450 individually carved aspens along nearly 20 miles of formal and informal trails.

Models for studying these expressions lacked consistency and did not have a comparable catalog of examples. This seems, at least in part, related to the diverse and sometimes inward-looking reasons for, and approaches that scholars have taken in, studying arborglyphs. Archaeologists and foresters in Canada, Australia, and Scandinavia have crafted detailed guides for recording CMTs, yet they tend to focus on trees as raw materials since arborglyphs seem relatively rarer than other forms of CMTs in these regions (Andersson et al. 2008; Long 2005; Resources Inventory Committee 2001; Stryd and Feddema 1998). In contrast, arborglyphs are found across the United States, and aspen graffiti are especially prevalent in the intermountain West (Worrell 2009). But diversity in research approaches reigns even here. A few late-twentieth-century folklorists studied carved aspens in Utah and New Mexico, yet they are infrequently cited and appear rarely used as models by later scholars or those in other fields (Brunvand 1972; Brunvand and Abramson 1969; DeKorne 1970). Archaeologists—primarily working as cultural resource managers for government agencies such as the U.S. Forest Service or Bureau of Land Management—have recently cataloged large collections of arborglyphs. Their results, however, have tended to be narrowly distributed as part of the "gray literature" of government reports, conference

presentations, and self-published texts, or limited to specific study locations or historic events (Crawford 2005; Gulliford 2007; Hegberg and Sutton 2011; Pederson 2003; Thurman 2001). Historian Jose Mallea-Olaetxe (2000, 2010) has personally recorded many thousands of arborglyphs across Nevada, California, Idaho, and Oregon. His work appears to be not just the largest collection, but the most widely read and cited body of arborglyph research. It is seminal in both the study of carved aspens in the region and the story of Basque immigrants in the United States, who are his research specialty and—since so many worked as sheepherders in the area—who marked thousands of trees during the nineteenth and twentieth centuries. His approach is primarily that of a Basque historian; he focuses on the carvings as textual documents that primarily illuminate a very specific immigrant experience.

As I looked for models or correlates for my own research, it became clear that the process of recording, defining, and cataloging arborglyphs is varied because of researchers' particular disciplinary guides. These parallel some of the fundamental debates in recording and interpreting other forms of visual display and graffiti, such has occurred with rock art (Lovata 2013). Archaeologist Paul Bahn's (2010) discussion of the graffiti artist Banksy's unsanctioned inclusion of fake rock art in the British Museum provides a good example of the dilemmas people have when attempting to delineate hard lines between prehistoric art, fine art, and graffiti when studying rock art (see also Măndescu in this volume). These are part of critical debates about the appropriateness of applying Western concepts of art to non-Western cultures and their rock carving (Whitley 2011). They mirror the statements of archaeologists and anthropologists such as Arnoud Stryd and Vicki Feddema (1998), who declare that CMTs in the Canadian province of British Columbia are significant specifically because they are the product of historic indigenous peoples. Yet, other researchers find value in expanding the field wider and recognizing them as both a past and present cultural manifestation. They complain, for example, that Mallea-Olaetxe is too focused on Basque immigrant sheepherders in one area of the American West, overshadowing the variety of CMTs and the ways they might be studied (Sayre 2001; Worrell 2009).

Moreover, much CMT research is guided by legal definitions that privilege the study and preservation of antiquity by default over more recent cultural expressions. Many CMTs in the Americas are on public lands and are recorded or ultimately protected because of their age, while newer features of the same type are usually deemed not significant because they are less than a half-century old (Lovata 2007). Similarly, the high value that Canadian archaeologists and cultural resource managers place on older, indigenous CMTs, and the corresponding lack of value given to recently carved graffiti of

immigrants, is an artifact of laws that use 1846 as cut-off between protected and unprotected archaeological sites (Stryd and Feddema 1998). Likewise, Australian government guides to CMTs note that both Aboriginal groups and early European settlers marked trees, sometimes in similar ways (Long 2005). Yet they also take pains to separate the practices and define the study of CMTs as important for what they might tell about Aboriginal rather than more recent immigrant peoples (Long 2005).

Although many slow-growing and centuries-old trees are CMTs, the American aspens that contain so much graffiti are not themselves ancient trees. Aspens have a lifespan of 60 years or less east of the Mississippi River, and between 80 and 120 years in the higher-elevation and drier—which slow both a tree's growth and decay—intermountain West (Perala 1990). Aspens' lifespans blur lines between historically significant and modern graffiti. In fact, I have found no researchers who explain how they ascribe age to the graffiti on trees beyond those examples that include a date or mention of a definitively dated person or event in their text.

The value—or lack of it—placed on graffiti itself also complicates the study of markings on trees. Mallea-Olaetxe (2000) questions whether carvings on aspens are truly graffiti at all and, after seemingly reaching no definitive statement either way, defines Basque immigrant arborglyphs as first an ethnohistorical statement, second an art form, and third a literary form. He seems to waver in part because so many people denigrate graffiti as a low expression of culture or the valueless work of outsiders (Mallea-Olaetxe 2000). Confusion over historic and cultural value abounds in the recording of arborglyphs, as it does with the study of graffiti in general. For example, many representatives of the U.S. government that record and study the carvings on aspen trees stress the importance and worth of historic and prehistoric carvings to other researchers and the public at large while simultaneously exhorting that modern people should never deface trees themselves (Bastone 2005; Gulliford 2007). They place value on the past while creating a firm disjuncture between past and present behaviors.

What I found most lacking from carved aspen studies was not an expansive definition of graffiti or an understanding of the range of arborglyphs, but the absence of context. For example, geographer Nathan Sayre's (2001) review of Mallea-Olaetxe's work notes that he is focused on presenting a culture history rather than understanding the landscape populated by trees and people or considering carved trees' roles in a cultural ecology. A few archaeologists in California and Colorado have looked at carved names and dates for an understanding of how sheepherders returned to places seasonally and conceive of groves of carved aspens as comprising historic districts rather

than being isolated examples of graffiti (Crawford 2005; Hegberg and Sutton 2011). They have also tentatively measured attributes of the trees themselves to capture some context. Yet, even they appear to have collected less contextual information about arborglyphs than other archaeologists and foresters have about other types of CMTs in other parts of the world (Andersson et al. 2008; Long 2005; Resources Inventory Committee 2001). Much research focuses on the text or image of the graffiti alone. In fact, Mallea-Olaetxe (2000) goes so far as to explicitly state that detailed mapping of individual trees is overly fastidious when such a large number of carvings have yet to be recorded, although he does explain how the conspicuous location of some trees were central to some carvers. He and others have also recognized the sense of geographic isolation expressed in some sheepherder's graffiti (Mallea-Olaetxe 2000, 2010; Pederson 2003). Nonetheless, Mallea-Olaetxe's (2000) guidelines for recording arborglyphs give ample directions for recording and interrupting textual and visual themes or considering the identities of carvers while at the same time stating that there is little worth recording about the trees themselves beyond the general location of a grove.

Landscape as Context

My perception of a lack in recording context is no doubt related to how I came to study arborglyphs as an offshoot of the archaeological examination of trails and how people mark the landscape (i.e., from a landscape archaeology perspective). Landscape archaeology is broadly concerned with the material and conceptual things that locate culture (David and Thomas 2008). It is a study of how people visualize the world, how people engage with each other across space, how people manipulate their surroundings, and how those surroundings affect behavior. The connections between trails and arborglyphs led me to see that many carvings are placed with intention and reflect the constraints and opportunities their context offers. I see landscape affecting human organization, but also that, as archaeologists Vicki Cummings and Robert Johnston (2007) argue, landscape itself is structured by the ways in which people navigate it. Trails and markings along them are artifacts of movement. But people further interact with the trail and its surroundings, shape the land, and leave artifacts and evidence in response. People on the landscape often mark this environment for themselves and others with intention. There is undeniable value in understanding the iconography of aspen carvings, but there is also something to be learned from examining the kinesthetic practices of those who created and view graffiti. My prior work had familiarized me with the phenomenological perspective of archaeologist

Christopher Tilley (2008a, 2008b; Tilley and Bennett 2004), which places people's bodies—as a basis for their sensory perceptions—in action on the landscape. Tilley's work with both megaliths and rock art considers how an artifact or feature's placement and its physical properties affect both those who first construct and later view or interact with them. People's corporeal perceptions and their cultural landscape provide context.

Phenomenological Approaches to Arborglyphs

Tilley isn't the only researcher to explore context from a phenomenological perspective, but he provides a clear methodology that can be a framework for examining arborglyphs (2008a, 2008b). He asks a series of questions about where people might be in relation to features and artifacts, how the feature might be encountered and from what direction, and how they are positioned in relation to the landscape at large (Tilley 2008a). Moreover, he advocates visiting sites at different times to judge diurnal or seasonal differences, and visiting similar places with little evidence of cultural activity that might contrast against cultural sites (Tilley 2008b). I considered these guidelines and recorded not just the text and images of graffiti in my preliminary survey of arborglyphs of the southern Rocky Mountains, but also contextual information such as season when viewed; exact location of each tree (latitude, longitude, and elevation); cardinal direction that the carvings faced; whether the graffiti faced up, down, or across slope; whether the carvings faced up, down, across, or away from a trail; if an arborglyph faced into open space like a meadow or away from open areas and into the woods; height of the graffiti above the ground; and diameter at breast height of the tree (a common forestry measurement that indicates very relative age). These measurements were paired with qualitative notes based on walking trails in different directions and speeds, moving off trails into brush or woods, and viewing whether graffiti marking trees appeared bunched, visible, or related to each other.

Tilley (2008a, 42) begins with questions about the body in relation to the rock art he studied, such as, "In order to see and encounter the images . . . do we need to move, or can they all be seen at once, requiring only motion of the head and the eye?" and, "Do we need to look up at the images on the rock above us? (Are the images dominant in relation to the observer?)." Tilley (2008a, 42) then asks how this relates to directionality with questions like, "Do we need to move across the rock in a particular direction—for example, from north to south or east to west?" and, "To experience certain iconic or figural images . . . from a 'correct' perspective, rather than seeing

them upside down, where do we have to stand?" Finally, there are queries about the wider functions of the landscape, considering, "What might be the intent of locating images in one place rather than another in relation to the wider sensory landscapes of vision, sound, touch, taste, and smell?" and "How might weather and seasonal changes in the climate affect this location?" (Tilley 2008a, 43).

Phenomenological Examples

Most of Tilley's (2008a) questions relate to senses of presence. Scholars have noted how aspen bark stands out as a smooth, white, welcoming canvas, and that entire groves of aspen are prominent features of landscapes (Mallea-Olaetxe 2000, 2011). The unique composition of the trees, their contrasting colors, and the sounds experienced in a quaking aspen grove have been noted by hikers and scholars alike (McCool 2001). As I made a preliminary survey of southern Rocky Mountain arborglyphs, I noticed how moving

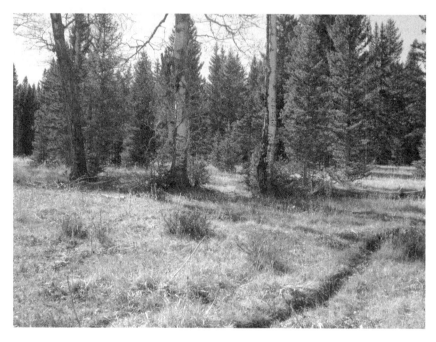

FIGURE 6.3 Three large, graffiti-covered aspen trees in the San Pedro Parks Wilderness, New Mexico. The trees are situated along the Rio de Las Perchas Trail (visible cutting across the grass in the foreground), where it leaves a large, open park and enters dense forest. Photograph courtesy of the author.

along various trails from tree to tree or grove to grove often matched Mallea-Olaetxe's description (2011) of viewing marked aspens in the Sierra Nevadas as akin to traveling between galleries in a museum. I recorded numerous trees that appeared billboard-like and matched the conspicuous placement of arborglyphs noted by other scholars (Mallea-Olaatxe 2000; Pederson 2003). For example, the trees pictured in Figure 6.3 are at a key transition along the adjacent trail: trails in this area often disperse in the middle of meadows, but they reconvene as they enter the dense forest. Not only do the white aspen trunks stand out against the evergreen forest curtain, but the graffiti were conspicuously posited, as they lie at or just above eye level.

However, the same set of marked trees (Figure 6.3) also indicates that simply labeling them as conspicuous fails to capture their nuance. The directional context of these trees is noticeable because their graffiti—including a variety of names, dates, and hometowns—all face into the meadow and down the trail rather than across the trail or up the trail and into the forest. These messages are conspicuous to people crossing the park, but nearly indistinct to people leaving the woods. I encountered many similar examples across the survey area, such as graffiti that were visible at eye level when ascending a slope and alternatively below eye level and barely visible when descending the same trail (Figure 6.4).

Analyses that use the body as a scale allowed me to consider other questions about place and make judgments about the extent of arborglyphs' conspicuous placement. For example, a recently carved name and date on a slender aspen along the 10K Trail stands the highest of any graffiti I recorded, while one arborglyph along the Switchback Trail is the lowest off the ground: 2 to 3 standard deviations above or below average image height. Both marked trees are in the Sandia Mountains, which have been a winter recreation destination for skiing and snowshoeing for more than a century, particularly along these two trails (Beard 1988; Salmon 1998). Snowfall tables show that winter snowpack would often bury the lower mark and, when on snowshoes or skis, bring the higher mark from a neck-straining tilt of the head down to near eye level. Thus, new questions about the method of encounter and the intentions of the writer arise when the context of the environment is considered, such as seasonal change. A few arborglyph researchers have noted the seasonal cycle of sheepherders in the mountains affecting when carvings were made, but not many seriously explore the links between recreation and graffiti (Crawford 2005; Hegberg and Sutton 2011). Examining the high and low Sandia Mountain graffiti placement and seasonality brings up a very different perspective on who left graffiti and when they were carved.

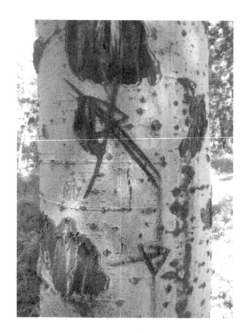

FIGURE 6.4 An arborglyph facing downslope and down the Las Palomas Trail as it climbs a ridge from the trailhead to the plateau of the San Pedro Parks Wilderness, New Mexico. The image is of two arrows, the left one crossed out or negated and the other pointing right. As you head up the trail it is tempting to leave the rocky ridge and ascend via an inviting drainage to the left, but the drainage eventually reaches a dead end of undergrowth and rockfall. Although the climb is strenuous, it is better in the long run to stay on the ridgeline. The arborglyph acts as guide and reflects an easier path through the landscape. Photograph courtesy of the author.

Questions about context not only illuminate the workings and range of conspicuous graffiti, they touch on what few other scholars seem to address about CMTs: that some arborglyphs appear intentionally inconspicuous. A few researchers have noted that graffiti were sometimes left on trees for specific people or other sheepherders in general, but they haven't really written about how this might be reflected in context (Mallea-Olaetxe 2000; Pederson 2003). I found that many southern Rocky Mountain carvings faced across the trail, rather than up or down it, and they are only visible by those immediately passing by, making them less conspicuous markings. But attempting to answer Tilley's (2008a) questions also led me to carvings that faced away from the trail entirely and were often in dense woods rather than on the visible edges of trails, open parks, or meadows. I encountered a number of genuinely inconspicuous trees. For example, Figure 6.5 shows an arborglyph placed well into the woods and far above the adjacent trail. It is not visible to those on the trail, but the trail is quite visible to those looking at the aborglyph from the "correct" perspective. Not only may the graffiti have meant to be viewed from a specific direction as Tilley's (2008a) phenomenological questions ask, they may function to draw the viewer to other parts of the landscape rather than stand out themselves or reflect why the creator or viewer isn't necessarily conspicuous themselves. For example, I encountered meadow's edge graffiti both like that in Figure 6.3, which is visible from inside

a park, as well as images like those in Figure 6.6: on the forest's edge, off formal trails, and only visible when looking from the woods into open ground. It is easy enough to image such graffiti linked to well-known tropes of lonely, sexually frustrated sheepherders as described by Mallea-Olaetxe (2000). However, it is clear that graffiti continue to be left on trees long after sheepherding fell out of favor by the 1940s in the southern Rocky Mountains (DeKorne 1970; Hegberg and Sutton 2011). Further consideration of landscape adds speculative detail. It offers several possibilities: while sheep were browsing in the open meadow, the herders sat in the shade of the forest edge away from the abundant southern Rocky Mountain sun, looking out on their flock; hunters used the woods as blinds while stalking deer or elk; hikers rested in the forest shade rather than in the open sun along the trail; and all may have consequently left their graffiti facing into the woods and away from open ground. Thus, inconspicuous graffiti circle back to a wider consideration of landscape and how human behavior unfolds across it.

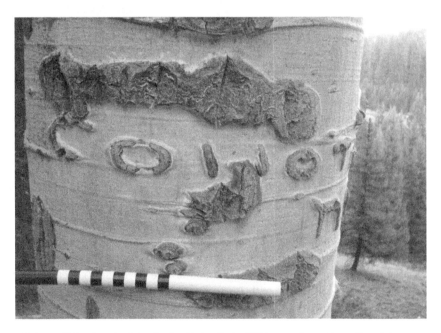

FIGURE 6.5 This arborglyph in the San Pedro Parks Wilderness bears the colloquial spelling of Coyote, New Mexico, a town not far from the site. The tree sits in the fairly dense woods on a steep slope rising several hundred feet above the Rio de Las Perchas Trail. The graffiti are not visible from the trail, but a person carving or observing them has a nearly unobstructed view down the slope, across the valley, and over the trail. Photograph courtesy of the author.

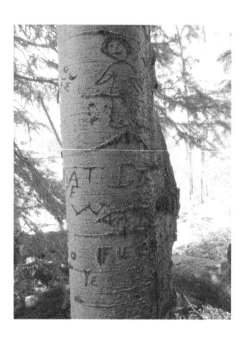

FIGURE 6.6 A graffiti-covered tree on the edge of a meadow to the east of Buckles Lake in southern Colorado. The arborglyphs include the image of a naked woman and what appears to be a conversation among different individuals (inferred from text in different handwriting) reading, "FUCK ME," "WHAT DO WE WANT," "WE WANT TO FUCK," and "YES." Photograph courtesy of the author.

Examining landscape as context widens our understanding of why graffiti were left on trees, who left it, how they are viewed, and why they might stay consistent or change over time since landscapes themselves are diverse. Although I observed arborglyphs around Buckles Lake and the San Pedro Parks that appeared to be evidence of lonely individuals in the wilderness—perhaps even stereotypical lonely sheepherders—the record along the trails of the Sandia Mountains is different. There are few naked women or declarations of sexual frustration. Here some of the most common arborglyphs are pairs of initials or names encircled by hearts (Figure 6.7). Wilderness here is one of romance and joined couples instead of separation. These arborglyphs are most often conspicuous markings, visible along trails, bunched together at trailheads or near parking areas, and generally accessible. The Sandia Mountains' terrain is generally steep and the tree cover dense, yet not extremely so when compared with Buckles Lake or the San Pedro Parks. Nor do the small-scale phenomenological questions about place and body appear to operate much differently. Instead, differences and, perhaps, answers for questions about them, can be found in Tilley's (2008b) directive to visit and explore landscapes with different forms and extents of cultural impacts for comparative fodder.

Thus, the three separate survey areas prove informative when compared with each other. Northern New Mexico and southern Colorado were once

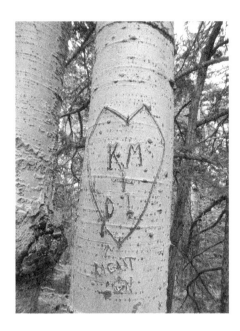

FIGURE 6.7 One of many hearts or sets of initials carved into trees along the Switchback Trail, just below the crest of the Sandia Mountains, New Mexico. The graffiti include the image of a heart encircling the message "KM + DI" and a comment, which appears to have been inscribed later, of an arrow pointing to the heart and reading "RIGHT ON." Photograph courtesy of the author.

home to thriving sheep operations and many numbers of herders, but are now active recreation areas with small public allotments for cattle grazing. But the Sandia Mountains were never a primarily pastoral landscape. Rather, theirs is a recent and current history of recreation (Salmon 1998). All three sites have a wild character though they are situated and affected by nearby settlement, but they differ significantly in their proximity and accessibility to large populations. Historic and contemporary uses of the Sandias are inextricably linked to the Albuquerque metropolitan area; the mountains act as a landmark for its nearly 1 million inhabitants and thriving tourist industry (Salmon 1998). The limestone-topped granite escarpment rises dramatically up from the surrounding flatlands and seems to draw people in the Rio Grande Valley toward it because of its presence (Salmon 1998). At the same time, a paved scenic byway and a tram have long allowed easy, year-round access, in contrast to the seasonally impassible dirt roads leading to Buckles Lake and San Pedro Parks. The view from the Sandia Crest is a popular destination that encompasses the city of Albuquerque, and the visual links between mountain and metropolitan area travel in both directions between the two (Salmon 1998). This larger context helps explain the abundance of hearts and declarations of attachment: the Sandias are a short-term—but nonetheless deeply connected—wilderness destination. People travel to and through the mountains far less for economic gain than for profoundly cultural rea-

sons. The Sandia Mountains are a connected rather than disconnected wilderness. They are visible across the metropolitan area and experienced by people in conjunction rather than in isolation. It is clear that many aspects of carved aspens function the same—especially in relation to the scale of the body and placement of graffiti—across the southern Rocky Mountains. But it is also apparent that wider contexts have a tangible impact on how and why people mark the trees.

Conclusions and Future Directions

When I began a preliminary survey of carved aspens I didn't discount recording and assessing their iconography: indeed, as my rumination on hearts and names in the Sandias shows, the iconographic is not fully removed from the contextual. Yet, I clearly found context lacking in much previous research. In response, I searched for models and found a phenomenological approach to context valuable in the study of arborglyphs. It allows me to add nuance to concepts like conspicuous display as well as record and interpret their opposites. It also allows me to stretch my perspective from prehistory to the historical to the graffiti of the present day and understand that human behaviors are comparable and worth contrasting. A phenomenological approach is a labor- and time-intensive undertaking. It requires repeatedly returning to sites and collating large amounts of qualitative and quantitative data outside the field. Such an approach does not quickly provide results; my work is genuinely preliminary, with more planned in the future. But, as I consider the graffiti on nearly 500 trees in the southern Rocky Mountains, I have little doubt about the worth of understanding these cultural artifacts in their place on the landscape.

Reclaiming the Ruins: A Case Study of Graffiti Heritage Interpretation at the Evergreen Brick Works in Toronto

BRUCE BEATON & SHANNON TODD

"It just seemed like a wonderland for graffiti artists . . . "
—ARTCHILD on what it was like to create at the Brick Works.

"Graff is like weeds. It is wild and you can't tame it. I think that's good for the spirit."
(Ren in Farkas 2011)

eritage storytelling can take inspiration from many sources. Tradition-ally, museums and heritage institutions weave a narrative from objects: a vase, a coat, a building, or historic site. The communication and in-terpretation of this narrative often facilitates a meaningful experience for the visitor. At the Evergreen Brick Works (EBW) in Toronto, Canada, heritage narrative creation is inspired by the industrial, natural, and geographical landscape of a former brick works. The layered industrial heritage here goes beyond the presence and use of the brick-making machinery still on the site to include the graffiti that transformed an abandoned factory to a space of words, imagery, and color.

Founded in 1889, the Don Valley Pressed Brick Works produced bricks that helped to build the city of Toronto. The clay found at this site fired up into a reddish-brown color popular in the rapidly growing Victorian build-ing trade. The high-quality bricks made at the factory won awards of excel-lence at the Chicago World's Fair of 1893 (*The Globe* 1897). By 1989, however, the brick-makers abandoned the facility: the natural resources necessary for brick production were tapped out. This abandoned site then slowly trans-

Understanding Graffiti edited by Troy Lovata & Elizabeth Olton, 105–116. © 2015 Taylor & Francis. All rights reserved.

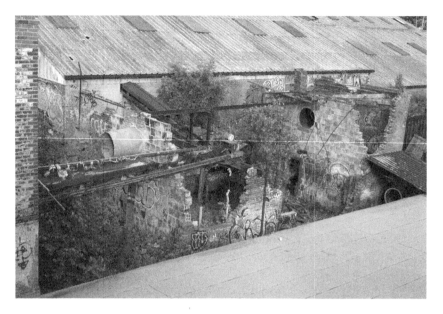

FIGURE 7.1 The abandoned and reclaimed Don Valley Brick Works before the Evergreen redevelopment. Photo by Michelle Scrivener.

formed; it became a place for illicit activities, particularly by area youth, who used the large empty buildings to host parties, concerts, and even the occasional pig roast. The walls of the vacant buildings became a blank canvas for local and international graffiti artists (Figure 7.1).

Evergreen is a Canadian environmental charity founded in 1991 whose mission is "to inspire and enable action to green cities" (Evergreen n.d., para. 1). In 2008, Evergreen broke ground on a massive redevelopment of the abandoned Don Valley Brick Works site and turned its crumbling postindustrial buildings, damaged floodplain ecosystem, and toxic, contaminated soil into an international showcase for green design and urban innovation. This is now where Evergreen has its head office. Evergreen's rental agreement with the owners of the site, the City of Toronto, stipulates that they engage in a publicly accessible heritage interpretation of the history of this former brick works. The communication of this transformation of a crumbling industrial site into a tangible showcase of urban sustainability also supports the narrative that is at the center of Evergreen's mission (Toronto City Clerk, Administration Committee 2006).

There is graffiti everywhere at EBW. This collection of graffiti is the only surviving artifact of the site from 1989 to 2008. The on-site graffiti are a

vibrant reminder of an entire generation of young people who snuck onto the site and made it their own. There are no written records of the life of the site for this period, though Evergreen did compile some oral histories of this era at the time of redevelopment. The ephemeral and illegal aspects of urban graffiti mean that they are not often preserved. The preserved graffiti at EBW offer an opportunity to remember and communicate a particular era of EBW's history. The Ontario Heritage Trust (OHT) recognizes the graffiti at the site as having unique heritage value. The Baseline Documentation Report, part of the easement that the OHT has on the property, includes this graffiti. Significantly, none of the other 200 easements that the OHT has on any other properties in Ontario includes graffiti as part of their important heritage (Wicks, personal communication, 2013).

For marginalized youth of the late twentieth century, graffiti writing was a way to leave an indelible mark on society (McCormick 2011b; Thompson 2009). Modern graffiti styles quickly evolved from scribbled tags to sprawling masterpieces ("pieces"), with individuals recognized for their own unique graffiti tags. Canadian graffiti appear to be an amalgamation of many styles seen across the globe, as public arts advocate Zion (2013) commented:

> What creates Canadian graffiti? I believe Canada definitely intermingles many different styles from abroad best, but I feel it's still a work in progress. My belief is that we should make our mark in history by first defending our art form, and then welcoming the world to come and look.

This merging of styles, which is particularly evident in the graffiti of multicultural Toronto, has allowed the local graffiti community to constantly evolve, producing an internal mechanism for competitive creation of new and more highly skilled work. The graffiti community of Toronto is a "meritocracy," as a writer's skill is valued more than any ethno-cultural affiliation (Snyder 2009, 29). In addition, the Toronto Police Services recognize that graffiti in the city are "seldom gang related" (Toronto Police Services 2011). The city even appeared to support the creation of graffiti as art: in 1996, the first graffiti art gallery in Toronto opened on Simcoe Street, and the same year the Toronto School Board established "Graffiti Arts" programs at some local high schools (Bilton 2013). Despite these inroads to the acceptance of graffiti in Toronto, the act does remain officially illegal.

The City of Toronto differentiates between acts of "graffiti art" and "graffiti vandalism." "Graffiti art" are exempt from removal by either property owners or the city, but to be "graffiti art," a work must be properly commissioned and sanctioned through municipal permits (City of Toronto n.d.a,

para. 6). Pre-existing graffiti are eligible for exemption by a decision of the Graffiti Panel, a group of appointed city officials who determine the value of the graffiti in question. The city also seeks to reduce graffiti by promoting commissioned street art through the StreetARToronto (StART) program (City of Toronto n.d.b). This program engages emerging artists and promotes partnerships for the creation of commissioned artwork. This both beautifies the city and deters vandals from tagging on top of this officially sanctioned art.

"Graffiti vandalism" is illegal; property owners must remove it at their own expense, or the city will remove it and charge the property owner the incurred costs (City of Toronto n.d.a, para. 7). While the fight against graffiti had been ongoing since the mid-1990s, more extreme measures have begun only in the last decade. In 2005, Mayor David Miller introduced the anti-graffiti bylaw, making property owners responsible for the removal of graffiti from their properties (Bilton 2013). In 2010, mayoral candidate Rob Ford announced graffiti removal as one of his campaign promises. Once elected, Ford launched his "war on graffiti" (CBC News 2011). By April 2011, "The mayor's pro-active approach has seen the number of removal orders jump to 3,381 so far this year, compared with about 2,400 in all of 2010" (Rider 2011). The city has undertaken many measures to remove and reduce graffiti, including encouraging public reporting through the city's 311 non-emergency service line and a mobile application (Chen and Criger 2012; Moloney 2013). It was through a public complaint in January 2011 that Evergreen received an order from the city to remove all of the graffiti on their site (Milley 2011). The city rescinded this order when Evergreen explained the importance of the work's unique heritage value to their overall institutional narrative.

Our Project: Graffiti Works 1989–2008

In 2012, as students of the Master of Museum Studies (MMST) program at the University of Toronto, we (Bruce Beaton and Shannon Todd) created an exhibition about the graffiti at EBW. The project came about after Beaton, while working as a site animator at EBW, mentioned to EBW General Manager David Stonehouse that he was about to begin a nine-month-long class in exhibition creation. Stonehouse suggested that the graffiti at the EBW might be an excellent subject matter for this. Beaton enlisted the help of Todd to co-create an exhibition at EBW.

Our exhibition, Graffiti Works 1989–2008, aspired to communicate the chapter of the Brick Works' history when the site sat "abandoned," using the graffiti as the artifacts of that time. Our goal for this exhibition was for it to be a pilot project for deeper interpretation and engagement in the history

of the graffiti on the site. We recognized the importance of the graffiti as the only remaining evidence of a period that covers almost a fifth of the entire lifespan of the EBW site, and that the public routinely overlook and therefore underappreciate this history. The prominence of the graffiti at EBW made this location an ideal place to engage with this topic in an exhibition format. We hoped that visitors might gain an appreciation and understanding for the narratives revealed in these expressions. Furthermore, exposure to graffiti in this context might lead to an understanding of the graffiti they see around them every day in their own environment.

Graffiti Works 1989–2008 was to consist of three major components: 1) an interpretive self-guided tour, specifically focusing on 10 pieces of graffiti at the site; 2) a centrally located main station (The Hub) featuring introductory text panels and a video touchscreen presenting contextualizing information; and 3) videos featuring informed experts speaking on five significant pieces along the tour, available through the touchscreen at The Hub or online via QR code on site or through the Evergreen website. By using these different techniques, we hoped to broaden the EBW audience and provide access to graffiti for visitors both at the site and online. In particular, we hoped to provide in-depth information in the video while the one-page self-guided tour or text panels would provide more general interpretations. By creating three forms of educational and outreach texts, we hoped to engage visitors according to their interest level. The scope of the project was limited to 10 objects on the tour and five in video.

Falkian Explorer Satisfaction

When we began the process of creating our exhibition, we thought about our target visitor, or to whom we would best appeal. EBW attracts more than 350,000 visitors per year (Evergreen Brick Works n.d.). We decided that John Falk's "Explorer" visitor typology would be interested in what we were creating. Most of the graffiti we chose for the tour were located in the massive Kiln Building, an abandoned industrial labyrinth, and so our setting already had built-in Falkian Explorer appeal.

In Identity and Museum Experience, John Falk classifies museum visitors into five distinct typologies. Falk (2009, 11) is careful to articulate that his model of museum visitor understanding is "not about types of visitors, but about the types of visitor needs." According to Falk, the Explorer is motivated to visit museums by the need to satisfy their curiosity about subjects with which they are already familiar. They see their museum visit as a chance to expand upon this knowledge (Falk 2009). We hoped to enrich our visitor's

EBW experience by facilitating an insider community-based interpretation of something that is common in the urban landscape, an interpretation of something they cannot currently find anywhere else in the Toronto area. Falk notes that Explorers sometimes shy away from a fully structured guided tour. Our self-guided tour would allow the Explorer to create a personalized, nonlinear pathway through the Evergreen site. We identified key visitor outcomes for this group as a deeper understanding of the full heritage of the EBW site and a new consideration of the "art versus vandalism" debate inherent in graffiti. We would achieve these by showing how this debate has played out at EBW, through the city-issued decree that Evergreen must remove all the on-site graffiti followed by the exemption based on the heritage significance of this artifact. However, based on our museum study, we also knew that visitors would construct their own ideas about the meaning of the graffiti they experienced. We hoped this variance of visitor experience would foster some debate on this subject.

Graffiti as "Artifact"

The public discourse surrounding graffiti primarily revolves around its place as either art or vandalism, as can be clearly seen by the City of Toronto's own definitions of the subject. By limiting the discussion to only these topics, a number of important aspects of the subject are ignored, particularly those which involve examining the history and intent of graffiti. The graffiti at EBW range from large complex pieces featuring polychrome splashes, texts, and shapes to simple scribbled tags and many variations in between. For the purposes of our exhibition, we did not want to only highlight the artistic abilities of those pieces; we wanted to tell the missing chapter of the EBW story and communicate the history of the works, who wrote them, what they meant, and why they were here. We wanted to examine the work not as art or vandalism, but as "artifacts," physical remnants of a bygone era, to communicate a deeper history of the site.

In one of the few books that specifically addresses Canadian graffiti, Adam Melnyk (2011, 14) emphasizes the importance of knowing the history of the subculture:

> When I personally got into graffiti in the mid-90s I was taught to know your history and respect your elders—not just in general, like everyone else, but in the particular subculture. These are the ones who did it before you and went through the trials and tribulations to get the culture to where it is now.

Melnyk recognizes that although the work of these predecessors may no longer be visible, without their influence, graffiti culture would not have the recognition that it does today. He points out that the lifespan of a work is miniscule, but the feelings of excitement and accomplishment through creation are really the driving forces for this art form (Melnyk, 2011). Writers are aware of the inherent ephemerality of their work. In fact, one could argue that it is the knowledge that graffiti will be removed or covered that continues to fuel the community, pushing writers to be more creative, more technically skilled, and more daring to reach the point that their work is deemed untouchable. This ties in to the hierarchical nature of the graffiti community, as those works that are left untouched are typically those of masters, or "kings." At EBW, there is evidence of this in the Kiln Building, where the words "You went over a KWEST from '98 you retard" are scrawled across a large piece. Kwest is a well-known graffiti writer in the Toronto area, and this message indicates the writer's dissatisfaction with the other for covering Kwest's work, either because the work that is now present is not of the same caliber, or for not paying their respects to Kwest.

The work at EBW provides an important glimpse into the cycle of destruction and re-creation of graffiti. Aside from some minor edits during the redevelopment of the site (primarily to remove lewd pictures and curse words that were deemed by Evergreen to be potentially offensive to their family-based audience), the work has remained untouched since 2008. As such, the walls of EBW act as a time capsule or snapshot reflecting nearly 20 years of writing. This site was abandoned and not publicly accessible, and therefore the graffiti were unlikely meant for public consumption. Rather than being a place to produce public art, EBW appears to have been more a place to communicate within the graffiti community and to practice, as reflected by Lisa Martin of Well and Good, a Toronto-based art organization, who referred to the walls at Evergreen as a "sketchbook" (Wilson 2012). The work on the walls at EBW are of variable size and quality and, because of Evergreen's redevelopment and the OHT designation, have been exempt from the standard cycle of destruction and re-creation. These works, therefore, are not necessarily representative of the writers' best work. This encouraged us to look at the graffiti as artifacts representing a period of time rather than as art. When creating our exhibition, we recognized the need to point to a few select pieces but were concerned about curating the space, because unlike at other galleries displaying graffiti art, this work has not been curated. Evergreen adapted itself onto the work that was there, providing a unique space for the work and allowing thousands of people a year to view it; the writers had not intended their work for that kind of public acknowledgement.

Applying any type of curatorial vision to the site would label certain works as more valuable than others, something that we wished to avoid through a discussion of the work as an artifact rather than as art, as we saw each piece as equally significant in displaying something about the culture of that location and time in this unique context.

When graffiti enter into a gallery space, there is often controversy because the works are no longer in their original context and are therefore less "authentic" (Duncan, this volume; Thompson, 2009, 143). Felisbret (2009) states that the original context of the artwork is essential to an understanding of the nature of that work. At EBW, the graffiti are technically in its original context; no curator has moved or transferred it onto another surface. Yet, the space is no longer an abandoned brick works: it is now a site of public engagement for an environmental charity, with clean floors, office spaces, and a family-friendly atmosphere. Even though this is the original location, the atmosphere of the environment has shifted. The institutionalization of the space disconnects the work from its original context and its intent. This calls to mind McCormick's (2011a, 19) suggestion:

> Art as it occurs on the streets is an "other" history. Inherently anti-institutional, it has never fit well within the academy or the museum; basically free, it has consistently had a problematic relationship with the art market; iconoclastic, it is often hard for many to read; and stemming from the counter cultural or underground tendencies of youth, it is by and large all too easy for those who "know better" to dismiss it without regard to either its content or its intent.

The graffiti present at EBW does represent just such an "other" history, one of urban youth culture in a developing city. Without acknowledging and understanding the graffitists' connection to the context of the brick works, it is difficult to provide heritage interpretation of these artifacts to the visitors of EBW. Visitors tend to dismiss the tags as vandalism, but appreciate the murals as art, just in the way Snyder (2009) describes the mainstream consensus surrounding these divisions. In our exhibition, it was difficult to communicate to these visitors that all of the works were equally important to the heritage of the site, especially as they do not directly tell a narrative. We realized we needed to build a connection with that community to find these writers and hear about their time writing at EBW. We needed to hear and then, with permission, communicate their intimate creation stories to the visiting public through our exhibition.

Source Community Challenge

Our exhibit aspired to fulfill Mary Louise Pratt's (1991, 34) idea of a "contact zone": a "social space[s] where cultures meet, clash, and grapple with each other." We wanted to create a "contact zone" where graffiti artifacts "function as a source of knowledge and as catalysts for new relationships"; new relationships between the Toronto graffiti community, Evergreen, and the Evergreen visitors who are uninformed about many of the aspects of graffiti culture (Brown and Peers 2003). Without graffiti community buy-in and participation, we knew we would have a limited amount of meaningful information to communicate within our contact zone.

The creation of our exhibition was akin to the process that museums now engage in to ethically work with originating or "source" communities. In what Brown and Peers refer to as the great age of museum collecting that began in the mid-nineteenth century, objects and information about them went from the peoples of the world into museums that then consolidated knowledge as the basis for curatorial and institutional authority. Brown and Peers (2003, 1) further state that:

> In recent years, however, the nature of these relationships has shifted to become a much more two-way process, with information about historic artefacts now being returned to source communities and with community members working with museums to record their perspectives on the continuing meaning of those artefacts.

Most museums now make every effort to foster new collaborative relationships with their source communities. Philips (2003, 163) notes that this sort of collaborative exhibition work generally falls into two distinct models, which she terms "community-based exhibits" or "multivocal exhibits." We hoped to facilitate the creation of a community-based exhibit, a space for our source community to communicate their thoughts and ideas about the messages and meaning of the graffiti at the Brick Works.

To build an ethical bridge to the graffiti community that worked at the Brick Works, we made sure to clearly position ourselves within the exhibitionary creation process. Everyone who received any correspondence from us about this project received a clear description of how we saw ourselves as facilitators or bridge-builders. We wanted to build trust with a transparent declaration about who we were. Neither of us has ever been a graffiti writer, but living in a dense urban area we do see graffiti every day. Up until

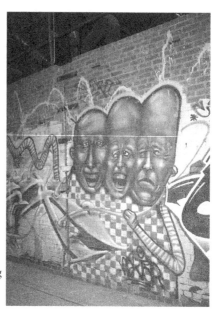

FIGURE 7.2 Nektar's work in the Kiln Building at the Evergreen Brick Works. Photo by Bruce Beaton.

Evergreen's invitation to create our exhibit, we had never really given much thought to the meaning of graffiti. We felt it was important to communicate this as part of our outreach efforts.

Prior to our project, Evergreen had met and worked with members of the Toronto graffiti community in an effort to interpret the work on site. Through an Evergreen contact we were able to correspond with a prominent Toronto graffiti writer named Nektar, whose spray-can portraiture is at EBW. Nektar now works internationally. At first, he agreed that what we were trying to do was important for the community, and even sent us a few photos of him working on one of the pieces we wanted to feature (Figure 7.2). Then Nektar inexplicably disappeared. All communication stopped. All other efforts to build our exhibition with the writers who worked at the Brick Works were met with limited success. We did have some communication with ARTCHILD, who did work at the Brick Works, and also with a few writers who worked in the city between 1989 and 2008 but who did not actually create at the Brick Works. ARTCHILD did not want to participate in our project, though he did allow us to directly quote him. We still do not know why our communication with Nektar suddenly stopped, but public arts advocate Zion informed us that the writers who created at the Brick Works did so for themselves and their community, with the work often functioning as a form of dialogue or as an internal expression. We were not members of

this community; we were outsiders, and our outsider status may have kept us from gaining a community-based access to any subjective meaning of the graffiti. Without an informed insider perspective, we could never hope to begin to communicate an understanding of the work, as the writers did not create it for us or for the curious "Evergreen Explorers." Our lack of a solid, trustworthy connection to our source community meant we had to reduce the scope of our exhibition. We dropped the video/QR code component of our exhibition. We could only present the limited information about the work at EBW that we had managed to uncover. This is an ongoing challenge in the interpretation of any heritage artifact.

Conclusions

Even with our reduced scope, we did fulfill our goal of being a pilot project for Evergreen to continue to build interpretive and educational programs around the graffiti. The exhibition does supply an introduction to the topic of graffiti, the art versus vandalism debate, and this particular chapter of EBW

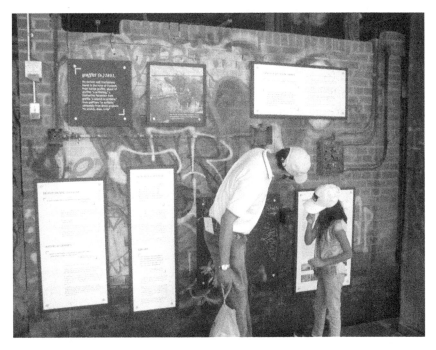

FIGURE 7.3 The finished Hub portion of our exhibition with a visiting family chalk tagging. Photo by Bruce Beaton.

history. Examining graffiti as "artifact," favoring cultural significance and history rather than visual form, is something that is rarely undertaken but it is essential to gaining a deeper understanding of this ubiquitous urban phenomenon (Figure 7.3). But the designation of graffiti as an important heritage artifact carries with it the challenges of preservation and maintenance. At present, Evergreen does not have a heritage conservator to maintain, treat, or protect this work. Their primary concern is keeping the graffiti in place to ensure that there is a minimal degradation to the heritage buildings and industrial machinery of the site. Evergreen is an environmental charity; museum-quality preservation is not within the realm of their core mission.

Working with source communities is a challenge that confronts ethical display/ownership issues. Any institution planning on interpreting graffiti should leave ample time to develop trust with the graffiti community and allocate resources to fund experts or consultants (i.e., graffiti writers) from this field. We had nothing to offer our experts but some public recognition and a platform to talk about their work; however, not all graffiti writers want the general public to understand them. Despite graffiti's movement into the mainstream, it is still at present an outsider art.

Acknowledgments

We would like to acknowledge the guidance and support of Professor Cara Krmpotich, Professor Matt Brower, David Stonehouse, Melissa Yu, James Gen Meers, Anthony Westenberg, and Zion. We would also like to acknowledge the support of our classmates in the Museum Studies Program at the University of Toronto.

CHAPTER 8

Ornament as Armament: Playing Defense in Wildstyle Graffiti

GABRIELLE GOPINATH

Wildstyle Defined

When wildstyle graffiti appeared around 1980, it signaled the close of the classic era of New York City graffiti writing and heralded the emergence of a Mannerist late phase.[1] The Mannerist painters who emerged across Europe at the close of the High Renaissance[2] prized stylistic exaggeration for its own sake; likewise, wildstyle writers distinguished their pieces from earlier writers' tags by exaggerating letters' visual appearance to such a degree that their sense was rendered illegible.[3] Interpreters had long asserted that classic-era graffiti were motivated by writers' desire to assert personal identity.[4] In the 1980s, wildstyle represented a perverse recalibration of that writerly ambition. Graffiti writers of the 1970s had inscribed their names all over the city, making sure that everyone could read them. By contrast, wildstyle writers filled the city streets with illegible, unspeakable names that no one could interpret. The kinetic energy these words possessed was unmistakable. Their mysteriousness was intentional. The sense of exclusion they produced in most viewers was calculated. No one knew exactly what these inscriptions were *about*, but the words themselves were impossible to ignore.

Wildstyle writers of the 1980s worked throughout a decade in which municipal and state authorities devoted unprecedented levels of resources to the project of obliterating graffiti and, sometimes, to eliminating other forms of public art[5] (see also Mitman in this volume for a discussion of New York City policy on vandalism and graffiti). Hardships proliferated in this adversarial environment, but writers persevered. Theirs was an extreme style, created for extreme times. However, it would only flourish for a moment: New York's

Metropolitan Transit Authority (MTA) succeeded in curtailing the production of graffiti on subway trains by decade's end. While this brought about the end of wildstyle writing as it had originally been practiced in its city of origin, the style itself evolved and spread. By the late 1980s and 1990s, the elements of wildstyle had been extensively documented in films and photo essays, and were being reproduced by graffiti writers all over the globe[6] (see also Lennon's chapter in this volume on the global presence of graffiti).

In wildstyle work, individual letters' forms become so exaggerated that their elaborate appearance radically limits their legibility. Wildstyle writers prized "pieces" in which style had been developed to such a degree that it completely overcame lexical substance. Trying to read a wildstyle piece is like encountering a snatch of Tin Pan Alley melody rendered abstract and alien at the hands of John Coltrane or Ornette Coleman. In each instance, the marvel is not the commonplace origin of the original utterance, but the quasi-miraculous way in which a banal text morphs into something fantastic. Uncoupled from substance, style irradiates the everyday, making it strange.

Consider this wildstyle piece, photographed by documentarian Henry Chalfant in 1981 (Figure 8.1). When Chalfant reproduced it in the book he published with Martha Cooper in 1982, *Subway Art,* he noted that it was the fruit of a collaboration between the graffiti writers KASE 2 and EL KAY (Cooper and Chalfant 1982, 70–71). However, it is unlikely that many of the viewers who saw this piece in motion would have been able to parse the tangled thicket of arrows, slabs, and colored clouds surrounding the letters of the writers' names to appreciate the works' authorship. The massive, mobile artwork that Chalfant photographed has long since been destroyed.

FIGURE 8.1 Two details of a wholecar wildstyle burner by KASE 2 (below) and EL-KAY (opposite), 1981. Photograph by Henry Chalfant.

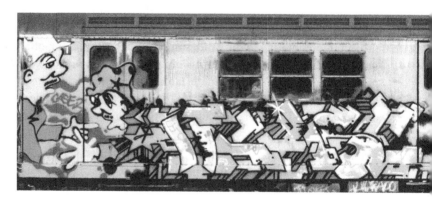

Contemporary viewers' only access to this work comes through Chalfant's documentary image. And even now that the piece has been stilled and miniaturized, made accessible at this manageable scale, it remains difficult to make out individual letters' forms.

Illegibility prevails, but sustained assessment of these forms does yield some clarity. What initially looks like an undifferentiated mass reveals an underlying structure on closer inspection. Reading the image from right to left, the first thing the viewer sees is a slightly built figure in sideburns and a tight yellow turtleneck, framed against pink clouds. His left hand is clamped rigidly to his side, index finger extended; his right stretches out, holding a pistol. He trains the pistol on a word. Never mind for now what that word *says;* take note of how it conducts itself at gunpoint.

Crouched low, the word recoils from its armed assailant. At the same time, it is clearly the more formidable physical presence. Its surfaces are complex and numerous: flat, sleek, and silvery on top, red and striated like living flesh where they recede into space. Their coloration is metallic, glistening, fungible. They are variously marked with black freckles, veinlike traceries in icy blue, shifting patterns of light, and irregular dapples of jungle green. One slablike shape toward the word's right margin bells out and rears up, like a cobra ready to strike. This is a rare passage of cursive grace in a word mostly characterized by the presence of thrusting, daggerlike forms. Its exceptional presence is marked with a gracile sign, a black mark that reads in relation to the perimeter's lush curve like the F-hole of a stringed instrument, just slightly deviated from the norm.

In this wildstyle piece individual letters make less of an impression than the mass of the word as an entity. Letters' blunt ends lock and fuse at every opportunity. See, for instance, the tightly overlapped aqua-blue extremities

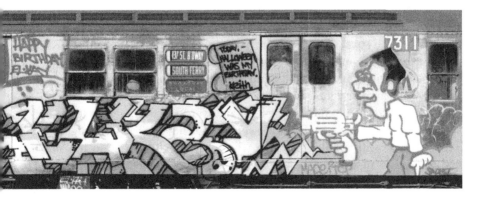

that seem to be holding clenched hands at the center of the word's top margin; the arrow extending from the top of the last letter that shoots back across the top of the word, covering it as though to protect it; the turgid, tubular element of the first letter's periphery that twists and kinks upon itself like a demented garden hose. A bright appendage shooting from the word's lower margin turns into a lightning bolt that whips out in the direction of the word's assailant.

This word I have just described takes up the entire right-hand half of a New York City subway car, which is approximately 60 feet long in its entirety. A puff of toxic-looking yellow smoke fills the space between this word and another word, which occupies the left-hand side of the same car. The first word takes shape in a tangled concatenation of biomorphic forms; this second word is more crystalline. Its contours tend toward hard edges, right angles, and illusionistic chrome. Its highlights are brighter, harder, and more numerous, the pattern of pink and blue traceries across its surfaces more complex. These letters' stout hunks of substance go flexible at their extremities, often forking into arrow-shaped vectors that point in every direction. Like its neighbor, this word is well armed, and it appears to be equally committed to the righteous project of self-defense. The letter at the word's left margin morphs into a stylized blue bazooka emitting spurts of inky smoke. The word extends this weapon back across the car, countering the threat of the stickup artist's handgun.

One of this piece's most striking characteristics is the vehemence with which its writers insisted on words' existence as kinetic entities. The letters in these words are depicted in such a way that they appear to possess surface texture, volume, and velocity. And they are defined by their commitment to forward momentum. The black blanket of wet paint on the foremost surface of one of the left-hand word's strong verticals shows which way the word is moving: drips fly backward as it accelerates to the left, away from threat.

The most important characteristic of this unique script is its materialized existence. These wildstyle words are not inert; they are entities endowed with volition. As such, they have more in common with words in illuminated manuscripts, kufic inscriptions, and other forms of complex hieroglyphs than they do with standard written English. See, for example, the way words interact with human figures in the artwork's narrative. A b-boy urchin in a floppy pink Kangol cap hustles the left-hand word to safety, one hand outstretched to show the way. Shooting sideways at high speed, these figures almost collide with a taller character who throws his hands up in the air, crying, "Geez!" in a tone of comic grievance. It's not immediately apparent

whether he is referencing the drama of the stickup scenario, or just the over-the-top quality of the words' style.

It is possible—but difficult—to cease contemplating these forms as depicted objects and read them as one reads a word. With some effort, the convoluted form at the car's left margin can be parsed into two kicking diagonals overlapping with a doubled, slablike vertical form. Together they constitute a reimagined version of the letter K, the first letter of KASE's name. The other letters in the name have been subjected to equally radical species of formal revision. While they yield reluctantly to orthographic analysis, they remain hard to read at best.

The scribbled dedication texts floating like footnotes at the piece's margins are exceptions to this rule. Their functional appearance and everyday content purvey a deadpan comic relief in this context. A blue tag scrawled across the middle of the car congratulates: "HAPPY BIRTHDAY EL-KAY." A first-person proclamation on a pink scroll to the right confirms: "TODAY, HALLOWEEN, WAS MY BIRTHDAY. KEITH." These legible fragments stand outside the work's fiction, offering exit from the otherwise unbroken sweep of its narrative.

My first goal in this analysis has been to demonstrate the degree to which wildstyle words are depicted as active, embodied entities. My second goal has been to show that this effect is abetted by the fact that wildstyle words are nearly impossible to read. Illegibility is not an ancillary by-product of these words' elaborate style; it is an essential part of their effect. The graffiti writer, multimedia artist, and theoretician RAMMELLZEE identified a key principle of the aesthetic logic that prompted wildstyle's evolution when he observed that wildstyle ornament *is* armament.[7] The radical ornamentation of wildstyle letters is armor in the sense that it defends letter-forms from being read.

In conventional forms of writing, letters are understood as arbitrary signs, empty ciphers that acquire meaning only by virtue of their proximity to one another. Wildstyle graffiti liberates these forms, making it possible for them to take on unaccustomed significance as independently motivated, mobile subjects. Wildstyle lettering dramatizes the experience of ciphers that evolve into subjecthood by refusing to be *read*, resisting the imperative to be subsumed as part of a text whose meaning is externally imposed. The potential for allegorical parallel with the lives of disenfranchised individuals, living at the margins of the metropolis, is immediately apparent. Yet this parallel often is elaborated in unexpected ways.

Wildstyle in Context

Graffiti writers called time-consuming, elaborate wildstyle pieces like the one I have described *burners* because of their flamelike virtuosity. Such pieces were based on meticulous sketches compiled in notebooks ahead of time. Execution took place in a single sustained work session that might take up to eight hours and twenty or more cans of spray paint to complete.[8] Writers who executed pieces at this degree of complexity and scale trespassed to stay out in the train yards all night, when parked subway cars could be most readily accessed. Because of the grand scale at which the pieces were realized, the technique necessarily involved the writer's whole body. It admitted scant revision, and it called for a steady hand. It also required substantial amounts of athleticism. Because a train's writing surface was high above eye level, writers used a variety of hand- and footholds to suspend themselves eight to ten feet off the ground. They climbed, stretched, and straddled, often bracing themselves hands-free for long periods of time in the narrow space between two parked cars.[9] The tight spaces within which writers often worked meant that their ability to gauge proportion had to be highly accurate; it was often impossible to orient oneself by backing up and viewing the piece at a distance, in relation to the whole car. In addition to these challenges, writers typically had to execute their pieces in near-total darkness, illuminated only by whatever portable light sources they were able to bring along.

The illegal nature of graffiti writing meant that writers had to travel light and fast. Bringing a ladder would have been impractical. It was important to use readily portable materials and maintain vigilance at all times, ready to make a quick getaway if need be. Everything about this activity was dangerous, from the hazardous physical exploits involved to the ever-present risk of the electrified third rail to the threat of police pursuit, harassment, and arrest. Railyards were raided by anti-graffiti squads of the MTA and the New York City police on a regular basis throughout the 1980s. For many writers, the experience of breaking the law to write this way—and getting away with it—was accompanied by a huge adrenaline rush and a sense of accomplishment. The fact that authorities and other members of the public would not even be able to *read* the names that wildstyle writers had labored on illegally all night added insult to injury. It underscored writers' assertion of a proud identity that existed outside society's mainstream, in defiance of its laws.

The burners by KASE 2 and EL-KAY that I have mentioned (to the left and the right of the subway car in Figure 8.1, respectively) exemplified the visual qualities that wildstyle writers prized. The way these pieces were exe-

cuted made one thing clear: how these letters *looked* was more important than anything they might *say*. Paradoxically, wildstyle writing's characteristic elaborations evolved as the works' anticipated longevity was curtailed. By the early 1980s the MTA had begun to combat subway graffiti by buffing train cars with chemical solutions that effaced the writing on their sides. Burners like the ones represented here might last days or weeks at best before their inevitable "buff." Writers risked life, limb, and legal sanction to complete these works, lavishing extraordinary care on the details of their execution in full knowledge of the fact that they would shortly be destroyed.

A basic yet profoundly significant aspect of wildstyle writing is that the most developed examples of the art were written on subway trains. Inscriptions on trains could actually *be* kinetic. The same word might travel from the housing projects of the Bronx to the working-class neighborhoods of Brooklyn, cruising through the affluent Upper East Side en route. Writers' words remained in motion for much of their brief existence, shuttling from areas of wealth to neighborhoods on the margins of mainstream society. The graffiti writer who "bombed" trains set words free in the world, accepting that he or she was unlikely to have sustained access to the work after its creation (the public nature of wildstyle is in contrast with varied audiences detailed in Lovata's arborglyphs discussion in chapter 6).

A scene in Tony Silver and Henry Chalfant's 1983 documentary *Style Wars* ([1983] 2003) illustrates the unusual modes of viewership these mobile works engendered. It shows the writers SEEN, MIN, and IZ THE WIZ assembled along an isolated stretch of track to view their words in action. The writers wait a while, killing time in the tall weeds and trash that typify the post-industrial landscape of the outer boroughs. When a train approaches they start to yell, "Here it is! Here it is! Here it is!" Excitement is audible in their voices. They start jumping up and down like a ragged chorus line next to the tracks, shouting out to greet each car as it comes by. The enormous, colorful words arrive in a whoosh of hot air. They race by with a deafening clatter. The writers look very small as they celebrate beside the tracks, saluting their words from a distance in the brief seconds before they disappear. Viewing their names at large in the world is like catching awed glimpses of dear old friends, now improbably risen to glamorous celebrity. The words are like superhuman avatars of their creators, endowed with the power and mobility their makers lack.

When words become kinetic like this, they behave in ways reminiscent of actual bodies. A writer might know that his name was out there in the city, but he could never be sure exactly where it was at any given moment, or how

it was doing: whether it was still out there dazzling the streets, or whether the MTA's dreaded buff had effected its demise. Subway trains lent big steel bodies to writers' words, making it possible for them to perform in the world.

This embodied, performative style of writing evolved during an exceptionally fraught period in New York's public transit history. Since the mid-1960s New York City mayors John V. Lindsay (1966–1973), Abraham Beame (1974–1977), and Ed Koch (1978–1990) had made the elimination of graffiti a major priority. During this period the campaign against subway graffiti expanded to unprecedented levels and became personalized, capturing the imagination of a large sector of the public.[10] By the 1980s, Koch's campaign against graffiti could draw support from recent work in sociology. A widely cited 1979 article by Nathan Glazer proposed that graffiti was undesirable because it created the impression that the city was out of authorities' control (Glazer 1979). Glazer's work influenced George Kelling and James Q. Wilson's famous "broken window" theory, cited as a rationale for the implementation of aggressive policing strategies in many inner-city districts during the 1980s (Kelling and Wilson 1982).[11] Kelling and Wilson's work proposed that extending a degree of tolerance to picayune "quality of life" offenses sent a damaging message by creating the perception of a tolerant civic attitude toward all crime. Perhaps in response to these theories' popularity, civic officials did not shrink from imposing moral terminology on the graffiti debate. According to David Gunn, MTA chairman from 1984 to 1990, "the people who were doing graffiti in New York City were bad people . . . if you're defacing public property, you're a bad person!"[12]

What were those people "doing graffiti" actually like? Questions of moral turpitude aside, one of the things that *can* be determined about graffiti writers of the 1980s is that they made up a strikingly diverse group. The population of writers encompassed African-American, white, Latino, and mixed-race individuals from a wide variety of ethnicities and origins.[13] Writers were mostly teenage boys and young men, but they also included a vocal minority contingent of girls and young women (Miller 2002, 17, 29–32; Gastman and Neelon 2010, 28–29). Most were from poor or working-class families, although a few famous writers came from privileged backgrounds. What these people had in common—besides their devotion to the written word—was their sense of solidarity with the margins. The multiple criminal acts involved in pieces' execution saluted the continuing existence of the excluded and "underserved": those who sometimes lived outside the law for one reason or another, scraping out an existence at the great city's socioeconomic fringe.

The Elements of Wildstyle

The key elements of wildstyle writing were its illegibility and its pronounced appearance of embodiment. Wildstyle burners confronted the would-be reader with a dizzying experience of illegibility, emphasizing how letters *looked* while successfully impeding viewers' ability to ascertain what they *meant*. Some graffiti writers disliked wildstyle because it was hard to read (see CHINO, cited in Gastman and Neelon 2010, 91). But Martha Cooper observed as early as 1982 that others were attracted to the style precisely *because* of that quality, noting that ". . . inaccessibility reinforces that sense of having a secret society inaccessible to outsiders. . . . A writer will therefore often make a piece deliberately hard to read" (Cooper and Chalfant 1983, 70).[14] Wildstyle writers explained their pursuit of illegibility as a device that excluded most members of the public while remaining comprehensible to an inner circle of initiates. In 1982 the teenage writer SKEME, nonplussed and unimpressed at a gallery opening for a show of "graffiti art," exclaimed, "I didn't start writing to go to Paris, I started to go all-city, to destroy all lines. It's for us and other graffiti artists, so we can read it. All the people in the public, I don't care if they can read it, they're excluded" (*Style Wars* [1983] 2003).

Many of the wildstyle writers interviewed by graffiti historian Ivor L. Miller in the 1980s and 1990s explained their commitment to illegibility in similar ways.[15] The celebrated wildstyle writer KASE 2, who made one of the pieces I describe in the first section of this chapter, proudly mused on the way his style functioned as camouflage: "I got styles already that's more complex, that nobody know about. I mean, super-duty tough work. . . . If I really get into it and start camouflaging it, l don't think you even be able to read it" (*Style Wars* [1983] 2003).[16] Achieving the appearance of embodiment was equally important. The writer LEE once asked an interviewer, "Have you ever seen wildstyle? The letters are movements. They are actually images of people. The way some Rs are styled, they look like they're dancing. Some of the letters look like they're hitting each other, and the Fs, they look like they're trotting along. And the movement of the trains brings them to life" (Miller 2002, 39).

Wildstyle letters appear embodied because they are rendered in an illusionistic style that emphasizes the fiction of their three-dimensional existence. Wildstyle writers did everything humanly possible to materialize language, making letters more like living entities than texts. Exaggeration, distortion, highlights, dropped shadows, 3-D effects, and trompe l'oeil make these writers' burners look vivid and alive. The fact that these letters are written on

trains reinforces the impression of embodiment by literally setting them in motion. Wildstyle letters also were embodied in absolutely literal fashion through performance. The writer and breakdancer DOZE said that he imitated the stylized forms of wildstyle letters in various locks and freezes. For instance, the letter D took shape in the movement called the "baby freeze," which is performed by balancing the body on the arms and head while the feet kick back over the torso. B-boys like DOZE knowingly engaged in a visceral subgenre of wildstyle writing, lending their bodies to give letters fleeting substance in the air.[17]

Ornament was armament, and the point of both strategies was to protect the letter from decipherment. Wildstyle letters were defended against would-be readers by the stylistic devices I discuss earlier in this chapter. Writers sought to camouflage their letters' meaning by wrestling language into something close to unadulterated form. When wildstyle writers depicted letters in 3-D and morphed their shapes away from easy recognition, they were defending against interpretive sallies. Their ornaments protected letters from readers' attempts to impose narrow constructions on their meaning. Letters thus protected were emancipated. Unchained from syntactical logic, they were free to signify in unexpected ways.

Wildstyle words were often also literally armed. Weapons like machine guns, arrows, and laser beams, depicted as attached to words, protected them from harm.[18] Why did a letter need to be armed? Describing a wildstyle piece that he made in collaboration with RAMMELLZEE, the writer DONDI put it like this. "He (RAMMELLZEE) says . . . the Christians put a Catholic symbol on the letter, and the only way to destroy a symbol is with a symbol, so . . . in order to destroy a symbol you have to arm a symbol. And he thinks by arming letters . . . this Christian symbol will be destroyed" (*Style Wars* [1983] 2003). Ornaments and armaments allow wildstyle letters to resist subjection to standard ("Christian") English-language usage. Each letter constitutes an enclave of politicized resistance.

Wildstyle writers thought most letters had been constrained by mainstream modes of use. Their inherent capacity for multiple levels of signification had been hindered by the restrictions grammar and syntax imposed. In standard usage, these rules mandated that letters generate content through syntactical chains, minimizing their ability to signify through the structural elements of sound and visible form. The point of wildstyle is that it allows letters to escape these limitations. Leaving the paradigmatic plane of meaning, where content is generated through letters' position in relationship to one another, they shrug off pedestrian logic and enter a discursive space where meaning might be generated exclusively through the properties of form.[19]

Wildstyle in Discourse

Other wildstyle writers embraced RAMMELLZEE's ideas about the importance of illegibility, in spite of or because of the fact that they constituted a radical departure from the way graffiti writers' motivations had previously been characterized.[20] Early accounts asserted that graffiti was ultimately about asserting the writer's identity. The first book to take graffiti writing seriously as artwork and cultural act, *The Faith of Graffiti* (Naar et al. 1974), presented the legible name as the fundament of writers' practice (see Beaton and Todd in this volume for an alternative method of preserving and appreciating graffiti). Mailer took his essay's title from an observation made by 1970s writer CAY 161: "The name is the faith of graffiti" (Naar et al. 1097, 9–10). Variants of this thesis dominated accounts of graffiti throughout the 1970s, sometimes figuring in derogatory accounts that characterized graffiti writing as a rote, animalistic gesture. Such accounts were inflected by the stereotypes middle-class audiences associated with what they assumed to be graffiti writers' race, class, and gender identities. A 1980 *New York Times Magazine* article titled "Graffiti: the Plague Years" featured patronizing comments from a social worker likening graffiti writers to "male dogs who raise their legs every ten feet" (Stern and Stock 1980).

While names have indisputably been important in graffiti, they did not always signify in the straightforward manner described in popular accounts.[21] As RAMMELLZEE implied, the emergence of wildstyle writing around 1980 represented a watershed moment in writers' practice. Earlier, legible names had confronted viewers with citywide evidence of individual writers' seemingly ubiquitous presence.[22] However, wildstyle writers were more interested in negation than assertion. They wanted to impede viewers' ability to read their work, and they labored to frustrate would-be readers' expectations of access.

Earlier writers' approaches might have been founded on the assertion of personal identity and will, but the wildstyle burners of the 1980s asserted a will intrinsic to the word that allowed them to escape the writer's control and signify in unexpected ways. Appearances were not auxiliary to this message: they *were* the message. The wildstyle letter was not a vessel of expression: it was an aspirational model, a proxy for the subject. The birth of wildstyle marked a shift from a mode of practice that placed emphasis on personal identity and intent to a mode of practice that downplayed authorship to investigate the limits of form.[23]

When subway cars alive with wildstyle burners departed the darkness of the yards and illuminated the streets of one of the world's richest cities,

they confronted urban viewers with the unfamiliar experience of trying—
and failing—to read. Viewers responded to this experience in a variety of
ways. Some reacted angrily when presented, however fleetingly, with a sense
of themselves as the excluded. Others reveled in the knowledge that pub-
lic space could still be inscribed with meanings that had not been officially
sanctioned.[24] Wildstyle writing flourished for a fleeting interlude. While it
lasted, the streets of New York City were beautifully saturated with informa-
tion that would remain inaccessible to most members of the elite, because it
was not for sale (see the next chapter for Duncan's discussion of graffiti in an
art gallery).

From the Street to the Gallery: A Critical Analysis of the Inseparable Nature of Graffiti and Context

ALEXANDRA K. DUNCAN

Modern graffiti have become an unavoidable visual element of the urban landscape in nearly every city around the world.[1] If you live in an urban center, you likely see a great deal of graffiti around your city's alleyways, underpasses, and transit lines. Maybe you even recognize the recurrent appearance of certain graffiti writers' pseudonyms or "tags." If you travel, perhaps you notice the unique styles of street art particular to different geographic regions. In many ways, graffiti are the illustrations in the story of a city. When graffiti artists choose to make the move from creating graffiti in the street to creating graffiti-style work in the gallery, however, the meaning and experience of the work changes. For example, imagine "burners" from a subway train transported to a gallery: static in a clinical environment. In other words, when modern graffiti are recontextualized from a free, public setting to a private, institutional space, such as a gallery or museum, which is inextricably connected to established systems of regulation and valuation, graffiti cease to function as a democratizing means of communication, and instead become part of a dialogue that has historically privileged certain voices while excluding others.

In the street, a work of graffiti appears to have been created by a fellow citizen—an equal—and we can interact closely with the work. Yet in the gallery, we are expected to maintain a certain distance from the work, both physically and critically, as the institution has legitimized it as fine art. Art historian Carol Duncan writes, "in the liminal space of the museum, everything—and sometimes anything—may become art"; this transformation is exemplified by Marcel Duchamp's *Fountain*, 1917 (Duncan 1995, 79).

Moreover, through the careful sequencing of space and the arrangement of objects, as well as through lighting and architecture, art museums and

galleries create a structured environment that imposes a particular narrative, decorum, and liminal mode of consciousness on museum visitors (Duncan 1995). In *Inside the White Cube: The Ideology of the Gallery Space,* Brian O'Doherty, an arts scholar from Ireland, explores the way in which the space of the gallery influences the way in which artworks are read, proposing that upon entering a gallery the visitor first sees the space rather than the artworks (O'Doherty 1986, 14).

Thus, the experience of viewing graffiti in a constructed gallery space is not at all the same as discovering a new work of graffiti, commonly referred to as a "piece," in one's city streets. The simple replication or simulation of aesthetic style does not necessarily involve the transference of street graffiti's unique qualities (namely its site specificity, and the particular dialogue in which it is engaged). According to a 2012 article in *The Independent,* written by Michael Glover, street art "is art made on the run" (Glover 2012; see also Gopinath in this volume for a discussion of how burners are created). Glover goes on to describe the unique nature of street art, which, in his opinion, is exemplified in the illegal public works of French street artist Zevs. Glover writes, "The canvas on which [the street artist] works is entirely unprimed and unready for his assault. The fact that it is at odds with the authorities means that art of this kind often feels hectic in mood, hasty in execution, urgently political in its impulses, and prepared for the fact that it may disappear again just as quickly as it has appeared" (Glover 2012). The uncertain lifespan of street art works, as well as its inherent spirit of urgency and rebellion, make for unique and exceptional encounters. Yet when exhibited and curated in a gallery or museum, visitors can be certain that the works have been carefully placed on the wall and preapproved by a committee (see also Beaton and Todd in this volume for a discussion of their attempts at working within a non-"curated" industrial space with graffiti). Ephemeral art is anathema to a curator, but its immediacy is an empowering tool for the street artist; in a gallery context, the imagery remains static and unchanging.

French street artist Aghirre Schwartz, better known by his tag "Zevs," pronounced "Zeus," creates what he calls "Visual Violations," taking spray paint to public advertisements in his "Visual Kidnappings" and "Liquidated Logos" (Zevs 2013). The latter involves the application of water-based paint, which drips down heavily from well-known corporate logos such as the luxury design house Chanel and the fast-food restaurant McDonald's. He first created works illegally in public spaces, "liquidating" logos on billboards, storefronts, and city walls, and later adapted them for his gallery shows. In an article written for *PaperMag* just before Zevs's first solo New York exhibition, Carlo McCormick referred to him as the "most subversive" of all contem-

porary French street artists (McCormick 2011b). In fact, Zevs was arrested in Hong Kong in 2009 after spraying a liquidated Chanel logo on the side of a Giorgio Armani shop. However, while the formal qualities and compositions of Zevs's liquidating paintings remain identical to one another, their subversive power is diminished when relocated in the rarified environment of a gallery or museum setting.

Zevs has been showing his work in galleries for more than a decade, and has voiced his opinion that a change in location has no impact on the message conveyed by the work. In a 2013 interview with the Italian magazine *Sette*, Zevs addressed this issue, stating, "What matters is the work and its message, not where you display it, and I will continue to be a street artist. Certainly here [in the gallery] we are surrounded by beautiful people. But what's the harm in that?" (cited in Sarto 2013, para. 3). Not only does Zevs's comment conflict with the views of many visual culture theorists, graffiti writers, and street artists, but it also contradicts the experience of street art in both the gallery and in the urban setting. In February 2011, I attended Zevs's first solo New York show, *Liquidated Version*, at the privately owned De Buck Gallery in Chelsea, New York City. The De Buck Gallery was founded in 2011 by David De Buck, a Swiss banker turned private art dealer who chooses to exhibit new media and work by accomplished "bad boy" street artists like Zevs (De Buck Gallery cited in Pasquarelli 2013).[2]

Upon entering the gallery, I found myself in a white-walled, wood-floored space typical of most galleries in which Zevs's works were hung at eye level on the walls, or in the case of more sculptural pieces, displayed atop simple white rectangular plinths. A single modern, black leather sofa sat in the center of the room behind a square blue plastic coffee table with simple metal legs. Ahead and to my right, the space opened into a second room of approximately the same dimensions as the first, with a bar serving wine and other beverages set up at the back.

The works on display in these rooms included liquidated Louis Vuitton logos (both on canvases on the walls and on dresses worn by hired models), as well as liquidated and non-liquidated logos of prominent financial institutions, such as the Bank of America, Lehman Brothers, Merrill Lynch, Morgan Stanley, Bear Stearns, and Goldman Sachs. The largest piece on the walls of the gallery was a large liquidated map of the world. The show also included other mixed-media pieces, such as a Louis Vuitton logo made of three hatchets attached to a canvas, and a framed page from the *New York Post* (March 18, 2009), containing only the words "NOT SO FAST YOU GREEDY BASTARDS" in large type (Figure 9.1).

FIGURE 9.1 Zevs's *Liquidated Version* exhibition at the De Buck Gallery in Chelsea, Manhattan, 2011. Photo courtesy of the DeBuck Gallery.

The liquidated logos, when seen in the street, explicitly and directly confront corporate capitalism. Bold graffiti imagery surprises viewers through visual appropriation of recognizable motifs, but these familiar "perverted" slogans also register as protest, vandalism, art, and, finally, the viewers' sense that they are witnessing is also a crucial part of the experience.

Viewing Zevs's fine art amid the crowd of well-dressed connoisseurs in the space of the De Buck Gallery was an entirely different experience than my previous encounters with Zevs's street graffiti, which appeared unannounced in the city streets amid the hustle and bustle of daily life. These contrasting encounters and their subsequent readings indicated a failure on the part of the artist to adequately recognize the importance of context. Sipping champagne, nibbling hors d'oeuvres, and schmoozing with elites, including Zevs himself, in the clean and orderly space of the De Buck gallery was an inexplicable and curious experience. In the gallery space the biting satire and wit of the liquidated logos appeared almost like a shrill anti-industry cliché.

The liquid logos' most striking fail was their spruced-up legal status. These permanent paintings were treated as precious commodities that were intended to adorn walls, not to violate them. Illegal street art boldly occupies our public spaces, disobeys laws, and challenges socially accepted notions of who is permitted to visually modify public property. Meanwhile, the same imagery in a gallery space lacks the agitation, hostility, and contradiction, which according to Claire Bishop, "can be crucial to any work's artistic impact" (Bishop 2012, 26). Such a hostile, confrontational attitude once seemed

to be the driving impulse behind Zevs's work. In a 2007 interview for *Libéra-tion*, Zevs said about his illegal street art, "They impose their images on me, I impose on them my manner of seeing them" (Lechner 2007, 30; my own translation).[3] Here, we see the way in which Zevs views advertisers as "adversaries" who "impose" upon the citizen, and thus makes it his mission to combat them, to fight back with his own form of visual language, which he quite literally superimposes directly upon the advertisers' images in an ongoing battle for visibility and control of the materiality of specific spaces. By simply recreating these pieces or rather, the aesthetic form of these pieces in the De Buck Gallery, this fundamental sense of confrontation is, at best, artificially constructed.

To better understand the implications of moving work by graffiti artists from the street to a gallery space, it is necessary to more closely examine the way in which street graffiti function as a democratizing form of com-munication in the open air of modern cities and towns. It is also essential to recognize the differences in audience interaction with imagery on the street and in a gallery, which is characterized by hierarchical systems of judgment and valorization.

With graffiti, there exists an important sociopolitical aspect linked to a work's geographical location, and as such, the work's placement within a community, and within a system of relations, is much more crucial to its meaning than its aesthetic form alone. As art historian Miwon Kwon pro-poses in *One Place After Another: Site-Specific Art and Locational Identity* (2004), site specificity should be considered "not exclusively as an artistic genre but as a problem-idea, as a peculiar cipher of art and spatial politics . . . which combines ideas about art, architecture, and urban design, on the one hand, with theories of the city, social spaces, and public space, on the other" (Kwon 2004, 2–3).

For Kwon, the "site" of site-specific art "is not simply a geographical loca-tion or architectural setting but a network of social relations, a community, and the artist and his sponsors envision the art work as an integral extension of the community rather than an intrusive contribution from elsewhere" (Kwon 2004, 6). Bruno Corà, author of "Note Sull'Arte Ambientale" ("Notes on Site-Specific/Environmental Art"), describes this "*rapporto inscindibile*" ("inseparable relationship") that exists between artwork and site/location, including the aesthetic qualities of the site, the sounds and odors present in the space, and the particular quality of light that falls within the space, and proposes that site-specific art cannot be moved without losing an integral part of its significance (Corà 2004, 36–38).

Mark Halsey and Alison Young (professors of criminology at the University of Melbourne), as well as Tracey Bowen (communications professor at the University of Toronto) describe a number of site-specific attributes of graffiti, and they assert that it should be viewed as an affective, performative process that transforms the bodies of graffiti writers and graffiti audiences alike, rather than as a "static or two-dimensional activity" (Bowen 2010, 85–87; Halsey and Young 2006, 276–277). Moreover, they view the experience of encountering graffiti as highly dependent on specific (urban) locations, as street art works "form a critical part of the plane of signification investing urban landscapes" (Halsey and Young 2006, 276). In this way, site specificity along with all of its complex attributes plays a central role in the practice of graffiti and street art.

Scholars have praised graffiti for its unique ability to give a voice to minority groups and marginalized people such as black and Latino youth who otherwise struggle to be heard (Bowen 2013). Bowen sees the act of creating graffiti as both a "celebration of existence" and "a declaration of resistance" (Bowen 2013). Similarly, Slovenian feminist writer Tea Hvala views graffiti as "the most accessible medium of resistance" for oppressed people to use against dominant culture due to its tactical, non-institutional, decentralized qualities (De Certeau 1984; Hvala 2008). For both Bowen and Hvala, as well as for Halsey and Young, these unique positive attributes of graffiti are heavily reliant on its location in unique types of public urban spaces.

Bowen and Halsey and Young view graffiti as an example of what de Certeau called a "spatializing practice" that "may challenge or complement our understanding of how diverse individuals inhabit the city and perform their experiences of such habitation" (Bowen 2013). Bowen connects this to Edward Soja's concept of "thirdspace," which refers to "lived spaces of representation" in which various social forces and institutions, as well as hegemonic values and beliefs, collide "with the reality of various modes of lived experience" (Bowen 2013).[4] As such, when encountering graffiti in urban "thirdspaces" such as alleyways or underpasses, the viewer "engages in a form of mapping urban space" (Bowen 2013). Alternatively, when viewers enter a gallery space, they are cut off from these lived urban spaces, and street art works viewed in a gallery become disconnected from such urban ecologies.

Bowen also cites Ella Chmielewska (professor of cultural and visual studies at the University of Edinburgh), who views the grimy materiality of space and uneven texture of surface as crucial elements that come into play in the bodily experience of viewing graffiti (Bowen 2013, para. 10). Concurrently, Halsey and Young identify street graffiti as occupying what Gilles Deleuze

and Felix Guattari have termed "smooth spaces," as opposed to "striated spaces" (Halsey and Young 2006, 296). For Deleuze and Guattari, smooth space is directional, intensive, and a space of affects and distances, while striated space is dimensional, extensive: a closed space of measures and properties for linear and solid things (Deleuze and Guattari 1996). Halsey and Young assert that while "the modern state has sought to transform smooth and nomadic territories into [striated] places where everything is ordered, numbered, monitored and controlled," illicit street art and graffiti fundamentally challenge this prescribed order, control, and cleanliness, which characterizes art galleries like De Buck (Halsey and Young 2006, 296).

Another defining characteristic of illicit graffiti is its inherent ease of access, for creators and viewers (Felisbret 2009, 4; Ganz 2006; Hunter 2012, 6; Schacter 2013, 7). Graffiti can be created and seen by anybody, regardless of age, race, gender, education, sexual orientation, or political affiliation. The only prerequisite for creating street graffiti is the desire to be heard. By contrast, art galleries and museums restrict participants, allowing only certain legitimized artists to exhibit their works, thereby silencing those whom they choose to exclude.

In the streets, individual graffiti writers and street art audiences come together to form unique urban communities, which exist within the broader ecologies of a city. American sociologist Richard Lachmann has observed "[graffiti's] value is derived from the social relations within which it is created and is transformed by taggers' developing ties to mentors and audiences" (Lachmann 1988, 240). These social relations among taggers or writers, mentors or experienced graffiti writers who influence new writers, and urban and public audiences shift drastically when graffiti move from the street to the gallery. Mentors are replaced by gallery directors and curators, and audiences change from a heterogeneous urban public, to a privileged, fine art–literate, gallery-going audience whose motives and tastes differ greatly from the former.[5]

Brazilian street artist Deninja views graffiti as "an art that is there in the street for those that don't have a culture, don't understand art but like it for what it is . . . for the beggars, poor children, prostitutes, lunatics and drunks of the streets" (as cited in Ganz 2006, 40). Yet, beggars, poor children, prostitutes, lunatics, and drunks rarely enter galleries. In other words, Zevs's works, when relocated to a gallery space, cease to be a part of the graffiti dialogue, and instead come into dialogue with institutionalized art practices that are consumed by the art-buying public. In a September 2013 interview with *ArtSpace*, Zevs identified several artists whose work has most influenced him. The list included Matisse, Magritte, Duchamp, Pollock, Warhol,

and a number of others renowned in the world of fine art, yet no mention was made of other street or graffiti artists (Greenberger 2013).

In fact, modern graffiti have developed completely separately from traditional, institutionalized art forms (Stahl 2009). Graffiti artists today draw inspiration from art history at times, but it cannot be said that graffiti grew directly out of any such canon or typology. Modern graffiti did not begin as an art form at all, but rather, as a form of text-based urban communication that developed its own networks (Stahl 2009, 6–10). As Lachmann notes, rather than submitting to the criteria of valuation upheld by the institutionalized art world, early graffiti writers developed an entirely new and separate art world based on their own "qualitative conception of style" and the particular "aesthetic standards" developed within the community for judging writers' content and technique (Lachmann 1988, 242–243). Zevs's assertion that the aesthetic qualities of an artwork are more important than the context in which it is displayed ignores these contrasting systems of valuation that exist in the gallery and in city streets.

Zevs stands to gain widespread recognition as a fine artist, and to profit financially by affiliating himself with galleries, museums, and the commercial art market. However, it is inaccurate, even cavalier, to presume that such a change in location has no impact on the meaning of a work of art. As evidenced by Zevs's illegal Liquidated Logos, his primary intent in the earlier stages of his career was purportedly to "attack" advertising. For many street artists working illegally, including Zevs, certain public sites are selected to reclaim public space, most often from advertisers and large corporations (Lewisohn 2011; Seno 2010). It is not mere coincidence that graffiti have developed as a parallel message to public advertising. In fact, Stahl proposes that graffiti writers' mentality has been directly pre-formed by advertising strategies (Stahl 2009, 39). Many graffiti artists have adopted a confrontational attitude toward marketing, asking: If advertisers are permitted to visually pollute purportedly "public" places, why can't citizens be a part of that dialogue?

Whether by adding their own images to the visual pollution of public spaces, or by directly modifying pre-existing advertisements (as in Zevs's illegal work), graffiti artists insist on reclaiming a portion of urban public spaces for the ideas and opinions of individual citizens. In this way, illegal street graffiti have created a particular dialogue among artists, artworks, audiences, and, quite often, property owners and/or advertisers (Halsey and Young 2006). However, regardless of the efficacy of Zevs's liquidation technique in combating advertisers in public spaces, the regurgitation of

this same technique in a private gallery setting results in a blurring of art, context, and meaning.

The experience of viewing graffiti in a city's streets and back alleys is thrilling, characterized by discovery and unexpected encounters, by turning a corner and seeing a piece that wasn't there yesterday, and which may be gone tomorrow (Bowen 2010; Hvala 2008). In the street, graffiti and context come together to form a narrative about local communities and struggles for power and visibility. When removed from this context, graffiti in a gallery space are rendered incomplete, privileging one voice over others. Thus, in stating that "What matters is the work and its message, not where you display it," Zevs has failed to recognize that a work's message fundamentally derives from where it is displayed, and that the problem-idea of site specificity is particularly essential in discourses surrounding modern graffiti and street art.

SECTION III

UNDERSTANDING GRAFFITI AS
A WITNESS TO HISTORY

Many scholars look at graffiti as a historical voice that often runs counter to our understanding of a particular culture and period of time. Graffiti's power to surprise and provide us with alternative narratives can bring us closer to the past, while its expressions also can complicate our understandings of history. Discoveries examined in chapters by Shelia and Thomas Pozorski, Elizabeth Drake Olton, and Colleen Beck and colleagues were unexpected and reveal the complex nature of graffiti in both ancient and contemporary contexts. Interestingly, these expressions are all associated with institutional architecture: official square platform structures from Initial and Horizon periods in the Andes, Classic Maya elite sanctuaries, and concrete tunnels constructed by the U.S. Department of Energy in Nevada. After careful contextual and visual analysis, these unofficial expressions indicate the presence of a transgressive message (in the case of chapter 12, these emotions are quite overt). Significantly, with few exceptions, these three chapters discuss graffiti found in secluded contexts, but not hidden from view. Hans-Georg Gadamer's (2004, 102) identification of dialogue and experience between artist and audience is different from the same type of dialogue found in the subway tunnels of New York City in the 1970s and 1980s or along urban streets today. The viewing experience is intimate, but not necessarily private

or anonymous. It is in contrast with the experience of latrinalia, but similar to Plesch's work in the church of San Sebastiano in northern Italy. The contexts of the graffiti from the Casma Valley, Structure 5D-65 at Tikal, and from the Nevada Peace Camp tunnels reveal that the audience was small and the artists may not have been anonymous. Narratives incised in stone or painted on concrete may have functioned as a commentary on the current events of their times, reflecting resistance to authority, satire, or all-out protest.

In the contemporary discourses on witnessing—usually referencing film from surveillance cameras, satellite imagery, new photography, or the works of a police sketch artist—the image is often considered a credible representation of an event or a person because these texts are found in structures of authority. In contrast, unofficial visual cultures—including those that contradict or redefine established, inevitable social convention—are often linked to the loud voices embedded in contemporary graffiti. Not all of these expressions are simply irresponsible acts of vandalism; instead, they can provide historians with an intimate and subjective view of society from a specific time. The very existence of graffiti from the Peace Tunnels at the Nevada Test site are a witness to years of protests, while the analysis of individual images and texts reveals that they mirror the social environments of the protestors and of society. These images are like a time capsule precisely because they were inadvertently preserved. Art historian and cultural critic Jane Blocker explores witnessing as an "act of representation, of picturing, an act that is staged in the aesthetic domain of the visible and invisible" (2009, xvii). Illustrating an event, memory, or figure in a private or interior space where it might not naturally belong is a forceful act. Depicting scenes on these walls that question authority, employing culturally recognizable events or figures as tools of critique, are witnesses to a historical moment that reveal a certain agency or desire.

The graffiti examined by the Pozorskis, Olton, and Beck et al. represent a visual narrative that questioned the status quo of each respective culture. An independent voice expressing subversive messages is rarely seen or documented in the ancient Americas. Ancient American graffiti are often misunderstood and the work by the Pozorskis and Olton will hopefully inspire future investigations of these scratches, signs, and marks found on walls. Beck et al.'s work, although of a modern nature, is similarly essential in our understanding of political protest in the United States. Protestor activities are documented in photographs and in newsreels and video, but the preservation of the visual and material culture of these activities is unusual.

To witness an event is not an unbiased experience, as it involves translating actions or feelings into words or images. Graffiti interpret events from inside a culture in what anthropologists call an "emic perspective" and what art historian Michael Baxandall (1985) has labeled a "period eye." The authors of these chapters show what can come from exploring these lines between perspectives.

CHAPTER 10

Graffiti as Resistance: Early Prehistoric Examples from the Casma Valley of Peru

SHELIA POZORSKI † THOMAS POZORSKI

Introduction

In this chapter we explore the nature and function of a sample of early prehistoric graffiti in the Andean area of the ancient Americas, few examples of which have been previously reported (Bischof 1994; Fuchs et al. 2006). The examples we describe here were lightly incised into the silty-clay plaster of ancient walls; few component lines exceed 1 to 2 mm in depth. As a result, many preserved examples of graffiti defy interpretation because they are incomplete or too abstract to connect with known Andean imagery. Nevertheless, even though the sample is small, very ancient, and represents preliterate cultural developments, it is possible to discuss changes and consistencies through time with respect to the context of the graffiti and the motivation of the artists.

During the Initial Period (2100–1000 BCE), the Casma Valley on the north coast of Peru was home to one of the grandest mound-building cultural developments in ancient Andean America. At that time, the Sechín Alto Polity occupied the entire Casma Valley zone (Figure 10.1), controlling it with a heavy-handed form of leadership that permeated all aspects of people's lives. Settlements were clearly planned, component architecture followed established architectural tenets, movement of people and goods were closely monitored and controlled, and craft production was overseen by means of administrative structures within residential zones. Strategically placed graffiti that mar public buildings provide possible evidence of clandestine resistance to such overt efforts to monitor and control people's lives (see Olton in this volume for another example of ancient graffiti expressions that might have run counter to the established rule).

Understanding Graffiti edited by Troy Lovata & Elizabeth Olton, 143–157. © 2015 Taylor & Francis. All rights reserved.

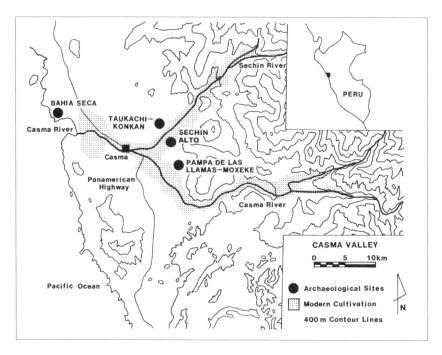

FIGURE 10.1 Casma Valley area showing the location of Sechín Alto Polity sites.

After the decline of the Sechín Alto Polity, a very different social and political system characterized the Casma Valley during the time span known as the Early Horizon, which ranged from 1000 to 200 BCE. The large mound-dominated centers of the Initial Period gave way to sprawling communities with agglutinated complexes of small platforms, plazas, and residential zones (Chicoine and Ikehara 2008; Pozorski and Pozorski 1987). Also during this time, several Sechín Alto Polity sites were reoccupied, including the Sechín Alto site and the coastal site of Bahía Seca. Early Horizon graffiti at this coastal satellite are highly visible, yet they still likely represent resistance to the legacy of the Sechín Alto Polity.

The Sechín Alto Polity

The Peruvian Andes comprise one of few areas in the world where complex societies arose independently. As early as 3000 BCE, numerous complex planned settlements with platform mounds and economies based on irrigation agriculture and marine resources characterized the central Peruvian

coast (Haas and Creamer 2006; Shady 2004). Possibly influenced by precocious developments to the south, cultural development within the Casma Valley to the north escalated during the subsequent Initial Period (2100–1000 BCE) with the rise of the Sechín Alto Polity. This polity, centered at the Sechín Alto site, occupied and controlled both branches of the Casma Valley river system as well as the adjacent coastal zone. The polity's success depended on a system of interrelated sites with large platform mounds that performed complementary functions within the polity (Pozorski and Pozorski 2005, 2008). Pampa de las Llamas-Moxeke, in the southern Casma branch, housed two large mounds that functioned as a storage facility and a temple. Within the northern Sechín branch of the river system, the main Sechín Alto site served as the polity capital. Its principal platform mound, an immense structure with a surface the size of 15 football fields, housed areas dedicated to polity administration as well as a sacred precinct. The largest structure at the nearby site of Taukachi-Konkán is the Mound of the Columns, a platform mound that likely served as a palace for the leader of the Sechín Alto Polity. The Mound of the Columns has public areas for receiving visitors as well as a private, restricted residential area with raised benches for sleeping and other domestic activities.

There is ample evidence that Sechín Alto Polity control affected many facets of people's lives. It is readily apparent in overall site plans that persist across centuries, and it can be seen in highly standardized artifact forms, including ceramics, spindle whorls, and especially figurines (Pozorski and Pozorski 1987). Even more overtly, polity control was both implemented and symbolized by a distinctive architectural form, the square-room unit. These units are square in form, with rounded exterior corners, square or rounded interior corners, wall niches well above the floor, raised thresholds, entrances constricted by pilasters, and bar closures that further restrict access (Pozorski and Pozorski 2011). They occur at all major Sechín Alto Polity sites, where they can be found on main mounds as storage structures, near large mounds to monitor access, as the central room of intermediate-sized administrative structures, and within site areas dedicated to craft production.

The Sechín Alto Polity relied on protein from marine resources supplied by three coastal satellites. Among these three sites, Bahía Seca is the largest, and is dominated by an administrative structure with a square-room unit at its center that duplicates administrative structures at inland sites. This suggests that Bahía Seca administered the coastal zone by coordinating the procurement of fish and shellfish for inland polity sites.

Initial Period Graffiti at the Sechín Alto Site

Initial Period (1800–900 BCE) graffiti were documented in two contexts on the principal Sechín Alto site mound, the central administrative structure for the Sechín Alto Polity. The front half of this mound consists of a central staircase that leads to a large atrium bordered on the north and south by raised wing structures with architecture. Toward the east, a tall terrace face forms the facade of the mound summit, which was accessible from the atrium via a second large staircase. The first example of graffiti recorded on the Sechín Alto site main mound is a small patch discovered on the south wing of the structure where a likely audience room was excavated. The area covered measures 17 cm by 17 cm and is 115 cm above the floor. Carefully made by shallow incisions into the wall plaster and apparently complete, the design seems abstract, consisting of intersecting vertical and horizontal elements (Figure 10.2A). It was executed by someone standing on the east wing of the upper mound terrace near a corner formed by the east terrace facade and the north wall of the audience room. This would have been a relatively concealed area well within the architecture of the mound summit that would also have been difficult for unauthorized persons to access.

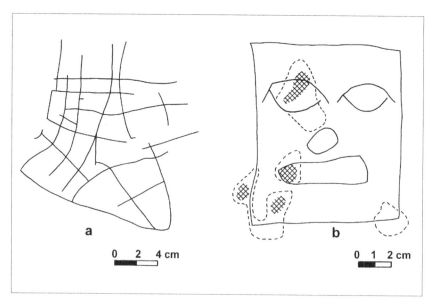

FIGURE 10.2 Graffiti from the main Sechín Alto site. (A) Abstract graffiti on the south wing. (B) Square face on penultimate construction phase. Dashed lines show outer limits of gouging; cross-hatched zones are deep gouges.

The second area of graffiti on the Sechín Alto main mound consists of three exceptionally well-preserved examples of graffiti that clearly pertain to an earlier construction phase because they were eventually buried by fill; this sealed context secures their Initial Period date. These graffiti are located some 70 meters to the west of the example recorded on the south wing structure and clearly predate it because the fill that seals them provided the base for mound summit construction that included the south wing architecture. At the time when this earlier construction formed the mound surface, the tallest part of the mound was a rectangular adobe platform 90 meters by 30 meters in area near the mound center and bordered on its long sides by dozens of columns with polychrome friezes. Immediately east of this raised platform, at a lower elevation and still near the mound center, is an area of square-room units that we partially excavated. The three examples of graffiti are located on the south wall of a platform that supported a square-room unit. At the time the graffiti were executed, the architecture was still so well preserved that white, black, red, and yellow paint colors were still vibrant on the structure's walls. During part of the Initial Period these graffiti would have been exposed, but later in the Initial Period, the area with square-room units was covered by 12 meters of fill as part of a massive construction effort that evened out the upper mound surface at the level of the adobe platform surface, burying the graffiti.

Three images that appear to be human figures comprise these buried graffiti. They are arranged with a square face on the left, a near life-sized individual in the center and a smaller composition to the right. This places the principal images at or above eye level. The left or westernmost image is a square face, 10.5 cm tall, 9 cm wide, and 160 cm above the floor. The face and its features were created with few shallow incisions: two each for the oval eyes, one for the rounded nose, and three for the ovoid mouth (Figure 10.2B). Interestingly, this image appears to have been vandalized by a series of gouges up to 4 mm deep in the area of the figure's right eye, the right side of its mouth, and near the lower right corner. This suggests at least two artists and two episodes: creation of the square face and a later an event that vandalized the square face. The second or later phase is also when all or part of the remaining graffiti were created.

The central figure is the largest, a nearly life-sized individual with a round face (Figure 10.3A). The figure measures 130 cm tall to the top of its raised hand, and the center of its face is 138 cm above the floor. The entire figure was executed using shallow incisions, and the face is the most detailed part. The eyes consist of arching incisions with smaller, rounded pupils. The location of the pupils suggests that the artist may have been depicting pendant

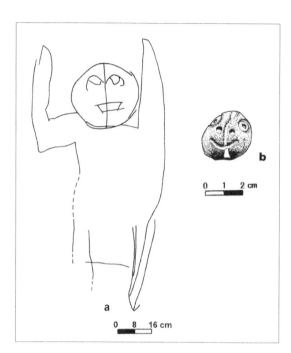

FIGURE 10.3 Graffiti from the main Sechín Alto site. (a) Standing figure with divided face on penultimate construction phase. (b) Carved avocado seed with divided face.

pupils (pupils located at the top of the eye), a common motif in early Andean iconography (Roe 1974). A vertical line down the center of the face divides it in half.

The easternmost image is the most elaborate (Figure 10.4). It measures 35.5 cm tall by 50.5 cm wide, and the center of the composition is 142.5 cm above the floor. Near the center is a male figure about 19 cm tall with an upraised right arm and a prominent erect penis, emphasized by using a deeper incision and a double-wide incised line. Three diagonal lines cross or partially intersect the figure's head, and the figure is enclosed in a ladder-like arc of two incised lines connected by cross elements.

Some traits within the three images just described on the platform side can be linked to known Initial Period imagery, thereby suggesting some consistency in the visual language employed. The best link to known Initial Period iconography is the pendant-pupil trait in the eyes of the central full figure. It is possible that pendant pupils are also represented in the square face, but this is less clear because the lower eye boundary is much nearer the size of the upper arch of the eyes. The face of the standing figure bears some resemblance to an example from an unusual class of Sechín Alto Polity artifacts: carved avocado seeds. More than a dozen carved seeds were recovered from trash heaps in the residential area of the Sechín Alto site,

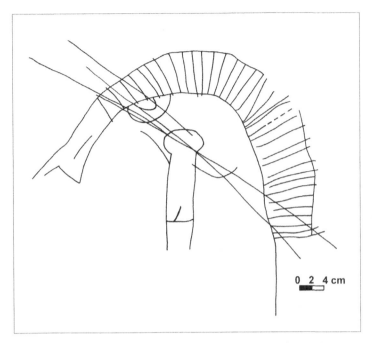

FIGURE 10.4 Graffiti from main Sechín Alto site consisting of a standing figure framed by a ladder-like arch.

several of which represent faces. One face in particular resembles the face of the standing figure because of its round shape and especially the presence of a vertical line that divides the face in half (Figure 10.3B). Perhaps this divided face was once a common local motif in Initial Period iconography. The large standing figure and the smaller figure share the traits of raised right arms and squared-off lower torsos.

The artist(s) may not have needed to look far for inspiration because columns with polychrome friezes that comprised the adjacent sacred precinct would likely have been visible to the creator(s) of the graffiti as they were executed, perhaps inspiring their content. Unfortunately, the friezes were almost totally destroyed during later prehistoric times, making direct comparisons with the graffiti impossible.

The location of these figurative graffiti in an obscure area seems strategic because the artist(s) were likely largely hidden from view as they defaced the side wall of the raised square-room-unit support platform (see Beck et al. in this volume for a contemporary discussion of graffiti artists applying protest imagery within a hidden locale). The height of the images above the floor indicates that the artist(s) were standing while working. It is also significant

that the graffiti targeted square-room-unit architecture, possibly because this architectural element symbolized Sechín Alto Polity power and control. The group of figurative images on the square-room-unit platform and the isolated example on the south wing architecture were created at different times, but both were made during the Initial Period when this capitol building of the polity was in active use. In both cases, the artist(s) were able to gain access to the highly restricted space near the mound interior and, in the case of the square-room-unit platform, a key symbolic architectural form was defaced or intentionally altered. The time depth reflected by the chronology of the two events may also be significant. Persistent efforts to deface the capitol building across time during the Initial Period reveal that local resistance was more constantly present rather than a response to a single event. On a smaller scale, evidence of vandalism of the square face among the figurative images also documents some time depth, the presence of multiple artists, and varied ideas about "appropriate" graffiti while also providing evidence that graffiti are part of a long-standing tradition of resistance (questions of vandalism and modern-day interpretations of illegal marks on walls are discussed in Mitman in this volume).

Initial Period Graffiti at Taukachi-Konkán

Excavations on the Mound of the Columns, the principal structure at the Sechín Alto Polity site of Taukachi-Konkán, exposed two areas with Initial Period graffiti: the southern entry court and the corridor near the south staircase. The Mound of the Columns, which measures 97 meters by 85 meters in area, gets its name from 118 regularly spaced columns in the eastern third of the mound summit (Pozorski and Pozorski 1999). These columns would have supported a roof that furnished shade while also shielding this sector of the mound from potential prying eyes on the nearby hillside. This eastern sector is symmetrical and composed of two mirror-image architectural units containing square-room-unit audience and storage areas that face each other across a central court. Graffiti were recorded in the southwest corner of the first entry court into the southern architectural unit near a rounded corner suggestive of a square-room unit.

Two images comprise the graffiti on the west wall of the entry court. The more elaborate example, which covers an area 20 cm tall by 9 cm wide, has its center some 58 cm from the south wall and 36 cm above the floor. The image may represent a face. This interpretation is based on the presence of a mouth with a possible fang and two concentric circles that may be an eye (Figure 10.5A). The second example is a blocky L-shaped design—also re-

ferred to as a step fret—that measures 5 cm tall by 5.5 cm wide (Figure 10.5B). The incisions that form the top arm of the L are unusually wide (3 mm). The center of this design is 79 cm from the south wall and 42 cm above the floor.

Both examples of graffiti within the entry court are well concealed behind a column, and their heights above the floor indicate that the artist was crouching and hiding behind the column when they were executed. The fact that the artist needed to hide suggests that the Mound of the Columns was in active use when the graffiti were created, thereby confirming its Initial Period date (see Gopinath in this volume for discussion of danger and adrenaline "defacement" of public property in 1980s New York subway graffiti). The artist had clearly penetrated well into the relatively restricted space of the mound to express resistance through the medium of graffiti. Furthermore, even though the artist opted for a concealed location, it is significant that the resultant images defaced one of two architectural units containing square-room-unit architecture.

Six additional examples of graffiti were documented within a corridor on the Mound of the Columns. The eastern sector is separated from the rest of the mound by a passageway that runs north-south, becoming a walled corridor near the north and south edges of the mound. At the south edge of the

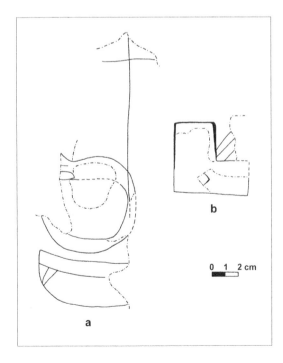

FIGURE 10.5 Graffiti from Taukachi-Konkán. (a) Possible face. (b) Step-fret design. Dot-dash lines show limits of wall plaster. Both images were executed behind a column.

Mound of the Columns, the corridor connects with a narrow, inset, roofed staircase that would have allowed access to the mound surface by persons largely hidden from view. The staircase ends at ground level to the south of the mound near a food-preparation area. Scattered examples of Initial Period graffiti are present on the west wall of the southern end of the corridor and on a step near the top of the staircase.

The image on the staircase consists of four vertical elements crossed by a single horizontal element (Figure 10.6C), covering an area 5.5 cm tall by 4 cm wide. It was incised into the front of the fourth step near the top of the inset staircase and well within the corridor where the remaining graffiti were documented. Five additional images were incised into the west wall of the corridor. The northernmost image is small, 2 cm by 2.5 cm, and consists of two concentric circles that may represent an eye (Figure 10.6D). It is 150 cm above the corridor floor. Forty-eight cm south of the possible eye is a more complex image measuring 10 cm tall by 8 cm wide and located 144 cm above the corridor floor. Preservation is poor, but fragmentary elements suggest an arm, leg, and head of a possible human form (Figure 10.6E). About 115 cm south of the possible human form is a large geometric image that appears to have been shaped like an inverted stepped pyramid (Figure 10.6B). It is incomplete because it is near the upper limits of the preserved wall plaster, but what remains measures 55 cm tall by 85 cm wide, and is centered about 175 cm above the corridor floor. These three images are located well above the corridor floor and were likely executed by a standing artist.

Further south, about 130 cm from the geometric pyramid image, is a fourth zone of graffiti measuring 10 cm tall by 21.5 cm wide and located 50 cm above the corridor floor. This near-complete image consists of two long, wavy, roughly parallel horizontal incised lines combined with 15 generally parallel vertical lines, most of which seem to hang from the upper horizontal line (Figure 10.6A). The final example of graffiti within the corridor is 108 cm further south. It measures 11.5 cm tall by 5 cm wide, and is 42 cm above the corridor floor. It resembles a constricted hourglass, consisting of two cup-shaped elements connected by a single incised line (Figure 10.6F). The incisions that produced this design were unusually deep, up to 2.5 mm or 3 mm in places. The location of these last two images near the floor suggests the artist was crouched or squatting when they were executed.

The corridor at the upper end of the side staircase was a secluded part of the Mound of the Columns that was also likely poorly lighted due to the roofing that covered the staircase and possibly the corridor. The near-hidden staircase, which was used by the support population that served the ruler—and possibly by the ruler himself—in lieu of the "front door," was also likely

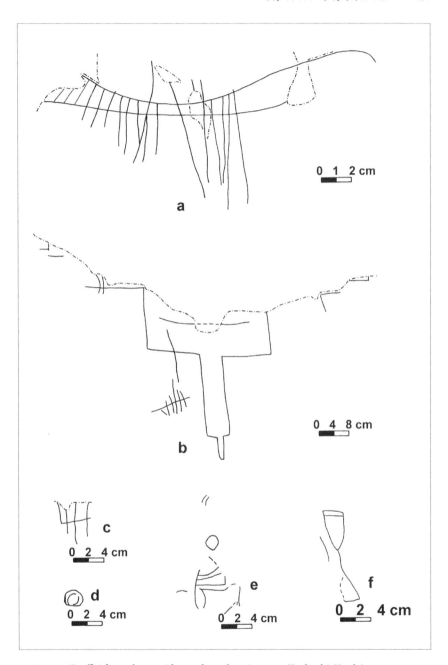

FIGURE 10.6 Graffiti from the corridor and south staircase at Taukachi-Konkán.
(a) Ladder-like abstract band. (b) Inverted stepped pyramid form. (c) Geometric
design. (d) Possible eye. (e) Possible human figure. (f) Hourglass shape. Dot-dash lines
show limits of wall plaster.

used by the artist(s) to gain access to the mound summit and leave their marks on the corridor wall. Like the south entry court, the corridor/staircase area was also in active use when it was marked by numerous examples of graffiti that may reflect several artists and/or several occasions.

Early Horizon Graffiti at Bahía Seca

The site of Bahía Seca was one of three coastal satellites established by the Sechín Alto Polity to ensure a supply of vital marine protein (Figure 10.1). These satellites, likely administered by Bahía Seca, provided fish and shellfish to inland polity sites in exchange for agricultural products. This particular site contains an intermediate-sized mound with a square-room unit at its center (Pozorski and Pozorski 1992); this key architectural form symbolized and implemented control by the Sechín Alto Polity.

The Sechín Alto Polity declined about 1300 BCE, probably due to a combination of internal strife and an El Niño event that affected its subsistence base. Nevertheless, the impact of the polity on Casma Valley society was profound, and its legacy continued to influence local cultural developments centuries after the polity declined (Canuto and Andrews 2008). This was clearly manifested during the Early Horizon (1000–200 BCE), a time of considerable cultural change within the valley. The massive mound/plaza complexes of the Initial Period were replaced by villages with agglutinated complexes of small platforms and associated courtyards. New ceramic types appeared that are much more abundantly represented, and maize and domesticated camelids were added to the diet. Significantly, in response to its Initial Period legacy, key Sechín Alto Polity sites were reoccupied. Early Horizon people built a small town on the surface of the main Sechín Alto site mound, the former administrative center of the polity. They began this process by intentionally destroying both the colonnade of friezes at the mound center and a 50-meter by 10-meter expanse of friezes that adorned the east wall of the central room of the mound. They then tore apart much of the remaining architecture to level the mound surface and also for use as construction materials in their own buildings. The coastal satellite of Bahía Seca was also reoccupied during the Early Horizon, and the sample of graffiti there pertains to this time period. The Early Horizon use of Bahía Seca for residential purposes is documented by intrusive hearths, ceramics, and makeshift walls.

The Early Horizon graffiti at Bahía Seca are located on the front of the intermediate-sized mound near the corner of the atrium that leads into the central square-room unit. The images cover a relatively large area, 53 cm tall by 73.5 cm wide. Many of the incised lines seem abstract, but the eastern por-

tion of the graffiti seems to depict a bird with spread wings or possible seated human form (Figure 10.7). The center of this image is about 32 cm above the floor; this low location on the wall may indicate that the artist was crouching when drawing the image. However, in this case it may also relate to the preserved height of the wall plaster. Today, the wall plaster is only preserved to a maximum height of 65 cm, and it may have been significantly eroded when the images were incised into it.

Like much of the graffiti documented at Sechín Alto and Taukachi-Konkán, the Bahía Seca graffiti are located near a square-room unit, likely reflecting the artist's intention to express resistance by defacing this key power symbol of the earlier Sechín Alto Polity. However, the location of the Early Horizon graffiti at Bahía Seca is much more public, reflecting the fact that by this time, the Sechín Alto Polity had declined, leaving key power-symbol structures accessible and paving the way for graffiti to more publicly deface the memory of the polity.

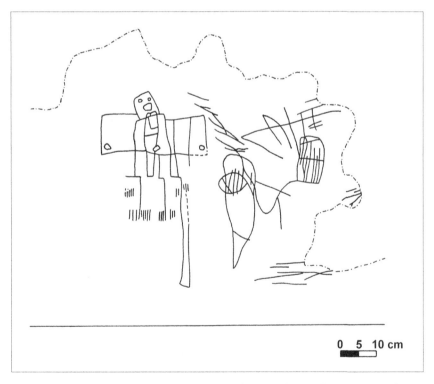

0 5 10 cm

FIGURE 10.7 Graffiti from the facade of the intermediate-sized mound at Bahía Seca depicting a possible bird or seated human figure. Dot-dash lines show limits of wall plaster.

Conclusions

In this chapter we attempt to assess examples of prehistoric graffiti executed on the walls of public buildings within the Casma Valley of Peru. Despite the small sample size, the poor preservation of some images, and the preliterate nature of the societies under study, it has been possible to analyze the graffiti based on their content and especially their context and to argue that their underlying motivation was resistance to authority. The graffiti under study have been reliably assigned to specific prehistoric time periods: the Initial Period (2100–1000 BCE) and Early Horizon (1000–200 BCE). Some images can also be connected to the limited sample of contemporary iconography: the pendant pupil and divided face (Figures 10.2b and 10.3) in examples of graffiti from the Sechín Alto site main mound are the best examples of this, and may suggest some uniformity in visual language. Considering the total sample of graffiti, additional consistencies may be significant, such as the presence of similar parallel and crossed lines, characterized by pairs of parallel lines with pendant cross-pieces or streamers from graffiti at the Sechín Alto site and Taukachi-Konkán (Figures 10.4 and 10.6a). These two sites seem to share traits, and there are images from all three sites excavated that consist of patches of criss-crossed lines (Figures 10.2a, 10.6b, 10.6c, and 10.7). These criss-crossed lines appear to transcend time because they are present in both the Initial Period and Early Horizon. They may be schematic diagrams of the carefully planned, regularly laid-out architecture that characterized the Sechín Alto Polity and were preferred targets for graffiti.

The broader context of the Casma Valley sample of graffiti in both space and time is especially relevant to issues discussed in this volume. Initial Period examples tend to be in obscure locations and were likely made by individuals who were trespassing and even hiding when they penetrated into the innermost areas of monumental architecture where access was strictly monitored and controlled. Working behind columns and in the shadowy areas of Sechín Alto Polity monumental architecture, sometimes standing and other times crouching, they carved their mark on wall faces near square-room units which symbolized polity power and comprised the administrative heart of the polity. While doing so they also targeted two of the largest and most significant monuments of the polity: the Sechín Alto site main mound, analogous to the U.S. Capitol building, and the Mound of the Columns at Taukachi-Konkán, the polity equivalent of the White House. Graffiti at another Sechín Alto polity site also seem to have targeted architecture containing square-room units. At Sechín Bajo, graffiti were found along the rear side of the earliest Initial Period mound structure that contains a central square-room unit

(Fuchs et al. 2006). Based on these data, it seems likely that examples of Initial Period graffiti provide tangible evidence of undercurrents of resistance to the heavy-handed administration of the Sechín Alto Polity as symbolized by square-room-unit architecture. Such evidence attests to significant opposing factions even while the polity seemed to flourish, and the presence of sealed-in graffiti associated with the penultimate construction phase attests to the time depth of this opposition.

Centuries later, negative social memories connected with the Sechín Alto Polity persisted; they were manifested on a grand scale by the Early Horizon peoples' efforts to erase remnants of polity iconography and literally dismantle and recycle its administrative center. Negative social memories played out on a smaller scale in the form of Early Horizon reoccupation and graffiti at Bahía Seca, the administrative node among the coastal sites dedicated to marine resource procurement. By this time, however, "resistance" was much more overt because the administrative structure had been downgraded to serve a residential function, the artist no longer needed to hide, and the associated graffiti could be prominently displayed on the building's façade (see Lennon's analysis of Tahrir Square graffiti as a form of overt resistance to political power in this volume). Nevertheless, even after centuries, the targets were still the "capitol building" at the largest site and square-room-unit architecture at the key satellite site.

A Sub-Rosa Narrative: Graffiti from Room 9, Structure 5D-65, in Tikal, Guatemala

ELIZABETH OLTON

The historical efficacy of ancient Maya graffiti and the agency of the writers/artists become a tantalizing subject when these images are approached as an alternative to state-sponsored visual culture. A close examination of these markings suggests they are components of a codified form of expression that should be read and interpreted like other forms of visual texts. Ancient Maya graffiti can be understood in various ways: as an archive of events, practice sketches of artists, drawings by children, fantastic markings inspired by hallucinogenic trance or, as I propose here, evidence of a politically transgressive commentary. Graffiti emerge then as a sub-rosa form of expression bound by different rules than that of official Maya imagery or inscriptions. By subverting canonical forms of communication, either through form, subject, or context, these seemingly "arcane" visual narratives become a valuable resource for today's scholars. Graffiti should be considered an artistic genre, equal to ancient Maya architecture, sculpture, epigraphy, mural painting, ceramics, and the lapidary arts. When carefully studied, these informal texts are representative of an ancient voice heretofore unknown or ignored by Maya scholarship.

J. Eric Thompson described ancient Maya graffiti as "doodlings of bored or inattentive novices" (1954, 25). His is an easy assessment when one casually glances at these scenes. Maya graffiti are usually found clustered together and include recognizable depictions of courtly life, enlivened by linear "stick-like" figures that, upon first glance, appear to be the work of "unschooled" artists. The figures are simplified, but the artist's understanding of seventh- and eighth-century Maya poses, gestures, costume, and environments animates them. The graffiti reflect a familiarity with elite life and tradition. These

Understanding Graffiti edited by Troy Lovata & Elizabeth Olton, 159–175. © 2015 Taylor & Francis. All rights reserved.

representations may have served as a commentary on people or places or, more pointedly, as a form of horizontal communication and criticism among elites.

Investigating ancient Maya graffiti is an outgrowth of my research on the carved lintels inside Temple 1, ca. 734 CE Tikal, in the Peten region of Guatemala (Figure 11.1; Olton 2010, 2015). Temple 1 is the burial monument of Ruler Jasaw Chan K'awiil, who reigned over the city from 682 to 734 CE (Simon and Grube 2007). Three wooden lintels span the interior passage of Temple 1's superstructure. Two of the lintels are intricately carved with hieroglyphic inscriptions and include two different yet equally authoritative portraits of the ruler Jasaw. The composition and decorative details of Lintel 3, which spans Doorway 3 of the superstructure, part of the Tikal state narrative, are striking in their similarity to a series of graffiti from Room 9 of Structure 5D-65, a building located in the Central Acropolis, a multiuse compound adjacent to Temple 1 and the Great Plaza (Figure 11.2). By comparing and contrasting the portrait of Jasaw from Lintel 3 with graffiti from Room 9 of Structure 5D-65, I will explore visual evidence that suggests the presence of an independent and subversive voice at Tikal in the seventh and eighth centuries. This particular voice was preserved not in cut stone or bas-relief inscriptions but in loosely sketched drawings incised on the plaster walls inside an elite sanctuary.

Ancient Maya political authority was based on a hereditary elite class. This dynamic of families and intercity alliances is depicted in the surviving public texts and images. The many polities comprising Classic period Maya society are bounded by a geography composed of competing city-states (Coe and Houston 2015; Miller and O'Neil 2014; Sharer and Traxler 2005; Simon and Grube 2008). The visual arts, hieroglyphic inscriptions, complex stone architecture, and the environment of open plazas reveal a culture of elaborate histories, myths, and pageantry (Miller and Martin 2004; Schele and Mathews 1998). Inscriptions tell us of a political system populated by the ruler, an elite class, attendants, and valued captives. A ruler's full title, which denoted his dynastic line and named important captives under his control, emphasized his elevated status. His title, image, and additional inscriptions combined to define the ruler as a divine king descending from deities and possessing special powers (Coe and Houston 2015; Miller and O'Neil 2014;

FIGURE 11.1 (opposite) Lintel 3, Temple 1 superstructure interior, Tikal, Guatemala, ca. 750 CE. Reproduced from Adams and Trik, Tikal Report 7. Courtesy of the University of Penn Museum.

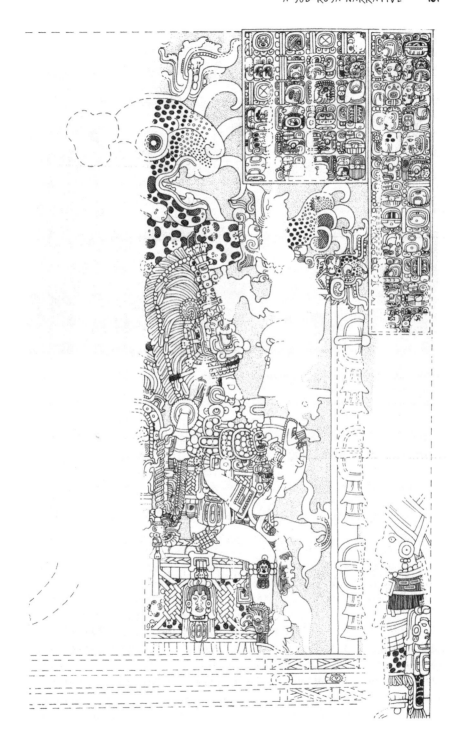

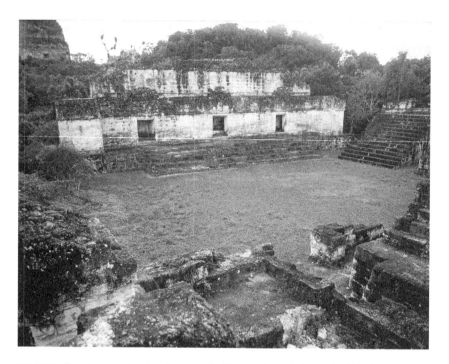

FIGURE 11.2 Structure 5D-65, view from inside Plaza 2, Central Acropolis, Tikal, Guate-ma-la, ca. mid- to late seventh century CE. Courtesy of Jorge Pérez de Lara from Mesoweb.

Schele and Mathews 1998; Simon and Grube 2008). Equivocal expressions about the ruler and his family, in texts or visual narrative, are rare or nonexistent. Hidden or oblique forms of criticism or satire have not been identified, but scholars have not sought them out. The possibility that the graffiti from Room 9 of Structure 5D-65 functioned as an archive of witnessed events—and may also be politically transgressive—is intriguing.

Prior to the analyses of Maya graffiti published by Helen Webster, Helen Trik, and Michael Kampen in the 1960s, 1970s, and 1980s, it was assumed that the graffiti were created by unskilled people, perhaps squatters living in Maya buildings after the collapse in the ninth century CE. The unschooled and seemingly disorganized views of courtly life, landscape, ritual, and architecture were deemed inferior and thought to have had no relation to the art of the Classic period. Scholars have interpreted these unconventional images as subpar markings (Kampen 1978) or the visual narratives of hallucinogenic expression (Haviland and Haviland 1995). More recently, Scott Hutson examined a select group of graffiti from the Central Acropolis complex and compared the style of lines, composition, and scale to children's art (2011).

He distinguishes unskilled graffiti, presumably the work of young artists, and skilled graffiti, presumably drawn by experts (2011, 417–423). *Los Grafitos Mayas* (Lorenzo and Cosme 2009), an edited volume from the University of Valencia, Spain, contains new questions and fresh interpretations that complicate our readings of ancient Maya graffiti, its contexts, and audiences.

One of the first scholars to closely look at the graffiti from Tikal was Helen Webster (1963), who wrote a short article for *Expedition* magazine, a journal published by the University of Pennsylvania Museum. In it she observes that these images could be depicting the world as seen and interpreted by the writers/artists. This uncomplicated yet observant interpretation is, for me, an exciting reading of these images because it considers the possibility that the graffiti express a point of view arising from the writers'/artists' contemporaneous observation. In 1998, Linda Schele and Peter Mathews also considered the graffiti from the Central Acropolis as a type of witnessing. Both Webster (1963) and Schele and Mathews (1998) regarded these sketchy marks as quick drawings reflecting events seen in Maya elite society. My work is inspired by many of their interpretations. Tikal has a large number of graffiti, most of which share repeated themes and subjects, found in private, interior, spaces. *The Graffiti of Tikal, Tikal Report #31* (Trik and Kampen 1983) has been immensely valuable to my research because Trik and Kampen have carefully redrawn and documented the graffiti from Tikal. The images are centered on court life, depicting the pageantry (processions, public ritual, ball games, and executions), architecture, and the spaces of performance. Some graffiti appear more abstract, while others consist of enigmatic portraits and

FIGURE 11.3 Drawing of an elite male figure seated on a bench; detail of graffito from south wall of Room 9, Structure 5D-65. Image reproduced from Trik and Kampen, Tikal Report 31 (Figure 75). Courtesy of the University of Penn Museum.

imagery of nature (Figure 11.3). The graffiti's diverse and animated subjects, together with a sketchy, linear style, suggest the writers/artists were depicting informal scenes of everyday elite life. The graffiti might have served to document, archive, and interpret witnessed experiences.

In contrast to most public or state-sponsored imagery from the seventh and eighth centuries, ancient Maya graffiti are almost exclusively found in private or tightly controlled environments. The graffiti are usually carved in the walls of palaces or range structures or found in the superstructures of temple-pyramids.The imagery was incised into thick plaster walls using a sharp instrument. Structure 5D-65 is one of a number of range structures in the Central Acropolis, but it is different in that it has an unusually large number of graffiti incised on its interior walls. Like other range structures, it is a multiroom structure, with a second story. Its appearance as a large, horizontal mass is defined by a low and wide foundation platform with laterally placed porches, accessed by stairways and accentuated by ribbons of doors and windows. Range structures are human in scale and distinctly social, as these "palaces" are arranged in groups with stairs and porches open to a shared plaza.

Structure 5D-65 is known as Maler's Palace, from Teobert Maler, a late nineteenth/early twentieth-century explorer and photographer who lived in the building during his tenure at Tikal. Maler was likely inspired by the graffiti that decorated the rooms of the structure when he incised his own moniker on an interior wall along with the dates of his residency. According to archaeologist Peter Harrison, Structure 5D-65 was built in the late eighth or very early ninth century. Maler's Palace was a later addition to the Central Acropolis complex, and its period of use was likely short because the demise of the Classic period at Tikal began during the ninth century (Martin and Grube 2008, 53). The structure belongs to Harrison's "Category 1" class of range structures, the most complex of range structures. How these structures functioned during the seventh and eighth centuries is debatable. Their design and style remain relatively consistent among cities in the Maya lowlands throughout the Classic period. Painted imagery from polychrome vessels depicting court scenes reveal an environment that was both public and private. The term *elite sanctuary* is a more neutral descriptor of these multiuse structures; I use this term for the remainder of this chapter.

Structure 5D-65 consists of a singularly large and elevated manmade platform mound not characteristic of other palace structures in the Central Acropolis (Harrison 1999, 172). The structure includes a main front stair, several windows, interior niches, and rooms with masonry benches. Room 9 is immediately adjacent to the central room, which was publically accessed by

the main stair. The bench in Room 9 is covered with graffiti (Harrison 1970, 94–15, 120, 122, 125, 170). Lively scenes of court life are scratched on three walls of the room surrounding its bench (Schele and Mathews 1998, 91). The inclusion of a bench in the room might indicate a more intimate setting, and its placement afforded a closer viewing of the graffiti clusters' imagery.

The graffiti imagery was likely drawn quickly using an abbreviated calligraphic style. The gestural style suggests a relation to a performance rather than an intellectual exercise in public narrative and aesthetics. Modern viewers tend to think these clusters of scenes lack a sense of thoughtful composition. Spatial relationships and scale are unclear, confounding our reading of and appreciation for this informal imagery. These elements of design are hallmarks of traditional western art and Maya canonical imagery. But graffiti (ancient and modern) deemphasizes western notions of composition, scale, and depictions of space. The comparison of graffiti with coeval Maya sculpture and painting usually requires a different set of criteria. A set of graffiti in Room 9, however, uses these visual elements of composition, scale, and space to depict a repeated motif, well known in ancient Maya art as the Ruler and Protector theme (a visual motif reproduced at a select number of ancient Maya cities), while also creating an atypical portrait of the ruler.

A distinctly dramatic and unmistakable version of the Ruler and Protector theme is carved on the underside of Lintel 3 in the superstructure of Temple 1. This imagery typifies the Classic Maya–period canonical portrait. Jasaw the ruler is depicted as a symbol of divine rule as well as a man with gravitas. Jasaw is portrayed seated and in profile, a pose that emphasizes the details of his heavily encrusted costume. A large supernatural feline, also in profile, looms over the ruler, working as a visual foil that protects and frames him. The jaguar is in an offensive posture, standing on hind legs while its two front legs reach out with claws bared. Its mouth is open in a snarl. The creature lunges like a man while attacking like a giant feline. The Ruler and Protector theme in the graffiti from Room 9 depicts variations of the enthroned ruler and his anthropomorphized protector. When the composition from Lintel 3 is compared with the graffiti in Room 9, the looming jaguar figure becomes an increasingly complex and visually jarring motif.

The scene in Lintel 3 from Temple 1 and the graffiti in Room 9 share the same subject, the Ruler and Protector theme. The artistry in the lintel scene is not reproduced in the graffiti from Room 9, which consists of a series of sketchy images. However, while the lintel scene and the graffiti share a well-known motif, the graffiti in Room 9 reinterpret it. The graffiti are abbreviated vignettes, including only the essential elements of the Ruler and Protector theme. This includes profile depictions of the seated Ruler and of the looming

jaguar Protector, a Ruler adorned in familiar yet simplified costume elements, and varying types of human/feline attributes in the Protector. The Ruler and Protector theme was seen elsewhere at Tikal during the Classic period; it was likely a familiar sign for an elite audience.

Room 9's interpretations of the Ruler and Protector theme are incised in the plaster of its north, south, and east, or center, walls. The first image, on the north wall, depicts the seated ruler and an elevated architectural structure (Figure 11.4). Imagery beneath the elevated structure suggests the scene is organized in loose registers depicting possibly related narratives. A sense of depth within a lively narrative scene is indicated by the presence of a possible ground line, which provides a rare sense of receding space on a two-dimensional plane. Ancillary characters add to the impression that this is a depiction of a ceremony in the landscape.

Two figures are depicted on the elevated structure from the north wall. The larger figure stands above and frames the figure of a man seated on a stool marked with an "X" design (Figure 11.5). Compared with the looming figure behind him, the seated person appears diminutive. The two figures are proportionally dissimilar, but they share similar poses. Their arms are

FIGURE 11.4 Section of north wall, Room 9, Structure 5D-65, with Ruler and Protector theme. Image reproduced from Trik and Kampen, Tikal Report 31 (Figure 71). Courtesy of the University of Penn Museum.

FIGURE 11.5 Detail of Ruler and Protector theme from the north wall of Room 9, Structure 5D-65. Image reproduced from Trik and Kampen, Tikal Report 31 (Figure 71). Courtesy of the University of Penn Museum.

outstretched and rest on vertical supports. The support for the Protector's arms appears to be more substantial and is marked by a bolder line than the ruler's support. Both figures are depicted in profile; facing to the left of the graffiti's audience, their gazes are focused in the same direction. The larger figure is spotted, his eyes are large, his mouth is open, and he has long feline whiskers. The small, seated person is a little man with no distinguishing physical features or costume detail. He appears to be a generic Maya elite person with just a hint of cranial deformation.[1] Given the close integration of the large feline Protector standing over the small, seated Ruler, the Ruler and his Protector look more like a unified whole than two distinct figures. The small figure of the seated Ruler is tucked under the large body of the standing feline as if the ruler is vulnerable, in need of support and protection, rather than as a powerful leader.

Three additional representations of the Ruler and Protector theme appear on Room 9's east wall. Together they form a loose circular grouping (Figure 11.6). Viewed as a collective narrative scene, these three images of the Ruler and Protector might be depicting an event witnessed by the artist and reinterpreted on the east wall. The depictions provide a closer view of the scene, while the adjacent image on the north wall appears to place the ceremony within a landscape. As with the figures on the north wall, the east wall's images convey a sense of spatial depth, with the inclusion of figures participating in the same events that surround the Ruler and his Protector.

The Ruler and Protector composition on the left side of the circular grouping includes a stepped, temporary platform in the process of being paraded or moved by two small figures standing beneath and to the rear of the platform, apparently carrying the large structure on or above their shoulders.

FIGURE II.6 Clustering of three Ruler and Protector themes from the east wall of Room 9, Structure 5D-65. Image reproduced from Trik and Kampen, Tikal Report 31 (Figure 72). Courtesy of the University of Penn Museum.

The Protector is anthropomorphized; he appears unambiguously human, with the physiognomy of a robust Maya elite male. He has a prominent nose, protruding chin, an open mouth, and a rotund belly. He is adorned with a double-curl headpiece, earflares, and belt. The diminutive figure of the Ruler, seated on a stool marked with an "X" design, wears a huge spiked headdress (presumably feathers) that serves as a focal point overshadowing his small, childlike body. As with the Ruler/Protector depiction on the north wall, the proportional dissimilarity of the two figures in this composition is striking. As with the figures on the north wall, the two figures in this composition are posed similarly: their arms are outstretched and rest on vertical supports, their two gazes focused in the same direction, to the left. And, as on the north wall, the vertical support for the Protector's arm in this composition is more substantial and much more conspicuous (it is cross-hatched) than the support for the Ruler's arms.

The middle composition of the circular grouping depicts a similar platform structure and associated stairs. The scene, however, sharply contrasts with the other depictions because of a distinctive lack of detail. The feline Protector figure is emphasized at the expense of the Ruler. The Protector is shown with a double-curl headpiece, large protruding ears, a snout, whiskers, an open mouth, and a tail-like motif at his rear. There are no spots or earflares. His arm is extended to a vertical support marked by several diagonal incisions. The diminutive figure of the seated Ruler, in contrast, is barely recognizable, as if the drawing is incomplete, with only the remnants of a stool (devoid of the "X" design), arms (extended to an unmarked vertical support), and legs apparent to the viewer. Compositionally, the artist used the same postures seen in previous depictions of the Ruler and Protector: both the figures face left, their outstretched arms resting on vertical supports. The Protector figure, however, is depicted more substantially and conspicuously.

The final image in this triad, on the right side of the circular grouping, is equally fascinating. Like the middle scene, it lacks detail. The temporary structure, shown as a rectangular form, is not elevated, and there are no stairs. The Protector figure is depicted unambiguously as human; he continues to stand, facing left, and his arm rests on an unmarked vertical support. The stool is marked with the "X" design but the stool, previously associated with the Ruler, is unoccupied. A small figure, also facing left, is to the left of the empty stool, standing or in the act of stepping off the rectangular form. The small figure itself is ambiguous; he might be an attendant of the Ruler or the Ruler himself. The unoccupied stool, with its double frame and "X" design, heightens the ambiguity. The visual uncertainty signaled by the empty stool and the diminutive figure appears in stark contrast with the Protector figure, who is drawn with a strong line and organized in a clear composition.

All three scenes on the east wall depict the Protector in the same position: standing above and behind the diminutive figure of the Ruler. In two of the scenes, the Protector figure is human; in the third scene he is feline. While each Protector has been individualized in various details, the figures of the Protector are compositionally consistent. Because of the codified composition and the scale and placement of the Protector figures in relation to the Ruler figures, we read the figures as part of the well-known Ruler and Protector motif. In contrast, the diminutive figures of the Ruler are inconsistent. In the left scene, he wears an outsized spiked headdress larger than his body; in the middle scene, he is only partly visible; and in the right scene, he is shown exiting the platform. All three scenes depict the Ruler ambiguously relative to the Protector, the essential fierce nature and dominant visual tone of which remain unchanged.

Room 9's south wall includes another clustering of incised imagery depicting the Ruler and Protector motif. These images, however, are less clear than the imagery on the north and east walls (Figure 11.7). The missing areas of the narrative might be a result of a lack of preservation of the incised imagery, or less care or pressure by the artist in making their incisions on the plaster walls. A looming feline Protector figure is in the middle of the program (Figure 11.8). The composition, scale, posture, and the feline's tail are similar to that of the middle figure from the circular grouping on the east wall. The belt and vertical support for this Protector figure are prominently cross-hatched like the belt and support for the anthropomorphic Protector figure on the left of the east wall's grouping. Once again, the figure of the Ruler is strikingly diminutive; it is barely visible at the base of the scene, sitting on a stool bearing the "X" design. Another Protector figure is incised on the

FIGURE 11.7 Clustering of two Ruler and Protector themes from the south wall of Room 9, Structure 5D-65. Image reproduced from Trik and Kampen, Tikal Report 31 (Figure 73). Courtesy of the University of Penn Museum.

south wall to the right. Like the middle and left Protector figures from the east wall, this figure, which is human, wears a double-curl headpiece (Figure 11.9). In this example, the Ruler is completely missing and the platform is referenced only by the Protector's outstretched arm resting on a cross-hatched vertical support.

Official Maya art presents the Ruler as charismatic, authoritative, and powerful. The Ruler and Protector motif depicts the Ruler nestled within the body of his looming Protector. The form, volume, and posture of the Ruler's body, his facial expressions and costume, and his compositional dominance within a scene signal his power. But the Ruler/Protector images recorded in Room 9's graffiti are conspicuously different. The graffiti on the east and south walls, and the middle graffito of the south wall's program, reconfigure the Ruler and Protector motif by deemphasizing the Ruler. This de-emphasis is seen in changes in scale between the Ruler and Protector figures. The graffiti in Room 9 exaggerate the size of the Protector figure relative to the Ruler figure. With its disproportionate size, the Protector in

FIGURE 11.8 Detail of central feline Protector with Ruler from the south wall of Room 9, Structure 5D-65. Image reproduced from Trik and Kampen, Tikal Report 31 (Figure 73). Courtesy of the University of Penn Museum.

FIGURE 11.9 Detail of top right human Protector from the south wall of Room 9, Structure 5D-65. Image reproduced from Trik and Kampen, Tikal Report 31 (Figure 73). Courtesy of the University of Penn Museum.

Room 9's graffito appears more like a giant rather than a supernatural royal companion. The commensurate diminution of the Ruler figure is even more striking. The diminutive Ruler figure on the walls of Room 9 does not fit into the standard visual motif of a powerful and authoritative ruler. When the ruler is present in the graffiti, he is diminished in the Protector's presence and altogether lacks stature. And when the Ruler is absent from the scene, the viewer's focus moves easily to other characters in the narrative, as his absence is not missed. The north wall's graffito of the feline Protector/diminutive Ruler more closely resembles official representations of the Ruler and Protector motif, but even here, by virtue of his disproportionate scale, looming posture, fierce facial expression, and details of costume, the figure of the feline Protector dominates the scene. Compared with official images of the Ruler and Protector theme, which emphasize the Ruler's power and authority, the images of the Ruler in the graffiti of Room 9 are visually jarring and even humorous. These features, combined with the informality of the graffiti form, suggest the images were created and read as sub-rosa—subversive or satirical— narratives rather than as state-sanctioned representations. To dismiss these features, common to the graffiti scratched into the plaster of Room 9's walls, as practice drawings of novices, bored doodlings, or the works of hallucino-

genic trance, risks overlooking the possibility that these images served as a critical commentary for a contemporaneous audience.

The portrayal of the Ruler Jasaw in the far more detailed, carved imagery of Temple 1's Lintel 3 depicts the Ruler and Protector motif seen in Room 9, but without any of the ambiguity observed in Room 9's portrayals (Figure 11.1). Lintel 3's Protector figure looms behind the proportionately sized Ruler like an oversized jaguar; its mouth is open, as if growling. It stands on its hind legs while reaching out to grasp the railing of the structure, its claws exposed. In contrast, the feline Protector from Room 9 is shown in a more anthropomorphic mode, or as an elite human. The Ruler appears magisterial, certainly unlike the diminutive figure shown in the graffiti. In Lintel 3, the Ruler is adorned with a many-layered feather headpiece; he sits on an elaborate woven throne/stool. Like the graffiti depictions, he is oriented in the same direction as the jaguar Protector, but faces to the right of the lintel's audience, unlike the graffiti images, which face to the left. Unlike the Ruler shown in the graffiti, Lintel 3's Ruler holds a scepter rather than merely resting his arm passively on a vertical support. The lintel includes an additional figure in the form of a small man or dwarf that is absent from the graffiti. This figure stands opposite the Ruler, facing toward him, further accentuating the Ruler's presence.

The artists of both the carved lintel and the graffiti use the formal compositional elements of proportion and scale to communicate status and identity. Lintel 3's jaguar Protector is a supernatural feline, while the graffiti Protector figure is drawn like an oversized, costumed man-feline. The motionless serenity, gravitas, and ostentatious accoutrements of Lintel 3's Ruler are characteristic of official portraits of Jasaw Chan K'awiil. The graffiti's Ruler images portray none of these characteristics. The images are, instead, patently unroyal. The Ruler's proportions and stature can be read as a miniature-man cartoon rather than a divine leader. Accoutrements marking the Ruler's status in the graffiti lack detail, while features of the physiognomy, costume, and headgear of the Protector are readily comprehended. The graffiti's diminution of the Ruler (or depiction of his absence entirely) is unusual in Maya imagery. The visual evidence of the graffiti's informal images compared with official and laudatory portraits of the Ruler and Protector depicted in Lintel 3 suggests that a transgressive change of focus has occurred among the artists and visitors to the elite sanctuary, Room 9 of Structure 5D-65.

Exploring ancient Maya imagery that expresses a sub-rosa message is a difficult task. A state-sanctioned interpretation of history depicted on permanent materials is more accessible than interpretations recorded in fragile and informal media such as graffiti. These official narratives are interred with

kings, carved in durable stone or dense wood, depicted in frescoes, painted on ceramics, and modeled in lapidary pieces. The durability of these media suggests the narratives recorded in them were meant to speak to future generations as well as the contemporaneous generation. The incorporation of a message in a fragile medium such as graffiti incised on a plaster wall, in contrast, suggests the message was intended only for a contemporaneous audience. The graffito from Room 9 depicts a looming Protector figure that dominates the scene. The contemporaneous viewer would recognize the supernatural feline/man as a familiar element of the Ruler and Protector visual motif, and, at the same time, would experience the ambiguity of depicting the Ruler as miniaturized and doll-like. Maler first noticed these informal wall scenes and documented them. As his interpretations in the early twentieth century (1911, 56–62) show, the graffiti and their seemingly odd depictions disarmed and charmed him. Today, these graffiti and their context, including their placement in an elite sanctuary, challenge our assumptions about who the artist was and how these drawings may have functioned for the ancient Maya.

Writing about dissenting Greco-Roman elite graffiti and other forms of ancient marks, Alexi Zadorojnyi interprets wall inscriptions as a powerful tool of criticism for an influential minority (2010, 111–128). Zadorojnyi explores how "horizontal criticism" might have influenced political power. In a similar manner, the ancient Maya "bureaucratic" classes, far from being in fear of the ruling dynasty, might have voiced criticism of its authority through cartoonish depictions of the ruler. In contrast to Greco-Roman graffiti, these images on the walls from Room 9 are in private spaces. Rather than publicly stirring a viewer's emotions, these seemingly satirical images communicated dissent among the Tikal elite toward the ruler(s).

One might assume that graffiti critical of authority are the purview of marginalized classes or petty delinquents, a stereotype popularized by the "Broken Windows" social theory (see Mitman and Gopinath in this volume). Zadorojnyi notes that graffiti "makes a show of its problematic relationship towards the physical and semiotic complexion of the surface it is written on" (2011, 110). Thus it can be labeled both as a form of defacement and as commentary of authority. From this vantage point, the examples of graffiti at Tikal, found in an elite sanctuary and surrounded by a privileged space of wall niches, windows, and masonry benches, may be considered as a more serious criticism of authority. Placing these insubordinate images within an elite environment might have operated as a warning to the ruler from his privileged subjects. As a form of horizontal commentary, the scratches from

Room 9 potentially were more powerful than if they had been scratched on the walls of a public building.

Documentation of the incised drawings from Structure 5D-65 and the other graffiti from Tikal, dating from the Late Classic period (700–800 CE), is poor when it is not absent. The absence of a close examination of these sub rosa narratives reflects our prejudice as to the value of unofficial scratches. Unquestionably these images lack the artistry and attention to detail and composition seen in the official canonical works of Tikal, but if our goal as scholars and Mayanists is to learn more from this complex society, these informal images are worth examining. Imagery and art are texts to be translated and deciphered as visual language. These expressions memorialized in the graffiti of Room 9 belong to a larger genre of image-making that is both global and ancient. Today, Room 9's graffiti are in danger of erasure, not because they offend or have marred the surface of the plaster, but because of mold and vegetative growth that have obscured the imagery (Jeanette Favrot Peterson, personal communication, 2014). My hope is that renewed interest in ancient Maya graffiti will inspire a more robust conversation about the preservation of these vulnerable yet significant cultural expressions.

Careful study of the graffiti incised on the walls of Room 9 of Structure 5D-65, including its dating, offers a promising avenue for problematizing the politics of Late Classic Maya society. The bulk of Maya art and architecture glorifies the ruler and his dynasty. Evidence of an alternative, or transgressive, voice at best is fleeting or disguised. Read as an aggregate statement, the group of drawings from Room 9 suggests an interpretation of the Ruler and Protector theme that upsets the state narrative depicted in Temple 1's Lintel 3. The graffiti should be re-examined in relation to and as a foil of the official narrative. For art historians, the linkage between form, subject, and context comes together when we ask new questions of these works and consider their unschooled style as a possibly significant aspect of their function and performative nature. These questions inevitably will complicate the role of artist and critic within the highly developed society of Classic period Maya and especially the culture of seventh- and eighth-century Tikal.

CHAPTER 12

Inside the Tunnels, Inside the Protests: The Artistic Legacy of Anti-Nuclear Activists at a Nevada Peace Camp

COLLEEN M. BECK, LAUREN W. FALVEY, + HAROLD DROLLINGER

Introduction

Anti-nuclear protests are public actions of the nuclear disarmament movement, a social campaign that reached its apex during the Cold War in the latter half of the twentieth century. Whether in the United States or elsewhere, activists would carry placards and chant slogans as they marched to or gathered at a location, usually a government building or facility that had ties to nuclear testing and policy. The Nevada Test Site, 65 miles northwest of Las Vegas, was one of these facilities. In spite of its remote location, it became a focal point for anti-nuclear and pro-peace activists because it was the U.S. continental nuclear weapons testing ground. Over a span of 41 years (1951–1992), 100 atmospheric and 828 underground tests were conducted there.

Protests began at the Test Site in the mid- to late 1950s and increased in frequency and size over time, with at least 8,500 supporters at one event in the 1980s. More than 200 different national and international groups, including Native American tribes, were involved in these activities. Since the 1992 nuclear testing moratorium, the demonstrations have dwindled and now have dozens instead of thousands of participants. In the past and even today, the activists congregate near the Test Site at a place they named the Peace Camp.

While the activists' marches and chanting are a very public manifestation of their dissension with government policies, they also express their beliefs in a more private setting at the camp (public protest graffiti are also discussed by Lennon in this volume). Hidden from onlookers, they use the faces of two

Understanding Graffiti edited by Troy Lovata & Elizabeth Olton, 177–191. © 2015 Taylor & Francis. All rights reserved.

concrete highway drainage tunnels as a canvas for anti-nuclear and pro-peace sentiments. It is difficult to see into these drainage channels from the outside; the only way to view the inscriptions is to actually walk through the tunnels during daylight hours (see chapters by Meade, Pozorski and Pozorski, and Olton in this volume for hidden or more private expressions of protest or satire in graffiti). The natural and mostly indirect sunlight enters from the ends of the tunnels with no apparent correlation between the placement of panels and the fluctuations in sunlight. These graffiti are not a redundant presentation of the protest slogans used in public; instead, many of the inscriptions contain individualistic text and images created for display in this private setting. The personal nature and individuality of the graffiti add a new dimension to our understanding of the activists' concerns and goals.

Archaeological research at the Peace Camp developed as a corollary to nuclear testing archaeology. Desert Research Institute archaeologists have documented the vestiges of Cold War nuclear testing at the Nevada Test Site since 1991 (Beck 2002). The purpose of the Peace Camp archaeological project is to study a very different aspect of nuclear testing history, the material culture of those opposed to the Test Site activities. This camp was an integral part of the protest community's activities, but was enigmatic to those outside the protest community.

Over the past 12 years, archaeological research at the Peace Camp by the Desert Research Institute and the University of York has identified more than 900 features within 815 acres (Beck et al. 2009). This research revealed the existence of imagery and texts in the tunnels and, in their analysis, demonstrated the historic and contextual importance of Peace Camp graffiti painted in the tunnels. This location is the only preserved anti-nuclear and pro-peace camp in the United States and the associated unofficial imagery, made by the activists, is a testament to their personal and shared sentiments related to the anti-nuclear and peace protests during and after the Cold War. This study describes and analyzes the compositions in these tunnels and discusses their relationship to nuclear testing and politics as well as to the Peace Camp and the Nevada Test Site.

Historic Context

Following World War II, the United States conducted nuclear tests at the Pacific Proving Grounds in Micronesia until 1962 and at the Nevada Test Site from 1951 to 1992. The Cold War intensified as the United States, the Soviet Union, and others tested nuclear weapons in a world that lived under the constant threat of nuclear annihilation. Concurrent with escalating tensions

between the two superpowers was an increase in anti-nuclear and pro-peace protests, particularly at the Nevada Test Site. According to Futrell and Brents (2003), the anti-nuclear protest movement at the Test Site consisted of three phases: the Early Years (1957–1984), the Peak Years (1985–1994), and Post-Testing, with all demonstrations relatively peaceful and nonviolent. The first documented protest at the Test Site was held in 1957 by a newly formed organization, Non-Violent Action Against Nuclear Weapons (Bigelow 1959; Wittner 1997). In 1982 and 1983, a group of Christian organizers held the Lenten Experience, a six-week peace vigil. The success of these actions led to the development of a faith-based organization with prayer-based action for peace, called the Nevada Desert Experience, an organization that remains active today (Butigan 2003).

By the mid-1980s, the protests centered on the Test Site boundary and along the main road entering the Test Site. In August 1986, Art Casey, an anti-nuclear activist, began living full-time in the desert near the Test Site with support from his Catholic parish in San Diego. His presence became the basis for the establishment of the Peace Camp (Butigan 2003). At the camp, the protesters organized themselves and armed with professionally printed, stenciled, and handwritten signs conveying their points of view, marched together through a large highway underpass and congregated along the road, praying, chanting and, at times, obstructing the flow of traffic. During some demonstrations, they blocked the entrance to the Test Site and trespassed onto this restricted facility, resulting in their arrest.

The protests increased in frequency and size as activist groups became better organized and worldwide tensions increased. They were joined by the Western Shoshone National Council, who highlighted their claim to the Test Site land under the Ruby Valley Treaty and their concerns about the effects of testing on the health of their land and the planet. The Western Shoshone efforts eventually were organized under the Shundahai Network (Harney 1995). During this era, there were more than 500 demonstrations involving more than 37,000 participants from at least 200 national and international organizations, resulting in 15,740 arrests for trespass (Rogers 2002). Also, during the late 1980s, the protesters incorporated their dissent to a proposal to store nuclear waste on the Test Site into these demonstrations.

Since the 1992 nuclear testing moratorium, the demonstrators have continued to address concerns about the existence of nuclear weapons in the world and proposed nuclear waste disposal at the Test Site. Today, the protests are small and infrequent, usually corresponding to specific days of the year, such as Easter, Mother's Day, and the anniversaries of the bombings of Hiroshima and Nagasaki. This reduction in the number of protests and

activists at the Peace Camp is only to some extent reflected in the graffiti. Instead of the art in the tunnels becoming dormant and only a preserved legacy, new texts and images have been added in the past 20-some years along with much older inscriptions (see chapters by Rodriguez and Plesch in this volume for other examples of graffiti-based dialogues). Most of these contributions continue the themes of peace and Mother Earth with fewer references to nuclear testing. However, there also are several examples of graffiti made by people not aligned with the protest community that have obliterated or damaged some of the Peace Camp–related art with statements that contrast with the general themes of the protest art.

Setting and Research Methods

Activists use two drainage tunnels as a canvas for their sentiments and messages. These tunnels are large, reinforced concrete culverts, built to safely channel stormwater under the highway. The protesters call them "the tunnel": a form of this nomenclature is used here. The archaeological study of the imagery and accompanying testimonials, assertions, and declarations placed in the tunnels by the anti-nuclear and pro-peace activists is another phase of the ongoing archaeological research at the Peace Camp.

The tunnels run under a section of elevated highway about a quarter-mile from the large highway underpass used to access the Test Site's entrance. They are in alignment north to south, one for each direction of traffic above, with an open space between them. The tunnels provide the only permanent shade in this area, a welcome respite from the extreme desert weather, but were not used for habitation. Each tunnel is 65 feet long and 10 feet square. At the north end, the tunnels face the Nevada Test Site (now named the Nevada National Security Site) and a large expanse of desert with occasional Test Site structures, a runway, and the Mercury base camp in the distance. The boundary fence is 120 feet from the north end of the tunnels. On the south end, the tunnels open onto the Peace Camp with views across the desert terrain toward a low mountain range. Besides the Peace Camp and the Test Site, there are no other habitations or developments within 15 miles.

At the entrance to the tunnels, one cannot help but stop and look around in amazement at the abundance and eclectic nature of the images and texts lining the walls in such an unexpected place. The natural light is mostly indirect and is sufficient to easily view the imagery and text on the tunnel faces. Direct light enters and moves around the ends of the tunnels, shining on the floors and walls throughout the day in a pattern that changes with the seasons. However, there is no obvious relationship between the sunlight and the

placement of imagery and texts, indicating public view and visual perception of the art was not the goal. It is not known if the original graffiti began in the middle or the end of the tunnels, or how people initially chose the place for their messages.

Walking through the tunnels with protesters, they often point out inscriptions to which they have a strong connection. Sometimes this is their own legacy on the wall, but more often it is graffiti made by others that are tied to memories. There is a sense of their unspoken collective right to this space and how texts and images represent their values and beliefs. They have created this gallery of anti-nuclear and peace graffiti, hidden from the public eye, in a communal area shared with other activists. In our conversations with protesters, they indicate these inscriptions were placed in the tunnels as their personal and, hopefully, enduring messages.

Recently, we conducted a study of the graffiti in the south tunnel (Figure 12.1). The tunnel has six faces based on its structure: the front and back, the two sides, the floor, and the ceiling. These faces were then divided into measured sections for photography and recording purposes. Within each section, the written text and imagery were categorized as panels, some of which have multiple elements. For the analysis, the term "panel" is used for images and text that individually, or in combination, form a cohesive artistic or written statement based on composition, color, style, and technique. The

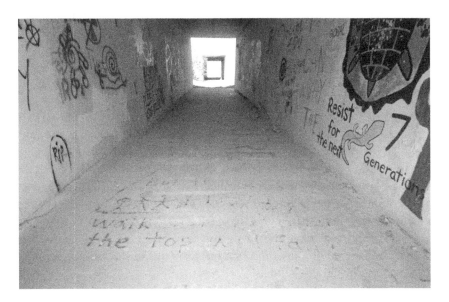

FIGURE 12.1 General view of tunnel interior. Photo by Keith Kolb.

panel designation is also applied to isolated images and text with no direct relationship to other panels. We divide the panels into three basic categories: 1) only text, 2) only imagery, and 3) combined imagery and text. These categories are then subdivided into types of images and types of text. Other data collected include the identification of the medium used to create each panel, along with the color(s), condition, and, when available, the date of the panel. Some panels include written dates; in a few instances, dates were obtained through interviews with those who witnessed their creation or knew the artist. Also, photographs from 2002 and 2005 are used for comparative purposes.

Most panels were clearly visible and easy to record; however, in some instances, several factors made the documentation process difficult. The tunnels have been used for more than 25 years and some of the panels have faded over time, especially those on the floors. Newer panels added over the years occasionally overlap and obscure older panels. On occasion, persons not affiliated with the protest movements have added text or symbols. For example, members of a motorcycle group wrote their group's name across panels in black spray paint; someone used black paint to place tagger's symbols on panels at random locations; and pro-Nazi comments and symbols were added to panels with black ink. The ends of the tunnels have been repeatedly repainted or whitewashed by government agencies intent on restoring a clean appearance. In the case of the motorcycle group's additions, activists repainted the area themselves to obliterate the unwanted contributions. Through enhanced photography, it was possible to see evidence of earlier panels beneath some of the repainted surfaces.

Results

We recorded 164 panels in the south tunnel. Most of the panels (n=151) are on the walls and floor: 51 on the west wall, 57 on the east wall, and 43 on the floor. Of the remaining 13 panels, six are located on the front (south face) of the tunnel, five are on the back (north face), and two are on the ceiling. In terms of presentation, there are 62 panels with text, 58 with images, and 44 with combined imagery and text. The panels range in size from 18 feet by 10 feet to 1 square inch. Sixteen panels had dates ranging from 1988 to 2013. This time span demonstrates the evolving character of the panels as images and text are added and obscured through the years due to the ongoing reuse of the Peace Camp and the tunnels.

A variety of media were used to apply the panels, such as chalk, charcoal, crayon, ink pen, paint, pencil, marker pen, Sharpie, spray paint, and, in one

case, a bumper sticker. No etchings are present. The majority were created with paint or spray paint, each used on one-third of the panels. Colors include various hues of black, blue, brown, metallic gold, green, orange, pink, purple, red, white, and yellow. Black, used alone on one-third of the panels, is the predominant color, with blue at 12% and red at 8%. There are 117 panels drawn with one color and 45 with between two and five color combinations.

The interesting aspect of these panels is their diversity. The individualistic nature of the artwork and the multiple artists involved over the almost three decades of use has created a variety of content and styles. Many panels include multivocal ideas, making it problematic to place them into thematic categories. For example, the content of some panels have text and/or imagery that reflect both anti-nuclear and pro-peace themes. Also, it is difficult to discern whether a statement about radiation or a symbol of radiation is a political statement, a personal statement, or another type of statement. Nuclear testing and radiation were pervasive themes throughout and underlie the greater abundance of compositions related to peace and protection of the environment. The tunnel's faces with such imagery and art look like eclectic murals not set up in any way by content, size, or application method. There is no overarching plan for the displays, only individual decisions through time in this space.

Texts

There are 62 panels in the tunnel that contain only text. Most text was printed using block letters rather than cursive script. Statements were written in sentence case, all uppercase, and a mix of both lower- and uppercase. Applied in most colors and media, but predominantly in black, the themes of the texts are diverse. "War is womb envy" presents a female view of violence; "This is nuclear fallout . . ." is incomplete in its intent. Some are positive, such as the statement, "Love Rules" spray-painted in red on the east wall of the tunnel. Others are declarative about what the person needs to express, such as, "Hiroshima day, 93. No more hibakasha" [*hibakusha* is the Japanese name for the survivors of the atomic bomb blasts]. The bombing of Hiroshima was a theme found on several other panels in this tunnel.

Quotations are striking because of their familiarity in this mix of personal and often unique sentiments. Barely visible beneath a painted-over surface is a Martin Luther King, Jr. quote. Another is attributed to Jerry Garcia of the Grateful Dead, and a third is the name of an anti-nuclear song by Flux of Pink Indians, a 1980s English anarcho-punk band. On the right side of Figure 12.2, it is possible to see the beginning of the words "Bad Brains," the

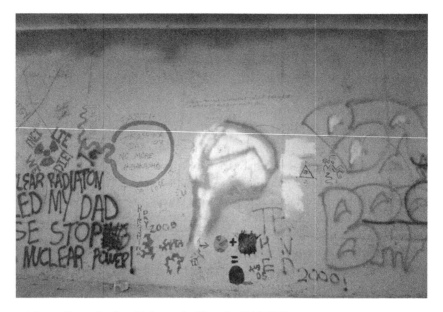

FIGURE 12.2 Example of multiple panels. Photo by Keith Kolb.

name of an American hardcore punk band from this era. Mottos or slogans include "Peace," "Shoshone homeland not waste land," "Nevada is not a wasteland," "Walk for the earth pray for healing," and "Food not bombs." Other texts contain a person's initials or signature and sometimes a date, such as "Mother's Day 2003." Fragments of indecipherable words and sentences remain in places where panels overlap or the walls have been partially repainted.

Images

In total, 102 panels contain images. Some panels consist of a single image; in others, multiple images or elements combine to create a single panel. Fifty-eight panels are only imagery, and 44 panels combine imagery and text. Types of images include anarchy symbols, a cactus, crosshatches, female Venus/nudes, handprints, a ladybug, a lizard, medicine wheels, Mother Earth, Nazi symbols, mushroom clouds, peace symbols, a rainbow, runes, a snake, spirals, a tortoise, trefoils (radiation symbols), and a white dove. Peace symbols are the most frequent, with 22 separate examples found in the tunnel. There are eight or fewer examples of all other types. Some images are grouped within a panel, such as nine handprints in one panel and

FIGURE 12.3 Part of a multicolor painting of the woman on the ceiling. Photo by Keith Kolb.

eleven handprints in another panel. There are four mushroom clouds, the iconic image associated with nuclear weapons. The largest of these is 3 feet tall and has a white interior with purple and green paint denoting the shape of the cloud (Figure 12.2). Adjacent to this cloud are other panels showing the crowded context of the images and text in the tunnel.

The largest panel consisting of a single image is located on the 10-foot-high ceiling at the south end of the tunnel (Figure 12.3). The image is 18 feet long and 10 feet wide at its base. It depicts a woman who resembles a Native American and conveys the idea that she is Mother Earth looking over those passing below. This multicolored mural begins with her dress at the tunnel entrance and is by far the most artistically complex. The light entering the tunnel highlights her dress but not her face.

Images and Text

The 44 panels that include both images and texts range from simple expressions of love, "Derek ♥ Sally," to elaborate murals with long statements. Many of the more complex murals use multiple images and written sentiments to convey anti-nuclear, pro-peace messages. In some cases, even small images are used to emphasize text. Near the south entrance to the tunnel, the walls have been repeatedly whitewashed. In response to this action, a panel drawn on the west wall near the roof declares, "U cannot cover up everything

with your nuke grey paint₁ paint₂ because [drawing of two eyes] real eyes real-
ize real lies." Below this in cursive is "No More Nukes N." This signature re-
fers to No Nukes Norb, Lawrence Norbert Drouhard, a well-known peace
activist who participated in many demonstrations at the Test Site. Peace
symbols were sometimes used to replace or embellish letters. In a panel on
the west wall reading, "Elvis says stop killing me!," the O in "stop" is a red
peace symbol.

In other cases, the textual element of a panel consists of a small signature
or expression added to a larger image. On the north end of the west wall,
an 8-foot-wide Western Shoshone panel contains 28 connected spirals that
are positioned to form two larger spirals (Maurice Frank, Western Shoshone,
personal communication, 2012). The spirals were drawn in purple and
have red highlights. Spirals are a common motif used in prehistoric Native
American rock art in the region and are also included in seven other panels
in non–Native American contexts, showing the universality of this symbol.
Below the spirals in purple, red, and green paint are eleven handprints: seven
right hands and four left hands (Schofield 2010). Next to some of the hands
are small faded signatures and affirmations such as "Strong Tree Running,"
"Innis Free," "Freedom," and "¡Por Amor De La Paz!" [translated as "For the
Love of Peace"]. A separate panel above contains the word, "NEWE," the

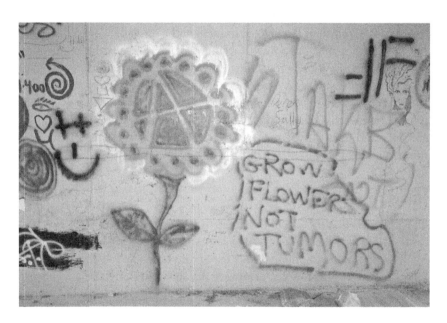

FIGURE 12.4 Painted flower with anarchy symbol and slogan. Photo by Keith Kolb.

name the Western Shoshone call themselves, in black and outlined in green. These panels document Western Shoshone involvement in the protests.

Images and texts work together equally to express ideas. A panel on the west wall to the right of the "Elvis" panel features a large yellow sun surrounded by the words "All the energy we need!" Another panel found a few feet to the north on the opposite wall depicts an image of a yellow flower growing from the soil alongside the words "Grow flowers not tumors" (Figure 12.4). The flower's central area contains a yellow anarchy symbol outlined in red with purple used as filler. This image and accompanying statement conveys the need for nurturing the Earth in combination with pro-anarchy and anti-radiation sentiments.

The two most elaborate panels containing both images and text are found on the east wall at each end of the tunnel. The one located on the north end is the oldest dated panel recorded (Figure 12.5). It was painted sometime in 1988 and presents a view from the year in which the number and size of protests peaked. The panel is 8 feet by 5 feet and consists of a wrist and hand emerging from the ocean, with the hand holding the Earth against a night sky complete with moon and stars. In black within the blue sea is "The universe is ours . . ."; above is "Don't blow it!" In small text on the bottom right are three female symbols above the name "Laura D'Antoni," possibly the artist. Small text to the left of the image says "A.P.T. [American Peace Test] '88 To Norb: For His Perseverance." Below this is another reference to No Nukes Norb, written after his death: "2005 Norb the great mother embraces you. They will not drag you on the road to Mercury again." This panel is a representative depiction of the concern that nuclear weapons could destroy our world. The darkened areas around the panel are of interest because at some time in the past someone covered this panel with papier-mâché as a means of protection; the panel was later exposed before the 2005 inscription. Papier-mâché remains on the adjacent panel, and it is possible that more art lies hidden beneath.

A panel on the east wall at the south end dates to 2005 and commemorates the 60th anniversary of the bombing of Hiroshima (Art Casey, personal communication, 2013). Filling a space approximately 7 feet by 7 feet, the panel depicts a tortoise as its central figure, surrounded by other images of desert flora and fauna: a snake, paw prints, a cactus, and a lizard (Figure 12.1). A peace sign with a pink interior and the word "Global" written in black lettering is located to the left of the tortoise. To the right, "60 years later . . . g3p" is written in black above a pink and black coiled snake. On the bottom, written in black, divided by a brown and tan lizard, is "Resist for the next 7 Generations." The Seventh Generation is a Native American view that

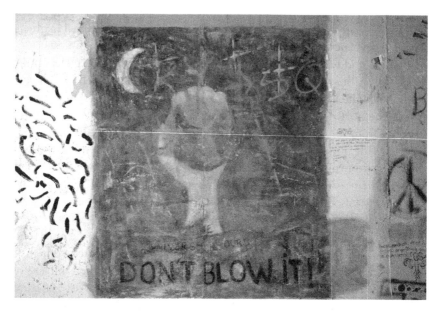

FIGURE 12.5 Oldest panel painting depicting the Earth with a plea to protect it. Photo by Keith Kolb.

decisions should be based on how they will affect the lives of people or descendants seven generations from now. This is in line with anti-nuclear and pro-peace activists' desire to preserve the Earth. To the right of the panel, the tunnel face has been repainted, but done in such a way as to avoid affecting this panel.

Comparative Analysis

Anti-nuclear activists and peace activists usually are shown in the media walking, chanting, and carrying placards with slogans. Using protest photographs from the *Las Vegas Review Journal* and other historic photographs from southern Nevada, we developed a list of 16 symbols and 64 slogans or statements from Nevada demonstrations to compare with the tunnel art. Nine of the 16 images on placards were found in the tunnel. These are doves, the Earth, flowers, hands, trefoils, medicine wheels, mushroom clouds, suns, and, most often, peace symbols (Figure 12.6). As found in our study, only four of the slogans on protest signs were in the tunnel. These included, "War is not healthy for children and other living things," "No More Nukes," "Food Not Bombs," and "Nevada Is Not A Wasteland." It is worth noting that many

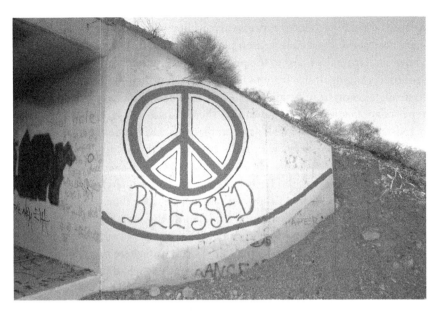

FIGURE 12.6 Peace symbol at the end of the tunnels, facing the Nevada Test Site. Photo by Keith Kolb.

symbols were used both in public and in the more private setting of the tunnel, while slogans were used predominantly for public events and not for the more intimate personal messages. This indicates that symbols have a more personal meaning and convey a personal sentiment in contrast to slogans that represent a group's ideology more than the individual's perspective. The small number of slogans also points to the activists' decisions regarding the appropriate contexts for their use. The results of this comparative analysis support our understanding of the personal nature of the tunnel graffiti (see Daniell in this volume for more analysis of personal sentiments in graffiti). As previously mentioned, the hidden location, the absence of consideration of light on the imagery, and the content indicate this artistic legacy has not been created as a public display.

Conclusions

Most protests take place in the paved world, with little residue remaining from the political action. However, at the Nevada Peace Camp, anti-nuclear and pro-peace protesters' ideas and thoughts are captured for posterity on highway drainage tunnels. Hidden from public view, the tunnel faces provide

a canvas for the activists to express their feelings through literary quotes, images, abstract designs, and written pleas, all illustrating and conveying their viewpoints from the 1980s to the present. In one tunnel, 162 panels have been recorded, ranging in size from 18 feet to only a few inches, from multicolored to a single color, from bright hues to a dull black, using paint, ink, or other types of applications that were handy. There is a great difference between the activists' public displays of slogans on placards and banners from the 1980s and the personal messages within the confines of the tunnel, but symbolism has a place in both contexts.

The Peace Camp graffiti have some qualities that differentiate them from other graffiti; furthermore, they are unusual because they have recognized value as heritage. In contemporary societies, the architecture commonly used for graffiti in urban environments are government-built structures, particularly edifices associated with infrastructure where the graffiti can be easily seen by the public. The highway drainage tunnels at the camp fall into this construction category as well, but the desert location is very rural and not easily accessible. The casual passersby cannot see into the tunnels and view the art from afar because, in contrast to most urban graffiti, it was not created for public display. Another difference is that graffiti often are found in a location where the content of the graffiti is unrelated to the setting or nearby environment. These tunnels and the inscriptions are related to the larger historic landscape at the Peace Camp and the nearby Nevada Test Site. The area was and continues to be the base camp where anti-nuclear protesters and peace activists stay and organize for their demonstrations for peace and against nuclear testing. The tunnel graffiti were made by the people who use the camp, and this graphic display of texts and images has historic and contemporary importance to them and value to society as a legacy of the anti-nuclear and peace protest movement (in this volume, Scheinman explores large polychrome graffiti/murals on a street in Mexico City, many of which have elaborate personal and political messages).

Photographs and footage of the protests were common in the news media during the days of nuclear testing, but outside the protest community, little was known about the camp where they stayed for days and, in at least one case, for years. It is the archaeological documentation of the material culture that brings the camp public recognition as a place of historical importance and has led the State of Nevada and the federal government to identify the Peace Camp as significant in history. The material culture at the camp represents a relatively unknown aspect of the nuclear testing era, and the graffiti, more than any other material culture found there, unequivocally convey the purpose and objectives of the activities in this place. In addition

to its historic value to the general public, the protesters who made this camp participated in a reunion there recently, showing the importance of this place to them and their strong attachment to its legacy of protests and civil action.

Often history tells the mainstream story of society, but in this case, the archaeological remains and the artistic legacy at the Peace Camp tell the story of a marginal political movement that expressed its opposition to government policies with protests, an activity that has a long tradition in American history. There is nowhere else with such an abundance of pro-peace and anti-nuclear texts and imagery preserved in place for present and future generations. From an archaeological perspective, the most interesting aspect of the graffiti is its manifestation of a living history that will change and evolve with the times, at least as long as the Nevada Test Site exists and activists continue their dissent.

Acknowledgments

The authors would like to thank the Desert Research Institute for its support, Keith Kolb for his photographs of the graffiti, and Tatianna Menocal for her contributions to this project.

SECTION IV

UNDERSTANDING THE POLITICS OF GRAFFITI

n contrast to contemporary art, which usually draws its detractors from the ranks of unsatisfied esthetes or a subset of disgruntled taxpayers who wish to bottom-line art out of public support, contemporary graffiti are often deemed a societal problem. Indeed, some scratches and paint marks are unintelligible, aggressive looking, and can run contrary to visions of a picturesque city. The increase in unsanctioned marks and scratches and the proliferation of street art since the 1970s have become a public policy conundrum. The worth of these expressions is continuously debated in public governance and policy. Often graffiti are erased, yet the so-called vandalism of yesterday becomes an important social document for tomorrow. Ironically, the United States Park Service and other organizations currently views some graffiti dating from the late nineteenth and early twentieth centuries as historically important, enacting ordinances ensuring its preservation. This attribution of value in the face of so much devaluing brings up questions about graffiti's perceived function in a society.

In this last section of this book, Tyson Mitman, Chris Daniell, and Pamela Scheinman describe three examples where perceptions of graffiti are challenged. Mitman traces the evolution of graffiti practice from intermittent and casual marking in New York City to its wallpapering of public space. He presents these unsanctioned expressions as both an index of public ills and

as easy scapegoat for the John Lindsay and Edward Koch mayoral adminis-
trations. In contrast, Daniell's chapter concerns UK military history and
questions what it means to declare graffiti illegal if these marks are tacitly al-
lowed and, perhaps, even encouraged. He considers scratches on several
army barracks as a glyphic device rather than simple graffiti and explores
how new definitions change perceptions of what marks mean. Scheinman's
chapter takes yet another tack in considering how graffiti have evolved into
expansive and complex narratives that have facilitated community dialogue
and urban renewal on a forlorn street in Mexico City. These chapters critique
our understanding of graffiti and propose alternative approaches to this
genre. In turn, they close a synthetic circle and bring readers back to the first
chapters of this volume, which explore the ways people talk about graffiti
and how its study might have value.

CHAPTER 13

Advertised Defiance: How New York City Graffiti Went from "Getting Up" to "Getting Over"

TYSON MITMAN

On July 1, 1971, *The New York Times* ran a story titled "Taki 183 Spawns Pen Pals." It discussed early graffiti writer Taki 183's motivations for doing graffiti and claims that he has "spawned hundreds of imitators" ("Taki 183 Spawns Pen Pals" 1971, 37), implying that he began the graffiti movement in New York City, a movement the article described as centered in the city's subway system. The article portrays graffiti as something of a harmless youthful novelty, but by the end of the 1980s, New York City would come to treat graffiti as one of the worst quality-of-life offenses plaguing the city. In 10 years, the city government positioned graffiti and graffiti writers as representing an ugly and pervasive criminal phenomenon. New York City reacted to what it saw as this graffiti scourge by redesigning subway storage and maintenance facilities, filing the largest lawsuit ever brought against graffiti writers, and tacitly supporting aggressive police actions that resulted in the death of at least one writer. The writers reacted too, reconstructing their identities as graffiti writers and shifting how they interacted with the city.

But at the time of the *Times* article, subway graffiti were "not a major crime" ("Taki 183 Spawns Pen Pals" 1971, 37). In fact, "The actual offense, the Transit Police said, is classed as a violation because it is only barred by Transit Authority rules, not by law. Anyone who is older than 16 who is caught would get a summons" ("Taki 183 Spawns Pen Pals" 1971, 37). What happened to move subway graffiti from mere violation to serious crime?

New York City Graffiti starts around 1968. Writers like Taki 183, Julio 204, and Frank 207, to name a few, were writing on the walls of their neighborhoods and in the subways as they traveled through the city. But to understand how graffiti became so vilified, the Lindsay years of New York City

politics that predate graffiti must be understood. John Lindsay took office in 1966. The election was hard fought and Lindsay won by cobbling together a diverse voting base. He gathered the support of minority and impoverished populations by promising them greater social justice and political agency.

Once in office, Lindsay encountered difficulty fulfilling his campaign promises. His hope of creating a civil review board to oversee the police department was rejected in a referendum (Austin 2001, 77) and his proposed public housing improvements were also denied (McNickle 1993, 216–236). The city was near bankruptcy, manufacturing jobs were vanishing, the middle class was leaving for the suburbs, crime was rising, municipal workers were striking and the transit system was in disrepair (Lankevich 1998).

To win reelection in 1969, Lindsay again promised populist ideas of helping the poor and improving the public transit system. While these platforms put him back in office, he now had to deal with a subway system that was plagued with issues (Austin 2001). Delays and breakdowns were common, trains caught fire, and doors did not open at stops. Lengths of track were in such poor condition that they could only be navigated at about 10 mph, and crime in the subway was on the rise (Kates et al. 1981). In short, the simple act of commuting became unpleasant and dangerous. This was also the time when graffiti began to appear all over subway cars, both inside and out. Cleanliness in the subway had long been a concern, but as graffiti became more and more ubiquitous it became a more prominent ridership complaint. Riders saw the graffiti that covered the interior of the cars and the windows as a persistent aspect of the filth that they had to endure on their daily commutes.

The "dirtiest" graffiti, which was seen as the ugliest and most offensive, were the tags and throw-ups (typically solid color block or bubble letters with a different color outline) that covered the interior of the cars. These expressions were also the most difficult to combat because they were often done while the car was in service, an activity called "motion tagging." Graffiti writers simply got on at one stop, put their tags up inside the car while they rode it to wherever their stop was, then got off.

After the Taki 183 article came out in the *Times* in July of 1971, more practitioners emerged and the subway car interiors became increasingly covered in graffiti. The activity was garnering media attention and notoriety for some graffiti writers. Further, because of the city's budget crisis there was a reduction in the police presence in the subways, which meant graffiti writers had an easier time getting away with what was still deemed "not a major crime."

But in the summer of 1971, the inside and outside of the subway trains looked markedly different. They looked like guestbooks, signed with

names and street numbers:[1] MIKE 171, SJK 171, TAN 144, EEL 159, STITCH 1, TREE 127, SNAKE 1, FRANK 207, JUNIOR 161, and CAY 161. On the trains, the names sometimes would be small, up near the door and obviously written in haste with a marker by someone on their way out-that made much sense. But the florid moss of larger spray-painted signatures was baffling. How were they doing this? What was going on? (Gastman and Neelon 2010, 58)

By 1972, the graffiti in the subway system had reached such a level that *The New York Times* editorial board claimed it had become an "epidemic" (Prail 1972, 39). Mayor Lindsay had gone so far as to claim "that the rash of graffiti madness was 'related to mental health problems'" and that graffiti writers were "insecure cowards" (Ranzel 1972, 66). In the early 1970s the city and the press shifted their positioning of graffiti writers from mischievous youth to dangerous vandals destroying the subways. This characterization of graffiti and graffiti writers was in Mayor Lindsay's best interests, for it kept the ridership focused on the graffiti issue and not on the serious functional problems that were affecting the subway system.

In 1972, Lindsay began the "graffiti war" (Castleman 1984, 139). This declaration of war against graffiti writers sought to battle those whose crimes were trespassing and vandalizing city property. He straightforwardly asked that police be more vigilant for graffiti writing and for writers to quit the practice. But when Ed Koch took office in 1977, the tenor of the war changed. The rhetoric became more aggressive, as did the strategies used against writers. Graffiti writers became "enemy-combatants," and Koch sought to eliminate them entirely. These changes would not only affect how graffiti writers saw themselves, but also how they incorporated themselves into the city.

In 1977, New York City had an image problem. Movies like *Death Wish* (1974) and *The Taking of Pelham One Two Three* (1974) portrayed the city, and specifically the subway, as a place where one was likely to be assaulted, mugged, raped, or murdered (Figure 13.1). The city was close to bankruptcy, tourism was down, crime was up, and businesses were leaving (Cannato 2009, 565–575). Koch believed a tough-on-crime stance would help, and that the city needed to be tough on all crime no matter how serious. He was a strong adherent of the "broken windows" theory (Kelling and Wilson 1982), which posits that if the visual evidence of minor infractions is allowed to mar the landscape, increased criminality will occur in these spaces until they collapse into lawlessness. This is the mentality with which Koch enacted policy to handle the graffiti problem.

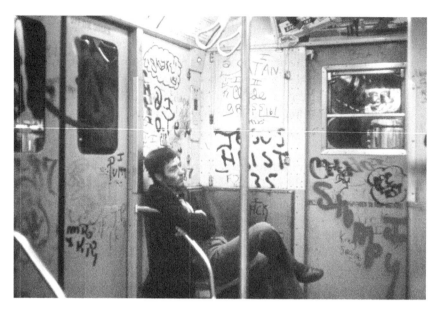

FIGURE 13.1 Heavily tagged subway car in New York City, 1973. Photo by Erik Calonius.

Koch's understanding of the broken windows theory was well articulated in Nathan Glazer's essay "On Subway Graffiti in New York" (1979).

> He [the subway rider] is assaulted continuously, not only by the evidence that every subway car has been vandalized, but by the inescapable knowledge that the environment that he must endure for an hour or more a day is uncontrolled and uncontrollable, and that anyone can invade it and do whatever damage and mischief the mind suggests. (Glazer 1979, 4)

For Koch, graffiti were evidence of a lack of authoritarian order; as such, the presence of graffiti had a psychological effect that made all citizens its victim through a disruption of the visual order, thus promoting a feeling of confusion and fear among people. While the graffiti writers claimed what they were doing had artistic merit, Koch's positioning made "the consideration of [graffiti] writing as an art, or as an alternative vision of the city, seem irresponsible and even dangerous" (Austin 2001, 150). This understanding caused Koch to wage a much more intense war on graffiti.

But the city was still in a budget crisis. Koch knew that the current cost of removing graffiti was $10 million a year, and that it would cost the city about

$24 million a year to get graffiti removal to a point that the mayor's office would deem acceptable (Austin 2001, 91; Jonas and Weintraub 1973, 3–4). As such, Koch's war on graffiti was fought on two fronts: he fought a propaganda war through the media, and he battled the visual "broken windows" of graffiti in the physical spaces of the subways and train yards.

Koch's media attack began in 1982 and worked to disparage graffiti writing through the "make your mark in society, not on society" campaign (Bennetts 1982). Posters and television ads used celebrities and athletes to promote an anti-graffiti message. These posters were featured prominently in the subway stations and cars and worked to defame the idea of writing graffiti. One ad featured boxers Joe and Marvis Frasier telling people, "We got where we are by messing up other fighters, not by messing up our city's walls." Another poster of Latino boxers Hector Camacho and Alex Ramos read, "Take it from the champs, graffiti is for chumps." A television spot even aired that featured 1980s Broadway stars Gene Ray and Irene Cara in which Cara tells the audience how hard they worked to get where they are and for everyone not to "waste your time making a mess" (*Style Wars* 1983). While this campaign did little to deter graffiti writers from painting the trains, it did serve to further the mayor's office's agenda of increasing the public derision of writers.

The more effective side of Koch's war on graffiti was waged in quieter policy changes and alterations to the physical subway system[2] beginning in 1980. For example, his administration petitioned manufacturers to sell less-permanent inks and paints, and to prevent anyone under the age of 18 from buying spray paint or markers. Retailers were to keep markers and spray paint where they could not be easily shoplifted, and security was increased in and around train yards (Austin 2001, 217–221). He had fences built around train lay-up yards, and he started the "clean car" movement, which was a zero-tolerance policy that did not allow any trains with graffiti to be put into service, even if it meant delays for riders. The city was beginning to see some success in their fight, and city officials declared that the subways would be graffiti free by 1985 (Daley 1984).

But even though the public would no longer see graffitied trains, many were still being painted. To really prevent graffiti on the trains, Koch would have to turn the train yards into places that literally resembled prisons. Fences were put up and razor wire was put along the tops to prevent them from being climbed (Goldman 1981a). Dogs were placed in yards to attack writers who cut holes in the fences. Koch also suggested building two fences and having guard dogs run between them to protect workers from being

attacked and anyone from getting in (Goldman 1981b). He even went so far as to suggest using wolves to keep graffiti writers out (Fitzpatrick 2009). While these measures seem draconian, they were effective. The dogs, razor wire, fences, and "clean car" policy worked well, and by 1989 subway graffiti was no more (Kelling 1991). This was an important victory for Koch. Eight years earlier, the city borrowed $8.7 billion to update and repair the subway system (MTA 2012); after having made such a public case about the destructive nature of graffiti, improving the subway system functionally but not being able to prevent graffiti would seem like a failure. The ridership would be less likely to appreciate the safety and efficiency improvements to the trains if they were still covered in graffiti.

The trains were clean, and Koch declared victory in his war on graffiti. However, writers did not stop writing simply because they could no longer paint the trains. They just took their practice aboveground onto the streets. This shift in place of performance was indicative of a greater shift in axiology and ideology. Koch's winning of the war on subway graffiti caused a change in the collective ideology of graffiti writers. Koch defined writers exclusively as criminals who attack the city and its population through their work. This rhetoric no longer allowed for the possible construction of graffiti writers as artists who sought recognition by doing illegal work. Graffiti writers now no longer just wanted to "get up" (the term writers use for the act of writing graffiti); they also wanted to "get over." To "get over" on the city meant to put up their work and "attack" it and its authoritative body through cunning, intimidation, deception, and trickery. This is what Koch had long been saying writers were doing, but after he made painting the trains impossible, it became one of their explicit motivations.

It was far from their only motivation though. Graffiti writers are primarily motivated by fame (Castleman 1984; Ferrell 1996; Lachmann 1988; Snyder 2009), but they are also motivated to write graffiti for other individual and internal reasons. Hasley and Young (2006) document the importance of friendship among graffiti writers. Castleman's authoritative work, *Getting Up: Subway Graffiti in New York* (1984), details the importance of self-expression and mentorship. Schacter (2008) describes how important artisanship can be to writers, and Macdonald (2001) clearly shows that graffiti writers write as an act of rebellion. Still others have shown how central the claiming of space (Ley and Cybriwsky 1974), the desire to have fun and feel a "rush" (Monto et al. 2012), and the demand to have their voice heard in a system that offers them little opportunity for this (Waldner and Dobratz 2013) are to the subjective identity of graffiti writers. But writers universally cite acquir-

ing fame—having others know and respect their work—as an important central goal.

In the graffiti world, fame is not easily achieved. Writers compete within a system of symbolic capital to produce an identity that is based on prestige and respect. Symbolic capital is capital built through "the acquisition of a reputation for competence and an image of respectability and honorability" (Bourdieu 1984, 291). The way symbolic capital is built within the graffiti world is fairly straightforward: do work that the graffiti community deems of high quality in the places that the community considers important and valuable. An individual will rise and fall within this symbolic capital system based upon the quality of their work, the frequency it appears, where they are able to place their work, and how they are able to maintain it. Those with great symbolic capital will have well-known reputations, and their work will be very respected both for what it is and for who produced it. Those with little symbolic capital can grow their reputations by showing a dedicated work ethic (i.e., getting up a lot, and getting over by putting work in conspicuous locations).

In the heyday of New York City subway graffiti (1971–1985), the symbolic capital market was clear. The subway trains were the coveted and important places of performance and competition, with subway exteriors being the most prestigious spaces to place one's name. These were the largest and most visible spaces the trains offered. It is in these spaces where writers built their reputations within the symbolic capital system. The most popular trains to paint were those that ran where the most people would see them. The 2 and 5 trains were particularly popular, as they both ran from the Bronx, through Manhattan, and into Brooklyn. The 6, which went from the Bronx to Manhattan, and the 7, which went from Queens to Manhattan, and all of the Brooklyn Mass Transit (BMT) lines were also important places for the production of symbolic capital. They were highly visible spaces that ran above- and belowground through prominent neighborhoods. When aboveground, the trains could be seen from the streets and highways. As such, competition in these places revolved around who was "up" (Chalfant and Prigoff 1991) the most (had their work appear regularly everywhere), and who produced the best work. The "best" works were the large, colorful "pieces" that adorned the exteriors of the subway cars. Yet, being consistently "up" on or in the subway cars, or along the subway routes with tags or throw-ups, granted a writer symbolic capital in accordance with how "up" they were. By 1989, subway graffiti was no more, which also meant that the trains were no longer the unified place of performance and capital production. Writers began to move

out of the subways and onto the city streets. Street graffiti had always been a presence, but the frequency dramatically increased once the subways were no longer an option for writers.

Graffiti writers fall along a continuum of two loosely defined endpoints; *piecing* and *bombing* symbolize these endpoints. Piecing is done by graffiti writers who wish to build a reputation by elevating graffiti to an art form by painting large, ornate, intricate, and vibrant works that are time and labor intensive to display their names. Bombing, on the other hand, is done by graffiti writers who want to build their reputation simply by being "up" in a lot of places. For bombers, quantity is more important than quality (Cooper and Chalfant 1984, 27). There are some graffiti writers that just piece and some that just bomb, but most writers do both and simply favor one style over the other based on the space they are working in, the time and resources they have, and their own artistic skill set.

When writers moved from the subways onto the streets they knew that they were more vulnerable to observation and needed to work faster. Anyone could see them and call the cops, or a cop could come by unexpectedly. This affected the artisanship of piecing, which began to matter less as the much faster bombing style of graffiti writing became more popular among writers working in the streets. Piecers were still around, but they largely saved their talents for safe, secluded spaces and legal or permission walls. By the end of the 1980s, the preponderance of writers opted to build their reputation by painting a lot of throw-ups and tags all around the city instead of dedicating hours of time and a lot of paint to a piece. The tags and throw-ups were, of course, the two types of graffiti that the city had deemed the ugliest and most offensive during the war and, based on their application of the broken windows theory, these were the types of graffiti they had taught the citizenry to associate with danger and criminality.

Further, because the subway no longer carried their work throughout the city, writers themselves had to move through as much of the city as they could to build their reputations. Any place with public visibility now became a target. City walls, highway retaining walls, handball courts, and city vehicles, specifically garbage trucks ("Battle Line On Graffiti Is Shifting" 1987), became the new symbolic capital marketplaces where writers worked to build their reputations. Writers were moving through all of the city's neighborhoods, getting up everywhere they could and causing people who previously only interacted with graffiti on their commutes to see it all over as they went about their daily routines.

As writers competed for status and space on the walls, the important writers became the ones that were simply "up" the most. The more one was

represented in the streets, the more symbolic capital one had. Cope2 sums up this shift in mentality nicely: "A lot of people think pieces are better than throw-ups. I mean, pieces look better than throw-ups, but it's still the same thing. Throw-ups get you up and pieces get you up. It's the same type of thing" (Cope2 1996, n.p.). The graffiti writer Ghost echoes this sentiment but goes one step further: "I guess that's how I got my style. I did it fast and quick, not really caring how it came out. My thing was getting over and away" (GHOST 1997, p. 9).

The Koch administration had embedded the rhetoric of the broken windows theory into its public representation of graffiti. It taught its citizens that the presence of graffiti was evidence that space was out of control, that spaces with graffiti were spaces where other crimes were likely to occur, that people should feel less safe in them. Sociologist Jeff Ferrell discusses how this construction of graffiti shifted the mentality of graffiti writers, writing, "Aggressive legal campaigns against youthful risk taking have time and again served to amplify both the risk and skill involved, and so to promote the very activity they seek to contain" (Ferrell 2010).

Graffiti writers liked being portrayed as outlaws, and were happy to use the whole city as their canvas to build their reputation and offend and affront the city and its officials. "Getting over" was now part of the job of being a graffiti writer, and it became fairly synonymous with "getting up." The city had demonized graffiti and had made its police force and citizens vigilant against them. The artistry that once served to legitimate graffiti to outsiders was much less prevalent. If a writer could attack the city and build their reputation by painting throw-ups or tags, why would they invest the time and paint to do a piece?

It is this ideological shift that moves graffiti from subculture to counterculture. A subculture is a culture within the larger culture, but with its own separate values, norms, practices, and beliefs; a counterculture is a culture whose values, norms, practices, and beliefs clash with or oppose those of the dominant culture (Hirsch et al. 1993, 419). It was the Koch administration's positioning of graffiti writers as criminals committing vandalism and psychological assault that not only caused graffiti writers to internalize this identity, but also work to embody it.

This was problematic; this overtly antiauthoritarian stance writers had taken made city officials all the more zealous in their efforts to stop and punish them. Prosecutions against graffiti writers began to rise, and stories of the police beating writers before they took them to be booked became more frequent. In 1983, the police killed a man for graffiti writing; in 1988, New York City filed the largest lawsuit ever filed against three graffiti writers.

On September 15, 1983, Transit police observed 25-year-old Michael Stewart tag the wall in the 1st Avenue and 14th Street subway station in lower Manhattan. Police confronted him, choked him with a nightstick, and severely beat him. When he arrived at Bellevue Hospital he was "in police custody, hog tied and badly bruised, with no pulse" (Nielson 2013). He died in the hospital after spending 13 days in a coma (Associated Press 1985). The police claimed he was resisting arrest, and all officers were later acquitted of all charges (Wilkerson 1985).[3]

Just five years later, the city would file an unprecedented lawsuit against graffiti-writing brothers Sane and Smith for climbing the Brooklyn Bridge and painting their names in house paint on both sides of the structure. Next to their names they wrote, "It's nothing new, Koch is thru, Sane 182" (Powers 1999, 67). The police arrested them outside of their home a few weeks later, but criminal mischief charges would not be enough this time; the city hit them, their mother, and their longtime graffiti partner JA with a $3 million dollar lawsuit, the largest lawsuit ever brought against graffiti writers (Toth 1995, 121). The lawsuit would certainly have bankrupted all of the defendants involved if the city had not let the case languish until the statute of limitations expired once noted civil rights activist and lawyer William Kunstler agreed to be Smith and Sane's attorney.

The city had clearly gotten very serious about conquering its graffiti problem. Koch and the MTA had taken action and achieved exactly what they set out to do: the subways were clean. However, they did not really understand the problem. They thought that by getting the trains graffiti free and setting up a system that would keep them clean they would eliminate graffiti and save New York City's citizens from their psychological tyranny. Unfortunately, something very different happened. "[T]he graffiti world started to attract more and more people who weren't looking for an alternative art canvas but simply wanted to be connected to an outlaw community, to a venerable street tradition that allowed the opportunity to advertise their defiance" (Heldman 1995, 52). Koch and the MTA misunderstood graffiti as merely a practice engaged in by mischievous city youth. They did not understand that it was a subculture unto itself, and that by vilifying and fervently combatting it they moved the practice of graffiti from the realm of subculture to counterculture. In doing so, they gave graffiti writers the power to position themselves as rebels attacking the city by putting their name on it. The city's reaction granted them a kind of infamy that made other individuals who felt disenfranchised or that they wanted that kind of fame to start writing graffiti as well.

In New York City today the subways are clean, but the unexpected ramifications of the battle to make them this way was that the self-conceptualization of the graffiti community moved to one of an antiauthoritarian counterculture. Framing graffiti as the Koch administration did allowed acts of graffiti themselves to be a big, antagonistic middle finger to the city and its officials. An unnamed graffiti writer expresses this mentality clearly: "It takes me seconds to do a quick throw-up; it takes them like 10 minutes to clean it. Who's coming out on top?" (Heldman 1995, 64).

Historic Graffiti and Calliglyphs on Two Military Establishments in England

CHRISTOPHER DANIELL

Definition and Legal Status of Graffiti

In English law there is a clear legal definition of what is—and what is not—graffiti. The definition is summed up by the Anti-Graffiti Association, which cites the Criminal Damage Act 1971:

> Graffiti is indiscriminate displays of a signature, mark or picture painted on structures where no permission has been given by the owner. In the UK it is illegal and considered to be Criminal Damage. A person who without lawful excuse destroys or damages any property belonging to another is guilty of Criminal Damage—[Criminal Damage Act 1971]. (Anti-Graffiti Association 2013)

The key part of the definition, which informs the discussion below, is that graffiti occurs "where no permission has been given by the owner . . . and damages any property belonging to another." Non-permission, and its opposite—permission—are thus key determinants of what constitutes "graffiti." This definition relies on the premise of permission, and modern commentaries describe graffiti as reacting against authority. Rock art specialist Sven Ouzman commented on the graffiti he recorded at the University of California, Berkeley, in a newspaper article: "When graffiti are written on public property, they are making a statement about who controls the space around us. . . . Find a society that is particularly over-regulated and you will find graffiti" (Meisel 2004).

The situation is changing in England, however, with the arrival of graffiti "stars" such as Banksy. Though Banksy's work is probably technically illegal,

the amounts of money generated from the sale of his illegal images mean that the owners of buildings with Banksy murals can benefit by removing the wall and selling the work at auction. A case in point occurred in London when a Banksy mural was "stolen," to the consternation of the local community. There was no formal request by the owner for its return, and it re-emerged at auction in Miami with a guide price of $500,000 to $700,000 (Vincent 2013). Therefore, although the graffito was illegally drawn, the victim accepted it; a situation could arise where "illegal" graffiti are actively encouraged, especially when the "victim" of the illegal act could financially benefit from the graffiti.

In historical terms, before 1972 there was no legal definition of graffiti in England. However, in some pre-1972 cases, graffiti can be classed as such because "no permission [had] been given by the owner" (Criminal Damage Act 1971). There are some obvious cases of illegal graffiti before 1972, as in the example of the Campaign for Nuclear Disarmament graffiti daubed on the internationally renowned stones of Stonehenge in the 1960s (Daw 2012). However, the further back in time that the graffiti occurred, the more unstable the modern definition of graffiti becomes (earlier in this volume, Mitman discusses the various legal questions surrounding graffiti in New York City).

Historical Background

There are three mains reasons for the difficulty of defining illegal graffiti in a historical context. The first is that the opinion of the owner or authority is not known. The second is that the person who created the writing or drawings is also not known, so it cannot be determined that the writing was indeed not permitted or damaging to another person's property. The third is that ideas about writing and the acceptable materials to write upon have changed over time (see chapters by Rodriguez, Plesch, Beaton and Todd, and Beck et al. in this volume).

Fleming has powerfully argued that in early modern England the country was "papershort," and that the "bulk of early modern writing" was on walls (Fleming 2001, 50), an idea which is reinforced by the Tudor proverb "A white wall is a foole's book." In the eighteenth and nineteenth centuries, the practice of writing on walls or objects was continued, mainly with chalk. The range of subjects in a domestic setting included games, recipes, school lessons, memorials, house rules, prayers, Biblical extracts and, in the outside spaces, political commentary, erotic musings, and personal slander were common (Cody 2003; Fleming 2001). Even in the nineteenth century it was acceptable for authority figures—in this case policemen—to carve their own

serial numbers onto a wall in Clerkenwell (Guillery 2005), and further historical examples have been analyzed from East Anglian churches (Pritchard 1967) and as "wild signs" (Oliver and Neal 2010).

The difficulty of automatically associating historic writing on walls with the modern concept of illegal graffiti is clearly shown by the historical background and the two case studies below. It has therefore been proposed that the word *calliglyph* be used for past handwriting or drawings imposed upon a surface at a later date (for a longer definition, see Daniell 2011, 464–467). In a Roman context, such writing can be described as *parietal* (from the Latin *parietalis* meaning "belonging to the wall"); *secondary* or *tertiary writing* is also used, but these largely concentrate upon writing, whereas the term *calliglyph* encompasses all human marks and inscriptions. In the archaeological lexicon there are other variants of *glyph*, such as *arborglyph* and *petroglyph*, and, like calliglyph, neither carry the modern illegal overtones of the term *graffiti*, therefore allowing them to be studied in their own unique historical or archaeological context (though see Lovata in this volume for a contrary discussion of glyphs as essentially graffiti).

The term *inscription* is a legally neutral term, but to assess whether it is a permitted calliglyph or non-permitted graffito, further analysis of the context is needed. The contextual analysis should include, but is not limited to, the ease of identification of the inscriber, whether there is a date or place mentioned, and a spatial analysis. It is only by analyzing the context of the inscriptions that one can derive a fuller understanding of the inscriptions and develop a theory about their purpose and function (see Scheinman in this volume).

In two case studies below I analyze a series of inscriptions in an attempt to give meaning to a seemingly random series of names and determine whether the names are graffiti or permitted calliglyphs. The first analysis is of two groups of names at Rowcroft Barracks that were written by recruits in the 1950s and the 1970s. The second case study is of a group of names at the Royal Military Academy at Sandhurst, which were written during the 1850s. Even though the names were written 100 years apart, between the two sites I argue that the reason and function were the same as a method to increase the cohesion between two groups of trainees.

Range Hut and Gate Piers at Rowcroft Barracks

Rowcroft Barracks was the former initial training establishment of the Royal Electrical and Mechanical Engineers (REME) between 1936 and 2004; thousands of trainees passed through the barracks. There were three intakes of

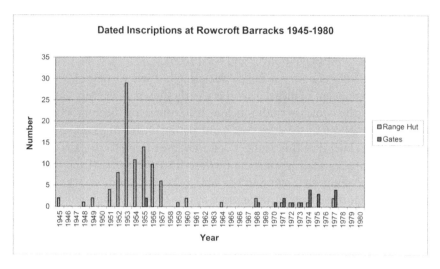

Dated Inscriptions at Rowcroft Barracks 1945-1980

FIGURE 14.1 Range hut at Rowcroft Barracks showing the western face. Photo by author.

recruits per year—spring, summer, and autumn—and each intake was given the respective letter A, B, or C and undertook an initial 14-week training at Rowcroft.

Within the barracks site there are two groups of inscriptions. The first—and largest—group is on the exterior of a range hut or ammunition point near the southern boundary of the site (Figure 14.1). The second, smaller, group is on the main entrance to the barracks. Thus, there are contrasts that are evident; in particular, the range hut is "within the wire," while the main gates are on the edge of the site, and the range hut inscriptions were permitted, while the main gate inscriptions were not.

The range hut fell into disuse and was abandoned, but it was formerly a key building for a busy 30-meter rifle range, which was used to teach the trainees basic rifle skills. Prior to its demolition, inscriptions on many of the bricks were discovered; following the clearance of ivy and debris, the inscriptions were photographed and transcribed. There are 186 readable inscriptions, but owing to the passage of time, ivy damage, and flaking bricks, many are unreadable; the total number is probably closer to 250 inscriptions in all. All but three were on the outside of the building. Most external inscriptions were on a single brick, though some bricks had two or three smaller inscriptions. The three interior inscriptions were more recent, with one reading "Bomber 77A" in ugly red spray paint. From these graffiti it is a reasonable assumption that the building was no longer used by 1977, which is confirmed by anecdotal evidence that it went out of use by the 1970s (Lt. Col. Tizard,

personal communication, September 2013). Of the 186 inscriptions, 80 had no indication of date, though four inscriptions had a place name. Two names were associated with places within England (Sunderland and Bristol), and two were countries: Burma and China. However, it is the names associated with the year and intake of entry that form the largest contingent with 106 inscriptions (57%).

The second structure is the main gateway into Rowcroft Barracks (Figure 14.2). The gateway has brick piers that support the iron gates and central archway; the inscriptions are carved on these piers, the majority on a single brick. The entrance is located on a civilian roadway and is thus accessible to both military and civilian personnel. There are 54 readable inscriptions on the gate piers, of which 19 (35%) have associated dates with names. The majority of names are written between waist and head height, though a few are high up (over 7 feet), perhaps written so high as a challenge. There are also over 50 circular holes—each about an inch across—in the brick work, which has been suggested were produced by trainees rotating their bayonets into the bricks. Though little more can be said about the holes, they are equally the marks of the trainees and can be treated as calliglyphs.

FIGURE 14.2 Entrance gates to Rowcroft Barracks. Photo by author.

Figure 14.3 gives the breakdown between the dated examples on the building and the gate piers. The peaks and troughs are evident, with the single largest grouping dating to 1953, with the 1950s generally comprising 83 of the 106 dated names on the range hut. The dated distribution on the gates is predominantly from the 1970s. It is assumed that the other, undated, inscriptions on the structures follow the same patterns.

The second element of the analysis is that of the spatial patterning of the inscriptions. The inscriptions on the gates are on the front and the inner sides, but those on the range hut have a more interesting distribution. The range hut has a floor plan of a rectangle (north/south sides being shorter) with a door on the shorter southern side, a window on the northern side, and windows on the eastern and western sides. Of all the 186 inscriptions, only three are inside, and externally only two are on the northern side. The northern side window was where the ammunition was passed to the trainees, and there were probably strict rules about trainees being there for any length of time, reducing the opportunity for inscriptions to be written. The

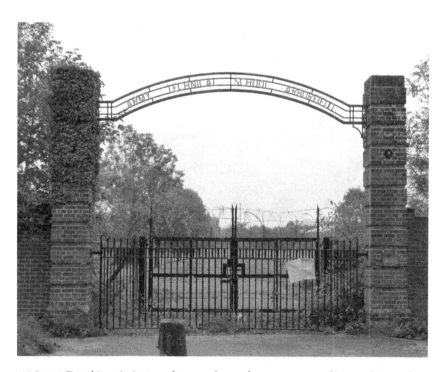

FIGURE 14.3 Dated inscriptions on the range hut and entrance gates of Rowcroft Barracks. Photo by author.

single greatest number of inscriptions (81 [43%]) is on the western façade; on the opposite eastern side there are 41 (22%). However, it is the high number of inscriptions (57 [30%]) on the southern side that is particularly notable because this is the side with the door. The inscriptions can be clearly seen by anyone entering the building.

An initial explanation for all the inscriptions is that bored apprentice trainees idled away time before or after going on the range and carved their names with the bayonets that they had been given. If this is the case, then the inscriptions could be classed as graffiti in the sense that they are illegal and without permission. However, the fact that the inscriptions are in clear view of superiors entering or leaving the range hut suggests that either a blind eye was turned to individuals writing their names because they were considered unimportant, or that equally there may be a reason behind the inscriptions.

Most of the dated inscriptions are from the 1950s, which in the United Kingdom was a time of National Service. National Service was an extension of the conscription during World War II, but was generally unpopular and ended in 1960. One possibility is that the more senior staff encouraged the writing of such names to bond the particular intake of the year, and it may be that trainees could, as a reward for some action, carve their name. This theory is supported by the fact that most of the inscriptions easily identify trainees as they give a surname, initial, date of entry, and the entry group, such as: "C Quarendon 54A," "J F Chadd 53A," and "J Mayfield 52B." The museum on site holds the trainees' joining cards and many of the names and cards can be matched, although unfortunately there is no indication why they were allowed to carve their names onto the building, nor are there details of their later military careers.

However, the inscriptions on the gates lead to a different explanation. The gates had brick piers onto which the inscriptions were carved, with an iron arch spanning the entrance as shown in Figure 14.2. Over time, the gates became synonymous with—and a dramatic visual indicator of—apprentices entering the barracks, and is still used today as the symbol for the Old Boys Association (www.arborfieldoldboys.co.uk/). While there are dates on the gates, these are rarely associated with names, and the names that are on the gate piers are for the most part unidentifiable; 29 (53%) are shortened first names only, such as Kev, Matt, Ken, and Jaza. Only two have associated names with years, which are both initials: "77 DW" and "CE 70B." There are two possible answers for this pattern. The first is that the inscriber could reasonably argue, if suspected, that someone else with the same common first name or initials was the inscriber. This implies a reasonably severe punishment if the inscriber was caught. The second is that non-military people

carved their names or initials as a civilian response to the military presence in the area. However, there was a strict 24-hour guarding regime at the barrack gates, which meant that civilians would not be able to carry out any inscriptions. For the guards themselves, who were often trainees, the worst guard duty was 02.00 to 04.00 in the morning, which was "dull and boring" (Lt. Col. Tizard, personal communication, September 2013) and it is likely that the inscriptions on the gates were by the guards. Therefore, although the dates cannot be determined, it is likely that the inscriptions were made in the early hours of the morning. This explanation would fit well with the blandly anonymous style of graffiti and the presence of entry dates and letters (17 of the 54 inscriptions have years, and 10 have associated intake letters such as "74C"), so that a group was defined as being on duty.

Thus, I propose that the two sets of inscriptions reflect different patterns: the inscriptions on the gates are non-permitted graffiti that required the inscriber to be kept anonymous. The inscriptions on the range hut, however, can easily identify the inscriber and the number of traceable trainees, which indicates that not only was there no penalty for inscribing the name, but inscriptions may have been encouraged, leading to the conclusion that the majority are calliglyphs.

Racket Court Sandhurst

Since its inception in the early nineteenth century, Sandhurst has been the elite officer training establishment of the British Army. As part of reforms undertaken by the British Army in the mid-nineteenth century, the cadets at Sandhurst were expected to undertake physical exercise and one such form was the playing of "Fives" (a form of tennis using the hands). A Fives court was built after 1842 and then enlarged into a racket court between 1857 and 1859. Historical map evidence shows that when the racket court was originally constructed, it was next to a large area of open ground that included assault courses and a "skittle alley."

In all there are 311 examples of names or initials carved or scratched into the external brickwork of the racket court. While most are carved onto a single brick, some carry over across two or three brick widths, and many of the earliest, deepest, examples can be seen easily from a distance of about 10 feet. One in particular is an oddity being in mirror writing, the first example I have discovered out of thousands collected. A total of 53 (17%) have associated dates, which can be broken down as follows: 15 from 1850 to 1859; 7 from 1860 to 1869; 2 from 1870 to 1879; 8 from 1880 to 1889; 5 from 1890 to 1899; 5 from 1900 to 1909; 2 from 1910 to 1959; and 9 from 1960 to 2009.

The high total for 1850 to 1859—the highest single total per decade of 15 dated instances—is all the more remarkable because the building was not built until 1857.

As well as dates, many of the earlier inscriptions have associated letters and numbers such as "B10" or "A9" (90 instances, or 90% of the total). The letters correspond to those at Rowcroft Barracks, with letters A, B, and C, but the number sequence ranges from 1 (such as B1, C1) to 91 (B91). Thus, the numbers likely are either rooms or beds in dormitory blocks A, B, or C: letter A has 10 instances; B has 71 instances; and C has 9 instances. At present it is not known why there are so many more instances of B than either A or C, though C Dormitory block was built later than A or B. The most carved letter and number is B41 (5 times), with B31 and B84 each appearing four times. As well as dates and dormitory letter and number, there are 16 inscriptions that have both.

A spatial analysis of the inscriptions reveals that the majority (61%) were in very prominent locations on the front of the building and close to the main doors, as shown in Figure 14.4; in other words, highly visible both to other cadets and also their instructors. One group (7%), however, was located approximately 3 meters high on one side of the building; those with dates

FIGURE 14.4 Sandhurst Racket Court main entrances. Photo by author.

were from the 1880s. There is no obvious reason for the height; because it is too high for the inscriptions to have been written while sitting on a horse, it is presumed that there was a scaffolding balcony erected in that area, though there is no evidence for this in the brick work.

The question arises as to whether the inscriptions were non-permitted graffiti or permitted and potentially encouraged calliglyphs. As with the Rowcroft Barracks trainees, records survive about the Sandhurst cadets but are more fulsome and record their progress through Sandhurst. An analysis of the dated names from the 1850s revealed that 19 names could be reasonably matched between the inscribed names and the records. All of the 19 cadets had received "three decorations of merit" during their time at Sandhurst. While many other cadets also received three decorations of merit, receiving three was still a mark of honor. The cadets were therefore within a privileged group of cadets rather than renegades of the cadet group.

Comparisons

The context of the inscriptions at Sandhurst and the range hut at Rowcroft have many similarities: both sets can be traced back to the individual inscriber, and they are placed in very prominent locations, often around the main entrances to the buildings at a readable height. If punishment was attached to inscribing names, it is unlikely that trainees would have left identifiable markings. In fact, it may be the reverse: trainees may have been actively encouraged by trainers to inscribe their names to enhance the cohesion of the trainee group. That both sets of calliglyphs are by trainees is probably significant: trainees, probably far from home in an alien and strict surrounding, likely need group cohesion the most. Cohesion within military training has an extensive literature, particularly from an American perspective (MacCoun and Hix 2011), and different forms of cohesion have different results. One element of cohesion is performance; MacCoun and Hix (2011) argue that "cohesion was reliably associated with performance." However, the causal link may be the other way around, and perhaps it is the performance that creates the cohesion (MacCoun and Hix 2011, 114): the better the performance, the better the cohesion of the group. This is reinforced by the fact that the inscriptions from both sites relate to performance locations—a rifle range with targets at Rowcroft, and a gymnasium next to an area for games and sports at Sandhurst—buildings and areas that lend themselves to performance achievements. We do not know why the trainees carved their names, but if it was related to a particular reward, there are various scenarios, such as earning the highest individual score, best individual improvement,

or highest group score. The names may even have been a sporting "Roll of Honor," which is more relevant at Sandhurst because the racket court was in the middle of an area of sport. That there was a sense of pride associated with the inscriptions is also shown by the complete absence of rude words or swearing: these inscriptions are not latrinalia from the back of a toilet door (see Rodriguez and Meade in this volume).

A final point relating to the two buildings at Sandhurst and Rowcroft indicates that the inscriptions were more than just idle graffiti: both buildings were relatively new when inscriptions were carved. The hut at Rowcroft was built between 1936 and 1945 (the date of the earliest inscription), with the majority of inscriptions dating to 1953. At Sandhurst, the five earliest dated inscriptions are from 1857, the year the racket court was started. It may be that Sandhurst cadets were continuing a tradition from elsewhere; that they were allowed to carve their names on the brand new building at least suggests an element of permission, and it may be they were even "inaugurating" the building.

The context of the calliglyphs at the Rowcroft range hut and Sandhurst gymnasium is therefore a key component of understanding their significance. While certainty can never be final, there are instances that writing on walls and surfaces need not have the overtones of illegality that the term *graffiti* has today, and it is for this reason that the term *calliglyph* has been devised. I argue earlier in this chapter that the majority of inscriptions at the Rowcroft range hut and on the racket court at Sandhurst are calliglyphs, which were permitted inscriptions, whereas the inscriptions on the Rowcroft gate piers were not permitted and thus can be classed as graffiti.

A Wall in Mexico City's Historic Center: Calle Regina 56

PAMELA SCHEINMAN

Introduction

In this chapter I analyze the first five years of a legal street art project in downtown Mexico City, focusing on the plywood-boarded façade of Regina 56, six streets due north of the Zócalo, or main square, where a graffiti mural has been painted approximately every three months since 2009. Within the three pedestrian blocks of Regina, as well as on San Jerónimo, the street directly behind it, several painted cement walls form a changing gallery of contemporary spray-can art. What are the advantages and pitfalls of such a scheme? How does it fit into the comprehensive Master Plan for the Historic Center, proposed in 2001 and implemented in five-year stages, that seeks to secure and revitalize the area (i.e., gentrify a former working-class neighborhood)? And what image of Mexico does its graffiti convey in a period of rampant globalization?

Background

Like its early predecessors in Los Angeles and Philadelphia,[1] the original series of artistic interventions at Regina 56 began as an anti-graffiti measure to prevent further deterioration of rundown property and preserve nearby landmarked colonial architecture.[2] In 2002 a powerful group of businessmen commissioned the consulting firm of former New York City mayor Rudolph Giuliani to propose improvements to public security in Mexico City. The Giuliani Plan reclassified misdemeanors as crimes and called for "zero tolerance."[3] Graffiti was viewed as an act of vandalism and antisocial behavior

Understanding Graffiti edited by Troy Lovata & Elizabeth Olton, 219–231. © 2015 Taylor & Francis. All rights reserved.

based on the "broken windows theory," which set strict norms for maintaining and monitoring a well-ordered urban environment.[4] Swift implementation of a similar plan in New York had cut crime by a dramatic 10% to 15% in one year (see chapters by Gopinath, Mitman, and Daniell in this volume).

In adopting Giuliani's recommendations, authorities questioned whether the prescription fit the Mexican case. For example, the Anti-Graffiti Squad set up under the Department of Public Safety conducted an unexpected test by sponsoring a graffiti-sketch contest in 2008.[5] On one level an obvious ploy to register graffiti writers and identify their styles resulted in direct dialogue with youthful artists. Subsequent interviews convinced superiors that adolescent tagging was not encoded with criminal or gang messages. The next year a full-blown competition, organized with police personnel at the prestigious Aztec Stadium (Estadio Azteca, site of the 1968 Summer Olympics, as well as World Cup soccer finals in 1970 and 1986), got massive press coverage. As a result, the "anti-" was dropped from the squad name, more legal outlets for spray-painters were sought, and public perception became slightly more positive. These encounters fostered exchange among street painters, allowing them to hone their aesthetics and master large-scale compositions. Beginning in 2009, annual graffiti competitions have taken place at the stadium, with winners' artwork exhibited in area museums. Cultural centers, youth associations, and district officials sponsored several other graffiti contests.

The embrace of a populist art must also be framed within the local political arena. Mexico City is an oasis of liberal rule by the Party of the Democratic Revolution (Partido de la Revolución Democrático; PRD), under successive conservative National Action Party (Partido Acción Nacional; PAN) and establishment Institutional Revolutionary Party (Partido Revolucionario Institucional; PRI) presidencies.[6] When Andrés Manuel López Obrador was elected head of the Federal District (D.F.; similar to the District of Columbia in the United States) in 2000, he infused generous funding for popular culture into marginalized and depressed areas of the city, a policy that benefited his working-class constituency. El Faro de Oriente ("Lighthouse of the East") emerged as a showcase of transformation and enfranchisement when the former sewage filtration plant became "a factory for arts and trades," roughly modeled on the Bauhaus.[7] Its massive rectangular exterior was covered with murals by the new artist collective Neza Arte Nel. The group selected potent Mexican symbolism—the ajolote (axolotl),[8] Virgin of Guadalupe, and revolutionary hero Emiliano Zapata—in an attempt to link traditional Mexican muralism with contemporary graffiti. This official commission encouraged sponsorship of murals on technical schools,

municipal buildings, and other public property. Such projects often were linked to job training in the expectation that graphic arts skills might provide future income.

Most important, real estate and business interests allied themselves with city government in developing and beautifying Mexico City's Historic Center, the largest and most emblematic in Latin America. In 1987, UNESCO designated the downtown area as a Cultural Heritage of Humanity because of its architecture, museum treasures, and famous murals. Multibillionaire entrepreneur Carlos Slim bought and was gradually rehabilitating more than a hundred properties damaged in the September 19, 1985, earthquakes through his private Foundation of the Historic Center of Mexico City (Fundación del Centro Histórico de la Ciudad de México, A. C.). These included the twin buildings at Regina 49-51, which face Regina 56. Since 2004, apartment rentals for artists and writers administered by his foundations, along with construction of a playground and cultural center, boosted the zone's amenities. Overall, property values climbed, some local residents benefited while others were displaced, and middle-class patrons and tourists gradually made Regina Street a destination.

However, an obstacle to the scheduled renovation of Regina 56 arose when the putative owner began squatting there and storing merchandise for street vendors. The notorious *ambulantes* (unlicensed sellers) were another target of zero tolerance. In 2007 the pavement was torn up to replace old drainage pipes and prevent chronic flooding. "Putos" ("faggot," "coward") appeared in huge white letters sprayed on the dirt surface in front of the derelict structure (Figure 15.1). Legible to the new residents, this common curse word spoke of local tensions, a mute protest against property annexation and nuisance citations for infractions. In retaliation, authorities barred entry to Regina 56. The following year, when Regina Street was repaved and closed to vehicle traffic, plywood panels were nailed across the entire street level of the building. Thus, the plan to create a pedestrian "cultural corridor" extending from the Monument to the Revolution through the Alameda Park and along Madero Avenue (with its fine shops and hotels) incorporated Regina as its northernmost point.

The wall became an urban art venue and instant attraction, snapped by thousands of cameras, from cell phones to SLRs and videos posted on YouTube. Its content mirrored both the rapid explosion in graffiti worldwide and Mexico's unique heritage in printmaking and muralism. Figurative work and patriotic themes predominated, but a pluralistic range of imagery and messages found expression. Old-school writers, committed to the clandestine and subversive, stuck to peripheral zones of the city, while the Historic Center

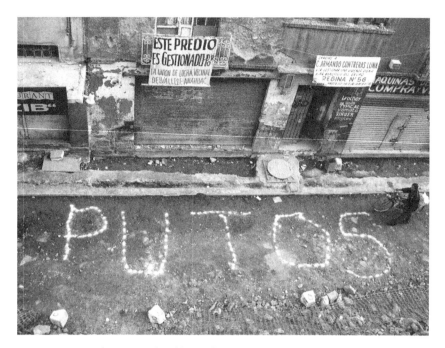

FIGURE 15.1 Unpaved street graffitied "Putos" ("Faggot") before wall construction, 2007. Photo by author.

showcased an emerging generation of graffitists with art credentials and youthful flair. Robbed of the adrenaline rush of "bombing," artists gained a large canvas, time to execute on an ambitious scale, and direct feedback (and suggestions) from a public fascinated by the process (for an interesting counterpoint, see Duncan in this volume).

Redefining Community

The initial mural project involved artist-residents of Regina 49-51 interested in engaging other neighbors. Israel Cortés, who lived in Regina 49, created one of the first murals in October 2008 (Figure 15.2). The simple landscape—a white ground, two tall trees with red and yellow leaves, a flock of migrating birds, a black silhouetted male figure, and patches of blue sky amid a dense cloud cover—matched the crude lettering running like a subtitle below the sunken horizon line: "Cuando sobrevenga el Fuego, el Fuego mismo discriminará y prenderá sobre todas las cosas" ("When Fire bursts forth, Fire itself will choose the condition and ignite all things"). This fragment of a quote from the pre-Socratic Greek philosopher Heraclitus of Ephesus (ca. 535–ca.

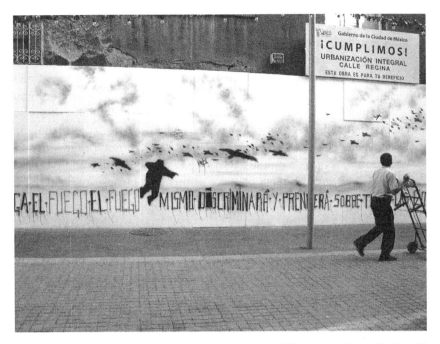

FIGURE 15.2 Israel Cortés, "Cuando sobrevenga el fuego . . ." ("When Fire Bursts Forth . . .") graffiti mural, 2008. Photo by author.

473 BC) insists on the ever-changing nature of the universe and fire as the primary element. The Aztecs performed a New Fire Ceremony to rekindle the sun and renew the agricultural calendar every 52 years. So, although the imagery looked like Siberia in autumn, the concept resonated with indigenous cosmology. Like Robert Frost's humble poem "Fire and Ice," the quote was meant both to stimulate metaphysical thought and reflect on the condition of urban space in constant flux. It is a metaphor for the changes taking place on Regina, and perhaps a bandaging over of the previous controversy. In retrospect, the wistfulness of the message also anticipated the current Mexico City trend in graffiti poetry and inspirational phrases.[9]

At Regina 56, three installations on local urban themes alternated with graffiti murals, two of which were photographic. Claudia Adeath's January 2009 "El rostro cambia cuando tiene nombre" ("The Face Changes When It Has a Name") portrayed Regina merchants in color enlargements, identified them by name, and included a mirror to reflect the face of the viewer. Oaxacan photographer Alejandro Echeverría mounted more than 200 color abstractions of walls and drains, printed on adhesive-backed vinyl in different formats. "El Centro" (August 2009) challenged the onlooker to create

his own visual excursion. The third, "Des-prenderse" (November 2009), by María Ezcurra (b. 1973 Buenos Aires, but a resident of Mexico City since 1978), invited the public to "detach" clothing hung on the wall. As intended, the installation disappeared. People carried off items of dress, sometimes trying them on in the street. These installations engaged the passersby in a more intimate connection with the street and its inhabitants. They also posed questions about identity, community, and recycling—issues at the core of a redevelopment plan that on paper sought neighborhood cohesion, participation in governance, and better services. Featured artists showed their commitment to working in public space while simultaneously navigating the art world.

At first, cultural promoters Antonio Calera-Grobet and Jessica Berlanga proposed an ambitious list of six to eight projects for July 2009 through March 2010. Calera-Grobet served briefly as director of Casa Vecina, a progressive art center a half-block from the wall. Hosteria La Bota ("Boot Tavern"), a lively literary hangout that Calera-Grobet co-owned with a brother, operated on the ground level. La Bota moved one street north, to San Jeronimo 40, but continued to schedule and feed artists working on site. The Historic Center Trust of the City of Mexico (Fideicomiso Centro Histórico de la Ciudad de México), a city agency that funds and promotes the project, gradually increased its curatorial role. Staff members Hugo Alejandro Gómez Partida and Manuel Flores Osorio reached out to youth-oriented institutions such as Happy People Gallery and Central del Pueblo. Overall, the goal has been to expose the public to a democratic gamut of fresh artistic expression. To date, that has included pictorial and sculptural interventions, but not tags, throw-ups, pieces, or stickers.

Mexicanist Themes

In 2005, printers, sewing machine suppliers, small grocers, butchers, and a few repair shops lined Regina Street, which was considered a marginal outpost. Yet, despite its makeover—interspersed with snack bars, beer joints, and small restaurants—or perhaps because of it, the wall at Regina 56 displays subject matter accessible to all. The emphasis on Mexican symbols and historical themes resulted partly from timing. In 2010 the city and nation celebrated the start of historic insurrections: the bicentennial of the Mexican War of Independence from Spain and the centennial of the Mexican Revolution. A similar yearlong series of exhibits and events commemorated the famous caricaturist José Guadalupe Posada and his satirical skeleton prints in 2013. These joyous outpourings counterbalanced international reporting

on drug-war violence. Moreover, they consolidated efforts to consecrate the Historic Center as a cultural mecca.[10]

In March 2010, seven members of the Collective PIB ("producto interior bruto" means gross domestic product or GDP, an economic index of a country's wealth) created a colorful, complex, and satirical graffiti mural at Regina 56 (Figure 15.3). The extravagant Pop Art collage referenced identity and diversity along with key events in Mexican history. It was like a visual pop quiz. The country's great monuments—the Pyramid of the Sun at Teotihuacan, colossal Olmec heads, the Metropolitan Cathedral, National Palace, Angel of Independence, and Latin American Tower—loomed over naked indigenous protesters from the 400 Pueblos, figures of revolutionary leaders Emiliano Zapata and Pancho Villa, a bearer of the 1968 Olympic torch, former president Carlos Salinas de Gortari (1988–1994, a technocrat whose privatization policies caused the 1994 peso plunge and hemisphere-wide "Tequila effect"), masked lucha libre wrestlers, and film goddesses, among others. Smack in the middle was a full-length gay couple kissing, because the centennial and bicentennial festivities coincided with the passage of a same-sex marriage

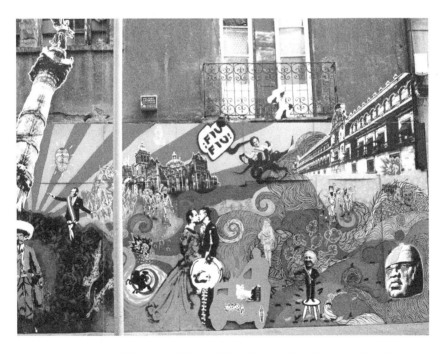

FIGURE 15.3 Colectivo PIB bicentennial mural (detail), mixed media, 2010. Photo by author.

law in Mexico City. The aesthetic was as over the top as the annual Gay Pride March or Zombie Parade through downtown streets. It was also blatantly Mexican: ironic, self-critical, and deliriously fun.

Composed of wheat paste, silkscreen, stencil, and sprayed elements, the mural's technique elaborated on the assemblage graffiti mural "Xólotl" (2000) created by the art collective Neza Arte Nel for the 1,000-meter façade of El Faro de Oriente, which, in turn, drew upon historic narrative and symbolism of Mexican muralism from the 1920 and 1930s. It also showed advances made possible by computer technology and Internet imagery. The resurgence of artist collectives is noteworthy: like a graffiti crew, a group can create elaborate compositions and quickly cover large areas. More significantly, collectives tend to express polemical concerns, whereas much contemporary graffiti favors design over political and social messages (with the obvious exception of slogans and stickers posted by demonstrators).[11] Today's collectives inherit a strong muralist tradition that spans from prehispanic wall painting to artist-activists painting Mexico City neighborhoods after the 1968 student movement[12] (i.e., Grupo Suma[13] and Tepito Arte Aca[14]).

At Regina 56, another mixed-media mural took the nearby Merced market[15] as its theme. "Untitled" (June 2009), by the Oaxacan collective LaPiztola,[16] featured a huge boy with an aerosol can crouched on a black ground. To his right were cutout figures of a sweeper, hauler, food cart operator, and reclining homeless man on a pattern composed of hundreds of tiny Zapata heads. It left multiple readings to the viewer: the rough-and-tumble street life, the heroic work of common laborers, and the unattained goals of the revolution that displaced peasant-farmers into urban areas throughout the twentieth century, turning Mexico City into the megalopolis it is today. Superseded decades ago by a vast wholesale market on the city's outskirts, La Merced looks like a nostalgic artifact of the past, made famous as a set in several film classics such as Luis Buñuel's *Los Olvidados* (1950), but remains a vital commercial area and a refuge for new immigrants. One subway stop from the Regina wall, it, too, has become a local icon.

International Exchange

Versions of how graffiti came to Mexico City stress its U.S. roots. In the 1970s, tags marked boundaries between rival street gangs in both Neza and Iztapalapa. Middle-school students in the 1980s painted tributes to their favorite rock bands with house paint and brushes on cement retaining walls in outlying neighborhoods like Santa Fe. Territorial styles evolved at the city's periphery, incorporating influences from New York "wildstyle" and Chicano

symbolism from California via Guadalajara. Helen Somers from the Los Angeles–based Earth Crew 2000 taught aerosol techniques and mural design to youth groups in D.F. from 1991 to 1994.[17] This experience improved skills and brought crews together. With limited colors available, Mexican graffitists developed sophisticated methods for injecting enamel from one aerosol to another, using cans from hairspray and cleaning products, and customizing caps with needles. Before the Internet, inspiration came from film, magazines, and group expos such as the pioneer one organized by Neza writers on August 5, 1995.[18] After that, everything accelerated. By the 2000s, a wider range of products became available, new artists emerged with some formal university training, and politicians and curators began paying attention. Opportunities to travel and invitations to paint abroad increased. As street art entered galleries, museums, and auction houses, outdoor mega-events proliferated.

In May 2012, the Museo de Juguete ("Toy Museum"), along with the collectives Arto and Mammut, coordinated All City Canvas, the first major international festival of urban art with corporate sponsorship in downtown Mexico City. That same year, the magazine *Juxtapoz* began publishing its first Spanish-language online edition from an office in D.F. Mexico clearly had become a focus of international attention. Seven foreign artists and two Mexicans painted prominent downtown walls, including skyscrapers, along or near the Paseo de la Reforma.[19] Herakut, the German graffiti duo of Jasmin Siddiqui (Hera) and Falk Lehmann (Akut), created "El Pasado Puede Ser Un Regalo" ("The Past Can Be a Gift"). Their impression of a Mexican girl was skinny and doe-eyed, clutching a rag doll and Mexican hairless puppy (*xoloescuintle*) under one arm while her other hand dangles a male puppet—the kind sold to tourists—from a string.

Seeking other walls, they were offered Regina 56 on the spot. Their second idealized portrait showed a ponytailed girl in profile, slouched against a huge, docile, black xoloescuintle (Figure 15.4). A miniature self-portrait doll sat on her tummy. Mexicans found this sentimental rendering in muted colors appealing. Perhaps a bit of *malinchismo* (preference given to a foreigner's perception) was involved. "Feed the Kids Inside," its official title, proved so popular that it was allowed to stay up for more than a year. Thus, the Regina wall program demonstrated its flexibility and responsiveness to public taste, just as artworks from All City Canvas remained on semi-permanent view.

In July 2013, a well-known Los Angeles graffiti artist obliterated the image with black paint and covered the wall with a matte brick color that matched the pockmarked and faded stucco exterior of Regina 56 (Figure 15.5). With a fluidity that mimicked Palmer Method penmanship, Retna

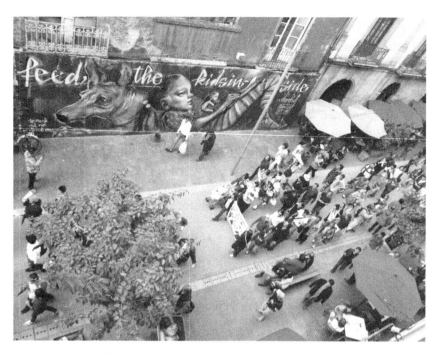

FIGURE 15.4 Herakut, "Feed the Kids Inside" mural and YoSoy132 march, 2012. Photo by author.

(b. 1979, California) sprayed three horizontal rows of his distinct script, inspired by Egyptian hieroglyphics and Arabic, Asian, and Hebrew calligraphy. To the viewer, these white glyphs looked flat, indecipherable, and repetitive. Neighbors predicted it would never last.

Big bubble letters covered the middle section just four days later, and a small yellow tag appeared overnight. In its first five years the Regina 56 venue had commanded respect from the public and graffiti writers, successfully deterring nonpictorial marks. Side streets and a few adjacent buildings had been bombed, but not the murals. Instead of being touched up or immediately removed, the defaced calligraphy remained for almost three months. An odd lapse, given the broken windows theory and the fact that a beloved mural just down the block, sponsored by a different foundation, was immediately restored after being hit with a thin streak of red enamel! In this case, the street weighed in as critic, more a thumbs-down than a "look at me" gesture (see connections to this "editorial" style of clustering in the chapters by Rodriguez and Mead in this volume).

FIGURE 15.5 Retna, calligraphy mural, 2013. Photo by author.

Emerging Artists

A drawing by Rodrigo Gómez (aka Dirty Mind), submitted for a wall on San Jerónimo, was chosen to replace the Retna calligraphy at Regina 56 in mid-September 2013 (Figure 15.6). It featured a horizontal, floating, barefoot female with compact body and short muscular legs. Her straight black hair, skin tone, and profile identified her as indigenous. She could have been one of the many young women hired to clean house and tend children who gather outside the nearby Pino Suarez metro station or Alameda Park on their Sundays off. Paying homage to ethnic culture rooted in rural village life is the artist's central theme. Gómez always works alone; the project took three weeks to spray paint. He incorporated suggestions from the public to fill the blue background with clouds, changing it from liquid to air, and to color the skirt jade green with geometric patterns, a symbol for the Aztec water goddess Chalchiuhtlicue. Originally he had planned to paint the missing hand on the building above. Instead, logistical problems left the powerful figure

FIGURE 15.6 Dirty Mind (Rodrigo Gómez), "Muchacha flotando" ("Girl Afloat"), graffiti mural, 2013. Photo by author.

unfinished, vulnerable. The fixed, upward gaze lent an air of mystery, like an El Greco saint.

The composition seemed to emphasize the difficulty of stepping back in the narrow street, crowded with pedestrians and lined with café tables and umbrellas. The interaction with passersby proved rewarding, just as Gomez's performance turned the street into action painting or theater. The YouTube video recording the process recalled photographs of tourists watching Diego Rivera paint at National Preparatory School, now the Museum of San Ildefonso, behind the Zócalo. For a self-taught artist, the opportunity to work large, get feedback, and learn from mistakes was invaluable in building a portfolio and finding new venues.

Conclusion

By creating a space for many voices and images, open to established visual artists and emerging talents, the wall at Regina 56 invites dialogue on contemporary issues and raises the bar for graffitists. At least that has been the expectation, one that has made urban art a category acceptable to policymakers. Among the proliferating number of venues, exhibits, events, publications, and online sites, the murals painted at Regina 56 occupy a middle ground. During the first five years there has been a sustained focus on forging links with the local neighborhood, reaffirming Mexican identity, and

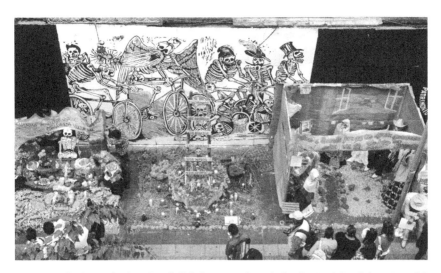

FIGURE 15.7 "Calavera las bicicletas" ("Skeletons on bicycles"; after José Guadalupe Posada) with Day of the Dead Altars, November 1, 2013. Photo by author.

promoting emerging Mexican artists and collectives (Figure 15.7). These goals have been consistent with the populist cultural policy of governing PRD officials and the gradual rise in downtown property values in general. Painters have gained larger spaces and more time to create bold, sometimes complex projects in direct contact with an audience. Overall, the results appear technically innovative, provocative, varied, and newsworthy. This wall and others nearby have contributed to the ongoing process of urban renewal and gentrification, while creating an aesthetic dialogue with graffiti from the periphery.

NOTES

Introduction

1. This is not to disavow the quality and engaging research that serves as a foundation for this endeavor. Works that inspired us to create an edited volume and gave us models from which to define this expression and organize the text for this book include: *Ancient Graffiti in Context* by J. A. Baird and Claire Taylor (2011); *Getting Up: Subway Graffiti in New York* by Craig Castleman (1984); *The Faith of Graffiti* by Norman Mailer and Jon Naar (1973); *Graffiti and the Writing Arts of Early Modern England* by Juliet Fleming (2001); Elizabeth Frood's "Egyptian Temple Graffiti and the Gods: Appropriation and Ritualization in Karnak and Luxor" (2013); and *Wild Signs: Graffiti in Archaeology and History* by Jeff Oliver and Tim Neal (2010).

Chapter 3

1. For a list of scenes and a consideration of Arborio's Passion cycle in the context of the cycles produced in the Duchy of Savoy, see Plesch (2004, *passim*).
2. On the pictorial decoration of small rural chapels in the area and their meaning, see, for instance, Mazzini and Romano (1976), Natale (2005), and Plesch (2004, 2006a).
3. For bibliography on Cagnola as well as a list of his works, see Natale (2005, 72).
4. For instance, repainting some faces; see Natale (2005, 68) for a list of the alterations.
5. See my articles listed in the references. I have suggested that to study graffiti, one should follow an analytical protocol based on the simple questions of what, where, when, how, by whom, and why (Plesch, 2010, 147–157).
6. In Plesch (2010, 154), I explain why the practice stopped at the end of the nineteenth century, when the chapel was condemned because of the roof threatening to collapse.
7. I've had the occasion to publish and comment on examples in chapels in villages near Arborio and further afield, for instance, in more famous sites such as San Zeno in Verona and the basilica of San Giulio on the lake of Orta (Plesch 2007, 54–56, Figs. 3–7 and 3–8; 2002a, Figs. 9–10; 2002b, Figs. 9–10).
8. Although Beatrice Radden Keefe, in her entry on medieval graffiti (n.d.), notes: "Not always illicit or destructive, graffiti was made to ward off danger, to note important events, to show the graffitist's presence in a place, and sometimes for no apparent or particular reason." See also Tedeschi (2012, 7), who similarly disputes this received conception, suggesting that it has more to do with contemporary mentalities than with medieval realities, and Frood (2013, 286), whose working definition of graffiti in Egyptian temples as an inscription on a surface "that was not originally intended to receive it . . . differs from many modern western perceptions of graffiti as illicit, counter-cultural, and often subversive."
9. Bartholeyns et al. (2008, 99–108) discuss (and pretty much reject) a transgressive function for medieval graffiti.
10. Of the 16 textual graffiti on St. Anthony (there are also some coats of arms and soldiers' heads), all but one contain dates that could be deciphered, of which three are from the sixteenth century, two from the seventeenth century, and eight from the eighteenth

century. On St. Sebastian there are 14 graffiti, all with dates: one from the sixteenth century, eight from the seventeenth century, and five from the eighteenth century.

11. For details on literacy in Arborio, see Plesch (2010, 155–156).

12. The town's coat of arms also appears a few times.

13. Formentin gives several examples dating from the fifteenth and sixteenth centuries from a range of locales (2012, 101).

14. For an agonistic dimension in word and image relations, see MacLeod et al. (2009), where "Conflict" was one of the sections structuring the volume. For an excellent introduction on word and image, see Mitchell (1985).

15. In several of my articles on Arborio, I have addressed the violence inherent in this practice. See, for example, Plesch (2002b, 183–184, 187-88; 2014).

16. Discussed in Plesch (2002a, 137), with Figures 12 and 13 reproducing two examples.

17. For graffiti as appropriation, see Plesch (2002b).

18. In addition to San Sebastiano, I have so far been able to record around 60 instances of sites with late medieval and early modern graffiti on fourteenth- and fifteenth-century frescoes in western Europe (this catalog is far from being comprehensive and for the reasons I just mentioned, information is lacking). Geographically, there is a strong concentration in northern Italy and neighboring regions, with Lombardy, Piedmont, and the Ticino Canton in Switzerland leading, with other examples elsewhere in Italy, as well as in France, England, and Spain. The graffiti in the Castle of Issogne in the Val d'Aosta form one of the rare ensembles to have been published in a comprehensive manner by Omar Borettaz (1995). In her thesis for the Laurea, Barbara Villa (2010) studied two sites in Lombardy: the church of San Francesco in Lodi and the oratorio di Santo Stefano in Lentate sul Seveso, fleshed out with some additional examples.

19. In Plesch (2007, 43), I give the example of graffiti on Giotto's very famous frescoes in the Arena chapel in Padua, for which the only mention known to me is by Luisa Miglio and Carlo Tedeschi, who identify them as being by early German travelers (Miglio and Tedeschi 2012, 618).

20. For instance, can altarpieces, when displayed in a museum, without an altar below and without the ritual they are meant for, truly be understood?

21. See examples reproduced in Plesch (2010, Figs. 6.6–6.8).

22. See, for instance, Gamboni (1997), Groebener (2008), and the exhibition at the Tate Gallery, *Art under Attack: Histories of British Iconoclasm* (3 October 2013–7 January 2014) and its accompanying catalog (Barber and Boldrick 2013).

23. The small Piero della Francesca exhibition at the Metropolitan Museum of Art in January–March 2014 shows how this state of affairs is changing: although recently restored, the four paintings in the show have all suffered from heavy abrasions to their pictorial surface (see Christiansen 2014).

24. See, for instance, my remarks in Plesch (2006b).

25. In that sense graffiti on paintings—and more specifically on bodies such as those of saints—call to mind tattooing; see Plesch (2002b, 187–188; 2014).

26. A sentiment shared by Mieke Bal: "In the tripartite relationship between student, frame, and object, the latter must still have the last word" (2007, 2).

27. Held at the Germanisches Nationalmuseum in Nuremberg, Germany, in July 2012. See also Jerôme Baschet's concept of "image-objet" (Baschet 1996).

28. Although published in 2005, it was first formulated in 1997 as a talk delivered to a group of medievalists from the state of Maine; because of my colleagues' positive response and questions, I decided to go back to Arborio and start in earnest recording the inscriptions and analyzing the corpus.

29. "Les espèces sont choisies non commes bonnes à manger, mais comme bonnes à penser" (Lévi-Strauss 1962, 128), translated as "We can understand, too, that natural species are chosen not because they are 'good to eat' but because they are 'good to think'" (Lévi-Strauss 1963, 89). His translator, Edmund Leach, discussed this phrase (1989, 31–32, 44).

Chapter 8

1. New York was only one of the cities in the United States where young people started to write graffiti seriously in the 1960s. In *History of American Graffiti*, Roger Gastman and Caleb Neelon (2010) suggest that Philadelphia has a stronger claim to be identified as the cradle of the art. By the 1970s, graffiti scenes were thriving in many East Coast cities including Baltimore, Boston, Cleveland, Pittsburgh, and Washington, DC. That said, wildstyle writing originated in New York, and it remained a quintessentially New York form. For an overview of the chronology, see Gastman and Neelon (2010, 48–53).

2. When I reference a "classic era" of New York City graffiti writing, I am using the periodization advanced by Gastman and Neelon (2010, 86).

3. My reference to mannerism is indebted to the classic text by Hauser (1986).

4. Perhaps the first to proffer such an interpretation was Jon Naar, Mervyn Kurlansky, and Norman Mailer in their photoessay *The Faith of Graffiti* (1974).

5. Public art became highly politicized during the culture wars of the 1980s and 1990s. Art-related situations that generated controversy included the 1989 demolition of Richard Serra's site-specific sculpture *Tilted Arc*, John Frohnmayer's 1989 vetoing of National Endowment for the Arts (NEA) funding for the performance artists later known as the "NEA 4" (Karen Finley, Tim Miller, John Fleck, and Holly Hughes), and the 1992 outcry over John Ahearn's cast bronzes in the Watson Avenue neighborhood of the South Bronx.

6. Influential documentary treatments of wildstyle graffiti from the 1980s include the films *Style Wars* ([1983] 2003) and *Wild Style* ([1983] 2002); Craig Castleman's *Getting Up: Subway Graffiti in New York* (1984); and Martha Cooper and Henry Chalfant's *Subway Art* (1984).

7. "In the 14th century the monks ornamented and illustrated the manuscripts of letters. In the 21st and 22nd century the letters of the alphabet through competition are now armamented for letter racing and galactic battles. This was made possible by a secret equation known as THE RAMM—ELL—ZEE" (RAMMELLZEE 2012). RAMMELLZEE wrote in another context: "In medieval times, monks ornamented letters to hide their meaning from the people. Now, the letter is armamented against further manipulation" (RAMMELLZEE 1993, 20 in Dery 1994, 183).

8. This time estimate was advanced in Cooper and Chalfant (1984, 34). Writers' use of preliminary sketches is documented in *Wild Style* and *Style Wars*; one of the opening scenes of the latter film takes place at the "Writers' Bench" in the Bronx, a place where writers would gather to share sketches and talk about style. Ivor L. Miller discusses the

importance of the writer's notebook and reproduces numerous writers' sketches in *Aerosol Kingdom: Subway Painters of New York City* (2002).

9. Several writers have reminisced about bracing in between parked cars in this way; see Miller (2002). Henry Chalfant made a particularly iconic photograph depicting the practice (reproduced in Cooper and Chalfant 1984). It is also documented in *Style Wars*.

10. "The Mayor said it was 'the Lindsay theory' that the rash of graffiti madness was 'related to mental health problems'" (*The New York Times* 1972). On the "personalized" character of the war on graffiti during Lindsay's administration, Mailer wrote, "How could he call the kids cowards? Why the venom? It seemed personal" (Naar et al. 1974, 23).

11. For an assessment of "Broken Windows'" reception, see Harcourt and Ludwig (2006).

12. Originally voiced in *Style Wars* ([1983] 2003); see Gastman and Neelon (2010, 23).

13. Several authors have compiled evidence to the effect that graffiti writers of the 1980s constituted a racially and culturally diverse group, such as Miller (2002); Castleman (1984); Cooper and Chalfant (1983); and the film *Wild Style* ([1983] 2002).

14. For another treatment of the same theme, see James and Villorente (2007, 10).

15. See statements by writers MARE 139, VULCAN, SHARP, and LEE in Miller 2002, 78–79, 82–83, 86).

16. In outtakes from *Style Wars* ([1983] 2003) on Disc 2, KASE 2 elaborates his theme, pointing to a burner study penciled in miniature in his sketchbook: "See how I got the smoothness camouflage? You see how A look like camouflage, real neat . . . dippin' through there with the S . . . You know, that shows you the art."

17. ". . . The wind-up, the freeze, when your legs twist and lock, just the way your body is and contorts, the way your body is positioned and contorted is definitely inspiration for, like, letters. For me, I mean, a baby is, like, a D, with two locks, wrapped around, coming out with arrows. Like you know, in boogyin', like you know, when you do waves—I picture you're doing an S, or an A…. More so with lockin' and poppin'—the body's moving in different positions that are like letters" (DOZE [aka Doze Green] from a 2002 interview included in new material on the 20th-anniversary re-release of *Style Wars* [1983] 2003).

18. In an outtake from *Style Wars*, when the famed writer DONDI describes a burner in detail he emphasizes the details on the letters' weaponry: "This is an arrow, which actually fires. And this is like . . . some type of . . . machine gun you would have. It actually shoots, like, rays. And this thing is also like a machine gun. And this piece right here, this is like a gauge or hinge. This thing is supposed to do, like, a full 360, so it could even, like, defend itself from behind or side or whatever. If it was actual, you know, if it was real, this would be a weapon. And this particular letter would be able to . . . defend itself" (see outtake material included on the 20th-anniversary re-release of *Style Wars* [1983] 2003).

19. My use of "paradigmatic" here draws on Ferdinand de Saussure's theory of semiotic analysis as constituted on two axes. The horizontal *paradigmatic* axis is where sense is conveyed through words' position in relation to one another; the vertical *syntagmatic* axis is where meaning can be conveyed through associative relations or substitutions. See de Saussure [1916] 1974, 122, [1916] 1983, 121).

20. RAMMELLZEE's theories were repeatedly referenced by fellow writers. The writers LEE and KOOR cite RAMMELLZEE in interviews reproduced in Miller (2002, 83, 85). DONDI describes RAMMELLZEE's theories in an outtake included on the 20th-anniversary re-release of *Style Wars* ([1983] 2003). DOZE refers to RAMMELLZEE in a 2002

interview also included as new auxiliary material on the 20th-anniversary re-release. In addition to influencing wildstyle graffiti writers and break dancers, RAMMELLZEE has also been cited as an influence by early hip-hop MCs. Miller cites the rapper KRS-1 to this effect (2002, 59).

21. To his credit, Mailer complicates this popular understanding even as he accepts the validity of its central tenet: see Naar et al. (1974, 6–7). Names have been important in graffiti writing for complex reasons that lie outside the scope of this essay. Some wildstyle writers' approach to naming was strongly influenced by naming practices that are unique to the cultures of the African diaspora. For an in-depth treatment of these influences, see Miller (2002, 51–69). These practices have been inflected by the forcible destruction of African subjects' original languages and cultural traditions under slavery and subsequent apartheid regimes, as well as by the existence of multiple naming traditions within some African cultures. Writers in the 1970s became aware of these traditions through the Black Power movement's emphasis on reclaiming African traditions and names. The 1966 invention of Kwanzaa by Maulana Karenga comes out of this discourse. So does Cassius Clay's 1964 name change to Muhammad Ali. So does Malcolm X's refusal of his "slave name" and embrace of the open-ended signifier "X" in its stead, described in *The Autobiography of Malcolm X* (Malcolm X and Haley 1965). The suggestion that these histories are relevant to all graffiti writing remains a matter of dispute, as historians and writers disagree substantially regarding the extent to which African-American culture has influenced the development of graffiti writing and the degree to which graffiti writing may/should be considered an intrinsically African-American art form. For a brief account of this controversy see Miller (2002, 16–17, 70–87).

22. The career of the famed early writer TAKI 183 from around 1969 to 1971 exemplifies this phase of graffiti's evolution. The seeming omnipresence of TAKI 183's throw-up tags in the summer of 1971 prompted the *New York Times'* first article on graffiti, "'TAKI 183' Spawns Pen Pals" (1971).

23. This reprised a shift that had happened in the art world 20 years before, when abstract expressionists' emphatic, ecstatic assertions of personal identity began to give way to skeptically motivated explorations of language and visual experience. At midcentury, multiple artists noted the similarities between modernist modes of expression and graffiti writing; see, for instance, William Faulkner interviewed by Jean Stein (1956). The many pictures of graffiti taken in the 1950s and 1960s by abstract expressionist photographers Aaron Siskind and John Gutmann also testify to this sense of common cause.

24. See Claes Oldenberg's frequently cited description of standing on a dank subway platform when "all of a sudden one of those graffiti trains slides in and brightens the place like a big bouquet from Latin America" (Goldstein 1973).

Chapter 9

1. In this chapter, the terms "graffiti" and "street art" are used interchangeably.

2. In fact, *Liquidated Version* was the inaugural exhibition of the De Buck Gallery, which has since moved to a ground-floor location down the street from the original site.

3. "Ils m'imposent leurs images, je leur impose ma manière de les voir."

4. Soja defines "thirdspace" as space in which "subjectivity and objectivity, the abstract and the concrete, the real and the imagined, the knowable and the unimaginable, the repetitive and the differential, structure and agency, mind and body, consciousness and the unconscious, the disciplined and the transdisciplinary, everyday life and unending history."

5. Studies undertaken by Pierre Bourdieu and Alain Darbel in the 1960s, published in *The Love of Art* (1999), concluded that people of higher socioeconomic standing generally attended museums and galleries more frequently and from an earlier age, and that individuals in this group felt more comfortable in these spaces than those of lower socioeconomic standing because they have acquired greater "cultural capital."

Chapter 11

Sub rosa is a term that captures the meaning of ancient Maya graffiti from Room 9 within Maler's palace. My mentor and friend, the late Flora Clancy, suggested its use here. I dedicate this chapter to her memory.

1. Cranial deformation was a marker of elite status. The process involved wrapping an infant's head and creating a slant in the forehead backward at a slight angle.

Chapter 13

1. It was common practice at that time for graffiti writers to write the street number where they lived after their chosen name: Taki 183 lived on 183rd Street, Julio 204 lived on 204th Street, Cay 161 and Junior 161 both lived on 161st Street, etc. This practice fell out of fashion as graffiti became more criminalized, since it gave the authorities a street where they could locate the graffiti writer.

2. It is important to note that the mayor's office has no authoritative control over the MTA's operations or budget allocations. The mayor's office works with the MTA and asserts power through political pressure and subsidies when it needs the MTA to change its position or policy on something.

3. While this case got only minor media coverage, many artists have remembered or paid tribute to Michael Stewart after the incident. Radio Raheem suffers the same police treatment and consequent death as Stewart in Spike Lee's *Do The Right Thing*. Lou Reed pays homage to him in his song "Hold On" with the lyrics, "The dopers sent a message to the cops last weekend/They shot him in the car where he sat/And Eleanor Bumpurs and Michael Stewart must have appreciated that," and both Jean-Michel Basquiat and Keith Haring created paintings in remembrance of Stewart and the incident.

Chapter 15

1. Social and Public Art Resource Center (SPARC), Los Angeles, formed in 1976 by Judith F. Baca, and the City of Philadelphia Mural Arts, founded in 1984 by Jane Golden, have transformed their cities through extensive mural painting.

2. Historic buildings include the University of Sor Juana Inés de la Cruz, the seventeenth-century Church of Regina Coeli at the corner of Bolivar Avenue, and, further west, the eighteenth-century College of Vizcainas. These buildings fall under the jurisdiction of the National Institute of Anthropology and History, which coordinates its preservation efforts with other agencies of city government and private foundations.

3. For a fee of US $4.3 million, Giuliani Partners LLC issued a report specifying 165 remedial actions to improve public security. Streets were cleared, and violators were jailed and/or fined. Within a year crime had dropped by 8%, below the dramatic 10% to 15% achieved in the Big Apple.

4. In 1982 James Q. Wilson posited this criminological theory based on the idea that vandalism occurs where "no one cares." He conducted an experiment, parking a car with the hood up, without a license plate, in the Bronx, which resulted in its being stripped within 24 hours. However, in Palo Alto, California, neighbors didn't join in the destruction of a similar parked car until the window was smashed a full week later. Independent tests in Albuquerque, New Mexico, Lowell, Massachusetts, and several Dutch cities confirmed these results. This theory has been generalized to explain the "domino effect" of urban deterioration and decay, and its prevention by repairing broken windows promptly and maintaining an orderly appearance.

5. In August 2003 the Secretary of Public Security of the Federal District set up an Anti-Graffiti Unit "to locate, analyze, classify, and describe distinct examples of graffiti." Their mission statement acknowledged "that graffiti is an art form (aerosol art), an expression, a form of youthful public communication, and above all, a social phenomenon, a participatory medium to construct a collective identity and sense of belonging." At the same time, it committed the metropolitan police squad to detect and combat clandestine symbols (related to robbery, drug-trafficking, or other criminal activity) and destruction to third-party property under several articles of the penal code (Article 26, fracc.V 32, 33, 36, 37, 38 of civil law and Article 239 of penal code). At the initiative of coordinator Denisse Mauries (and her boss, Joel Ortega), the Anti-Graffiti Unit co-sponsored the first contest, "Pinta tu estadio" ("Paint Your Stadium"), to decorate the enclosing walls of the Olympic stadium. Out of 960 drawings submitted on a theme related to the stadium, 300 were chosen. Additional spaces were allocated near ticket windows, turnstiles, parking lots (temporary panels), and at the Mexican Football Federation's training center. Cash prizes (15,000, 10,000, and 5,000 pesos) were awarded on January 16. This success also perpetuated annual contests at the stadium (from 2009 to 2013) in cooperation with the Instituto de la Juventud (Youth Institute) and Comex paint company. The Mexico City metro system and Leon Trotsky Museum held exhibits of selected graffiti artwork. The 20 most representative works of the contest were featured in *Las Cosas Chidas Rólalas* (*Cool Stuff, Share Them*, October 7–25, 2009).

6. The PRD was founded on May 5, 1989, by Cuauhtémoc Cardenas and other left-wing former members of the PRI, which dominated Mexican politics for 70-odd years, until the 2000 upset election of President Vicente Fox, candidate of the conservative PAN party.

7. Its mission was to offer free workshops as well as concerts, films, and lectures. The surrounding area did experience a regeneration of sorts, and the Faro model was replicated

in other marginal areas, such as Tlahuac, Indios Verdes, and Milpa Alta. Like the Galeria José María Velasco in Tepito (founded 1951), which showcases a graffiti artist on its façade with each exhibition cycle and has organized ground-breaking shows like *Invasores* (*Invadors*; 2007) and *También las calles son de nosotros* (*The Streets Also Are Ours*; 2013), El Faro del Oriente fosters youthful expression in aerosol and mixed media.

8. Of the 10 original members of Neza Arte Nel, those remaining active included Miguel Angel Rodriguez, Oscar Rivera Meneses, Martin Cruz Cuaya Uriaga, and Aurea Cyntia Jiménez Urbina, whose mentor was the distinguished Neza painter Alfredo Arcos Rivas. They chose as their symbol the *ajolote* (Spanish) or *axólotl* (Náhuatl), an amphibious salamander native to certain Mexican lakes, which is considered a scientific wonder because it can regenerate body parts and reproduce in its pollywog state. As a key symbol, the *ajolote* has been celebrated by exiled Argentine writer Julio Cortázar in a famous short story set in the Paris zoo and also in a book on Mexican identity by scholar Roger Bartra. Ciudad Nezahuacoyotl lies on the dried bed of Lake Texcoco, just east of the D.F. border; this area was a natural habitat of *axólotl*. Measuring up to 30 meters, five *ajolotes* swam across the front entrance to the Faro. Mexican revolutionary hero Emiliano Zapata and the Virgin of Guadalupe, wearing a halo of *ajolotes* in place of rays, adorned the building's back. Neza Arte Nel's successful attempt to define a contemporary Mexican iconography led to other large-scale commissions for the Neza Municipal Complex and the siding of the new Light Rail Line A of the metro system). The *ajolote* mural got lots of media coverage and helped define the Faro's progressive image, as well as enhance PRD standing with youth through its support of populist culture.

9. A good example appeared in May 2013, just around the corner, in yellow letters on the black-painted wall of the National Institute of Fine Arts (Instituto Nacional de Bellas Artes; INBA) music rehearsal hall, which read:

> la muerte es como
> una ecuación
> algebraica
> una serie de
> factores "x" y
> valores "y", sumados
> y mult. divididos,
> y restados que al final
> dan una solución simple
> y definitiva=∅

(death is like/an algebraic/equation/a series of/"x" factors and/"y" values, added/mult[iplied], divided,/and deducted that in the end/give a simple/and definitive answer=∅ /

Poetic Action F[ederal] D[istrict] (Acción Poética D.F.) is a project by the Monterrey writer Armando Alanis Pulido, who paints lyric phrases in black block letters on whited-out walls in Mexico City, such as "Nuestro secreto triunfó" ("Our secret triumphed") or "Condenado a tu lejania" ("Condemned by your distance"). See http://accionpoeticadf. blogspot.mx.

10. The annual Festival of the City of Mexico and the Zócalo International Book Fair, plus monthly open museum nights, are part of a vast roster of regular and special events scheduled in and near Mexico City's main square.

11. Andrés Manuel López Obrador, presidential candidate in the 2006 and 2012 elections, formed the Moreno Party after renouncing the popular leftist YoSoy132 Movement, which protested his defeat in mass rallies and demonstrated for educational and environmental goals, similar to Occupy Wall Street in New York and other American cities.

12. The May 1968 student uprising in Paris spread to cities around the world. On October 2, 1968, government forces massacred protesters—students, professors, laborers, office workers, housewives, and other citizens—in the Tlatelolco housing complex, adjacent to the Plaza de las Tres Culturas (Plaza of the Three Cultures) in Mexico City, 10 days before the Summer Olympics took place in the Azteca Stadium. An annual commemorative march on October 2 continues to generate anti-government slogans and political graffiti, which emphasize the unfulfilled goals of 1968.

13. Grupo Suma (1976–1982), a collective of 22 artists from the Escuela Nacional de Artes Plasticas (ENAP; National School of Plastic Arts), was founded specifically to participate in the X Biennale in Paris. They brought art into the streets, introducing forms of contemporary expression now common such as activist protest (political stencils, painted walls, posters, and flyers), installations, and artists' books. See http://gruposuma1.blogspot.mx/.

14. Tepito Arte Acá (founded in 1974) was an art movement led by Daniel Manrique (1939–2009). Members painted murals in the streets and housing projects reflecting local life in Tepito, which was home to Mexico City's black market and subject of an early study by sociologist Oscar Lewis. The collective also created murals at schools and universities in Mexico City and gained international recognition through projects in Canada, Spain, and France. See http://en.wikipedia.org/wiki/Tepito and www.tepitoarteaca.com.mx/portada.html.

15. La Merced Market takes its name from a 1594 monastery that was largely demolished by the 1860s when permanent buildings were constructed on the site. Additions were made in 1923 and 1957. The Merced neighborhood abounds in colonial churches and is home to Colegio de San Pablo (St. Paul's High School).

16. Oaxaca-based LaPiztola (the name is a pun on "pistol" and "pencil") includes graphic designers Roberto Vega and Rosario Martínez along with architect Yankel Balderas. They combine stencils, silkscreen, and digital images to highlight social and political issues (http://lapiztola.blogspot.com/).

17. Working with disadvantaged youth to channel their expression in creative directions and securing legal spaces has been a priority of programs aimed at combating graffiti. From February 1991 to November 1994, Mexico City's Youth Institute (Instituto de la Juventud) and the U.S. Information Service co-sponsored mural projects in Mexico City. One project was a memory wall to a slain youth on the Hotel Cortés, at the corner of Paseo de la Reforma and Avenida Hidalgo. Hector Rios, who supervised logistics, cited its goals as "youth change" and "a philosophy of endeavor" (www.linkedin.com/in/arternatives). This training promoted the active formation of crews and honing of aerosol skills. See Earth Crew (2000).

18. See Fly testimony in *Aerosol, Muros y Ciudad* (Mexico, 2013), a video directed and produced by Emilio Castillo Díaz. "Old-school" writers insist graffiti remain illegal, in the street, done with aerosol, and free in theme.

19. Participating artists included Roa (Belgium), Escif (Spain), Herakut (Germany), Sego (Mexico), Interesni Kazki (Ukraine), Vhils (Portugal), Saner (Mexico), and El Mac (Los Angeles); see http://allcitycanvas.com/df/.

Personal Interviews, Mexico City

• 25 May 2013: Antonio Luna and Javier Huerta, Ilegal Squad revista de grafiti y arte urbano (Magazine of Graffiti and Urban Art).

• 26 May 2013 Emmanuel Audelo and Victor Mendoza, Colectivo Graffitiarte: 12 × 12 relatos de la escena del graffiti en México (Tales of the Graffiti Scene in Mexico).

• 10 August 2013: Denisse Mauries, ex-coordinator, Unidad Graffiti, Secretary of Public Security

• 19 August 2013: Ricardo Bautista García, director of publicity and public relations, Fideicomiso Centro Histórico de la Ciudad de México (Historic Center Trust of the City of Mexico)

• 22 August 2013: Miguel Mouriño Fajardo, Museo Casa de León Trotsky, Coyoacan

• 31 October 2013: Oscar Rivera and Martin Cuayo, Neza Arte Nel, Ciudad Nezahualcoyotl

• 05 November 2013: Paulina Moreno (aka Minnah), muralist and graffiti writer, Centro

• 07 November 2013: Emilio Ocampo, Happy People Gallery, Condesa

• 10 November 2013: Karla Machado Silver, cultural liaison, Hosteria La Bota, Centro

• 16 November 2013: Ilana Boltvinik, Colectivo TRES, former resident of Regina 51

• 26 November 2013: Hugo Gómez and Mario Flores, Historic Center Trust of the City of Mexico

• 26 November 2013: Rodrigo Gómez (aka Dirty Mind), Centro

• 29 November 2013: Leonardo Cuevas (aka Suker), Centro

E-mail Communications

• Antonio Calera-Grobet and Jessica Berlanga, 21 October 2008, 19 August 2013, and 22 October 2013

REFERENCES

Abel, E. L., and Buckley, B. E. 1977. *The Handwriting on the Wall: Toward a Sociology and Psychology of Graffiti*. Westport, CT: Greenwood Press.

Alexandrescu, Alexandrina D. 1983. *"Tombes de chevaux* et pieces du harnais dans le nécropole gète de Zimnicea." *Dacia* XXVII: 45–66.

Alonso, A. 1998. "Urban Graffiti on the City Landscape." Paper presented at the Western Geography Graduate Conference, San Diego State University, February 14. www.streetgangs.com/academic/alonsograffiti.pdf.

Alpers, P. 1979. *The Singer of the Eclogues: A Study of Virgilian Pastoral*. Berkeley, CA: University of California Press.

al-Shater, K. 2012. *The Nahda Project*. www.currenttrends.org/research/detail/khairat-al-shater-on-the-nahda-project-complete-translation.

Andersson, R., L. Ostlund, and G. Kempe. 2008. "How to Find the Rare Trees in the Forest—New Inventory Strategies for Culturally Modified Trees in Boreal Sweden." *Canadian Journal of Forestry Research* 38: 462–469.

Anti-Graffiti Association. 2013. "Community Clean." www.communityclean.co.uk/news/anti-graffiti-association.aspx/.

Arenson, Karen. 1999. "Princeton Puzzle: Where Have Jewish Students Gone?" *The New York Times*, June 2. www.nytimes.com/1999/06/02/nyregion/princeton-puzzle-where-have-jewish-students-gone.html?.

Arnold, Dorothea, Lyn Green, and James Allen. 1999. *The Royal Women of Amarna: Images of Beauty from Ancient Egypt*. New York: The Metropolitan Museum of Art.

Ashley, K., and V. Plesch, eds. 2002. "The Cultural Processes of Appropriation" [special issue]. *Journal of Medieval and Early Modern Studies* 32.

Associated Press. 1985. "Date Is Set for Officers' Trial in Death of Michael Stewart." *The New York Times*, May 15. www.nytimes.com/1985/05/15/nyregion/date-is-set-for-officers-trial-in-death-of-michael-stewart.html.

Austin, J. 2001. *Taking the Train: How Graffiti Art Became an Urban Crisis in New York City*. New York: Columbia University Press.

———. 2010. "More To See Than a Canvas in a White Cube: For an Art in the Streets." *City* 14: 33–47.

Babeş, Mircea. 1999. „Staţiunea geto-dacă de la Cetăţeni. Descoperiri şi informaţii recuperate." *Studii şi cercetări de istorie veche şi arheologice* 50: 11–31.

Bahn, P. 2010. *Prehistoric Rock Art: Polemics and Progress*. Cambridge, UK: Cambridge University Press.

Baird, J., and C. Taylor, eds. 2011. *Ancient Graffiti in Context*. New York: Routledge.

Bakhtin, M. 1981. *The Dialogic Imagination: Four Essays*. Austin, TX: University of Texas Press.

Bakó, Géza. 1962. "Încă o mărturie cu privire la dominaţia primului stat bulgar la nord de Dunăre." *Studii şi cercetări de istorie veche* 13: 461–466.

Bal, M. 2002. *Travelling Concepts in the Humanities: A Rough Guide.* Toronto, Canada: University of Toronto Press.

———. 2007. "Working with Concepts." In *Conceptual Odysseys: Passages to Cultural Analysis,* edited by Griselda Pollock, 1–12. London: I. B. Tauris.

Bănescu, Nicolae. 1947. "Vechiul stat bulgar și țările române." *Academia Română–Memoriile Secțiunii Istorice* III: 29.

Barber, T., and S. Boldrick, eds. 2013. *Art Under Attack: Histories of British Iconoclasm.* London: Tate Publishing.

Barker, M. 1979. *The Writing on the Wall.* London: John Claire Books.

Barnea, Ion. 2001. "Bizanțul și lumea carpato-balcanică." In *Istoria românilor, III, Genezele românești,* edited by Ștefan Pascu and Răzvan Theodorescu, 29–38. Bucharest, Romania: Editura Enciclopedică.

Bartholeyns, G., P. O. Dittmar, and V. Jolivet. 2008. *Image et transgression au moyen âge.* Paris: Presses Universitaires de France.

Bartra, Roger. 1992. *The Cage of Melancholy: Identity and Metamorphosis in the Mexican Character.* New Brunswick, NJ: Rutgers University Press.

———. 2011. *Axolotiada: vida y mito de un anfibio mexicano.* Mexico City: Instituto Nacional de Antropología e Historia, Fondo de Cultura Económica y Secretaría de Medio Ambiente y Recursos Naturales.

Baschet, J. 1996. Introduction by J. Baschet and J. C. Schmitt. In *L'image. Fonctions et usages des images dans l'Occident medieval,* edited by Jérôme Baschet et Jean-Claude Schmitt, 7–26. Paris: Cahiers du Léopard d'Or.

Bastone, K. 2005. "Aspen Diaries." *Steamboat Magazine,* July. http://steamboatmagazine. com/2005/07/01/aspen-diaries.

Baudrillard, Jean. 1993. *Symbolic Exchange and Death Theory, Culture & Society.* New York: Sage.

Baxandall, Michael. 1995. *Patterns of Intention.* New Haven, CT: Yale University Press.

Beard, S. 1988. *Ski Touring in Northern New Mexico.* Albuquerque, NM: Adobe Press.

Beck, C. M. 2002. "The Archaeology of Scientific Experiments at a Nuclear Testing Ground." In *Matériel Culture: The Archaeology of Twentieth Century Conflict,* edited by J. Schofield, W. G. Johnson, and C. M. Beck, 65–79. London: Rutledge.

Beck, C. M., J. Schofield, and H. Drollinger. 2009. "Archaeologists, Activists, and a Contemporary Peace Camp." In *Contemporary Archaeologies: Excavating Now,* edited by C. Holtorf and A. Piccini, 95–111. Frankfurt, Germany: Peter Lang.

Belting, H. 1984. *Das Ende der Kunstgeschichte?* Munich, Germany: Deutscher Kunstverlag.

———. 1987. *The End of the History of Art?* Trans. C. Wood. London: University of Chicago Press.

Benavides-Vanegas, R. S. 2005. "From Santander to Camilo to Che: Graffiti and Resistance in Contemporary Colombia." *Social Justice* 32: 53–61.

Bennetts, Leslie. 1982. "Celebrities Join Mayor in New Battle against Graffiti Writers." *New York Times,* April 30. www.nytimes.com/1982/04/30/nyregion/celebrities-join-mayor-in-new-battle-against-graffiti-writers.html.

Bica, Ion. 2002. "Informaţii cuprinse în izvoarele bizantine referitoare la situaţia teritoriilor româneşti nord-dunărene în ultima treime a secolului al X-lea, Argesis." *Studii şi comunicări–Seria Istorie* 11: 131–135.

Bigelow, A. 1959. *The Voyage of the Golden Rule: An Experiment with Truth.* Garden City, NJ: Doubleday.

Bilton, Chris. 2013. "Graphic Content: Spray It, Don't Say It." *The Grid,* August 14. www.thegridto.com/city/local-news/graphic-content-spray-it-dont-say-it/

Bischof, H. 1994. "Toward the Definition of Pre- and Early Chavín Art Styles in Peru." *Andean Past* 4: 169–228.

Bishop, C. 2012. *Artificial Hells: Participatory Art and the Politics of Spectatorship.* London: Verso.

Bishop, K. 2013. "Did You Bag a Banksy Bargain for $60?" CNBC, October 14. www.cnbc.com/id/101109791.

Blocker, Jane. 2009. *Seeing Witness: Visuality and the Ethics of Testimony.* Minneapolis, MN: University of Minnesota.

Blotchy, A. D., D. M. Carscanddon, and S. L. Grandmaison. 1983. "Self-Disclosure and Physical Health: In Support of Curvilinearity." *Psychological Reports* 53: 903–906.

Blume, R. 1985. "Graffiti." *Discourse and Literature* 3: 137–148.

Bolliac, Cezar. 1871. Arheologia. *Trompeta Carpaţilor,* September 21.

Bonuso, C. A. 1976. "Graffiti." *Today's Education* 65: 90–101.

Borettaz, O. 1995. *I Grafitti nel castello di Issogne in Valle d'Aosta.* Ivrea, Italy: Priuli and Verlucca.

Bourdieu, P. 1984. *Distinction: A Social Critique of the Judgment of Taste.* Trans. R. Nice. Cambridge, MA: Harvard University Press.

———. 1991. *Language and Symbolic Power.* Cambridge, MA: Harvard University Press.

Bourdieu, P., and A. Darbel. 1990. *The Love of Art: European Art Museums and Their Publics.* Stanford, CA: Stanford University Press.

Bowen, T. 2010. "Reading Gestures and Reading Codes: The Visual Literacy of Graffiti as Both Physical/Performative Act and Digital Information Text." In *Mapping Minds,* edited by M. Raesch, 85–94. Oxford, UK: Inter-Disciplinary Press. www.inter-disciplinary.net/wp-content/uploads/2011/01/vl4ever2141210.pdf#page=97.

———. 2013. "Graffiti as Spatializing Practice and Performance." *Rhizomes* 25. www.rhizomes.net/issue25/bowen/index.html.

Boyd, S. R. 1981. "The Cultural Differences of Female Graffiti." *Journal of the Metropolitan Washington Communication Association* 9: 25–38.

Brass, O. M., and A. L. Roth. 2013. "Graffiti and Resistance: An Exploration of Everyday Acts of Subversion." Paper presented at the Eastern Communication Association Conference, Pittsburgh, PA, April 24–28.

Brewer, D. D., and M. L. Miller. 1990. "Bombing and Burning: The Social Organization and Values of Hip Hop Graffiti Writers and Implications for Policy." *Deviant Behavior* 11: 345–369.

Brown, A. K., and L. Peers. 2003. *Museums and Source Communities: A Routledge Reader*. London: Routledge.

Brown, W. K. 1978. "Graffiti, Identity, and the Delinquent Gang." *International Journal of Offender Therapy and Comparative Criminology* 22: 46–48.

Bruner, E., and J. Kelso. 1980. "Gender Differences in Graffiti: A Semiotic Perspective." In *The Voices and Words of Women and Men*, edited by C. Kramarae, 239–252. New York: Pergamon Press.

Brunvand, J. H. 1972. "Review of *Aspen Art in the New Mexico Highlands: A Photo Essay* by James B. DeKorne." *The Journal of American Folklore* 85: 338, 385–386.

Brunvand, J. H., and J. Abramson. 1969. "Aspen Tree Doodlings in the Wasatch Mountains: A Preliminary Survey of Traditional Tree Carvings." In *Forms Upon the Frontier: Folklife and Folk Arts in the United States*, edited by A. Fife, A. Fife, and H. Glassie Logan, 89–102. Logan, UT: Utah State University Press.

Bush, K. 2013. "'The Politics of Post-Conflict Space: The Mysterious Case of Missing Graffiti in "Post-Troubles" Northern Ireland." *Contemporary Politics* 19: 167–189. www.tandfonline.com/doi/full/10.1080/13569775.2013.785829#.VF1DivnF9y4.

Bushnell, J. 1990. *Moscow Graffiti*. London: Unwin Hyman.

Butculescu, Dimitrie C. 2010. *Călătorii și explorațiuni arheologice în Muscel*, edited by Dragoș Măndescu, 2nd edition. Ars Docendi, Bucharest University. Bucharest, Romania: Bucharest University.

Butigan, K. 2003. *Pilgrimage through a Burning World: Spiritual Practice and Nonviolent Protest at the Nevada Test Site*. Albany, NY: State University of New York.

Butler, J. 1993. *Bodies that Matter: On the Discursive Limits of Sex*. New York: Routledge.

Čangova, Yordanka. 1957. "Tărgovska pomeștenija krai iojnata stena v Preslav." *Izvestija na Bălgarskija Archeologičeski Instituta* 21: 233–290.

Cannato, V. 2009. *The Ungovernable City: John Lindsay and His Struggle to Save New York*. New York: Basic Books.

Canuto, M., and A. Andrews. 2008. "Memories, Meanings, and Historical Awareness." In *Ruins of the Past*, edited by Travis Stanton and Aline Magnoni, 257–273. Boulder, CO: University Press of Colorado.

Cardenas, M. 1995. Iconografia Lítica de Cerro Sechín: Vida y Muerte. In *Arqueología de Cerro Sechín, Tomo II Escultura*, edited by Lorenzo Samaniego, Mercedes Cárdenas, Henning Bischof, Peter Kaulicke, Ermán Guzmán, and Wilder León, 43–124. Lima, Peru: Pontificia Universidad Católica del Perú y Fundación Volkswagenwerk.

Castillo Díaz, Emilio. 2013. *Aerosol, muros y ciudad* [documentary video]. Mexico City. 58 min.

Castleman, Craig. 1984. *Getting Up: Subway Graffiti in New York*. Cambridge, MA: MIT Press.

CBC News. 2011. "Mayor Ford Declares War on Graffiti." *CBC News*, April 7. www.cbc.ca/news/canada/toronto/mayor-ford-declares-war-on-graffiti-1.1021543.

Chaffee, L. G. 1989. "Political Graffiti and Wall Painting in Greater Buenos Aires: An Alternative Communication System." *Studies in Latin American Popular Culture* 8: 37–60.

Chalfant, Henry, and James Prigoff. 1991. *Spraycan Art*. London: Thames and Hudson.

Chen, M., and E. Criger. 2012. "Ford Unveils New Toronto Graffiti-Fighting App." *City News Toronto*, April 18. www.citynews.ca/2012/04/18/ford-unveils-new-toronto-graffiti-fighting-app/.

Chicoine, D., and H. Ikehara. 2008. "Nuevas Evidencias Sobre el Período Formativo del Valle de Nepeña: Resultados Preliminares de la Primera Temporada de Excavaciones en Caylán." In *El Período Formativo: Enfoques y Evidencias Recientes. Cincuenta Años de la Misión Arqueológica Japonesa y su Vigencia. Primera Parte,* edited by Peter Kaulicke and Yoshio Onuki. *Boletín de Arqueología PUCP* 12: 349–369.

Chikikova, Maria. 1992. "The Thracian Tomb Near Sveshtari, in Helis II, Sboryanovo—Studies and Prospects." *Proceedings of the Conference in Isperih, 8 December 1988, Sofia, Bulgaria* 143–163.

Chiţescu, Lucien, Spiridon Cristocea, and Anişoara Sion. 1986. "Cercetările arheologice de la complexul monumentelor feudale de la Cetăţeni, jud." *Argeş, Materiale şi cercetări arheologice* 16: 275–281.

Chmielewska, E. 2007. "Framing [Con]text, Graffiti and Place." *Space and Culture* 10: 145–169.

Christiansen, K. 2014. *Piero della Francesca: Personal Encounters*. New York: Metropolitan Museum of Art.

City of Antioch. n.d. "Graffiti is not Art—Graffiti is a Crime." www.ci.antioch.ca.us/CityGov/Police/beatalert/031611.pdf.

City of Toronto. n.d.a. *Graffiti Management Plan*. www.toronto.ca/graffiti/plan.htm.

———. n.d.b "StreetARToronto." www.toronto.ca/streetart/

Cody, J. 1993. "Tread the Sidewalks of New York To Pick Up Off-the-Wall Wisdom." *The Wall Street Journal*, October 7.

Cody, L. F. 2003. "Every Lane Teems With Instruction, and Every Alley Is Big With Erudition: Graffiti in Eighteenth Century London." In *The Streets of London*, edited by T. Hitchcock and H. Shore, 82–100. London: Rivers Oram Press.

Cocroft, W., D. Devlin, J. Schofield, and R. J. C. Thomas. 2006. *War Art, Murals and Graffiti, Military Life, Power and Subversion*. York, UK: Council for British Archaeology.

Coe, Michael. 2005. *The Maya, 6th Edition*. London: Thames and Hudson.

Cole, C. 1991. "Oh Wise Women of the Stalls . . ." *Discourse and Society* 2: 401–411.

Colla, E. 2007. *Conflicted Antiquities: Egyptology, Egyptomania, Egyptian Modernity*. Durham, NC: Duke University Press.

Comşa, Maria. 1960a. "Câteva date arheologice în legătură cu stăpânirea bulgară în nordul Dunării în secolele IX-X." In *Omagiu lui Constantin Daicoviciu cu prilejul împlinirii a 60 de ani,* edited by Emil Condurachi, 69–81. Bucharest, Romania: Academia Republicii Populare Române.

Comşa, Maria. 1960b. "Die Bulgarische Herrschaft nordlich der Donau während des IX. und X. Jh." *Lichte der archäologischen Forschungen, Dacia, N. S.* IV: 395–422.

———. 1962. "Semne din epoca feudală timpurie incizate pe o coloană romano-bizantină." *Studii şi cercetări de istorie veche* 13: 177–190.

Cooper, Martha, and Henry Chalfant. 1984. *Subway Art*. London: Thames & Hudson.

Cope2. 1996. "Cope2: 'Keepin Shit Real in the Boogie Down.'" *Fat Cap Magazine*. NYC Special Part 1, Oslo, Norway.

Corà, B. 2004. "Note Sull'Arte Ambientale." In *Sentieri Nell'Arte*, edited by Anna Mazzanti, 35–38. Florence, Italy: Artout.

Crawford, K. 2005. "In the Sheep: Aspen Carvings as Indicators of Land Capacity and Use." *The Society for California Archaeology Newsletter* 39: 1, 26–29.

Cummings, V., and R. Johnston. 2007. "Leaving Place: An Introduction to Prehistoric Journeys." In *Prehistoric Journeys*, edited by V. Cummings and R. Johnston, 1–7. Oxford, UK: Oxbow Books.

Daley, S. 1984. "Kiley Sets Goal of 1985 for a Cleaner Subway." *The New York Times,* October 4. www.nytimes.com/1984/10/04/nyregion/kiley-sets-goal-of-1985-for-a-cleaner-subway.html.

D'Angelo, F. J. 1976. "Fools' names and fools' faces are always seen in public places: A study of graffiti." *Journal of Popular Culture* 10: 102–109.

Daniell, C. 2011. "Graffiti, Calliglyphs and Markers in the UK." *World Archaeologies* 3: 454–476.

David, B., and J. Thomas. 2008. "Landscape Archaeology: Introduction." In *Handbook of Landscape Archaeology*, edited by B. David and J. Thomas, 27–43. Walnut Creek, CA: Left Coast Press, Inc.

Davies, C. 2012. "Alaa Awad." *ArtForum,* February 27. http://artforum.com/words/id=30394.

D'Avino, M. 1964. *The Women of Pompeii*. Naples, Italy: Loffredo Press.

Davis, Diane E. 2007. "El Factor Giuliani: delincuencia, la cero tolerancia en el trabajo policiaco y la transformación de la esfera pública en la Ciudad de México." *Estudios sociológicos* 25: 639–681.

Daw, T. 2012. "Stonehenge Vandalism." Sarsen.org [blog], October 20. www.sarsen.org/2012/10/stonehenge-vandalism.html.

Death Wish [film]. 1974. Directed by Michael Winner. Paramount Pictures, USA.

De Buck Gallery. 2013. "De Buck Gallery." www.debuckgallery.com.

de Certeau, M. 1975. *L'Écriture de l'histoire*. Paris: Gallimard.

———. 1984. *The Practice of Everyday Life: Volume 1*. Berkeley, CA: University of California Press.

de Saussure, Ferdinand. (1916) 1974. *Course in General Linguistics*. Trans. Wade Baskin. London: Fontana/Collins.

———. (1916) 1983. *Course in General Linguistics*. Trans. Roy Harris. London: Duckworth.

Deiulio, A. M. 1973. "Desk Top Graffiti: Scratching Beneath the Surface." *Journal of Research and Development in Education* 7: 100–104.

———. 1978. "Of Adolescent Cultures and Subcultures." *Educational Leadership* 35: 518–520.

DeKorne, J. 1970. *Aspen Art in the New Mexico Highlands*. Santa Fe, NM: Museum of New Mexico Press.

Deleuze, G., and F. Guattari. 2006. *A Thousand Plateaus: Capitalism and Schizophrenia*. Minneapolis, MN: University of Minnesota Press.

Delumeau, J. 1978. *La Peur en Occident, XIVe-XVIIIe siècles*. Paris: Fayard.

Dery, Mark. 1994. "Black to the Future: Interviews with Samuel R. Delany, Greg Tate, and Tricia Rose." In *Flame Wars: the Discourse of Cyberculture*, edited by M. Dery, 179–222. Durham, NC: Duke University Press.

Dill, L. 1993. "Aerosol Paint Takes the Heat for Graffiti Boom." *Modern Paint & Coatings* 83: 8–10.

Dodson, A. 2009. *Amarna Sunset: Nefertiti, Tutankhamun, Ay, Horemheb, and the Egyptian Counter-reformation*. Cairo, Egypt: American University in Cairo Press.

Dumdum, S. 1986. "Graffiti Literature at the Water Closets of the Universities of Cebu." *Solidarity* 108–109, 146–148.

Dundes, A. 1966. "Here I Sit: A Study of American Latrinalia." *Kroeber Anthropological Society Papers* 34: 91–105.

Duncan, C. 1995. "The Art Museum as Ritual." *Art Bulletin* 77: 10–13.

Durmuller, U. 1988a. "Research on Mural Sprayscripts (Graffiti)." In *Methods in Dialectology*, edited by A. R. Thomas, 278–284. Clevedon, UK: Multilingual Matters.

———. 1988b. "Sociolinguistic Aspects of Mural Sprayscripts (Graffiti)." *Sociolinguistics* 17: 1–16.

Earth Crew 2000. n.d. "Images and Quotations." 50mm Los Angeles http://50mmlosangeles. com/artist.php?artistId=570.

Elian, Alexandru, and Nicolae Şerban Tanaşoca, eds. 1975. *Fontes Historiae Daco-Romaniae, Volume III (Scriptores Byzantini, saec. XI-XIV)*. Bucharest, Romania: Romanian Academy.

El Rashidi, Y. 2011. *The Battle for Egypt: Dispatches from the Revolution*. New York: New York Review Books.

Evergreen. n.d. "Mission and Vision." www.evergreen.ca/en/about/mission-and-vision/.

Evergreen Brick Works. n.d. "The Community Advisory Committee." http://ebw. evergreen.ca/about/whos-involved/community-advisors.

"Exhibition Notices: Don Valley Pressed Brick Works." 1897. *The Globe*, September 3. http://search.proquest.com.ezproxy.torontopubliclibrary.ca/docview/1401053712?accountid=14369

Ezrahi, S. D. 1988. "Considering the Apocalypse: Is the Writing on the Wall Only Graffiti?" In *Writing and the Holocaust*, edited by B. Lang, 137–153. New York: Holmes & Meier.

Fagan, S. M. 1981. "Ten Words for a Dollar: A New Campus Custom." *Western Folklore* XL, 337–343.

Fairey, S. 2012. "Obey Giant." http://obeygiant.com.

Falk, J. 2009. *Identity and the Museum Experience.* Walnut Creek, CA: Left Coast Press, Inc.

Farkas, Y. 2011. *Toronto Graffiti: The Human Behind the Wall.* Toronto, Canada: Toronto Graffiti.

Farnia, M. 2014. "A Thematic Analysis of Graffiti on the University Classroom Walls—A Case of Iran." *International Journal of Applied Linguistics & English Literature* 3 (3): 48–57.

Feiner, J. S., and S. M. Klein. 1982. "Graffiti Talks." *Social Policy* 12: 47–53.

Felisbret, E. 2009. *Graffiti: New York.* New York: Abrams.

Ferrell, J. 1996. *Crimes of Style: Urban Graffiti and the Politics of Criminality.* Lebanon, NH: Northeastern University Press.

———. 2010. "Precarious and Imperfect: Youth, Cultural Identity, and Crime." Keynote address, Youth Crime Reduction in the Nordic Countries Conference/Danish National Centre for Social Research, Copenhagen, Denmark, December.

Ferrell, J., and R. D. Weide. 2010. "Spot Theory." *City* 14:48–62.

Fideicomiso Centro Histórico de la Ciudad de México. "Plan Integral de Manejo del Centro Historico 2011–2016." www.centrohistorico.df.gob.mx/.

Fiedler, Uwe. 1992. *Studien zu Gräberfeldern des 6. bis 9. Jahrhunderts an den unteren Donau, I.* Bonn, Germany: Rudolf Habelt.

Fitzpatrick, T. 2009. *Art and the Subway: New York Underground.* New Brunswick, NJ: Rutgers University Press.

Fleming, J. 2001. *Graffiti and the Writing Arts of Early Modern England.* London: Reaktion Books.

Flint, A. 1992. "Hate Graffiti Are Reported in Wellesley College Dorm." *The Boston Globe,* December 18, 12.

Flores, Alonso. 2009. "El Portal arte urbano 24 hrs." *Km.cero. Mexico City* 13: 15.

Florescu, Radu, and Ion Miclea. 1979. "Tezaure transilvane la Kunsthistorisches." Museum din Viena, Bucharest, Romania: Meridiane.

Formentin, V. 2012. "I graffiti in volgare: uno studio filologico-linguistico." In *Graffiti templari. Scritture e simboli medievali in una tomba etrusca di Tarquinia,* edited by C. Tedeschi, 95–113. Rome, Italy: Viella.

Fraenkel, B. 2002. *Les Écrits de New York. Septembre 2001.* Paris: Textuel.

Fraser, B. 1980. "Meta-Graffiti." *Maledicta: The International Journal of Verbal Aggression* 4: 258–260.

Frood, E. 2013. "Egyptian Temple Graffiti and the Gods: Appropriation and Ritualization in Karnak and Luxor." In *Heaven on Earth: Temples, Ritual, and Cosmic Symbolism in the Ancient World,* edited by Deena Ragavan, Oriental Institute Seminars, 285–318. Chicago, IL: Oriental Institute of the University of Chicago.

Fuchs, P., R. Pazschke, C. Schmits, G. Yenque, and J. Briceño. 2006. "Investigaciones Arqueológicas en el Sitio de Sechín Bajo." In *Procesos y Expresiones de Poder, Identidad y Orden Tempranos en Subamérica, Primera Parte,* edited by Peter Kaulicke and Tom Dillehay. *Boletín de Arqueología PUCP* 10:111–135.

Futrell, R., and B. G. Brents. 2003. "Protest as Terrorism? The Potential for Violent Anti-Nuclear Activism. *American Behavioral Scientist* 46 (6): 745–765.

Gadamer, Han-Georg. 2004. *Truth and Method.* 2nd revised edition. Trans. J. Weinsheimer and D. G. Marshall. New York: Crossroad.

Gadpaille, W. J. 1971. "Graffiti: Its Psychodynamic Significance." *Sexual Behavior* 2: 45–51.

Gamboni, D. 1997. *The Destruction of Art: Iconoclasm and Vandalism since the French Revolution.* London: Reaktion Books.

Ganz, N. 2006. *Graffiti Women: Street Art from Five Continents.* New York: Abrams.

Garcia, P. A., & Geisler, J. S. 1988. "Sex and Age/Grade Differences in Adolescents' Self-Disclosure." *Perceptual and Motor Skills, 67*: 427–432.

García Canclini, Néstor. 1998. *Las cuatro ciudades de México.* In *Modernidad y multiculturalidad: la ciudad de México a fin del siglo,* edited by Néstor García Canclini, 19–39. Mexico City: UAM Grijalbo.

Gastman, Roger, and Caleb Neelon. 2010. *The History of American Graffiti.* New York: HarperCollins.

Gell, A. 1998. *Art and Agency: An Anthropological Theory.* Oxford, UK: Clarendon.

GHOST. "Writers Corner." *Stress* October: 9.

Gilligan, C. 1982. *In a Different Voice: Psychological Theory and Women's Development.* Cambridge, MA: Harvard University Press.

Gilmar, S. T., and D. Brown. 1983. "The Final Word on the Bright Adolescent or What To Do with Graffiti." *English Journal* 72:42–46.

Glazer, N. 1979. "On Subway Graffiti in New York." *National Affairs* 54: 3–12.

Glover, M. 2012. "Great Works: Flaming, 2008 by Zevs." *The Independent,* December 29. www.independent.co.uk/arts-entertainment/art/great-works/great-works-flaming-2008-by-zevs-8432039.html.

Goffman, E. 1974. *Forms of Talk.* Philadelphia, PA: University of Pennsylvania Press.

Goffman, I. 1961. *Encounters: Two Studies in the Sociology of Interaction.* Indianapolis, IN: Bobbs-Merrill.

Goldman, Ari L. 1981a. "City to Use Pits of Barbed Wire in Graffiti War." *The New York Times,* December 15. www.nytimes.com/1981/12/15/nyregion/city-to-use-pits-of-barbed-wire-in-graffiti-war.html?n=Top%2fReference%2fTimes%20Topics%2fSubjects%2fT%2fTransit%20Systems.

———. 1981b. "Dogs to Patrol Subway Yards." *The New York Times,* September 15. www.nytimes.com/1981/09/15/nyregion/dogs-to-patrol-subway-yards.html.

Goldstein, Richard. 1973. "The Graffiti 'Hit' Parade." *New York,* March 26, 34–39.

Gonzales, D. 1994. "Death Row." *Vibe* May: 66–71.

Goodwin, M. H. 2006. *The Hidden Life of Girls: Games of Stance, Status, and Exclusion.* Malden, MA: Blackwell Publishing.

Graddol, D., and J. Swann. 1996. *Gender Voices.* Cambridge, UK: Blackwell Publishers.

Grecu, A. 1950. "Bulgaria în nordul Dunării în veacurile IX-X." *Studii și cercetări de istorie medie* 1: 223–236.

Greenberg, M. A., and A. A. Stone. 1992. "Emotional Disclosure about Traumas and Its Relation to Health: Effects of Previous Disclosure and Trauma Severity." *Journal of Personality and Social Psychology* 63: 75–84.

Greenberger, A. 2013. "Meet the Artist: Street Artist Zevs on Attacking Luxury Brands with Their Own Logos." *Artspace*, September 12. www.artspace.com/magazine/interviews_features/zevs.

Grider, S. A. 1975. "Con Safos: Mexican-Americans, Names and Graffiti." *Journal of American Folklore* 88: 132–141.

Groebner, V. 2008. *Defaced: The Visual Culture of Violence in the Late Middle Ages.* Trans. P. Selwyn. New York: Zone.

Guillery, P. 2005. "The Secret Policeman's Graffiti in Clerkenwell." *English Heritage Research News* 1: 14.

Gulliford, A. 2007. "Reading the Trees: Colorado's Endangered Arborglyphs and Aspen Art." *Colorado Heritage* Autumn: 18–29.

Gumpert, G. 1975. "The Rise of Uni-Comm." *Today's Speech* 23: 34–38.

Haan, M. N., and R. B. Hammerstrom. 1980. *Graffiti in the Big Ten.* New York: Warner Books.

———. 1981. *Graffiti in the Pac Ten.* New York: Warner Books.

Haas, J., and W. Creamer. 2006. "Crucible of Andean Civilization, the Peruvian Coast from 3000 to 1800 B.C." *Current Anthropology* 47: 745–775.

Haley, Alex, and Malcolm X. 1965. *The Autobiography of Malcolm X.* New York: Grove Press.

Halliday, M. A. K. 1985. *An Introduction to Functional Grammar.* London: Edward Arnold.

Halsey, M., and A. Young. 2006. "Our Desires are Ungovernable—Writing Graffiti in Urban Space." *Theoretical Criminology* 10 (3): 275–306. http://melbournegraffiti.com/news/AUG2006_Our_Desires_Are_Ungovernable.pdf.

Harcourt, Bernard E., and Jens Ludwig. 2006. "Broken Windows: New Evidence from New York City and a Five-City Social Experiment." *University of Chicago Law Review* 73 (1): 271–320.

Harhoiu, S. V. Mormânt. 2000. "M-Q." In *Enciclopedia arheologiei și istoriei vechi a României, III,* edited by Constantin Preda, 148–150. Bucharest, Romania: Editura Enciclopedică.

Harney C. 1999. *The Way It Is: One Water . . . One Air . . . One Mother Earth.* Nevada City, CA: Blue Dolphin Publishing.

Harrison, Peter. 1970. "The Central Acropolis, Tikal, Guatemala: A Preliminary Study of the Functions of Its Structural Components during the Late Classic Period." Unpublished PhD dissertation, University of Pennsylvania, Philadelphia, PA.

———. 1999. *The Lords of Tikal: Rulers of an Ancient Maya City*. London: Thames and Hudson.

Hauser, Arnold. 1986. *Mannerism: The Crisis of the Renaissance and the Birth of Modern Art*. New York: Belknap Press.

Haviland, William A., and Anita de Laguna Haviland. 1995. "Glimpses of the Supernatural: Altered States of Consciousness and the Graffiti of Tikal, Guatemala." *Latin American Antiquity* 6: 295–309.

Hegberg, E., and W. Sutton. 2011. "Junk in the Trunk: Vintage Aspen Erotica from Bored Lonely Shepherds." Presented at the 76th Annual Meeting of the Society for American Archaeology, Sacramento, CA, March 30–April 3.

Heldman, K. 1995. "Mean Streaks: Amped, Angry and in Your Face, Graffiti Refuses to Die." *Rolling Stone*, February 9, 48–49, 51–52, 64.

Hentschel, E. 1987. "Women's Graffiti." *Multilingual Journal of Cross-Cultural and Interlanguage Communication* 6 (3): 287–308.

Higgins, R. 1989. "BC Investigates Painting of Racial Phrase in Dorm." *Boston Globe*, February 26, 28.

Hijabi Fierce. 2012. "Egyptian Graffiti-Tahrir Square Political Art" [video]. May 26. www.youtube.com/watch?v=GA1zZv3s6YE.

Hirsch, E. D., J. F. Kett, and J. S. Trefil. 1993. *The Dictionary of Cultural Literacy*. New York: Houghton Mifflin.

Holban, Maria, ed. 1968. *Călători străini despre Țările Române, Volume I*. Bucharest, Romania: Editura Științifică.

Hubler, S. 1993. "Tag Lines." *Los Angeles Times*, November 1, B1, B4.

Hunter, G. 2012. *Street Art From Around the World*. London: Arcturus.

Hutson, Scott R. 2011. "The Art of Becoming: The Graffiti of Tikal, Guatemala." *Latin American Antiquity* 22 (4): 403–426.

Hvala, T. 2008. "Streetwise Feminism: Feminist and Lesbian Street Actions, Street Art and Graffiti in Ljubljana." *Amnis* 8. http://amnis.revues.org/545.

Iorga, Nicolae. 1901. *Operele lui Constntin Cantacuzino*. Bucharest, Romania: Institutul de Arte Grafice și Editură Minerva.

Ivanov, Dimităr. 1980. "Le trésor de Borovo." In *Actes du II-e Congrès International de Thracologie* (Bucarest, 4–10 Septembre 1976), edited by I. Radu Vulpe, 391–404. Bucharest, Romania: Romanian Academy.

James, Todd, and David Villorente. 2007. *Mascots and Mugs: The Characters and Cartoons of Subway Graffiti*. New York: Testify Books.

Jonas, C., and A. Weintraub. 1973. *Cost of Graffiti to the City of New York: Final Draft Report*. New York: City of New York Bureau of the Budget.

Jones, P. E. 1991. "The Impact of Economic, Political, and Social Factors on Recent Overt Black/White Racial Conflict in Higher Education in the United States." *Journal of Negro Education* 60: 524–537.

Jones-Baker, D. 1981. "The Graffiti of Folk Motifs in Cotswold Churches." *Folklore* 92: 160–167.

Jorgenson, D. O., and C. Lange. 1975. "Graffiti Content as an Index of Political Interest." *Perceptual and Motor Skills* 40: 616–618.

Jourard, S. M. 1971. *The Transparent Self*. New York: Van Nostrand.

Juxtapoz Magazine. 2012. *Juxtapoz Presents: All City Canvas: the Short Film*. www.youtube.com/watch?v=5v8Uq-conc4.

Kampen, Michael. 1987. "The Graffiti from Tikal." *Estudios de Cultural Maya* 11: 155–179.

Kates, B., A. Browne, and B. Herbert. 1981. "Doomsday Express: All the Vital Signs Point to Death." *New York Daily News*, October 4, 3, 63.

Kelling, George L. 1991. "Reclaiming the Subway." *City Journal* Winter. www.city-journal.org/story.php?id=1614.

Kelling, George L., and James Q. Wilson. 1982. "Broken Windows: The Police and Neighborhood Safety." *Atlantic Monthly* March: 29, 38.

Kinsey, A. C., W. B. Pomeroy, C. E. Martin, and P. H. Gebhard. 1953. *Sexual Behavior in the Human Female*. Philadelphia, PA: W. B. Saunders.

Kirk, J. 1990. "Racial Graffiti Found on Walls at Wesleyan U." *The New York Times*, May 5, 29.

Klein, F. 1974. "Commentary." In *Sexual Behavior: An Interdisciplinary Perspective*, edited by L. Gross, 87–88. New York: Spectrum.

Košev, Dimităr. 1981. *Istorija na Bălgarija, II, Părva Bălgarska Dărjava*. Sofia, Bulgaria: The Editorial House of the Bulgarian Academy of Sciences.

Kwon, M. 2004. *One Place After Another: Site-Specific Art and Locational Identity*. Cambridge, MA: MIT Press.

La Barre, W. 1979. "Academic Graffiti." *Maledicta: The International Journal of Verbal Aggression* 3: 275–276.

Lachmann, R. 1988. "Graffiti as Career and Ideology." *The American Journal of Sociology* 94 (2): 229–250.

Lakoff, R. 1973. "Language and Woman's Place." *Language in Society* 2: 45–80.

Lankevich, G. J. 1998. *American Metropolis: A History of New York City*. New York: New York University Press.

László, Gyula, and István Rácz. 1984. *The Treasure of Nagyszentmiklós*. Budapest, Hungary: Corvinia Kiadó.

Lazarides. 2009. "Zevs Arrested in Hong Kong." Lazarides, July 30. www.lazinc.com/story/200,zevs-arrested-hong-kong.

Leach, E. 1989. *Claude Lévi-Strauss*. Chicago, IL: University of Chicago Press.

Lechner, M. 2007. "Zevs, de la Bombe de Militant." *Liberation*, October 1, 30. www.gzzglz.com/download/press/liberation-01.pdf.

Lennon, J. 2013. "Interview with Mahmud Graffiti, a Graffiti Writer in Alexandria, Egypt." *Rhizomes: Cultural Studies in Emerging Knowledge* 25. www.rhizomes.net/issue25/lennon_mg/index.html.

Lévi-Strauss, C. 1962. *Totémisme*. Paris: Presses Universitaires de France.

———. 1963. *Totemism*. Trans. R. Needham. Boston, MA: Beacon Press.

Lewisohn, C. 2011. *Abstract Graffiti*. London: Merrell.

Ley, D., and R. Cybriwsky. 1974. "Urban Graffiti as Territorial Markers." *Annals of the Association of American Geographers* 64: 491–505.

Lindsay, J. 1960. *The Writing on the Wall: An Account of Pompeii in Its Last Days*. London: Mueller.

Loewenstine, H. V., G. D. Ponticos, and M. A. Paludi. 1982. "Sex Differences in Graffiti as a Communication Style." *Journal of Social Psychology* 117: 307–308.

Lomas, H. D. 1973. "Graffiti: Some Clinical Observations." *Psychoanalytic Review* 60: 71–89.

Long, A. 2005. *Aboriginal Scarred Trees in New South Wales: A Field Manual*. Hurstville, NSW, Australia: Department of Environment and Conservation.

Longnecker, G. J. 1977. "Sequential Parody Graffiti." *Western Folklore* 36: 354–360.

Lovata, T. 2007. *Inauthentic Archaeologies: Public Uses and Abuses of the Past*. Walnut Creek, CA: Left Coast Press, Inc.

———. 2013. "Southern Rocky Mountain Arborglyphs: Correlates, Contrasts, and Comparative Research Opportunities in the Study of Carved Trees and Rock Art." *American Indian Rock Art* 40: 689–700.

Luca, Cristian, and Dragoş Măndescu. 2001. *Rituri şi ritualuri funerare în spaţiul extracarpatic în secolele VIII-X*. Brăila, Romania: Editura Istros.

Luna, Antonio, ed. 2013. *Ilegal Squad: revista de grafiti y arte urbano, Mexico City* 76: passim. http://issuu.com/ilegalsquad/docs/ilegal_squad_issue_76.

Luna, G. C. 1987. "Graffiti of Homeless Youth." *Society* 24: 73–78.

MacCoun, R. J., and W. M. Hix. 2010. "Cohesion and Performance." In National Defense Institute (collective authorship), *Sexual Orientation and U.S. Military Policy: An Update of RAND's 1993 Study*. Santa Monica, CA: RAND.

Macdonald, Nancy. 2001. *The Graffiti Subculture: Youth, Masculinity, and Identity in London and New York*. London: Palgrave.

MacLeod, C., V. Plesch, and C. Schoell-Glass. 2009. *Elective Affinities: Testing Word and Image Relationships*. Amsterdam and New York: Rodopi.

Mailer, N. 1973. "The Faith of Graffiti." In *The Faith of Graffiti,* edited by M. Kurlansky and J. Naar, 4-9. Westport, CT: Praeger Publishers.

Mairs, R. 2010. "Egyptian 'Inscriptions' and Greek 'Graffiti' at El Kanais in the Egyptian Eastern Desert." In *Ancient Graffiti in Context*, edited by J. A. Baird and Claire Taylor, 153–164. London: Routledge.

Malecki, D. S. 1992. "Restroom Graffiti No Joking Matter." *Rough Notes* July: 18.

Maler, Teobert. 1911. *Explorations in the Department of the Peten, Guatemala: Tikal.* Memoirs of the Peabody Museum of American Archaeology and Ethnology, Harvard University 5(1). Cambridge, MA: Harvard University Press.

Mallea-Olaetxe, J. 2000. *Speaking Through the Aspens: Basque Tree Carvings in California and Nevada.* Reno, NV: University of Nevada Press.

———. 2010. "Basque Aspen Carvings: The Biggest Little Secret of the Western USA." In *Wild Signs: Graffiti in Archaeology and History,* edited by J. Oliver and T. Neal, 5–14. Oxford, UK: Archaeopress.

———. 2011. Introduction. In *Basque Aspen Art of the Sierra Nevada,* edited by J. M. Earl and P. Earl, 10–11. Reno, NV: Baobab Press.

Măndescu, Dragoş. 2001. "Cezar Bolliac. Pagini uitate din zorii arheologiei româneşti." *Buletinul Centrului de Istorie Comparată a Societăţilor Antice–CICSA* 3: 17–28.

———. 2006. *Cetăţeni. Staţiunea geto-dacă de pe valea Dâmboviţei superioare.* Brăila, Romania: Editura Istros.

Martilla, L. 1971. "Write On!—Goodbye to Female Compliance." *Sexual Behavior* 2: 49–50.

Martin, M. A., J. Machalek, and T. L. Anderson. 2012. "Boys Doing Art: The Construction of Outlaw Masculinity in a Portland, Oregon, Graffiti Crew." *Journal of Contemporary Ethnography* 42 (3): 259–290.

Martin, Simon, and Nikolai Grube. 2008. *Chronicle of the Maya Kings and Queens.* London: Thames and Hudson.

Mayer, B. 2013. "The Egyptian Military Has Done the Muslim Brotherhood a Huge Favor." *Policy.Mic,* August 26. www.policymic.com/articles/60917/the-egyptian-military-has-done-the-muslim-brotherhood-a-huge-favor.

Mazzini, F., and G. Romano. 1976. *Opere d'arte a Vercelli e nella sua provincia. Recuperi e restauri 1968-76. Catalogo della mostra.* Vercelli, Italy: Civico Museo Francesco Borgogna.

McCool, S. 2001. "Quaking Aspen and the Human Experience: Dimensions, Issues, and Challenges." In *Sustaining Aspen in Western Landscapes: Symposium Proceedings,* United States Department of Agriculture, Forest Service, Rocky Mountain Research Station Proceedings, RMRS-P-18, 147–160.

McCormick, C. 2011a. "A Criminal Mind." *PaperMag,* February. www.papermag.com/2011/02/zevs_a_criminal_mind.php.

———. 2011b. "The Writing on the Wall." In *Art in the Streets,* edited by J. Deitch with R. Gastman and A. Rose, 19–42. New York: Skira Rizzoli.

McDonald, F. 2013. *The Popular History of Graffiti.* New York: Skyhorse Publishing.

McNickle, C. 1993. *To be Mayor of New York: Ethnic Politics in the City.* New York: Columbia University Press.

Melhorn, J. J., and R. J. Romig. 1985. "Rest Room: A Descriptive Study." *The Emporia State Research Studies* 34: 29–45.

Mersel, I. 2011. "Revolutionary Humor." *Globalizations* 8 (5): 669–674.

Metropolitan Transportation Authority. 2012. *The Road Back: A Historic Review of the MTA Capital Program.* New York: Permanent Citizens Advisory Committee to the MTA.

Miglio, L., and C. Tedeschi. 2012. "Per lo studio dei graffiti medievali. Caratteri, categorie, esempi." In *Storie di cultura scritta. Studi per Francesco Magistrale,* edited by P. Fioretti, 605–627. Spoleto, Italy: CISAM.

Mijatev, Kristo. 1929. "Madarskijat konnik." *Izvestija na Bălgarskija Archeologičeski Instituta* 5: 90–126.

———. 1943. "Krumovijat dvoreţ i drugi novootkriti postroiki v Pliska." *Izvestija na Bălgarskija Archeologičeski Instituta* 14: 73–135.

Miller, Ivor L. 2002. *Aerosol Kingdom: Subway Painters of New York City.* Jackson, MS: University Press of Mississippi.

Miller, Mary, and Simon Martin. 2004. *Courtly Art of the Ancient Maya.* London: Thames and Hudson.

Miller, Mary, and Megan O'Neil. 2014. *Art and Architecture of the Ancient Maya.* London: Thames and Hudson.

Milley, D. 2011. "Graffiti Ordered Removed at Evergreen Brick Works." *East York Mirror,* February 8. www.insidetoronto.com/news-story/60707-graffiti-ordered-removed-at-evergreen-brick-works/.

Mîrţu, Flaminiu. 1963. "Contribuţii la cunoaşterea vieţii dacilor de pe valea superioară a râului Dâmboviţa." *Studii şi articole de istorie* 5: 13–26.

———. 1964. "Fragment de rhyton ceramic geto-dacic descoperit la Cetăţeni-Muscel." *Studii şi cercetări de istorie veche* (15) 4: 529–534.

Mitchell, W. J. T. 1985. "Word and Image." In *Critical Terms for Art History,* edited by R. S. Nelson & R. Shiff, 51–61. Chicago, IL: University of Chicago Press.

Moloney, P. 2013. "Toronto Expands Anti-Graffiti Campaign by Hiring Private Company to Remove It." *The Toronto Star,* July 31. www.thestar.com/news/city_hall/2013/07/31/toronto_expands_antigraffiti_campaign_by_hiring_private_company_to_remove_it.html.

Monto, Martin A., Janna Machalek, and Terri L. Anderson. 2012. "Boys Doing Art: The Construction of Outlaw Masculinity in a Portland, Oregon, Graffiti Crew." *Journal of Contemporary Ethnography* 42 (3): 259–290.

Naar, Jon, Mervyn Kurlansky, and Norman Mailer. 1974. *The Faith of Graffiti.* New York: Praeger.

Nagourney, Adam. "Cities Report Surge in Graffiti." *The New York Times,* July 19. www.nytimes.com/2011/07/19/us/19graffiti.html?_r=0.

Natale, V. 2005. "Botteghe itineranti e frescanti nella seconda metà del secolo." In *Arti figurative a Biella e a Vercelli. Il Quattrocento,* edited by V. Natale, 59–84. Biella, Italy: Riverbanca & Progetti Editore.

Newall, V. 1986–1987. "The Moving Spray Can: A Collection of Some Contemporary English Graffiti." *Maledicta: The International Journal of Verbal Aggression* 9: 39–47.

Nielson, E. 2013. "'It Could Have Been Me': The 1983 Death of a NYC Graffiti Artist." National Public Radio, September 16. www.npr.org/blogs/codeswitch/2013/09/16/221821224/it-could-have-been-me-the-1983-death-of-a-nyc-graffiti-artist.

Nierenberg, J. 1983. "Proverbs in Graffiti: Taunting Traditional Wisdom." *Maledicta: The International Journal of Verbal Aggression* 7: 41–58.

Nilsen, D. L. F. 1978. "Graffiti vs Doublespeak: The Anti-Establishment Strikes Back." *English Journal* 67: 67–102.

———. 1981. "Sigma Epsilon XI: Sex in the Typical University Classroom." *Maledicta: The International Journal of Verbal Aggression* 5: 79–91.

Nora, P. 1984. "Entre Mémoire et Histoire. La problématique des lieux." In *Les lieux de mémoire*, edited by P. Nora, xvii–xlii. Paris: Gallimard.

Nwoye, Onuigbo. 1993. "Social Issues on Walls: Graffiti on University Lavatories." *Discourse and Society* 4: 419–442.

O'Doherty, B. 1986. *Inside the White Cube: The Ideology of the Gallery Space*. Berkeley, CA: University of California Press.

Oliver, J., and T. Neal. 2010. *Wild Signs: Graffiti in Archaeology and History*. Oxford, UK: British Archaeological Reports International Series, 2074.

Olton, Elizabeth Drake. 2010. "The Once and Future King: A New Approach to Ancient Maya Mortuary Monuments from Palenque, Tikal, and Copan." Unpublished PhD dissertation, University of New Mexico, Albuquerque.

———. 2015. "Spaces of Transformation at Temple 1, Tikal, Guatemala." In *Maya Imagery, Architecture, and Activity: Space and Spatial Analysis in Art History*, edited by Maline D. Werness-Rude, and Kaylee Spcencer, 271–305. Albuquerque, NM: University of New Mexico.

Ontario Heritage Trust. n.d. "Who We Are." www.heritagetrust.on.ca/Aboutus/Who-we-are.aspx.

Opler, M. K. 1974. "Commentary." In *Sexual Behavior: An Interdisciplinary Perspective*, edited by L. Gross, 86–87. New York: Spectrum.

Ortiz, Ramiro. 1916. *Per la storia della cultura italiana in Rumania*. Bucharest, Romania: C. Sfetea.

Panaitescu, Petre. 1994. *Interpretări românești*, 2nd edition. Bucharest, Romania: Biblioteca Enciclopedică de Istorie a României.

Pantoja, Sara. 2008. "Pintan Bardas del Estadio Azteca." *El Universal*, January 12. www.eluniversal.com.mx/notas/473732.html.

Pasquarelli, A. 2013. "Fashion Faux Pas: Logos as Art or Trademark." *Crains New York Business*, February 11. www.crainsnewyork.com/article/20130211/RETAIL_APPAREL/130219994#ixzz2KoQmYcBZ.

Pederson, C. 2003. *Mike Lucey the Crazy Herder and His Tree Carvings*. Aloha, OR: Author.

Pennebaker, J. W., and A. K. Beall. 1986. "Confronting a Traumatic Event: Towards an Understanding of Inhibitions and Disease." *Journal of Abnormal Psychology* 95: 274–281.

Pennebaker, J. W., and D. Y. Sanders. 1976. "American Graffiti: Effects of Authority and Reaction Arousal." *Personality and Social Psychology Bulletin* 2: 264–267.

Perala, D. 1990. "Quaking Aspen." In *Silvics of North America, Volume 2: Hardwoods,* Agriculture Handbook 654, edited by R. Burns and B. Honkala, 555–569. Washington, DC: U.S. Department of Agriculture, Forest Service.

Pertz, Georg Heinrich, and Friedrich Kurze, eds. 1891. *Monumenta Germaniae Historicae, Scriptores rerum Germanicarum in usum scholarum. Annales Fuldenses sive Annales regni Francorum orientalis.* Hanover, Germany: Hahnsche Buchhandlung.

Petrucci, A. 1986. *La scrittura: Ideologia e rappresentazione.* Turin, Italy: Einaudi.

Philips, R. B. 2003. "Community Collaborations in Exhibitions." In *Museums and Source Communities: A Routledge Reader,* edited by A. K. Brown and L. Peers, 155–170. London and New York: Routledge.

Phillips, S. A. n.d. "Graffiti." In *Grove Art Online. Oxford Art Online,* www.oxfordarton line.com.

Plesch, V. 2002a. "Graffiti and Ritualization: San Sebastiano at Arborio." In *Medieval and Early Modern Rituals: Formalized Behavior in Europe, China and Japan,* edited by J. Rollo-Koster, 127–46. Leiden: Brill.

———. 2002b. "Memory on the Wall: Graffiti on Religious Wall Paintings." In "The Cultural Processes of Appropriation" (special issue edited by K. Ashley and V. Plesch). *Journal of Medieval and Early Modern Studies* 32 (1): 167–197.

———. 2004. *Le Christ peint. Le cycle de la Passion dans les chapelles peintes du XVe siècle dans les États de Savoie.* Chambéry, France: Société Savoisienne d'Histoire et d'Archéologie.

———. 2005. "Body of Evidence: Devotional Graffiti in a Piedmontese Chapel." In *On Verbal/Visual Representation,* edited by M. Heusser et al., 179–191. Amsterdam and New York: Rodopi (Word & Image Interactions 4).

———. 2006a. *Painter and Priest: Giovanni Canavesio's Visual Rhetoric and the Passion Cycle at La Brigue.* South Bend, IN: University of Notre Dame Press.

———. 2006b. "Sixteenth-Century Pictorial and Dramatic Religious Cycles in the French Alps: Time for the Renaissance Yet? In Hamburger." In *Tributes in Honor of James H. Marrow: Studies in Late Medieval and Renaissance Painting and Manuscript Illumination,* 281–293. Turnhout, Belgium: Brepols.

———. 2007. "Using or Abusing? On the Significance of Graffiti on Religious Wall Paintings." In *Out of the Stream: New Directions in the Study of Mural Painting,* edited by L. Afonso and V. Serrão, 42–68. Newcastle, UK: Cambridge Scholars Publishing.

———. 2010. "Destruction or Preservation? The Meaning of Graffiti at Religious Sites." In *Art, Piety and Destruction in European Religion, 1500–1700,* edited by V. Raguin, 137–172. Farnham and Burlington, UK: Ashgate (Visual Culture in Early Modernity).

Plesch, V. 2014. "Come capire i graffiti di Arborio?" In "Immagini Efficacy/Efficacious Images" [special issue edited by Massimo Leone]. *Lexia: Rivista di semiotica/Journal of Semiotics* 16–17: 127–147.

Pollock, G. 2007. *Conceptual Odysseys: Passages to Cultural Analysis*. London, New York: I. B. Tauris.

Popa-Lisseanu, George. 1934. *Izvoarele istoriei românilor, Volume I*. Bucharest, Romania: Tipografia Bucovina.

Powers, S. 1999. *The Art of Getting Over: Graffiti at the Millennium*. London: St. Martin's Press.

Pozorski, S., and T. Pozorski. 1987. *Early Settlement and Subsistence in the Casma Valley, Peru*. Iowa City, IA: University of Iowa Press.

———. 1992. "Early Civilization in the Casma Valley, Peru." *Antiquity* 66: 845–870.

———. 2008. "Early Cultural Complexity on the Coast of Peru." In *Handbook of South American Archaeology*, edited by Helaine Silverman and William Isbell, 607–631. New York: Springer.

———. 2011. "The Square-Room Unit as an Emblem of Power and Authority within the Initial Period Sechín Alto Polity, Casma Valley, Peru." *Latin American Antiquity* 22: 427–451.

Pozorski, T., and S. Pozorski. 1999. "Temple, Palais ou Entrepôt? La Centralization du Pouvoir dans le Perou Prehistorique." In *La Ville et le Pouvoir in Amerique*, edited by Jérôme Monnet, 87–110. Paris: L'Harmattan.

———. 2005. "Architecture and Chronology at the Site of Sechín Alto, Casma Valley, Peru." *Journal of Field Archaeology* 30: 143–161.

Prail, Frank J. 1972. "Subway Graffiti Here Called Epidemic." *The New York Times*, February 11, 39.

Pratt, M. L. 1991. "Arts of the Contact Zone." *Profession* 33–40.

Preda, Constantin. 1973. *Monedele geto-dacilor: Biblioteca de arheologie 19*. Bucharest, Romania: Academy Publisher.

Prell, Riv-Ellen. 1990. "Rage and Representation: Jewish Gender Stereotypes in American Culture." In *Uncertain Terms: Negotiating Gender in American Culture*, edited by F. Ginsburg and A. Lowenhaupt Tsing, 248–266. Boston, MA: Beacon Press.

Pritchard, V. 1967. *English Medieval Graffiti*. Cambridge, UK: Cambridge University Press.

Quaglia, R., D. Bazzano, and W. Camurati. 2004. *Arborio: Storia, arte, fede, economia, tradizioni*. Arborio, Italy: Comune di Arborio and Vercelli: Provincia di Vercelli.

Radden Keefe, B. n.d.. "Graffiti in Medieval Art." In *Grove Art Online. Oxford Art Online*, www.oxfordartonline.com.

Rahn, J. 1999. "Painting without Permission: An Ethnographic Study of Hip-Hop Graffiti Culture." *Material Culture Review* 49: 20–38.

Rammelzee. 2012. Unpublished manuscript "Iconoclast Panzerism," reprinted for the exhibition *Rammellzee: The Equation, the Letter Racers* at the Suzanne Geiss Company. New York: Suzanne Geiss Company.

Randolph, L. B. 1990. "Racism on College Campuses: Racial Prejudice Makes Resurgence at Predominantly White Institutions." *Ebony* December: 128–130.

Ranzal, Edward. 1972. "Ronan Backs Lindsay Anti Graffiti Plan, Including Cleanup Duty." *The New York Times,* August 29, 66.

Read, A. W. (1935) 1977. *Classical American Graffiti: Lexical Evidence from Folk Epigraphy in Western North America: A Glossarial Study of the Low Element in the English Vocabulary.* New York: Maledicta.

Rees, N. 1979. *Graffiti Lives O.K.* London: Unwine.

Reisner, R. 1974. "Commentary." In *Sexual Behavior: An Interdisciplinary Perspective,* edited by L. Gross, 85–86. New York: Spectrum.

Reisner, R., and L. Wechsler. 1974. *Encyclopedia of Graffiti.* New York: MacMillan.

Resources Inventory Committee. 2001. *Culturally Modified Trees of British Columbia: A Handbook for the Identification and Recording of Culturally Modified Trees.* British Columbia, Canada: Archaeology Branch, B.C. Ministry of Small Business, Tourism and Culture.

Ricardo, Anaya Cortés. 2002. *El Graffiti en México¿ Arte o Desastre?* Querétaro, Mexico: Universidad Autónoma de Querétaro.

Rider, D. 2011. "Ford's Graffiti War Dings Businesses, Non-Profits." *The Toronto Star,* April 21. www.thestar.com/news/gta/2011/04/21/fords_graffiti_war_dings_businesses_nonprofits.html.

Rodriguez, A., and R. P. Clair. 1999. "Graffiti as Communication: Exploring the Discursive Tensions of Anonymous Texts." *Southern Communication Journal* 65: 1–15.

Roe, P. 1974. *A Further Exploration of the Rowe Chavin Seriation and Its Implications for North Central Coast Chronology.* Dumbarton Oaks Studies in Pre-Columbian Art and Archaeology 13. Washington, DC: Dumbarton Oaks.

Rogers, K. 2002. "Pleading for Peace." *Las Vegas Review Journal,* March 24. www.reviewjournal.com/lvrj_home/2002/Mar-24-Sun-2002/news/18354606.html.

Rosetti, Dinu V. 1960. "Un depozit de unelete, câteva ştampile anepigrafice şi o monedă din a doua epocă a fierului." *Studii şi cercetări de istorie veche* 11 (2): 391–404.

———. 1962. "Şantierul arheologic Cetăţeni (r. Muscel, reg. Argeş)." *Materiale şi cercetări arheologice* 8: 74–88.

Rosetti, Dinu V., and Lucian Chiţescu. 1973. "Cetatea geto-dacică de la Cetăţeni, jud. Argeş." *Buletinul monumentelor istorice* 42 (4): 55–58.

Rosner, Rebecca. 2000. "The 'Penn Girl' Stigma, Black Pants and All." *The Daily Pennsylvanian,* October 8. http://thedp.com/print/40256.

Ruvulcaba, Patricia. 2013. "La Bota cumple 8 añitos." *Km.cero. Mexico City* 64: 11.

Salmon, P. 1998. *Sandia Peak: A History of the Sandia Peak Tramway and Ski Area.* Albuquerque, NM: Sandia Peak Ski & Tramway.

Sarto, C. 2013. "The Provocations of Zevs, the Artist who Manipulates Designer Labels." De Buck Gallery, October 2. www.debuckgallery.com/news/60/le-provocazioni-di-zevs-l-artista-che-manipola-le-griffe.

Sassen, S. 2011. "The Global Street: Making the Political." *Globalizations* 8 (5): 573–579.

Sayre, N. 2001. "Review of *Speaking through the Trees: Basque Tree Carvings in California and Nevada* by J. Mallea-Oleatxe." *Geographical Review* 91 (3): 604–606.

Schacter, R. 2008. "An Ethnography of Iconoclash." *Journal of Material Culture* 13 (1): 35–61.

———. 2013. *The World Atlas of Street Art and Graffiti.* New Haven, CT: Yale University Press.

Scheibel, D. 1994. "Graffiti and 'Film School' Culture: Displaying Alienation." *Communication Monographs* 61: 1–18.

Schele, Linda, and Peter Mathews. 1998. *The Code of Kings: The Language of Seven Sacred Maya Temples and Tombs.* New York: Scribner.

Schiffrin, D. 1994. *Approaches to Discourse.* Cambridge, UK: Blackwell.

Schofield, J. 2010. "'Theo Loves Doris': Wild-Signs in Landscape and Heritage Context." In *Wild Signs: Graffiti in Archaeology and History,* edited by J. Oliver and T. Neal, 71–79. Oxford, UK: Archaeopress.

Sechrest, L., and L. Flores. 1969. "Homosexuality in the Philippines and the United States: The Handwriting on the Wall." *Journal of Social Psychology* 79: 3–12.

Seno, E. 2010. *Trespass: A History of Uncommissioned Urban Art.* Köln, Germany: Taschen GmbH.

Shady, R. 2004. *Caral: la ciudad del fuego sagrado.* Lima, Peru: Interbank.

Sharer, Robert L., and P. Loa Traxler. 2006. *The Ancient Maya, 6th Edition.* Stanford, CA: Stanford University.

Shepperd, A. 1980. *Sandhurst: The Royal Military Academy.* London: County Life Books.

Shulman, B. H., D. Peven, and A. Byrne. 1973. "Graffiti Therapy." *Hospital and Community Psychiatry* 24: 339–340.

Sîrbu, Valeriu. 2004. "The Ceremony Helmets—Masterpieces of the Getae's Toreutics and Figurative Art." In *Thracians and Circumpontic World II, Proceedings of the Ninth International Congress of Thracology,* Chişinău-Vadul lui Vodă, 6–11 September 2004, edited by Ion Niculiţă, Aurel Zanoci, Mihai Băţ, and Cartdidact Chişinău, 29–44. Chişinău, Moldova: Cartdidact.

Sîrbu, Valeriu, and Gelu Florea. 1997. *Imaginar şi imagine în Dacia preromană.* Brăila, Romania: Istros.

Snyder, G. J. 2009. *Graffiti Lives: Beyond the Tag in New York's Urban Underground.* New York: New York University Press.

Soja, E. 1996. *Thirdspace.* Malden, MA: Blackwell.

———. 2009. "Taking Space Personally." In *The Spatial Turn: Interdisciplinary Perspectives,* edited by Barney Warf and Santa Arias, 11–35. New York: Routledge.

Solomon, H., and H. Yager. 1975. "Authoritarianism and Graffiti." *The Journal of Social Psychology* 97: 149–150.

Spann, S. 1973. "The Handwriting on the Wall." *English Journal* 62: 1163–1165.

Spânu, Daniel. 2012. *Tezaurele dacice. Creaţia în metale preţioase din Dacia preromană.* Bucharest, Romania: Simetria.

Spender, D. 1980. *Man Made Language*. London: Routledge.

Stahl, J. 2009. *Street Art*. Köln, Germany: H. F. Ullman.

Stancev, Stančjo, and Stefan Ivanov. 1957. *Nekropolät do Novi Pazar*. Sofia, Bulgaria: Balgarska Akademia na Naukite.

Stancev, Stančjo, and Ţărkvata do s. Viniţa. 1952. "Izvestija na Bălgarskija Archeologičeski." *Instituta* 18: 305–328.

Starr, M. 1990. "The Writing on the Wall." *Newsweek*, November 25. www.newsweek.com/writing-wall-205980.

Ştefan, Gheorghe, Ion Barnea, Maria Comşa, and Eugen Comşa. 1967. *Dinogetia I. Aşezarea feudală timpurie de la Bisericuţa-Garvăn*. Bucharest, Romania: Romanian Academy.

Stein, Jean. 1956. "The Art of Fiction No. 12." *The Paris Review* (Spring) 12: 28–52.

Stern, Carol, and Robert W. Stock. 1980. "Graffiti: The Plague Years." *The New York Times Magazine*, October 19, 44–60.

Stern, K. S. 1990. *Bigotry on Campus: A Planned Response*. Report No. HE 024 094. American Jewish Committee. ERIC Document Reproduction Service No. ED 328 108.

Stiles, W. B., P. L. Shuster, and J. H. Harrigan. 1992. "Disclosure and Anxiety: A Test of the Fever Model." *Journal of Personality and Social Psychology* 63: 980–988.

Stoye, John. 1994. *Marsigli's Europe, 1680–1730: The Life and Times of Luigi Ferdinando Marsigli, Soldier and Virtuoso*. New Haven, CT: Yale University Press.

Stryd, A., and V. Feddema. 1998. *Sacred Cedar: The Cultural and Archaeological Significance of Culturally Modified Trees*. Vancouver, Canada: The David Suzuki Foundation.

Style Wars (1983) 2003 [film]. Produced by Henry Chalfant, Tony Silver. USA: Public Art Films.

Szentpétery, Imre II, ed. 1938. *Scriptores rerum Hungaricarum tempore ducum regumque stirpis Arpadianae gestarum*. Budapest, Hungary: Hungarian Academy.

Tanzer, H. H. 1939. *The Common People of Pompeii*. Baltimore, MD: John Hopkins Press.

Taylor, K. 2014. "List of Names in Sex Assaults Roils Columbia." *The New York Times*, May 13. www.nytimes.com/2014/05/14/nyregion/list-of-names-in-sex-assaults-roils-columbia.html.

Taylor, M. 1990. "Racist Remarks Spray-Painted at 2 Schools." *San Francisco Chronicle*, September 20, B7.

Tedeschi, C. 2012. "Introduzione." In *Graffiti templari. Scritture e simboli medievali in una tomba etrusca di Tarquinia*, edited by C. Tedeschi, 7–11. Roma, Italy: Viella.

Teixeira, R. P., and E. Otta. 1998. "Restroom Graffiti: A Study of Gender Differences." *Estudos de Psicologia*, 3: 229–250.

Teixeira, R. P., E. Otta, and J. D. O. Siqueira. 2003. "Between the Public and the Private: Sex Differences in Restroom Graffiti from Latin and Anglo-Saxon Countries." Universidade de São Paulo Faculdade de Economia, Administração e Contabilidade Working Paper No. 03/007. www.ead.fea.usp.br/WPapers/2003/03-007.pdf.

The New York Times. 1971. "'TAKI 183' Spawns Pen Pals." July 21. http://graphics8.
nytimes.com/packages/pdf/arts/taki183.pdf.

———. 1987. "Battle Line on Graffiti Is Shifting" [unsigned editorial]. April 19.
www.nytimes.com/1987/04/19/nyregion/battle-line-on-graffiti-is-shifting.html.

The Taking of Pelham One Two Three [film]. 1974. Directed by Joseph Sargent. Palomar
Pictures.

Theodorescu, Răzvan. 1974. *Balcani Bizanţ. Occident. La începuturile culturii medievale
româneşti (sec. X-XIV).* Bucharest, Romania: Editura Academiei Republicii Socialiste
România.

Thompson, J. Eric S. 1954. *The Rise and Fall of Maya Civilization.* Norman, OK:
University of Oklahoma Press.

Thompson, M. 2009. *American Graffiti.* New York: Parkstone International.

Thurman, K. 2001. "The Wooden Canvas: Documenting Historic Aspen Art Carvings in
Southwest Colorado." *Heritage Matters* November: 5.

Tilley, C. 2008a. *Body and Image: Explorations in Landscape Phenomenology 2.* Walnut
Creek, CA: Left Coast Press, Inc.

———. 2008b. "Phenomenological Approaches to Landscape Archaeology." In *Handbook
of Landscape Archaeology,* edited by B. David and J. Thomas, 271–276. Walnut Creek,
CA: Left Coast Press, Inc.

Tilley, C., and W. Bennett. 2004. *The Materiality of Stone: Explorations in Landscape
Phenomenology.* London: Berg Publishers.

Toronto City Clerk, Administration Committee. 2006. "Don Valley Brick Works—Lease
of Part of 550 Bayview Avenue to Evergreen Environmental Foundation (Ward
29-Toronto Danforth)." Report No. 5. Toronto, Canada: City of Toronto.

Toronto Police Services. 2011. "Fact Sheet: Graffiti Prevention & Control."
www.torontopolice.on.ca/community/graffiti/factsheet.pdf.

Toth, J. 1993. *The Mole People: Life in the Tunnels Beneath New York City.* Chicago, IL:
Chicago Review Press.

Touring Club Italiano. 1976. *Piemonte (non compresa Torino).* Milan, Italy: Touring Club
Italiano.

Tracy, S. K. 2005. "The Graffiti Method." *Australian Midwifery Journal* 18: 22–26.

Trahan, A. 2011. "Identity and Ideology: The Dialogic Nature of Latrinalia."
Internet Journal of Criminology 1–9. www.internetjournalofcriminology.com/
Trahan_Identity_and_Ideology_The%20Dialogic_Nature_of_Latrinalia_IJC_
September_2011.pdf.

Trik, Helen, and Michael E. Kampen. 1983. *The Graffiti of Tikal, Tikal Report Number
31.* University Museum Monograph 57. Philadelphia, PA: The University Museum,
Pennsylvania.

Tudor, Dumitru. 1967. "Răspândirea amforelor greceşti ştampilate în Moldova, Muntenia
şi Oltenia." *Arheologia Moldovei* 5: 37–80.

Varone, A. 1991. "The Walls Speak." *Archaeology* 11: 30–31.

Vasari, G. 1912–1915. *Lives of the Most Eminent Painters, Sculptors & Architects.* 10 vols. London: Macmillan and The Medici Society.

Vervort, L., and S. Lievens. 1989. "Graffiti in Sports Centers: An Exploratory Study in East Flanders. *Tijdsch Rift-Voor-Sociale-Wetenschappen* 34: 56–53.

Villa, B. 2010. "Graffiare gli affreschi: immagine e devozione in alcuni casi lombardi tra il XIV e il XVI secolo." *Laurea specialistica in Storia dell'Arte*. Siena, Italy: Università degli Studi di, Facoltà di Lettere e Filosofia.

Villhauer, Monica. 2010. *Gadamer's Ethics of Play: Hermeneutics and the Other.* Plymouth, MA: Lexington.

Vincent, Alice. 2013. "'Missing' Banksy Jubilee Work Listed for Auction at £450,000." *The Telegraph,* February 18. www.telegraph.co.uk/culture/art/artsales/9876797/Missing-Banksy-Jubilee-work-listed-for-auction-at-450000.html.

Vulpe, Radu. 1966. *Aşezări getice din Muntenia.* Bucharest, Romania: Editura Meridiane.

Waclawek, Anna. 2010. *Graffiti and Street Art.* London: Thames and Hudson.

Waldner, L. K., and B. A. Dobratz. 2013. "Graffiti as a Form of Contentious Political Participation." *Sociology Compass* 7 (5): 377–389.

Wales, E., and B. Brewer. 1976. "Graffiti in the 1970's." *The Journal of Social Psychology* 99: 115–123.

Walter, P., ed. 1996. *Saint Antoine entre mythe et légende.* Grenoble, France: Ellug.

Warakomski, J. 1991. "The Humor of Graffiti." In *Spoken in Jest,* edited by G. Bennett, 279–289. Sheffield, UK: Sheffield Academic Press.

Webster, Helen. 1963. "Tikal Graffiti." *Expedition* 6 (1): 37–47.

Whitley, D. 2011. *Introduction to Rock Art Research.* Walnut Creek, CA: Left Coast Press, Inc.

Wittner, L. 1997. *The Struggle Against the Bomb, Volume Two: Resisting the Bomb: A History of the World Nuclear Disarmament Movement, 1954–1970.* Stanford, CA: Stanford University Press.

Wild Style (1983) 2002 [film]. Director Charlie Ahearn, Rhino, USA.

Wilkerson, I. 1985. "Jury Acquits All Transit Officers in 1983 Death of Michael Stewart." *The New York Times,* November 25. www.nytimes.com/1985/11/25/nyregion/jury-acquits-all-transit-officers-in-1983-death-of-michael-stewart.html?scp=1&sq=%22michael+stewart%22+jury+white&st=nyt&pagewanted=all.

Wilson, J. 2012. "Getting Graffiti: Brick Works Shows Off What Rob Ford Would Clean Up." *Globe and Mail,* October 10, 2010 (updated August 23, 2012). www.theglobeandmail.com/news/toronto/getting-graffiti-brick-works-shows-off-what-rob-ford-would-clean-up/article1214695/?service=mobile.

Wilson, James Q., and George L. Kelling, "Broken Windows: The Police and Neighborhood Safety." *Atlantic Monthly* 249 (3): 29–38.

Wolf, N. 2002. *The Beauty Myth: How Images of Beauty Are Used Against Women.* New York: Harper.

Woolf, V. (1929) 1957. *A Room of One's Own.* New York: Harcourt Brace Jovanovich.

Worrell, C. 2009. "Expanding the Range: Pushing the Boundaries of Arborglyph Documentation." *Forest History Today* Spring/Fall: 40–46.

Zadorojnyi, Alexi V. "Transcripts of Dissent? Political Graffiti and Elite Ideology Under the Principate." In *Ancient Graffiti in Context*, edited by J. A. Baird and Claire Taylor, 110–133. London: Routledge.

Zevs. (2013). "Zevs." http://gzzglz.com/.

INDEX

ABOUT THE EDITORS & CONTRIBUTORS

About the Editors

Troy Lovata is an associate professor in the Honors College at the University of New Mexico. For the last 10 years he has taught and researched topics in the Honors College related to public archaeology, the demarcation of public space, and the ways in which people mark the landscape. His research includes studies of the links between contemporary public art and prehistoric monuments; examination of how people use the past as currency in the present; and using landscape archaeology to study historic carved aspen trees in New Mexico and Colorado. Dr. Lovata has also served as the mayoral-appointed chair of the Albuquerque Arts Board. His book, *Inauthentic Archaeologies: Public Uses and Abuses of the Past*, was published by Left Coast in 2007.

Elizabeth Olton is an independent scholar affiliated with the Department of Art and Art History at the University of New Mexico and the Institute of American Indian Arts, Santa Fe. With a PhD in art history from the University of New Mexico, she has also taught at St. Mary's Honors College in Maryland and the University of Texas at San Antonio. Olton's research interests include both historic and contemporary graffiti, modern visual culture, funerary arts, and the art and architecture of the ancient Americas. A portion of her master's thesis "The Art of Self Promotion: Representations of Authority, Autonomy and Wealth in the Murals from Structure 16, Tulum, Quintana Roo" was published in the Third Palenque Round Table in 2002; her most recent publication, inspired by her dissertation, is in the edited book *Maya Imagery, Architecture, and Identity* (University of New Mexico Press, 2015). In the fall of 2013 Olton presented her work on the graffiti from Tikal at the conference "Scribbling Through History: Comparative Studies of Graffiti from Ancient Egypt Onwards" at the University of Oxford.

About the Contributors

Bruce Beaton is a Toronto-based heritage practitioner, actor, and writer. He works as a museum educator at the Mackenzie House Museum and as an interpreter at Campbell House Museum and the Evergreen Brick Works. Bruce sits on the Board of Directors for the Kensington Market Historical Society, where he initiated and manages their oral history project *Kensington Talks*. He also delivers heritage-based walking tours for Heritage Toronto. Beaton is a graduate of the Masters of Museum Studies program at the University of Toronto. He also attended the University of Waterloo (Hon. B.A. English, Minor in Drama) and the London Academy of Music and Dramatic Art (LAMDA). For more information, see www.brucebeaton.info.

Colleen M. Beck is a professor at the University of Nevada's Desert Research Institute. She has conducted archaeological research in the Great Basin, California, the Southwest, the Southern Plains, and western South America. Since 1991, she has been involved in research related to Cold War archaeology, in particular the nuclear testing remains at the Nevada Test Site and the protesters' legacy at the Nevada Peace Camp. She is interested in the ways these types of remains embody the perceptions and views of their makers. She became curious about graffiti during a childhood visit to Independence Rock in Wyoming, where she was fascinated by the carved and dated names of the travelers who passed by long ago. This led to a lifelong interest in rock art and historic graffiti. The research at the Peace Camp was a natural extension of this pursuit and provided a rare opportunity to study contemporary graffiti in an archaeological context.

Christopher Daniell has more than 30 years of experience in the historic environment sector and has worked as an archaeologist and historian for York Archaeological Trust, as a historic environment consultant, and currently works for the Defence Infrastructure Organisation of the UK Government. He is an associate of the Institute of Historic Building Conservation (IHBC) and a member of the Chartered Institute for Archaeologists (CIfA). Daniell has written many books and articles, in particular "Death and Burial in Medieval England," "From Norman Conquest to Magna Carta England 1066–1215," and the *Atlas of Early Modern Britain*. His particular interest in the study of calliglyphs and graffiti derives from a particular building at the Royal Military Academy at Sandhurst (analyzed in detail for the first time in this volume), from which a much wider appreciation was established. In 2011

he wrote "Graffiti, Calliglyphs and Markers in the UK" (*Archaeologies, the Journal of the World Archaeological Congress*) which explored in depth the differences between graffiti and calliglyphs.

Harold Drollinger is a research archaeologist at the Desert Research Institute in Las Vegas, Nevada. He has more than 30 years of experience in prehistoric and historic archaeology in the Midwest, Southwest, and Great Basin regions of the United States. His recent work includes the Peace Camp located next to the Nevada Test Site. Other interests are spatial analyses and religious and symbolic expressions in archaeological landscapes.

Alexandra Duncan completed an Honors Bachelor of Arts in visual culture and communication at the University of Toronto in 2010, during which time she developed an interest in graffiti and street art that drove many of her scholarly and creative outputs (including the short documentary film *Wabash*). Duncan then received a Master of Arts in Communication and Culture from York University in 2012, focusing upon the shifting status of graffiti within the commercial art economy. She is now undertaking a PhD in the history of art, design, and visual culture at the University of Alberta in Edmonton, and her ongoing research seeks to analyze the development of disability arts (and particularly the work of neurodivergent artists) in Canada. Duncan continues to be passionate about following developments in graffiti and street art in her local communities of Edmonton and Toronto, in international urban settings, and online. In 2014, her experimental, interactive, multimedia ebook *What Does Graffiti Mean Now?* was made available for download (for free) at the Apple iBooks store.

Lauren W. Falvey began her career in archaeology studying material culture at prehistoric sites in the Southwest and Great Basin. Through her travels and her time growing up in Las Vegas, she developed a deep appreciation of street art and graffiti. When the opportunity to be involved with research at the Peace Camp came along, she jumped at the chance to combine her interests in material culture and graffiti. She now conducts archaeological research in Georgia and spends her free time photographing street art in and around Atlanta.

Gabrielle Gopinath is a historian of modern and contemporary art at Humboldt State University in Arcata, California. She received a PhD in the history of art from Yale University and an MFA from the Rhode Island School

of Design. She has written about video art, photography, graffiti, and sculpture. Her writing has appeared in the *Quarterly Review of Film and Video*, *The Soundtrack*, the *Oxford Art Journal*, and the *Yale University Art Gallery Bulletin*.

John Lennon is an assistant professor of English at the University of South Florida. His research is principally concerned with how marginalized individuals exert a politicized voice in collectivized actions. He has published *Boxcar Politics: The Hobo in Literature and Culture 1869–1956* (Massachusetts Press, 2014), and his work has appeared in various edited volumes and journals, including *American Studies*, *Rhizomes: Cultural Studies in Emerging Knowledge*, *Acoma*, and *Americana: Journal of American Popular Culture*. He is currently at work on a new project examining conflict graffiti from a global perspective, exploring the roots and routes of graffiti in areas of war, extreme poverty, and in the aftermath of natural disasters. Please contact him on Twitter at @hoboacademic or jflennon@usf.edu.

Dragoş Măndescu is a Romanian expert archaeologist focused on Iron Age field of research. He received his Master of Arts degree in ancient history and archaeology in 2001 and a magna cum laude PhD from Bucharest University in 2009 with a thesis on the Late Iron Age chronology in the North Balkans. He has conducted several training stages on archaeology and heritage at Eötvös Loránd University in Budapest and Complutense University of Madrid. At present, he is the deputy manager of the Argeş County Museum and the director of a scientific research program granted by the National Research Council under the authority of the Romanian Ministry of Education. He is the author of several books and articles on North Balkan archaeology and the history of archaeology in Romania. For three years (2002–2004) he conducted field research on the archaeological site of Cetăţeni (Argeş County, Romania, 125 km northwest from Bucharest) in the fringes of the southern Carpathians. Some results of this research program were presented in January 2013 at The Seventh World Archaeological Congress held at The Dead Sea–Jordan, in a session organized by Inés Domingo Sainz on the scenes of life and death in rock art.

Melissa R. Meade is a PhD candidate at Temple University in media and communication, and is an ethnographer currently engaged in fieldwork for her dissertation project in the anthracite coal region of northeastern Pennsylvania. Meade is the founder and editor of *The Anthracite Coal Region of*

Northeastern Pennsylvania, an interactive documentary, interpretive, and archival digital humanities project representing the extensive social effects and cultural transformations of the Appalachian region of northeastern Pennsylvania containing the only reserves of United States' anthracite coal. She holds a Master's degree in educational linguistics and intercultural communication and a graduate certificate in women, gender and sexuality studies from the University of Pennsylvania, and a postgraduate diploma in Intercultural Studies from the University of the Basque Country, Donostia-San Sebastián, Spain, where she was a Rotary Ambassadorial Scholar. She has taught at Temple University in the School of Media and Communication, at the University of the Arts, Philadelphia, and was a Visiting Professor of International Programs at Instituto Tecnológico y de Estudios Superiores de Monterrey (ITESM), Querétaro, Mexico. She serves as a reviewer for both the Global Fusion Conference and for the International Communication Association Convention.

Tyson Mitman is a professor and PhD candidate in communication, culture, and media at Drexel University. His interests lie in the areas of subjectivity, subculture studies, visual culture, the construction of identity, issues of public space, theories of democracy, and graffiti. His research focuses on graffiti culture, specifically how "writers" construct their identity within the subculture, how they practice their craft, how they see themselves in relation to other forms of art and social production, and how their interactions with space and the city are framed and constructed politically. He is also interested in how graffiti writers produce "art" both within and "outside" a capitalist system and what production in these different areas mean considering the juxtaposition of writers as a criminal class and as neoliberal agents. Mitman's other works include "Terrorism as Failed Political Communication" in the *International Journal of Communication,* "The Critical Moral Voice on American Newspaper Opinion Pages" in *Communication, Culture and Critique,* and a piece for the *New York Post* titled "Tagging Over Banksy, Why NYC 'Writers' Do It." He believes graffiti can be a legitimate form of art and expression, and that some things just look better covered in tags. He has spoken about graffiti's impact on cities and culture across the United States and Europe. He is also the editor of the graffiti lifestyle magazine *The Infamous.*

Véronique Plesch is a professor of art history at Colby College and has published on subjects ranging from Passion iconography to art in the Duchy of Savoy, and from passion plays to early modern graffiti, with forays into

contemporary art. She is the author of *Illuminating Words: The Artist's Books of Christopher Gausby* (Smith College Museum of Art, 1999), *Le Christ peint: le cycle de la Passion dans les chapelles peintes du XVe siècle dans les États de Savoie* (Société Savoisienne d'Histoire et d'Archéologie, 2004), and *Painter and Priest: Giovanni Canavesio and the Passion Cycle at Notre-Dame des Fontaines, La Brigue* (University of Notre Dame Press, 2006). She also co-edited (with Kathleen Ashley) *The Cultural Processes of Appropriation* (special issue of the *Journal of Medieval and Early Modern Studies*, 2002), (with Claus Clüver and Leo Hoek) *Orientations: Space/Time/Image/Word* (Rodopi, 2005), (with Catriona MacLeod and Charlotte Schoell-Glass) *Elective Affinities: Testing Word and Image Relationships* (Rodopi, 2009), (with Catriona MacLeod and Jan Baetens) *Efficacité/Efficacy: How to Do Things With Words and Images?* (Rodopi, 2011), and (with Claus Clüver and Matthijs Engelberts) the forthcoming *The Imaginary: Word and Image/L'Imaginaire: texte et image* (Rodopi). She is the current president of the International Association of Word and Image Studies.

Shelia Pozorski went to Peru for the first time as an undergraduate pursuing her B.A. at Harvard University, and her fieldwork in the Moche Valley resulted in an honor's thesis that detailed subsistence and seasonality at an agricultural village. She intensified this focus during her dissertation research while earning her PhD at the University of Texas at Austin. As part of this research, she conducted excavations at eight Moche Valley sites, including the Moche Huacas del Sol y de la Luna and the Chimu capital of Chan Chan. After earning her PhD, Shelia returned to the Moche Valley to work on a study of prehispanic irrigation. Shelia's attention turned to the Casma Valley in the 1980s when she and Tom Pozorski started fieldwork there. As a team, the Pozorskis have contributed more generally to Andean archaeology by demonstrating the importance of the Initial Period in Andean development. The Pozorskis continue to do fieldwork in Peru, most recently at the inland site of Huerequeque, a satellite of the Sechín Alto Polity.

Thomas Pozorski earned his PhD in anthropology in 1976 at the University of Texas at Austin. Most of his archaeological career has been spent investigating the prehistoric civilizations along the north coast of Peru. In the 1970s he excavated in the Moche Valley at Chan Chan, the Moche Pyramids, the Caballo Muerto Complex, Alto Salaverry, and Pajatambo, as well as numerous canals in the prehistoric irrigation system. Since 1980, his research has focused on the investigation of early cultures of the Casma Valley. Research activities have included excavation and survey of numerous Preceramic

(3000–2100 BC), Initial Period (2100–1000 BC), and Early Horizon (1000–200 BC) sites such as Pampa de las Llamas-Moxeke, Sechín Alto, Taukachi-Konkán, Las Haldas, Huaynuná, Tortugas, Bahía Seca, Huerequeque, San Diego, and Pampa Rosario. He also carried out investigations at the early Preceramic site of Almejas as well as at the raised field system in the lower Casma Valley. He also has done additional archaeological work in Arkansas, Pennsylvania, and Colorado. His research interests lie in the social, political, and economic aspects of early civilization as well as prehistoric subsistence, internal site organization, and settlement patterns. His work, done mostly in collaboration with Shelia Pozorski, has resulted in the publication of two books and more than 80 scholarly articles. He plans to continue to work in the Casma Valley for several more years.

Amardo Rodriguez is a Laura J. and L. Douglas Meredith Professor in the Communication and Rhetorical Studies Department at Syracuse University. His research and teaching interests look at the potentiality of new conceptions of communication to redefine and enlarge contemporary understandings of democracy, diversity, and community. He earned his PhD from Howard University.

Pamela Scheinman has photographed street art (murals, graffiti, trade signs, and billboards) for more than 30 years, focusing on Mexico City and New York, but including forays to Philadelphia and Baltimore as well as trips to Albuquerque, Buenos Aires, Lima, Paris, Strasbourg, Montreal, Madrid, Lisbon, and Santa Fe. Scheinman translates the online graffiti magazine *Ilegal Squad* from Spanish to English, and also did research and still photography for *Aerosol: muros y ciudad* (2013), a video documenting the history of graffiti in Mexico City, presented at the Museo Casa de León Trotsky and other venues with director-producer Emilio Castillo Díaz. Earlier interviews with the graffiti mural collective Neza Arte Nel were expanded into conference papers for the College Art Association in Seattle and the Community College Humanities Association in Philadelphia (2006), which led to collaboration with curator Chris Gilbert at the Baltimore Museum of Art, whose exhibit *Dark Matter* explored alternative art forms under the radar and included a visual loop on Baltimore graffiti. Since 2005 Scheinman has divided her time between teaching in the Department of Art & Design at Montclair State University in New Jersey and her apartment in Mexico City's Historic Center. A graduate of Barnard College, Columbia University, New York, she holds an MFA from Indiana University, Bloomington.

Shannon Todd is the assistant curator at Campbell House Museum in Toronto, Ontario. She holds a Master's of Museum Studies degree from the University of Toronto, as well as a Master's of Classics from King's College London. In 2014, she spoke at the Ontario Museum Association annual conference on a panel titled "Avast! The Internet, Pirates and Museums: A Treasure Map to Connectivity," which focused on the importance of making connections with local community groups and tapping into niche markets. Her exhibition with Bruce Beaton, *Graffiti Works 1989–2008,* was produced in 2013 as a student exhibition project. It has been on display at the Evergreen Brick Works since its installation in summer 2013.